The English Virtuoso

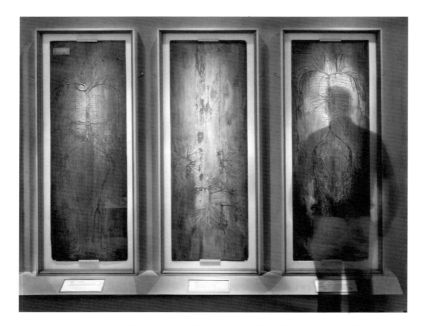

FRONTISPIECE *Arteries, Nerves, Veins, Royal College of Surgeons, London, 2007.*
Photograph: Matthew Pillsbury. Courtesy of the artist and the Bonni Benrubi
Gallery.

The English Virtuoso

Art, Medicine, and Antiquarianism in the Age of Empiricism

Craig Ashley Hanson

THE UNIVERSITY OF CHICAGO PRESS
CHICAGO AND LONDON

CRAIG ASHLEY HANSON is assistant professor of art history at Calvin College.

The University of Chicago Press, Chicago 60637
The University of Chicago Press, Ltd., London
© 2009 by Craig A. Hanson
All rights reserved. Published 2009
Printed in the United States of America

18 17 16 15 14 13 12 11 10 09 1 2 3 4 5

ISBN-13: 978-0-226-31587-4 (cloth)
ISBN-10: 0-226-31587-8 (cloth)

Library of Congress Cataloging-in-Publication Data

Hanson, Craig Ashley.
 The English virtuoso : art, medicine, and antiquarian-
ism in the age of Empiricism / Craig Ashley Hanson.
 p. cm.
 Includes bibliographical references and index.
 ISBN-13: 978-0-226-31587-4 (hardcover : alk. paper)
 ISBN-10: 0-226-31587-8 (hardcover : alk. paper)
 1. England—Intellectual life—17th century.
2. England—Intellectual life—18th century. 3. Art—
Collectors and collecting—England. 4. Physicans—
England. 5. Antiquarians—England. I. Title.
DA380.H36 2009
305.5'52094109032—dc22

 2008007640

For Kristine

Vehement desire (which is an ardent longing for the thing loved)
hath actions of wonder, astonishment and contemplation

—PAOLO GIOVANNI LOMAZZO
A Tracte Containing the Artes of Curious Paintinge,
trans. Richard Haydocke (London, 1598)

CONTENTS

Black and White Figures

ACKNOWLEDGMENTS

At the beginning of a book about the formation of interdisciplinary networks, social institutions, and avenues of intellectual cooperation, I am pleased to acknowledge the assistance I have received from many quarters on both sides of the Atlantic. Four scholars in particular provided essential direction. The book would have been unthinkable without the sage expertise of Barbara Stafford, who has so fruitfully probed the relationship between art and medicine in her own scholarship. I am grateful to Kim Rorschach for the generosity with which she shared her time, energy, and counsel. I thank Ingrid Rowland for her contagious enthusiasm for learning and life, and Carol Gibson-Wood for modeling fresh ways of thinking about old problems.

My time in London was made more profitable and enjoyable by the Wellcome Trust Centre for the History of Medicine, where I was a research associate in 2001. I am indebted to fellow researchers, staff, and especially the late Roy Porter, who exuded scholarly graciousness. I also benefited from attending the Attingham Summer School for the Study of British Country Houses in 1999, and thank both Giles Waterfield and Annabel Westman. In addition, I had the good fortune to participate in the 1998 summer session of the American School of Classical Studies in Athens, led by Anne Steiner and Sarah Peirce, and this experience informed much of my work, even as the original topic took new shape.

On September 12, 2001, the day after the attacks that ushered in the new millennium and sparked a catastrophic war of untold violence, I was introduced in the Royal Library at Windsor Castle to some of the most beautiful pictures I have ever seen: Maria Sibylla Merian's paintings for the *Metamorphosis Insectorum*. As an American I received kind expressions of support

from everyone I encountered that strange day after; I am especially grateful to Martin Clayton and Henrietta Ryan. The experience served as an intense memento mori, giving credence to the Hippocratic dictum that indeed life is short and art long. Others in England who provided encouragement and assistance include Michael Burden, Simon Chaplin, Alison Duke, Ludmilla Jordanova, Tim Knox, Simon Schaffer, Kim Sloan, Emma Shepley, Christine Stevenson, Iain Pears, and the welcoming community of St. Luke's in Islington, particularly Caroline Barton.

Perhaps the biggest challenge has been learning to coordinate writing and teaching, though again I have benefited from the generosity of institutions and individuals. A year as a visiting professor at Emory University was rewarding and instructive thanks to the support and camaraderie of the Art History Department. At Calvin College, I have outstanding colleagues and am particularly grateful to Henry Luttikhuizen and Lisa VanArragon. The obligations and joys of teaching have made me all the more grateful for the pedagogical model of professionalism and intellectual craft provided at Chicago by Martha Ward.

A reduced teaching load for one semester, supported by a Calvin Research Fellowship, was crucial for completing the final manuscript, and a generous subvention of $3,000 helped defray the cost of the images—as did a $500 publication grant from the Historians of British Art. The cost of the images for *The English Virtuoso* totaled just over $3,600. I am especially grateful to the following institutions, which provided images completely free of charge: the Burghley House Collection, Christopher Eimer Fine Medals, the Museum of the Royal College of Surgeons of London, Quaritch Rare Books, and the Victoria & Albert Museum. I am likewise indebted to Matthew Pillsbury for the frontispiece. Entirely reasonable rates of $25 or less per image were charged by the University of Chicago Library, the Newberry Library, the Thomas Fisher Rare Book Library of the University of Toronto, the Wellcome Library, and the Yale Center for British Art. Images priced between $25 and $145 came from Arcaid, the British Library, the British Museum, the National Gallery, the National Portrait Gallery, the Harry Ransom Humanities Research Center, the Royal College of Physicians of London, the Society of Antiquaries of London, and Worcester College. Images costing more than $145 came from the Bridgeman Library, the North Carolina Museum of Art, and the Royal Collection.

The book is much better as a result of conversations and advice from Kate Bentz, Erin Blake, Adam Budd, Douglas Fordham, Frances Gage, Jennifer Green, Mark Hinchman, Matt Hunter, Carla Keyvanian, Stephanie Leitch, Elizabeth Liebman, Jeremy Paden, Amy Partridge, Dawna Schuld, Stuart

Sillars, Stacey Sloboda, Trevor Thompson, and Alicia Weisberg-Roberts. At the University of Chicago Press, Susan Bielstein has been an inspiring editor, and Anthony Burton has facilitated countless details with generosity and astounding tact. Sandra Hazel's surefooted judgment as copy editor likewise deserves special recognition. I regret that I cannot thank the Press's anonymous readers by name, since their comments were immensely helpful, especially regarding Wenceslaus Hollar. Notwithstanding all of this wisdom and all of these resources, the shortcomings are entirely my own.

My wife, Kristine, has shouldered a large share of the project with extraordinary patience. I am glad to give the book to her, with loving gratitude.

Because the figure of the physician stands at the center of the book's argument, I have tried to use the honorific *Dr.* only in reference to degreed medical practitioners. Apart from a few instances in which I employ the language of early modern contemporaries, well-known divines and legal doctors appear only by name. Even the man who may lay claim to being the period's most famous "Dr." here goes simply by Samuel Johnson.

Unless otherwise indicated, dates can be assumed to follow the "old-style" Julian calendar, still in use in England until 1752, when the ten-day lag time was finally abolished in favor of the "new" Gregorian model. I have, however, adhered to the common convention of resetting the beginning of each year from March to January 1. In many instances, I have silently updated early modern spelling and punctuation for the sake of clarity—though I trust that the original meanings of the passages, as well as intonations of their now often strange character, remain intact.

A Painter, a Physician, and a Garden Quarrel

Amid the shadows of the Glorious Revolution, a quarrel now largely forgotten erupted in Covent Garden (fig. 1) between England's leading physician and its leading painter. Writing nearly three decades later, William Pittis references the highly charged year of 1688 in recounting the conflict between Dr. John Radcliffe and the doctor's neighbor Sir Godfrey Kneller (plate 1). Ever attuned to his own convenience, Radcliffe sought the painter's permission to install a gate between the two men's gardens. Kneller, "a gentleman of extraordinary courtesy and humanity," readily agreed—much to his subsequent regret. For in addition to his skills as a portraitist, Kneller possessed a remarkable garden of "exotic plants, . . . fine parterres, and a choice collection of herbs, flowers, &c," none of which fared well with the increased foot traffic. The doctor's servants had soon "made such a havock" among these "hortulanary curiosities," that Kneller threatened to have the gate bricked up. The ultimatum ignited Radcliffe's "cholerick temper," and the doctor retorted that Kneller could do whatever he liked with the gate as long as he "did but refrain from painting it." The professional attack penetrated like a surgeon cutting for the stone, and the artist responded in kind, "Tell him that I can take anything from him, but [his] physick."[1]

At a time when biography was still expected to offer models of exemplary character, Pittis justified his inclusion of the anecdote on the grounds that it demonstrates Radcliffe's wit. Three centuries later it provides a starting point for engaging the interaction of art and medicine in early modern England. As a parable of two related emerging professions, this garden feud suggests

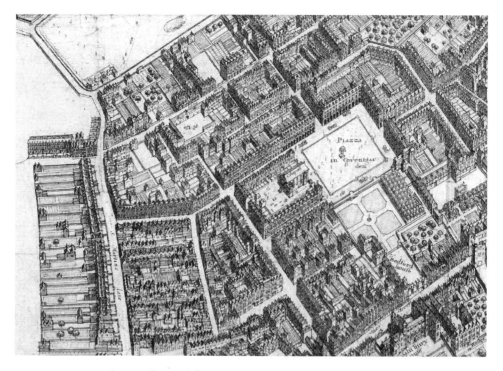

FIGURE 1 Wenceslaus Hollar, *Aerial View of Covent Garden*, ca. 1658. © Copyright the Trustees of The British Museum. Used by permission from The British Museum, London. The etching depicts the gardens that occasioned the feud between Radcliffe and Kneller. Because of the site's importance for English painting, the anecdote's geographic poignancy is even sharper than Pittis's account suggests. Peter Lely occupied the fifth house on the northeastern side of the piazza until his death in 1680; it was either this house or the one next to it that Kneller occupied from 1682. In 1718 Sir James Thornhill moved into Kneller's house, and from 1729 until 1733, his son-in-law William Hogarth also lived here.

a series of questions. Was such conflict the rule or the exception? In what ways were status and position claimed by practitioners of each field? In what ways did each depend on the other? Where did painters and doctors stand in relation to the curiosities of the natural world? What role did experience play for each? Just what sort of neighbors were art and medicine, and could they share a common garden without trampling upon each other's interests?

The English Virtuoso

Already by 1688 there had been a substantial degree of interaction in England between the fields of art and medicine, stretching back at least to 1598,

when Richard Haydocke, then a medical student, translated Giovanni Paolo Lomazzo's *Tracte Containing the Artes of Curious Paintinge, Carvinge, and Buildinge*.[2] It was the first treatise on art to be published in English, and it inaugurated a long tradition of engagement with the arts on the part of medical practitioners. *The English Virtuoso* maps the history of this relationship between art and medicine from the early seventeenth through the mid-eighteenth centuries. The formative intellectual contexts for both fields depended on the New Science of Francis Bacon, which helped redefine how people engaged the natural world, and on the Royal Society of London for the Improvement of Natural Knowledge, which from its founding in 1660 facilitated the collective implementation of Bacon's empirical program, grounded in experiment and observation. As evidenced by the contexts of early art publications, by the activities of connoisseurs who belonged to the Royal Society, and by the group's own records, it was the Royal Society that provided the first "public" institutional basis for the arts in England.

Well known for their polymathic appetites, Society Fellows, however, engaged the visual arts in conjunction with a much broader intellectual program; and consequently for most of the last century, the Royal Society's artistic interests have been dismissed as negligible, even embarrassing. The English virtuoso — epitomized by the Society Fellow interested in everything from human anatomy, to ancient burial sites, to the technical aspects of glass production — was characterized in a 1942 article by Walter Houghton as precisely the wrong sort of person for any serious engagement with the fine arts.[3] Owing more to twentieth-century aesthetics than early modern conceptions of representation, Houghton's argument nonetheless highlights ambiguities that have surrounded the *virtuoso* label since the seventeenth century.[4]

The earliest usage of the word in an English publication comes from Henry Peacham's treatise on deportment, *The Compleat Gentleman*.[5] The 1634 edition explains that "the possession of such rarities [antiquities including statues, inscriptions, and coins], by reason of their dead costliness, doth properly belong to Princes, or rather to princely minds. . . . Such as are skilled in them, are by the Italians termed *Virtuosi*." The introduction is appropriate, since Peacham's project can be seen more generally to follow the Italian lead of Baldassare Castiglione's *The Book of the Courtier*, a text familiar to English readers through Sir Thomas Hoby's 1561 translation. In a famous passage that must have later had Locke nodding in agreement, Castiglione proposes that virtue flourishes through education and cultivation, not as a result of purely innate characteristics. *Virtue* here denotes admirable behavior or moral goodness, broadly understood in Neoplatonic

terms, but for Castiglione the visual arts are also integral for honing "an understanding [of how] to choose the good" and rejecting that which leads us "to judge falsely."[6] Along with being articulate and well read, the model courtier should possess basic drawing skills (another prescription echoed by Peacham), and painting is praised as "honest and profitable."[7] It teaches one to assess the "excellencie of Images both olde and new, of vessels, buildings, old coines, cameos, gravings, and such," and it makes us "understand the beautie of lively bodies, and not onely in the sweetness of the Phisiognomie, but in the proportion of all the rest." Stressing the utilitarian and mimetic qualities of the pictorial arts—two central themes for the English virtuosi associated with the Royal Society—Castiglione proposes painting as a model for understanding the physical world at large, which itself is "drawne with the hand of nature and of God."[8]

This notion of virtue as the content of the character of an ideal aristocrat—bred and self-fashioned for service and success at court, politically effective, eloquent, commendable, and cultivated in terms of literature and the visual arts—held currency in England throughout the first half of the seventeenth century. In introducing the word *virtuoso* to describe, in particular, collectors of art and antiquities, Peacham was identifying a set of values already prominent within his own network of patrons and colleagues. Key figures of the early Stuart court, including most famously George Villiers, the Duke of Buckingham, and Thomas Howard, the Earl of Arundel, exemplified these ideals, and their careers took shape in a world that still believed it could discern its own reflection in the mirror presented by *The Courtier.*[9]

The profile of the virtuoso as a member of court, possessing a respectable collection, matches John Evelyn's use of the word in March of 1644, though he would enlarge its scope to encompass not only antiquities but modern works of art and natural objects. Within the context of describing several aristocratic collections in and around Paris, the twenty-four-year-old Evelyn records in his *Diary* his visit to "one of the greatest Vertuosas in France," Monsieur Perruchot, who possessed an array of pictures (including Titian's painting *St. Sebastian*), medals, agates, and flowers, "especially Tulips & Anemonys."[10]

Yet central to Castiglione's understanding of virtue is the regulatory function of balance, "the middle . . . nigh unto the two extremities, that be vices."[11] Just as the English Civil War and interregnum ignited the extremes to the detriment of a political *via media,* the figure of the Restoration virtuoso increasingly came to be seen as intellectually imbalanced and marginal, hopelessly lost at the edges of knowledge. Obsessed with the curious and the rare, the virtuoso was, after 1660, as likely to be associated with the labora-

tory as the humanist's cabinet. Thomas Shadwell provides a potent parody with his play *The Virtuoso*, which premiered in 1676. The protagonist, Sir Nicholas Gimcrack, memorably epitomizes the foolish pedant more interested in poking at insects and pondering the heavens than understanding people or the world at large. Splayed on a table and mimicking the motions of the frog by his side, he boasts that he swims "most exquisitely on Land," to the utter dismay of the other characters. When asked if he will ever "practise in the water," he explains that he contents himself only "with the speculative part of Swimming, [since] I care not for the Practick. I seldom bring any thing to use, 'tis not my way. Knowledge is my ultimate end."[12] For so long "as it be knowledge, 'tis no matter of what . . . [though] 'tis below a *Virtuoso* to trouble himself with Men and Manners."[13]

Similarly ridiculed and reviled, and yet also esteemed and vaunted, the Royal Society emerged as the institutional base for England's virtuosic culture, and the word *virtuoso* could itself still connote respect, depending on its context.[14] Along with Evelyn, John Wallis, Anthony Wood, John Ray, Samuel Pepys, John Dryden, and John Locke all used it positively. The Virtuosi of St. Luke, founded in 1689 and active until 1743, was one of the most important early art associations in England, and Robert Boyle employed the word in the title of his defense of the Royal Society's experimental philosophy, *The Christian Virtuoso* of 1691. Insisting that the virtuosi's dependence on experience could enrich rather than obstruct faith, Boyle's text demonstrates, on the one hand, the persistence of criticisms raised against the New Philosophy.[15] And yet, that Boyle took such pains to distinguish the "proper" or "true virtuoso" not only from the peripatetic philosophers who relied strictly on reason, but also from the "Libertines" and "Atheists" whom he feared might be confused with his own cohort suggests he was not about to cede control of the word to his opponents.[16]

The contested nature of the word is likewise evinced throughout the *Characteristics of Men, Manners, Opinions, Times* of 1711, an anthology of the previously published writings of Anthony Ashley Cooper, the third Earl of Shaftesbury. By no means an ally of the New Philosophy, Shaftesbury derided the likes of Boyle and his colleagues for their fascination with hypotheses and wonders, for their "strange fancy to be creators, a violent desire at least to know the knack or secret by which nature does all."[17] The virtuoso is, therefore, "made the jest of common conversations" for his role as a "minute examiner of nature's works . . . his superior zeal in the contemplation of insect life, the conveniences, habitations, and economy of a race of shellfish." "Mere virtuosoship" is the pursuit of the "cockleshell" and "a universe anatomized."[18]

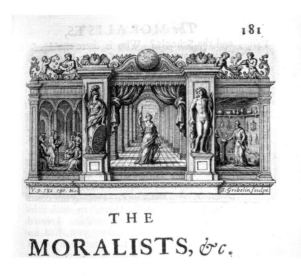

181

THE

MORALISTS, &c.

FIGURE 2 Simon Gribelin,
decorative header from *The
Moralist;* engraving from
Anthony Ashley Cooper (Lord
Shaftesbury), *Characteristicks
of Men, Manners, Opinions,
Times,* 2nd ed. (London,
1714). Used by permission
from University of Chicago
Library, Special Collections
Research Center.

Elsewhere in the same discussion, Shaftesbury appears less antagonistic. Yes, he likens abuses in philosophy—namely a dependence on Scholasticism and abstractions—to the whimsical explanations of the virtuosi, and asserts that "the defects of philosophy and those of virtuosoship are of the same nature." But his conclusion is key: notwithstanding the mistakes "rendered by their senseless managers . . . each of them are, in their nature, essential to the character of a fine gentleman and a man of sense."[19]

As Lawrence Klein notes, the frontispiece of Shaftesbury's *The Moralist* (fig. 2) supplies a visual argument for the central role of a balanced and civic-minded philosophy in society.[20] In the center panel Philosophy stands on the public stage of life, in contrast to the cloistered domains of the schoolroom and the laboratory shown on either side. The opposition highlighted by Boyle reappears, though here, both the Scholastic tradition and the new experimental program are displaced by Shaftesbury's notion of philosophy as a practical source of wisdom.

Embedded in this ideal of the public intellectual as an even-keeled moral guide lies Castiglione's insistence on balance, and indeed, it serves as a foundation for most of Shaftesbury's thinking. His model gentleman should be familiar with various European nations' "antiquities and records . . . their principal studies and amusements, their architecture, sculpture, painting, music, &c."—all the polymathic pursuits associated with the virtuosi, as Shaftesbury himself understands. Trouble arises, however, when "we push this virtuoso character a little further." In the worst cases, "the inferior virtuosi . . . fall in love with rarity for rareness' sake."[21] The problem, as diag-

nosed by Shaftesbury, again lies in the migration toward the margins. Still, for all of his caution, even Shaftesbury retains the word. He asserts, for instance, "that to be a virtuoso, so far as befits a gentleman, is a higher step towards becoming a man of virtue and good sense than the being what in this age we call a scholar."[22]

His personal relationship with Locke reinforces the ambiguity. Now thought of as a philosopher, Locke was educated as a physician, though he practiced little, except in the service of the first Earl of Shaftesbury, Lord Ashley's grandfather, whom he served from 1667 until 1675 (*virtue* and *virtuous*, incidentally, could also connote medicinal efficacy). Along with providing tutoring for the second Earl, Locke apparently assisted at the birth of the future author of *The Characteristics*, forty years his junior, and advised on the child's health. In the 1680s, he likely supplied direct instruction for the third Earl. During this same period in which he was attached to the Shaftesbury household, Locke was inducted into the Royal Society and formed friendships with Boyle and the man who would come to be seen as the British pioneer of observation-based medicine, Dr. Thomas Sydenham.[23] In the 1690s, after Locke had published *An Essay Concerning Human Understanding*, he and the third Earl corresponded on several occasions in cordial tones. In a letter from September of 1694, Shaftesbury criticizes the "new systems" of those who dedicated themselves to the study of curiosities and particularly the work of René Descartes and Thomas Hobbes. He doesn't, however, connect Locke with the targets of his criticism but insists that his studies have only aimed to make himself a better friend.[24] The relationship serves as a reminder of the degree to which life rarely adheres to rigid partisan alignments.

Early modern uses of the *virtuoso* label thus varied tremendously. Although Houghton believed he could discern a shift toward science around the mid-seventeenth century, the change is more accurately understood as a widening of interest more generally around the study of nature, which by no means precluded the visual arts.[25] A century later, Samuel Johnson still defined the virtuoso as "a man skilled in antique or natural curiosities; a man studious of painting, statuary, or architecture."[26] Importantly, the word could be used either to praise or to disparage. A central problem was assessing the value of any particular virtuosic pursuit. Whether a line of inquiry measured up as legitimate depended on subjective judgments. One person's trivial or self-apparent fact was another's seminal discovery, and these debates played out not only between Fellows of the Royal Society and their external critics but also within the group itself. Shaftesbury's relevance might best be seen here, in fact; for notwithstanding his reliance on well-

established humanist tropes, he understood the modern age as one in which issues of aesthetics and taste—judgments about value—would play a central role across all types of public discourse. It was a lesson the virtuosi would eventually learn, though ironically their mastery of the lesson would cause subsequent scholars to divorce them from the very virtuosic pursuits that continued to anchor their intellectual and cultural activities.

All too often, twentieth-century commentators simply followed the scripts established by the early modern critics of the virtuosi, with little judicious evaluation of their own. Nowhere perhaps is this more evident than in Houghton's assertion that virtuosity in its "pure" form cared little for utilitarian agendas. The point is made by Shadwell's Gimcrack but rarely if ever by members of the Royal Society. Debates raged over what sorts of knowledge might someday prove useful to society at large, and there were disputes about the proper balance between abstract and applied forms of knowledge; but one is hard pressed to find the utter disregard for utility described by Houghton.[27]

An interest in identifying a "pure" mode of virtuosity signals Houghton's tendency to essentialize in ways that mislead far more than they clarify. He strains to separate art and science, as if they conformed to "the two cultures" of the modern era identified by C. P. Snow.[28] And from there he attempts to winnow the "genuine scientist" from those who encouraged only the "dilution and distortion of the scientific mind."[29] The present study starts from the premise that the early modern virtuosi resist such neat categorization, along with anachronistic notions of what constituted art or explorations of the natural world during the period.

Significantly, assuming a more positive stance toward the virtuosi opens new avenues for understanding the early modern era. The agendas and ambitions of these men—Society Fellows such as Christopher Wren, John Evelyn, Robert Hooke, James Thornhill, Drs. William Aglionby, Walter Charleton, Richard Mead, Hans Sloane, and William Stukeley—provide the resources for constructing a much richer account of seventeenth- and eighteenth-century British art.

Art, Medicine, and Antiquarianism in the Age of Empiricism

In the face of a rigidly conservative College of Physicians (the professional governing body whose royal charter was granted in 1518), doctors working under the later Stuarts and early Georgian monarchs increasingly looked to the Royal Society for a professional affiliation that would both accommo-

date their curiosity about new sorts of knowledge and fortify their individual reputations.[30] In fact, physicians constituted the largest and most active occupational membership group in the society during its early history, and many members who were not doctors cultivated a keen interest in medical matters. Just as medical men figured disproportionately among the Royal Society's membership, they were also frequently participants in the society's artistic pursuits.

As a result of this institutional relationship, both medicine and the fine arts faced methodological challenges resulting from the application of the Royal Society's empirical principles to the unique character of each of the two fields. On the one hand, the New Science propagated by the Royal Society embraced observation and experimentation. Empiricism promised the future. Yet during this period, describing a university-educated physician as an "empiric" was anything but complimentary. For the empiric belonged to the company of nonlicensed healers that included practitioners (of both sexes) ranging from the barber and bonesetter to the quack, all of whom focused on treating symptoms and alleviating pain or discomfort. *A New General English Dictionary* of 1735 defined *empiric* as "one who pretends to skill in physick by meer practice, without a regular education and study fit for the purpose, a Mountebank or Quack"; and significantly, the only definition given for the adjective *empirical* was "after the manner of, or belonging to a Quack."[31] Two decades later, Johnson largely concurred (fig. 3). In contrast, the physician was identified by his (for doctors were always men) profession of *physic*—literally, his declared knowledge of *nature* (*phusis* in the Greek). His practice consisted of the application of received theory concerning natural philosophy and the maintenance of health, largely guided by the humoral system dating back to ancient Greece and Rome. Writing in 1670, the royal apothecary Nicolas Le Fèvre insisted that "whosoever meddles with chemical remedies without the previous grounds of Theory, can deserve no other name than of *Empyrick*."[32] Eighty years later, an anonymous apothecary—as eager as Le Fèvre to protect his area of specialization—argued that "the Regular Practice of Physick" would necessarily be "unsettled . . . till Physicians, Apothecaries, and Surgeons keep to their proper Stations in the Management of Patients and not break in one upon another by Nostrums and Empirical Methods of Cure, whereby the Art of Physick is exposed to Quackery and Empiricism."[33] For all of the polemics and finger-pointing, there was widespread consensus that empiricism was a fatal foundation for the construction of a healthcare system. Whereas the empiric or quack aimed *to cure the sick*, the physician sought beyond that *to preserve health*. The former trafficked in outward appearances, the latter in estab-

Sextus Pompeius
Hath given the dare to Cæfar, and commands
The *empire* of the fea. *Shakefp. Ant. and Cleopatra.*
3 Command over any thing.
E'MPIRIC. *n. f.* [ἐμπειρικός.] A trier or experimenter; fuch
perfons as have no true education in, or knowledge of phy-
fical practice, but venture upon hearfay and obfervation
only. *Quincy.*
The name of Hippocrates was more effectual to perfuade
fuch men as Galen, than to move a filly *empirick. Hooker.*
That every plant might receive a name, according unto
the difeafes it cureth, was the wifh of Paracelfus; a way
more likely to multiply *empiricks* than herbalifts. *Brown.*
Such an averfion and contempt for all manner of innova-
tors, as phyficians are apt to have for *empiricks*, or lawyers
for pettifoggers. *Swift.*
E'MPI'RICAL. ⎫ *adj.* [from the noun.]
E'MPIRICK. ⎭
1. Verfed in experiments.
By fire
Of footy coal, the *empirick* alchymift
Can turn, or holds it poffible to turn,
Metals of droffieft ore to perfect gold. *Milton's Parad. Loft.*
2. Known only by experience; practifed only by rote, without
rational grounds.
The moft fovereign prefcription in Galen is but *empirick*
to this prefervative. *Shakefpeare's Coriolanus.*
In extremes, bold counfels are the beft;
Like *empirick* remedies, they laft are try'd,
And by th' event condemn'd or juftify'd. *Dryden's Aurengz.*
EMPI'RICALLY. *adv.* [from *empirical.*]
1. Experimentally; according to experience.
We fhall *empirically* and fenfibly deduct the caufes of black-
nefs from originals, by which we generally obferve things
denigrated. *Brown's Vulgar Errours, b. vi. c. 12.*
2. Without rational grounds; charlatanically; in the manner
of quacks.
EMPI'RICISM. *n. f.* [from *empirick.*] Dependence on expe-
rience without knowledge or art; quackery.

FIGURE 3 Page from Samuel Johnson, *A Dictionary of the English Language* (London, 1755). Used by permission from University of Chicago Library, Special Collections Research Center. *Empiric* and its derivatives still are negative for Johnson, though a new emphasis on experimentation points to the modern connotations of these words.

lished theory, vouchsafed by the authority of Hippocrates and Galen.[34] The problem was vexing: how could physicians embrace the empiricism of the New Science without themselves becoming empirics?

Writing in 1702, Dr. Richard Mead grasped the dilemma perfectly. In his first publication, *A Mechanical Account of Poisons in Several Essays*, he describes his own experiments with snakes and provides an account of poison in keeping with the New Science. In the preface, however, he maintains the traditional character of the learned physician and looks to mathematics and ancient languages as a means of distinguishing true physic from "meer conjecture or base empiricism."[35] An abstract of the book soon appeared in *The Philosophical Transactions*, the journal for the Royal Society, and Mead was elected a Fellow the following November.[36] A trusted friend and physician of the society's president, Isaac Newton, Mead emerged as one of the most respected (and wealthiest) physicians working in London. He became a prominent patron of scholarly publishing and the arts, and he assembled

one of the most important nonaristocratic collections of art in England. Such were the potential rewards for the physician who managed both to embrace the intellectual program of the Royal Society and to maintain his ties to the traditional, learned medicine of the Ancients.

But as demonstrated by the past two decades of scholarship in the history of science, similar epistemological tensions between theory and empirical observation pervaded much of the Royal Society's agenda. After one penetrates the veneer of the Whiggish historiography that has ensconced Society Fellows as heroic masters of the raw fact, facile triumphalism yields to a more nuanced understanding of the Royal Society, in which social status, for instance, is seen to have played as significant a role in the production of knowledge as disinterested observation.[37]

Tensions between rationalism and empiricism likewise shaped the discourse of the fine arts as it emerged in England during the Restoration. On the one hand, Society Fellows sought to nurture an appreciation for the arts through the importation of Continental theory. And yet the impetus of the Royal Society's interests in architecture, painting, sculpture, and printmaking originated from a plan sketched by Bacon to produce a vast account of the History of Trades. The project aimed to collate all that was known about the constellation of natural resources and human manufactured goods. As the society hoped to promote a strain of serious connoisseurship, it did so with an open recognition of much more pragmatic concerns related to artistic technique and the potential for national economic dividends. More often than not, these competing demands resisted easy alignment.

Both in his own writings and in his translations of the works of others, Evelyn, for example, routinely referred to "the workers" for whom he hoped his publications would prove useful; yet his dedications and supplemental remarks more often than not identified the other Fellows of the Royal Society as his primary audience. In other instances, special commissions were appointed to study the technical aspects of the painter's craft, though these inquiries tended to be structured as informal experiments meant only to facilitate general observations. In any case, they failed to result in any comprehensive distillation of knowledge. Such compendiums, instead, came from the margins of virtuosic society, most significantly from the quack William Salmon, whose *Polygraphice; or, The Art of Drawing, Engraving, Etching, Limning, Painting, &c.* appeared in 1672 and ran through eight editions, the last of which was published in 1701. Combining practical advice on artistic techniques with miscellaneous information on topics ranging from astrology, to cosmetics, to medicinal remedies, Salmon himself exemplifies the polymathic instincts of the Royal Society, even as he threatened to undercut

the learned body's legitimacy by appropriating those interests for a much larger, popular (and paying) audience. Ironically, *Polygraphice* may be the seventeenth-century art text that most closely adheres to the aims of the History of Trades project. But it lacked the conventions of erudition that one finds with art publications associated with the Royal Society, which were characterized by a synthesis (however awkward) of practical and theoretical concerns. Because of these pragmatic interests, art historians have been reluctant to consider these publications as possessing any substantive theoretical value. Yet in looking to the Continent for models of art writing, the society had difficulty conceiving of art texts that would not ultimately privilege noble concepts of artistic accomplishment over the actual mechanical details of execution.

Related to the tensions between rationalism and empiricism are those between the whole and the part that characterized the antiquarian enterprise. Routinely brandished in the modern period as a pejorative term, antiquarianism was, from the nineteenth century, viewed as history's polar opposite, the rust-and-dust pedantry of misguided novices. The antiquarian's fascination with details, artifacts, and arcane bits of knowledge was believed to entail no larger theoretical purpose or program. Circumscribed by this presumed lack, antiquarianism began to be taken seriously only in the 1950s thanks, above all, to the work of Arnaldo Momigliano.[38] Over the last two decades scholars across the humanities have shown how vital, stimulating, and productive antiquarian engagements with the past could be in the early modern period as well as how crucial it is that these endeavors be taken seriously today.[39] In a forceful apologia for the history of antiquarianism, Peter Miller stresses the importance of reconstructing historical contexts, including the previously prominent components that have since faded into obscurity. Otherwise, he warns, we "make Fortuna, and not Clio, the muse of history."[40]

Cumulatively, this scholarship has shown the extent to which the antiquary assiduously sought to understand his surrounding world and genuinely believed the past had to be brought to bear on such a task. Ideally, physical remains—some tangible connection to a previous historical moment, however fragmentary—would suggest a way forward.[41] The antiquary's sweeping curiosity, coupled with a propensity for collecting all manner of natural and artificial objects (everything from bones, to fossils, to coins, to works of art), fanned the flaming words of critics who argued that such assemblages would never amount to anything of larger significance. The challenge was how to move from the particular artifact to an interpretation that would

somehow matter beyond the antiquary's own desktop. As with assessing the accomplishments of a virtuoso, relevance usually resided in the eye of the beholder.[42]

Many of the most blistering charges levied against antiquarian pedantry, for example, came from men who pursued projects we would now describe as antiquarian. The Scriblerians, Alexander Pope, John Gay, and Dr. John Arbuthnot, thus satirized Dr. John Woodward—himself a Fellow of the Royal Society and one of Mead's principal rivals—on the London stage in their 1717 play *The Three Hours after Marriage,* particularly mocking Woodward's fascination with fossils.[43] But they hardly intended to write off all forms of antiquarianism. Nor were they turning their backs on the classical past. Pope provided the first full English translations of the *Iliad* and *Odyssey* and was painted by Charles Jervas sitting below a bust of Homer (fig. 4). Gay worked throughout his career to formulate an appropriate modern response to ancient literary forms, and Arbuthnot published a treatise on ancient measures, weights, and coins. No, the Scriblerians were instead aiming to discredit one who, to their thinking, was guilty of abusing human learning, of wandering from a meaningful to a muddled dialogue with the past.[44]

Notwithstanding such raucous intellectual rivalries and the challenges involved with establishing one's legitimacy, antiquarian interests often (though hardly always) meshed well with the virtuosic instincts of the early Royal Society, and antiquarianism as an intellectual endeavor, grounded in the materiality of physical evidence, helps makes sense of the complex dynamic that existed between art and medicine.[45] Surveying the state of the arts in England, the French enamel painter André Rouquet made the same association in 1755. Of physicians eager to display their erudition, he writes that "one busies himself with paintings, antiquities or prints; the next with natural curiosities in general, or with particular departments of them; some preserve in bottles all the *lusus naturae* that are discovered or invented."[46] Drawing on a well-established trope and invoking the charge of quackery, he goes on to judge that these interests work to the "inestimable" advantage of the patient, since nature is a far more proficient healer than the learned physician: the more distracted the doctor, the better the patient's chances of recovery! The derisive tone of the passage should not, however, lead us to underestimate the seriousness of these collections or the intellectual energy from which they emerged and which, in turn, they generated. Neither should we take lightly the curious fact that the physician as a type receives a chapter of his own in a book about the arts in England.

FIGURE 4 Attributed to
Charles Jervas, *Alexander
Pope*, ca. 1713-15. Oil on can-
vas, 70 × 50" (177.8 × 127
cm). Used by permission from
National Portrait Gallery,
London.

Bridging the Seventeenth and Eighteenth Centuries

Rouquet's account of the interests of Georgian doctors could as easily have
been applied to the physicians of the Restoration period. Indeed, an im-
portant benefit of attending to the virtuosic roots of English art stems from
the continuity that emerges between the two centuries. Much changed po-
litically, religiously, economically, and artistically between the 1660s (much
less the 1630s) and the 1750s. Finding myself in general agreement with
those who would see in these transformations "the creation of the modern
world," I have little interest in reigniting debates about whether the eigh-
teenth century might be better understood as an ancien régime society.[47]

Instead, I am suggesting that in the midst of these dramatic changes, a virtuosic sensibility, nonetheless, persisted well into the eighteenth century. As Brian Cowan has demonstrated in *The Social Life of Coffee,* virtuosic culture was, in fact, a key catalyst for many of the developments that so profoundly reshaped British society.[48] Consequently, it holds the potential to provide a much needed bridge connecting these periods that, for too long, have been partitioned from each other.

As a rule, accounts of English art have looked to political milestones for their ordering principles, with the 1701 Act of Settlement or, more frequently, the 1714 Hanoverian accession serving as a temporal boundary.[49] Sir Godfrey Kneller, himself a German, is seen as the requisite transitional figure, and his Kit Cat portraits, which commemorate many of the most influential Whigs of the day, serve to underscore the political framework. Conveniently for this narrative, William Hogarth was apprenticed just six months prior to the succession of King George I, whose reign is understood as a period of initiation (the king was famously uncomfortable with the English language, cared little for the arts, and died during one of his frequent trips back to Hanover). Making the most of his own opportunities for development, Hogarth emerged as an acclaimed artist in the mid-1720s, just in time for the coronation of George II, who proved to be a better fit for the British nation and a more reliable patron of the arts. Members of the House of Hanover, however, notoriously fought among themselves, and an acrimonious dispute between George II and Prince Frederick in effect produced two separate courts in the 1740s. This general narrative of discord is echoed in the visual arts, as scholars have emphasized the differences between Hogarth, a proponent of British artists and institutions, and Richard Boyle, the third Earl of Burlington, who looked to the Continent for models of taste. Through a synthesis of these two positions, England's art world finally came of age under George III: the Royal Academy of London was founded in 1768, and with Sir Joshua Reynolds serving as the institution's first president, a mature English school of painting emerged, equal or superior to anything produced across the Channel.

This traditional narrative, only slightly caricatured here, is admittedly compelling and contains a substantial amount of truth. The degree, however, to which it corresponds to a Whiggish account of English political history should at least make us cautious and raise an eyebrow or two of skepticism. In particular, we would do well to consider what it renders insignificant or omits completely.

As described in the following chapters, the virtuosic support of the arts casts pictorial representation as a form of knowledge. While both politics

and nascent nationalist agendas played pronounced roles in the life of the Royal Society, including its artistic pursuits, the discourse of empiricism facilitated an English cultivation of the arts quite distinct from the discourse later forged by Reynolds. With fewer reservations about the appropriateness of imitation and little if any sense of an artistic style embodying some sort of essential English identity, early Society Fellows seemed to assume that an "English school" of art would take its lead from the dominant styles encountered on the Continent, especially those of a classicizing vein. To denigrate this more cosmopolitan outlook and to fault the Restoration and early decades of the Georgian period for not developing a significant "native" tradition of the arts is to fall into the trap of anachronism, since the nationalist expectations that such a judgment presupposes emerged only in the eighteenth century. In short, such expectations belong to the reception history of the very works that we now credit with instigating a "native" school in the first place.

Another result of the minimal role assigned to the virtuosi by traditional art-historical accounts has been the failure to appreciate one of the single most distinguishing features of England's engagement with the arts. In contrast to France and various states throughout Italy and Germany (all of which were tied to royal courts), the earliest English institutional framework for the arts — for better or worse — only tangentially included working artists. Ironically, for all of the Royal Society's interest in technique and its overtures to painters, architects, and printmakers, it at no point considered undertaking the *training* of artists. While improvements in the status of artists make such an arrangement nearly unthinkable today, present expectations must not blind us to this crucial period of artistic activity. Moreover, this virtuosic sensibility would, in fact, come to serve as the foundation for what is still commonly referred to as the golden age of English painting.

One reason the virtuosic tradition has yet to receive its due has been the sustained attention directed to the republican discourse of civic humanism, which situated the arts within a Neoplatonic tradition that stressed art's ability to serve the larger public good. Connecting aesthetics with political philosophy, which depended heavily on the Ancients, this approach to the eighteenth century allowed scholars working in the 1980s and '90s to assume a more critical stance toward the political framework that has traditionally structured the period. Rather than simply accepting Augustan politics as an absolute, art historians began asking how the art of the period itself shaped the political landscape.[50] Yet for all of the usefulness of this approach, politics remained not simply one factor but the central focus in approaching works of art. Indeed, the most persuasive accounts of the republican tra-

dition have been forced to make substantial concessions to accommodate the increasing prevalence of private "bourgeois" pleasures associated with eighteenth-century coffeehouse culture and the expanding role of consumerism. Responding to these problems, Carol Gibson-Wood makes the convincing revisionist argument that the work of the painter and theorist Jonathan Richardson owes more to the empiricism of Locke than to the public virtue espoused by Shaftesbury.[51] While the idealist tradition may have constituted a vital component of British aesthetics, especially toward the latter half of the eighteenth century, the role of the senses in relation to epistemology was of equal or greater significance and today provides a much broader platform for engaging the period.

Addressing Flanders, southern Germany, and the Netherlands from the fifteenth to the seventeenth centuries, Pamela Smith has also made the case for the importance of the empirical tradition for the history of both science and art. In *The Body of the Artisan*, she explicates what she describes as an "artisanal epistemology," demonstrating that early modern interactions with nature were inseparable from artistic practices.[52] Pursuing Smith's argument across the Channel into England, from the circle of Thomas Howard, Earl of Arundel, to that of Dr. Mead, the following chapters argue not simply that the history of medicine and antiquarianism are relevant to art-historical studies of the early modern period but that the traditional accounts of seventeenth- and eighteenth-century English art are fundamentally deficient and ultimately misleading, because they have failed to consider these additional intellectual domains.

The English Virtuoso considers the figure of the learned polymath in three historical moments: the early Stuart court, the Restoration, and the early Georgian period. Chapter 1 introduces the virtuoso as exemplified by the circle that formed around Lord Arundel in the 1620s, '30s, and '40s. Along with respected antiquaries, statesmen (Bacon was a close acquaintance), architects, and artists, the group included one of the most esteemed physicians of the seventeenth century, Dr. William Harvey, who first explained the blood's circulation. Placed within this larger social context, he attests to the interactions between art and medicine that occurred from the earliest moments of virtuosic culture. The connection is similarly supported by the career of Harvey's fellow physician Sir Théodore Turquet de Mayerne, whose chemical interests led him to consult directly with artists about their working methods. His fascination with the technical aspects of art production became a prominent feature of the virtuosi's interest in the arts, and notwithstanding the persistent problem of properly accommodating social relations between artists and gentlemen, it characterized the Royal Soci-

ety's artistic pursuits and helped shape the connoisseurship of Dr. Mead (eighteenth-century biographies went out of their way to note that painters were among those invited into his home). Far less well known than either Harvey or Mayerne, Richard Haydocke, the translator of Lomazzo's treatise on painting, demonstrates the way in which this culture of English virtuosity also placed enormous importance on established Continental theory. Legitimacy—and its opposite, quackery—is a theme that runs throughout all of the material here covered, and again Haydocke is useful, for he was involved in a hoax that ultimately came to the attention of King James.

Chapter 2 explains the roots of the Royal Society's History of Trades project and explores how this aspect of the society's agenda in effect created intellectual room for the visual arts within this institutional framework. Casting Evelyn and Wren as the central characters, the chapter addresses the medical interests of both men and employs the art publications of the latter, including translations of Roland Fréart de Chambray, to demonstrate important similarities and differences between English and Continental approaches to the arts.

The third chapter pursues this theme through a comparison of the careers of William Salmon and Dr. William Aglionby. The theme of legitimacy is again central, and contrasting Salmon's *Polygraphice* with Aglionby's *Painting Illustrated in Three Dialogues* further illuminates the Royal Society's artistic ambitions as well as the degree to which the virtuosic model for approaching the arts permeated English society more generally. Because Aglionby's text depends heavily on Dufresnoy's 1667 *De arte graphica,* it has been dismissed as insignificant and generally ignored. While the close relationship between the two texts is undeniable, what makes Aglionby's treatise interesting is the way in which it appropriates French theory for a distinctly English context, namely the Royal Society. Salmon's *Polygraphice,* a thirty-year work in progress, can hardly be described as theoretical in the way that one would apply the label to Fréart or Dufresnoy, but it, too, upon closer inspection, proves more remarkable than scholars have realized. Produced by an active medical practitioner (Salmon described himself as a physician), it further underscores the relationship between art and medicine during this period and evinces how an "empiric" approach to art neatly paralleled an "empiric" approach to medicine.

Quackery lies at the heart of chapter 4, which pursues these tensions between the New Science of the Royal Society and traditional learned medicine. These tensions demanded the renegotiation of theory and observation, of tradition and material evidence of the present. The growing skepticism toward medical theory is exemplified in the anecdote told of Dr. Syden-

ham, who, when asked by an eager medical student which physic books he could recommend, prescribed Cervantes's *Don Quixote*. While the comment is often taken by medical historians as a neat summation of Sydenham's approach to medicine, the role of the anecdote in the eighteenth century, when the incident first moved from oral tradition into print, has yet to be addressed. Allusions to Cervantes and his knight-errant appear throughout the 1719 pamphlet debate waged between Drs. Woodward and Mead. The character of Don Quixote encapsulates some of the major issues surrounding physicians' interests in antiquarian matters, where credibility, reputation, and proper interpretation of sensory evidence were crucial factors determining whether one was celebrated for his erudite appreciation of ancient artifacts and rarities or scorned for trafficking in dusty trinkets. The satire of misguided antiquarianism (particularly as defined over and against the certainty of history), in fact, resembles the charges made against medical quackery. Both are accused of ignorance, taking advantage of others, and above all pretending. In each case, the central issue is one of authenticity—in distinguishing between giants and windmills.

Chapter 5 then traces the virtuosic appreciation of the arts into the Georgian period, focusing on Dr. Mead and the Royal Society. The reconstruction of the social contexts and networks that brought some of the most highly regarded men in England in contact with painters, sculptors, architects, and engravers allows the empirical tradition to take its place beside that of Shaftesbury's Neoplatonism. Artists such as Allan Ramsay, Jonathan Richardson, William Hogarth, and Arthur Pond benefited from and helped shape this virtuosic culture. Antoine Watteau, who sought medical advice from Mead in 1719, likewise allows us to see how the virtuosi continued to engage Europe. The wide-ranging interests of Drs. Sloane and Stukeley point to the stamina of the Royal Society's collective curiosity, even as these polymathic instincts were reformulated into a Newtonian framework. For all that changed over this 125-year period, the persona of the virtuoso remained an attractive one for Georgian connoisseurs. Through his collection, Mead fostered ties between himself and Lord Arundel, and though he undoubtedly saw himself as playing a distinctly modern role, Mead eagerly embraced the preceding century of cultural aspirations.

As for the quarrel between Dr. Radcliffe and Kneller, Mead himself must have had a fine appreciation for it. For in addition to his own experiences with well-publicized rivalries, Mead courted the physician as a mentor and owned ten works by the painter. Among those pictures, I imagine he was particularly fond of Kneller's portrait of Radcliffe (plate 1). It would seem to indicate that the sitter thought far more of his neighbor's artistic abili-

ties than that 1688 garden outburst might, by itself, suggest. The hands and eyes—touch and sight—of physicians and artists in early modern England could hardly work alone.

Insisting on these links between art and medicine, these continuities between the seventeenth and eighteenth centuries, *The English Virtuoso* ultimately proposes a new framework for understanding the arts in the early modern period, a more malleable and far less tidy framework that stresses the virtuoso's fascination with objects in all their learned array. Here system and order have yet to eclipse erudition's promise, and Enlightenment need not exclude the messy world of images.

Art as "a Grace to Health"

Physic and Connoisseurship at the Early Stuart Court

In September 1668 there appeared in *The Philosophical Transactions of the Royal Society* a brief description of four books that the journal's editor, Henry Oldenburg, expected to be of interest to his readers.[1] The *Transactions* provided an important forum for publication that communicated and legitimated the intellectual concerns and activities of the members of the Royal Society of London, and this "Account of Some Books" demonstrates how wide ranging those interests could be. The volumes chosen for the review article addressed the history and progress of chemistry, applied geometry, the "nature, qualities, and uses of the Stagg," and the fine arts.[2] Representing the Royal Society's broader interests in natural philosophy, practical mathematics, and natural history, the first three texts likely strike us as understandable selections.[3] The inclusion of the last work, however, John Evelyn's (1620–1706) translation of Roland Fréart de Chambray's *Idée de la perfection de la peinture*, may come as a surprise three centuries later, as the arts and sciences have become increasingly specialized and segregated.[4] It attests to the early Royal Society's polymathic character and reminds us that for all the importance of this institution for the history of science, to approach the society as a modern scientific body owes more to anachronistic hindsight than historical contextualization. *Science* during this period still meant knowledge in general, and thus Evelyn's fellow society member John Locke could describe *science* as comprising three branches: natural philosophy, ethics, and the doctrine of signs (logic and the communicative arts).[5]

Attuned to the value readers of the *Transactions* placed on the Baconian virtues of utility and observation, the reviewer presents *An Idea of the Perfection of Painting* in terms that suggest its compatibility with these intellectual ideals.

The first sentence, taken from the book's subtitle, notes that the work explains "the *Principles* of *Art* . . . by *Examples* conformable to the *Observations*" of the Ancients Pliny and Quintillian and paralleled with "works of the most famous *Modern* Painters," Leonardo, Raphael, Romano, and Poussin.[6] Fréart's five principles of art—invention, proportion, color, motion, and composition— are then briefly described along with examples of specific works that illustrate their importance. Finally, the reviewer asserts that the translation

> will doubtless animate many among us to acquire a perfection in Pictures, Draughts, and Chalcography [engraving on copper], equal to our growth in all sorts of Optical Aydes, and to the fullness of our modern Discoveries. *Painting* and *Sculpture* are the politest and noblest of Antient Arts, true, ingenious, and claiming the Resemblance of Life. . . . And what Art can be more helpful or more pleasing to a Philosophical Traveller, and Architect, and every ingenious Mechanician. All which must be lame without it.[7]

The writer stresses the privileged status of art, even as he assures his readers of its practical value. Art, as the resemblance of life, here submits to the rules of observation not unlike a philosophical experiment.

Lurking in the background was also the nagging concern that the state of the visual arts in England lagged behind the nation's achievements in other fields. That Evelyn had translated a French text suggested, moreover, the superiority of the arts and their appreciation across the Channel. Whereas England could boast no state-sponsored academy of art until 1768, the Académie royale de peinture et de sculpture had, since its founding in 1648, promoted the visual arts as a central priority within the larger scheme of constructing an image of Louis XIV as an absolute monarch. Contrasts were routinely drawn by disgruntled critics, and yet the case of Fréart's text also shows how closely the English virtuosi followed the lead of the French. Within six years of its original publication, this canonical work on academic expectations of painting was available in London bookshops. Significantly, the Royal Society—which functioned with the king's blessing though with little financial support—provided the context for the dissemination of the book.

As a distinctly Restoration institution, the Royal Society took shape within the new political environment established in the aftermath of the failed ambitions of the English Civil War, and the collapse of the interregnum. And yet, in keeping with the larger Restoration project, early Stuart cultural agendas still loomed large in the collective memory of the virtuosi. These precedents of connoisseurship helped shape the attitudes of Society Fellows and held important implications even for how eighteenth-century

collectors fashioned themselves. Thanks to an ever-growing body of scholarship, the general features of early Stuart collecting and patronage are widely understood, though the integral role physicians played within this milieu has yet to be appreciated.[8] In addressing the oversight, this chapter looks at the careers of William Harvey, Sir Théodore Turquet de Mayerne, and Richard Haydocke to demonstrate the active interests with which members of the medical community approached the arts in the early seventeenth century.

Lord Arundel and the Emergence of the English Virtuoso

For all the insecurity early modern Englishmen felt in regard to artistic accomplishment, collecting of the highest order had been nurtured under the reign of Charles I. As court favorite, initially under James and then under Charles, George Villiers, first Duke of Buckingham (1592–1628), for instance, assembled a painting collection of about 325 (principally Italian and Netherlandish) paintings, including works by Leonardo, Tintoretto, Veronese, Bassano, Titian, Stenwick, Van Dyck, and Rubens along with small bronzes and "rarities of Amber, Christall, Aggatts, Cornelian, Elutropia, Ivory."[9] He seems to have been instrumental in bringing both Orazio Gentileschi and Van Dyck to London, and in 1626 he paid a small fortune of 100,000 florins for paintings, ancient statues, coins, and gems collected by Rubens, a testament to both the duke's artistic seriousness and his conflation of diplomatic and acquisition agendas.[10]

A less grandiose glimpse of the collecting process comes from a 1622 letter to Buckingham penned from Venice by Sir Henry Wotton.[11] After reporting the latest diplomatic news concerning the imprisonment of one "Mr. Mole" by the Roman Inquisition, the English ambassador describes a recent shipment for Buckingham, which included a *Madonna and Child* by Titian, *David and Bathsheba* by Palma, and an unattributed still life depicting a bowl of grapes. Both the letter and the shipment invoke rhetorical and artistic sophistication hinging on classical allusion, debates regarding the primacy of painting or sculpture, and the privileged role of mimesis more generally.[12] Regarding the Titian, Wotton writes that the Christ child appears "so round that I know not whether I shall call it a piece of sculpture or picture," or to judge "whether nature or art had made it." Of the Palma, he stresses the "action" of the figures, calling it "the speaking piece"; and of the grapes, he suggests the picture could facilitate a comparison between Italian and Flemish painters, since the latter were renowned for their extraordinary still lifes. Lurking behind the assessments lies Pliny's oft-repeated

account of the competition between the ancient Greek painters Zeuxis and Parrhasius. After the former succeeded in rendering grapes so convincingly that birds pecked at the surface, he requested the curtain be pulled back to display his opponent's work, only to realize that the curtain *was,* in fact, the painting. Zeuxis conceded defeat, noting that whereas he had fooled the birds, Parrhasius had fooled a fellow artist. What distinguishes the shipment from Venice, however, is the fact that Wotton also included actual samples of "the choicest melon seeds of all kinds" for King James. The familiar topos of art's imitation of nature thus not only suggests aesthetic value via an ancient refrain; it also here facilitates a literal joining of art and nature as Wotton cleverly demonstrates his own abilities to blur boundaries. The coupling would pervade the sensibilities of the Royal Society virtuosi, though they were much more likely to evoke the name of Arundel than Buckingham, as the rivalry between these two men (just as competitive though never as gracious as that between Zeuxis and Parrhasius) finally tipped in favor of the former after Villiers's assassination in 1628.[13]

Thomas Howard, second Earl of Arundel (1585–1646), stands out as a formidable connoisseur by any standards. Since his own lifetime, Lord Arundel (plate 2), even more than Buckingham, has been recognized as the dominant landmark on the terrain of seventeenth-century English art collecting.[14] The painter and writer Joachim von Sandrart, having visited Arundel House in 1627, described the earl as "that most famous lover of art" and clearly was impressed by his Thames-side garden, "resplendent with the finest ancient statues in marble, of Greek and Roman workmanship," and by his gallery, which contained "the superlative excellence of the works of Hans Holbein," pictures by "old German and Dutch masters," and Italian works by Raphael, Leonardo, Titian, Tintoretto, and Veronese (an incomplete inventory from 1655 lists 799 items).[15] Assessing the antiquarian value of the earl's collection in his *Compleat Gentleman,* Henry Peacham called Arundel House "the chief English scene of ancient inscriptions," and warned his reader that there "you shall find all the walls . . . inlaid with them and speaking Greek and Latin to you," just as the garden offers similar "learned lectures in this kind."[16] Recalling Arundel after the Restoration, Evelyn praised him as "a Maecenas and Protector of all the sublimer Spirits" and credited him with introducing to England the arts of painting and sculpture, which otherwise "had scarce been known."[17] By the eighteenth century, the earl's reputation had become part of the national patrimony. Horace Walpole, fourth Earl of Orford, described him as the "father of vertu in England," and the items from the Arundel collection were keenly prized by Georgian connoisseurs, including, as we shall see later, Dr. Richard Mead.

Along with respected antiquaries such as William Camden, Robert Cotton, John Selden, and Franciscus Junius, the Arundel circle included the statesman and philosopher Francis Bacon (who died at Arundel's House at Highgate in 1626), the royal surveyor Inigo Jones (with whom Arundel spent eighteen months in Italy), painters such as Van Dyck and Rubens, and prominent Roman collectors, including Cardinal Barberini, Cassiano dal Pozzo, and the Marchese Giustiniani.[18] For acquisitions, Arundel relied heavily on his agent, the Reverend William Petty, who not only maintained a presence in Italy but also traveled to Greece in search of ancient artifacts.[19] Arundel's ambition as a collector is perhaps most dramatically evinced by an object he deeply desired but in the end failed to acquire: the obelisk from the Circus of Maxentius that Bernini later erected in the Piazza Navona (fig. 5).[20]

FIGURE 5 Obelisk at Piazza Navona; from Athanasius Kircher, *Obeliscus Pamphilius* (Rome, 1650). Used by permission from University of Chicago Library, Special Collections Research Center.

Of course, as the example of Buckingham makes clear, Arundel was not (despite Evelyn's claims) the first Englishman to collect, and as David Howarth has stressed, the earl himself was aware he was "following not creating precedent."[21] The attention given to Arundel House in *The Compleat Gentleman* attests to the growing status of collecting and connoisseurship in seventeenth-century England, and in *The Gentleman's Exercises* of 1612, Peacham had already singled out not only Arundel but also the Earls of Worcester, Southampton, Pembroke, Suffolk, and Northampton as exemplary patrons. There is, of course, also the case of the royal collection presided over by Charles I, which upon its dispersal during the Commonwealth numbered well over fifteen hundred paintings.[22] Still, as Howarth notes, Arundel was unique for his "knowledge, instinct, . . . [and] breadth of taste."[23] Because of his wide-ranging interests and his vast network of learned and artistic acquaintances, the earl can be seen to anchor the arts of the Stuart era.[24]

William Harvey

Along with the scholars, artists, and collectors, Arundel also was closely acquainted with the most important English doctor of the period, William Harvey (1578–1657), the physician-in-ordinary to King Charles who first explained the circulation of the blood. Harvey was among those Arundel selected for his 1636 embassy to Ratisbon, Germany, which, in the midst of the Thirty Years' War, aimed to convince Holy Roman Emperor Ferdinand II to restore the Palatinate to Prince Charles Louis, the nephew of Charles I.[25] The prince's Protestant parents, Frederick V and Elizabeth, the sister of King Charles, had been forced into exile in The Hague in 1622, and in 1635 the emperor had reaffirmed his new son-in-law, the Catholic Duke of Bavaria, as the Palatine Elector.[26] Not surprisingly, persuading the emperor proved impossible; but despite the embassy's failure, Arundel's uncompromising efforts earned the approval of the English court, and the affair provided further acquisition opportunities.[27]

In his late fifties by this point, Harvey had published *De motu cordis* the previous decade and was now the talk of medical circles throughout Europe.[28] He had earned his MD from Padua in 1602 and was thus already acquainted with life abroad.[29] Nor was this his first time to travel with Arundel. Three years earlier, in 1633, the two men had accompanied Charles to his native Scotland, where the English sovereign was crowned King of Great Britain.[30]

The trip to the Continent provided Harvey with opportunities to consult

with other physicians and scholars. In Nuremberg he attempted, unsuccessfully, to win over Dr. Caspar Hofmann with his explanation of the blood's circulation; in Prague he met Dr. Marcus Marci, who had just published a treatise on generation; and in Venice he visited Dr. Giuseppe degli Aromatari, a "preformation" proponent Harvey later cited in his own *De generatione animalium*.[31] The journey also allowed the doctor to observe different natural environments. According to Wenceslaus Hollar, the Bohemian printmaker who joined Arundel's retinue in Cologne, Harvey tended to wander off by himself—much to Arundel's concern and anger—making "observations of strange trees and plants, earth, etc."[32]

In August 1636, as Arundel was still involved with negotiations over the Palatinate, Harvey set out to join William Petty in Italy, accompanied by the twenty-two-year-old Hendrick van der Borcht, another artist recruited into the earl's service, just a few days after Hollar. Arundel explained to his agent,

> I write still unto you though I am uncertain where my letters will find you, but I hope at Florence or Rome, & that little honest Doctor Harvey will be with you ere these, for Henry [van der Borcht] the young youth I sent unto you with the Doctor I hope you shall find him a very good boy. . . . I pray you show him all of art that you can, I hope in time he will have a good guess of originals from copy. I long to hear of an absolute buying of the Meleager for me, and I shall be glad [if] you buy some of the principal paintings of the Ludovisi [Collection] for the King, Our Majesty.[33]

That Arundel later placed Van der Borcht in charge of the pictures and drawings at Arundel House suggests the trip, in this regard, was a success.[34] Unfortunately, the quick-tempered Harvey, apparently now by himself, was detained in quarantine for several weeks outside Venice. In the absence of any news of the doctor, Arundel grew increasingly anxious, as seen in a letter to Petty penned the first week of September:

> Doctor Harvey parted from hence five weeks since, & from him we never received so much as one word since he went, where he was or how he did, which seems strange, he longs much to be with you, & as I wrote unto you, he will be glad to see those pictures of Ludovisi, & help with credit to buy them for our King, which I think His Majesty would like very much.[35]

Several days later, having finally learned of the quarantine, Arundel again wrote to his agent, explaining the delay and asking that Petty assist the

doctor—in Arundel's words, "the little perpetual movement"—in recovering "his time lost with satisfying his curiosity" in Florence and Rome.[36]

The Ludovisi Collection to which Arundel twice refers had been assembled by Cardinal Ludovico Ludovisi. His brother Niccolò, Prince of Piombino, had begun dispersing the collection after the cardinal's death in 1632, and Arundel was eager to secure what he could for King Charles. Several outstanding paintings went to King Philip IV of Spain, including Titian's *Bacchanal* and *Worship of Venus,* and a good number of pictures ended up in French collections (Cardinal Mazarin, for instance, acquired thirteen). No works have been traced to Charles's collection,[37] but the incident is important all the same—not only for the light it sheds on Arundel's dealings on behalf of the king, his relationship with Petty, and the competitive character of seventeenth-century collecting, but also for what it says about Harvey's interests in the fine arts. Given that the doctor was looking forward to seeing the pictures and that he was expected to assist in Petty's negotiations, a visit to the Villa Ludovisi perhaps remained a priority, even with Harvey's abbreviated timetable. The image of the doctor spending an afternoon in Rome viewing pictures at Porta Pinciana suggests the degree to which early modern spheres of learning were intricately intertwined as social activities.[38] Harvey accompanied Lord Arundel not only as a physician but as a man of erudition who shared his curiosity.[39]

It was this curiosity that led him in 1620 to assist with Inigo Jones's investigations at Stonehenge, recounted in John Webb's publications, which Harvey encouraged.[40] Impressed by what he saw as the site's "beautiful proportions, as elegant in order, and as stately as any," Jones dated the site to the Roman era and believed the circle to have been a temple dedicated to Coelus, the god of the heavens.[41] In making a claim for the stones' Roman origins, Jones had to argue against a Druidic provenance; toward this end, he turned to textual sources arguing the Druids produced no architecture as such and certainly nothing of this scale. And here, Harvey steps in, supporting the claim with his knowledge of comparative anatomy. Having found plenty of animal skeletons but no human remains where he surmised the ancient people must have offered sacrifices, the doctor corroborated Jones's theory, for—according to this reasoning—only the Romans abstained from making human sacrifices, and so it must have been their site.[42] The ground was now clear for Jones to erect his fanciful explanation of the site as a temple.

Significantly, in 1663 another physician, Dr. Walter Charleton, challenged Jones's interpretation, arguing instead for a Danish origin, and in the eighteenth century Dr. William Stukeley would address the site, in many

 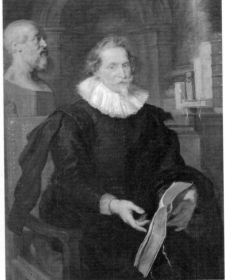

FIGURE 6 William van Bemmel, *Dr. William Harvey* (1578–1657), ca. 1650s. Oil on canvas, 44½ × 37" (113 × 94 cm). © Hunterian Museum and Art Gallery, University of Glasgow. Used by permission from Hunterian Museum and Art Gallery.

FIGURE 7 Peter Paul Rubens, *Dr. Ludovicus Nonnius*, ca. 1627. Oil on wood, 49 × 36½" (124.4 × 92.2 cm). © National Gallery, London. Used by permission from The National Gallery.

ways laying the foundation for modern researchers.[43] Physicians thus played a considerable role in shaping the early historiography of Stonehenge, and the site neatly demonstrates the involvement of medical men in antiquarian problems. The fact that Harvey was among those who persuaded Webb to publish Jones's argument in the mid-1650s suggests the site remained of interest to the doctor throughout his life.

A portrait of Harvey (fig. 6), now in the Hunterian Collection in Glasgow, pictures his dual engagement with the ancient and modern worlds.[44] Employing the conventions for depicting learned humanists exemplified by Rubens in works like *The Four Philosophers* and *Dr. Ludovicus Nonnius* (fig. 7), the painter—William van Bemmel, according to Dr. Mead[45]—presents Harvey seated at a desk with a roll of paper in his left hand and his right resting on the pages of an open book. The folio volume has been identified as the 1645 edition of Adriaan van de Spiegel's *Opera quae extant omnia*, a collection of anatomic texts that includes Harvey's *De motu cordis*.[46] In addition to the

velvet hat hanging on the chair, Harvey's status as a physician is signaled by the engravings of skulls to which he points. Against the background of Rome, the *Caput Mundi* of the ancient world, the plate can also be seen as an allusion to the doctor's intellectual capacities as well as a clever memento mori. Toward the middle of the picture, just beyond the doctor's shoulder, the lower portion of a column—obscured in part by the swag of the curtain—anchors the composition and leads our gaze out across the Roman skyline to Trajan's Column and S. Maria di Loreto. Geoffrey Keynes believes the portrait to have been painted from life but suggests the artist relied on prints for the background.[47] Both the identification of the book and the attribution to Bemmel (who would have been six in 1636) date the portrait to well after Harvey's visit to Rome.

As noted by both Keynes and David Piper, the portrait is related to that of Harvey's younger friend, Sir Charles Scarburgh (fig. 8), also a royal physician and a founding Fellow of the Royal Society whose library, especially

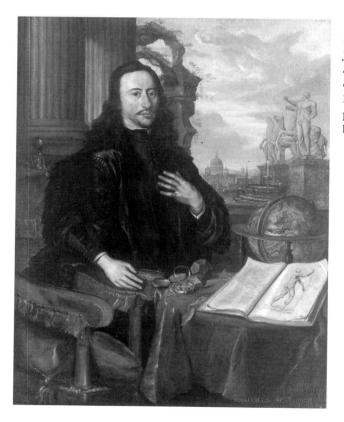

FIGURE 8 Attributed to Jean Demetrius, *Sir Charles Scarburgh*, ca. 1650. Oil on canvas. © Royal College of Physicians, London. Used by permission from Royal College of Physicians.

strong in mathematics, was judged by Evelyn to be one of the best in all of Europe.[48] Again, the subject is placed before a desk, surrounded with attributes of his learning: Vesalius's *Fabrica*, a gold watch, prisms, and a zodiacal globe. And again, columns appear just behind the doctor while Rome stretches out across the background, with St. Peter's and the Dioscuri dominating the view. The ruins can be understood as a reference to life's temporal nature, just as the skulls in Harvey's portrait serve as a reminder of death. The paintings are not the same size and may not have been painted at the same time or by the same artist. Nor is there evidence that the two were ever hung together. Yet even while these questions beg for further study, the kinship is undeniable.

Characterizing the portraits as an "enigma," Piper attributes the iconography to a "classical nostalgia" shared by Harvey and Scarburgh and frankly seems dismayed that doctors would be represented against the background of Rome. Similarly, Keynes finds the ruins in the latter picture "romantic and irrelevant."[49] And though this model of portraiture admittedly never became the standard means for depicting doctors (as it later did for Grand Tourists), we should not be surprised to see leading physicians shown as men of broad learning, at home with both the classical past and the contemporary culture to which they contributed with acute self-awareness. To dismiss the iconographic inclusions as irrelevant accessories is to ignore the aspirations of these men and the degree to which their erudition and fascination with the curious included art and architecture.

Wenceslaus Hollar

The prolific graphic production of Hollar (1607–1677) underscores the intellectual and pictorial ambitions of this circle around Arundel. With over 2,700 prints to his name, Hollar, like Evelyn, spans the early Stuart and Restoration periods with an extensive oeuvre that attests to his diligence. In the final part of his life he worked on a variety of antiquarian projects, providing, for example, engravings of the ruins of Persepolis and reconstructions of the Temple of Jerusalem.[50] Closer to home, he made drawings of Stonehenge, etched topographical views and maps, and produced scores of images for some of the century's best-known antiquarian volumes, including *The Antiquities of Warwickshire; The Monasticon Anglicanum; The History of St. Paul's Cathedral in London; The Institutions, Laws, & Ceremonies of the Most Noble Order of the Garter;* and *The Antiquities of Nottinghamshire.*[51] This

last volume, by Robert Thoroton, published the year Hollar died, returns us to the theme of physician-as-antiquary. For Thoroton combined the life of a landed country gentleman with that of a medical practitioner (though he never received an MD, he was licensed to practice by Cambridge in 1646). In the preface of *The Antiquities,* he employs a physician's metaphor, explaining the project as an attempt "to practice upon the dead . . . [so as] to keep all which is or can be left of them, to wit the Shadow of their Names, (better than precious Ointment for the Body) to preserve their memory."[52]

In Hollar's 1647 self-portrait, after a painting by Johannes Meyssens, the artist presents himself as a man of refinement in his own right (fig. 9). We see his etching tools, but the emphasis rests on the copperplate that he offers for our inspection. While the skyline depicts Hollar's native Prague, the learned viewer is meant to think also of Rome, thanks to the image of Raphael's *St. Catherine.* Hollar's lace collar and the coat of arms in the upper left-hand corner suggest he is much more than a mindless craftsman but an important link in the chain of cultural production (the caption notes his connections with the Duke of York, the future James II, for whom he may have provided drawing instruction).[53] The print also reinforces the importance of Arundel's patronage for Hollar: the image the artist wants to be identified with is a reproduction of a painting (now lost) by Raphael from the earl's collection (fig. 10).

Hollar returned to London with Arundel toward the end of 1636. He married Margaret Tracey, one of the countess's attendants, and spent the better part of the next decade in the couple's service. George Vertue, who helped assemble a collection of Hollar's prints for the Earl of Oxford in the eighteenth century, believed Arundel intended to produce an illustrated catalogue documenting "all his pictures, drawings, and other rarities."[54] If such a plan existed, the Civil War curtailed the project, though over seventy prints include a note tying them to objects in Arundel's possession. There are reproductions of paintings by the likes of Correggio, Brill, Holbein, Brueghel, and Dürer; of drawings by Leonardo and Mantegna; of ancient pieces of sculpture; and of armor designs. Although Hollar executed many of the prints after he moved to Antwerp in 1644 (following the Arundel household), and despite the notable gaps (one would expect much better coverage for sculpture), the prints are consistent with many of Arundel's collecting predilections.[55] Etchings of saints are common, and there are a substantial number of portraits (many by Holbein) related to the family and its role in English history. For that matter, one finds, more generally within Hollar's work, members of the Arundel circle, including both the earl and the countess as well as Inigo Jones, Francis Bacon, and Junius (fig. 11).

FIGURE 9 Wenceslaus Hollar, after Johannes Meyssens, *Self-Portrait*, 1640s. Etching. Used by permission from the Thomas Fisher Rare Book Library, University of Toronto. The image was initially produced for Meyssens's *Images de Divers Hommes d'Esprit Sublime,* a project inspired by Van Dyck's well-known collection of portraits, *Iconographia.*

FIGURE 10 Wenceslaus Hollar, after Raphael, *St. Catherine of Alexandria,* second state, 1640s. Etching. Used by permission from the Thomas Fisher Rare Book Library, University of Toronto. Once part of the Arundel collection, the original painting by Raphael is now lost.

Hollar's prints also point to the virtuosic dimensions of the collection. A number of works evoke the natural world: a stag and a lion by Dürer and seven anatomic studies by Leonardo (in addition to a dozen caricatures by the Tuscan Master). There are remarkable plates of shells and insects from the collection (fig. 12), and though Hollar's *New and perfect Book of Beasts, Flowers Fruits, butterflies, & other Vermine* did not appear until 1674, the plate for the title page (fig. 13) was etched in the 1640s. Derived in some cases from the images of others (Dürer's famous rhinoceros is readily identified), many of the animals would reappear over the course of Hollar's career, as in the *Fables of Aesop* and his illustrations for Virgil. But if this assemblage works like a pictorial reference bank for the artist, the scholars in Arundel's circle approached the natural world depicted here in a comparable manner. The physic garden in the background served as a similar bank of resources for apothecaries, doctors, and natural philosophers.

FIGURE 11 Wenceslaus Hollar, after Anthony Van Dyck, *Franciscus Junius*, third state. Etching, frontispiece portrait; from *De Schilder-Konst der Oude* (Middelburg, 1641), the Dutch edition of *De pictura veterum*. Used by permission from the Thomas Fisher Rare Book Library, University of Toronto. The small oil-on-panel portrait by Van Dyck is part of the collection of the Bodleian Library in Oxford.

Hollar's etching *Pallas* (fig. 14), after Adam Elsheimer's *Minerva as Patroness of Arts and Sciences* (ca. 1605, now in the Fitzwilliam Museum at Cambridge), likewise brings together a plethora of learned pursuits: anatomic study, painting, drawing, cartography, geometry, book consumption and production, alchemy, and music—all under the melancholic direction of Pallas. Less than 4 inches by 6 inches, the print approximates the size of the original oil-on-copper painting, and both images suggest an immediacy of intellectual energy. Brilliantly translating the dramatic lighting of Elsheimer's picture, Hollar infuses the interior with the buzz of action and thought. The scene's intimacy (resulting from the size of the miniature, the closeness of the figures, the scale of Pallas, and the uneven candle and lamplight) marks the room as a site of mental and physical aspirations—a space of possibility—even as these same features hint at the difficulty, if not outright futility, of such agendas.[56] For all of its allegorical intent, one has little trouble placing Harvey or Hollar within this interior.

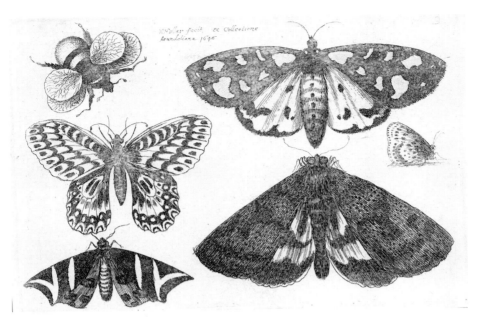

FIGURE 12 (TOP) Wenceslaus Hollar, *Three Moths, Two Butterflies, and a Bumble Bee*, third state. Etching; from *Muscarum scaraborum* (Antwerp, 1646). Used by permission from the Thomas Fisher Rare Book Library, University of Toronto.

FIGURE 13 (BOTTOM) Wenceslaus Hollar, title page, etching, first state; from *A New and perfect Book, of Beasts, Flowers Fruits, butterflies, & other Vermine, Exactly drawne after y* life & naturally by W. Hollar* (London, 1674). Used by permission from the Thomas Fisher Rare Book Library, University of Toronto.

FIGURE 14 Wenceslaus Hollar, after Adam Elsheimer, *Pallas*, 1646. Etching. Used by permission from the Thomas Fisher Rare Book Library, University of Toronto.

Sir Théodore Turquet de Mayerne

Another of Harvey's colleagues, Sir Théodore Turquet de Mayerne (1573–1655), provides further evidence of the interface of art and medicine during the early Stuart era. Born in Mayerne, near Geneva, to French Protestant parents, Turquet earned his MD at Montpellier, practiced in Paris, and then in 1611 settled in London, where he served as royal physician to James, Charles, and Henrietta Maria.[57] As a proponent of the chemical-based physic championed by Paracelsus, Mayerne was especially interested in the physical properties of paint and regularly consulted with artists in regard to the subject.[58] He seems to have been a frequent visitor at John Hoskins's studio, and in 1634 he discussed pigment preparation there with Samuel Cooper.[59] His research, moreover, was not limited to the English scene, for through his position at court he also came in contact with leading Continental painters.

Conducted over the course of two and half decades (1620–46), his inquiries are documented in the manuscript "Pictoria scultoria et quae subalternarum artium," which draws on both textual sources, such as Valentinus Boltz's *Illuminierbuch,* and direct interaction with some dozen or so artists, including Rubens, Van Dyck, Paul van Somer, Daniel Mytens, Cornelius Johnson, and Orazio Gentileschi.[60] The eclectic manuscript gives directions for mixing varnishes, inks, glues, and a wide variety of colors; there are

twelve recipes for "Azure" alone. Mayerne offers information on caring for brushes, preparing canvases, polishing and etching copperplates, gilding glassware, removing ink blots from paper, imitating Chinese lacquer, and making silk resemble stained glass. Not only was he taking notes on the technical practices of the painters with whom he spoke, he seems to have been working with them, too. In 1633 he noted giving a varnish to Van Dyck that he himself had prepared "after the fashion of Gentileschi." Van Dyck, however, found that "it thickens too much," and to Mayerne's "objection that a remedy for this was the addition of a little oil of turpentine," Van Dyck still "answered . . . with a no. It is a matter of experiment."[61]

Along with these tantalizing glimpses of seventeenth-century studio practice, there are peculiar inclusions as well. Mayerne offers suggestions for concealing "a page of normal handwriting" in "a gap in your teeth, or . . . in your ear," judging that with this "fine little art . . . you can bring about much." He explains how one can hide jewels or gold within a whetstone, and he takes special delight in recounting how Archimedes, while lounging in the bath one day, devised a means of measuring the purity of gold based on weight and mass.[62] In addition to the textual sources we now think of as artistic, he looks to alchemical texts, and for amber varnish he relies on "a commentary on the small surgery of Paracelsus."[63] For yellow, he cites the English surgeon and gardener John Gerard, who judged that the "the white blossoms of the nutmeg rose" will yield a pigment, which if "dried in the shade and carefully stored gives a very beautiful yellow paint, not only for illumination and glazing, but also for coloring sugared dough and jellied meat."[64] In several sections throughout the text, recipes for medicines and cosmetics appear.

As already suggested by the exchange with Van Dyck, Mayerne not only compiled information; he also played an active role in the production of art. While teaching anatomy in Florence, for example, he seems to have assisted with Lodovico Cigoli's famous wax *écorché* figure (fig. 15) known across Europe through bronze copies (Charles I was among those who owned one).[65] And in the late 1630s and early '40s, the doctor assisted Jean Petitot and Jacques Bordier in perfecting the process for making miniature enamel portraits, the first such objects to appear in England. Mayerne himself developed new colors, and appropriately, the doctor was among those depicted by Petitot in the new medium.[66]

Yet despite this impressive degree of artistic involvement, Mayerne is perhaps most familiar to art historians for his friendship with Rubens, who painted the doctor's portrait in 1631 on the occasion of his second marriage (plate 3). The picture shows Mayerne seated and facing the viewer, his cor-

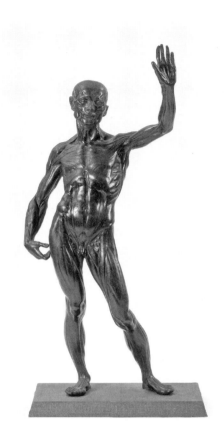

FIGURE 15 Lodovico Cigoli, *Écorché statuette*, ca. 1598–1600. Bronze, 24½" (62 cm) high. Bequeathed by Dr. W. L. Hildburgh, FSA. © Victoria and Albert Museum, London. Used by permission from Victoria and Albert Museum.

pulent frame and sloping shoulders grounding his persona with a weighty respectability.[67] The imagery of the lighthouse amid the storm and the statue of Aesculapius refer to his medical obligations to heal and save. These symbols suggest the authority of both antiquity and nature as well as the spiritual and religious dimensions of medicine that formed an integral part of Paracelsian thought. In a letter thanking Rubens, Mayerne praised the "excellent tableau" and the painter's "labeur exquis,"[68] and it is easy to imagine Harvey or Scarburgh nodding in agreement.

Although Mayerne's manuscript on painting was essentially a working document for personal use, he provided the impetus for another treatise that had a far wider impact. "At the request of that learned physician," Edward Norgate penned his influential *Miniatura; or, The Art of Limning,* which circulated in manuscript form beginning in the 1620s and was redacted in 1658 (without acknowledgment) by William Sanderson in his *Graphice: The Use of*

the Pen and Pensil.[69] Norgate enjoyed the patronage of King Charles and was employed by Arundel to instruct his sons in the arts of heraldry and penmanship, skills that in the seventeenth century provided a logical bridge between aesthetics and textual antiquarianism. Dedicated to his student Henry Frederick Howard (who succeeded his father as earl in 1646), Norgate's *Miniatura* addresses the technical aspects of portraiture, landscapes, and history painting. Though hardly a theoretical text, it is nonetheless an intelligent text, and at moments abstract principles of art pierce the pragmatic surface of Norgate's prose. Design and drawing are prioritized above color. Observation of "Nature herself" is to take precedent over absolute rules. Landscapes should represent either morning or evening scenes, for these afford the greatest "variety and beauty of colors." And history painting requires the artist heed not only the "lineaments of the body" but also the "passions of the mind," the understanding of which comes only through extensive reading, poetic expression, and the imitation of the "Italian Masters in this art."[70] Copies of the manuscript circulated well into the eighteenth century and were collected by the Yorkshire antiquary Ralph Thoresby, George Vertue, and Horace Walpole.[71]

Richard Haydocke

In contrast to the examples of Harvey and Mayerne, relatively little is known of the life and career of Richard Haydocke (1569/70–ca. 1642).[72] Yet as a student of physic, he produced one of the first art texts in English and provided for many of his readers their introduction to Italian art theory. In the 1590s, while Harvey was at Cambridge, Haydocke was at New College, Oxford, preparing for a career in medicine (like his grandfather, Dr. Thomas Bill, physician to Henry VIII and Edward VI). With what moments of leisure his studies afforded, he managed to "wean" himself "from Hippocrates to Apelles," translating Giovanni Paolo Lomazzo's *Trattato del arte della pittura, scultura, ed architettura.*[73] Published in 1598, *A Tracte Containing the Artes of Curious Paintinge, Carvinge, and Buildinge* (fig. 16) includes the first five of Lomazzo's seven books treating the topics of proportion, actions and gestures, color, light, and perspective, along with Haydocke's own unpaginated address to the reader, his marginal notes on important terms and "other difficulties," and a "Brief Censure of the Book of Colours."[74] The *Tracte* was dedicated to Sir Thomas Bodley, the founder of the eponymous Oxford library, who clearly was honored and spoke highly of the work.[75]

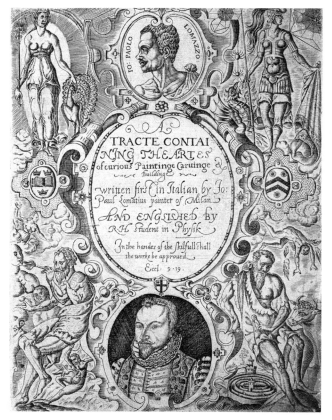

FIGURE 16 Richard Haydocke, title page; from Giovanni Paolo Lomazzo, *A Tracte Containing the Artes of Curious Paintinge, Carvinge, and Buildinge,* trans. Richard Haydocke (Oxford, 1598). Used by permission from Wellcome Library, London.

One of the most notable differences between the Italian and English editions relates to the religious aspects of image making and use. Adapting the text to a Protestant audience, Haydocke assures his readers that he has omitted several offensive passages from Lomazzo's original text, the first instance of which comes in the *Tracte*'s preface. Haydocke notes, "here the author entreth into a large discourse of the use of images, which because it crosseth the doctrine of the reformed Churches, and his greatest warrant thereof is his bare assertion, I have thought good to omit."[76]

Such religious concerns reinforce the normative aims of the translation, which was anything but a simple textual or academic exercise. Acknowledging his learned patrons who provided copies of Lomazzo's treatise, Haydocke defends his decision to translate into English rather than Latin on the grounds of "intending a common good."[77] He thus "taught a good Italian to speak a bad English" in hopes of educating both gentlemen and artists, the former "to judge and the other to work." Among Haydocke's acquain-

tances were painters including Nicholas Hilliard, whose hand Haydocke likened—in an outburst of hyperbole—to the "mild spirit of the late world's wonder Raphael," and it was at Haydocke's request that Hilliard wrote his "Treatise concerning the Art of Limning," which in turn depends heavily on Haydocke's *Tracte.*[78]

The "Brief Censure" provides an equally telling glimpse of Haydocke's interests and the degree to which they diverge from those of Lomazzo.[79] The nine-page addition opens with a criticism of the Italian text's handling of color as being impractical for artists. While Lomazzo's discussion is "most learnedly and judiciously set in down in general," Haydocke finds "it not altogether so apt for the use of the unexperienced Painter." Lomazzo describes color "by way of abstraction from the sense," rather than "as it immediately respecteth the Painter." Emphasizing practice, Haydocke defines color as "a material substance, indued with a quality diversely affecting the eye, according to the matter wherein it is found" and fully associates hue with particular sources: "minerals and earths . . . vegetables, and . . . animals."[80] Because of this material basis, colors must, he explains, be mixed with care according to their natural properties, since each responds to other substances differently. From here, he proceeds to explain the differences between tempera, oil, and fresco. He associates tempera with English artists, noting the origins of limning in manuscript production and praising again Hilliard along with Isaac Oliver. He states that oil painting "is in daily use amongst us and other nations" but supplies no examples, remarking only on the medium's durability.[81] And for fresco, he inserts a section from Vasari.

The remainder of the "Censure" addresses "The Painting of Women," by which Haydocke means cosmetics. The disparity between the visual arts in Italy and England is here encapsulated in a single phrase; for Haydocke, *"Painting upon the Life"* refers not to working with reference to an actual living model but painting directly *onto* the figure, when "a known Natural shape is defaced, that an artificial hue may be wrought thereon." He admits the utility of "fomentations, waters, ointments, [and] plasters" that help minimize natural imperfections, but distinguishes these medical preparations from the "laying on of material colours" meant only to hide one's "unpleasing defects." In detail, he warns against the use of sublimate, lemon juice, oil of tartar, and "all manner of salts" and alum-based concoctions, concluding with a list of adornments he does deem safe: cheerfulness, contentment, health, honesty, and wisdom.[82] One imagines the passage must have made the dangerous mixtures only more appealing.

Implicit in the "Censure" is an ambivalence about color itself. Lomazzo

presents it third, after proportion and after actions and gestures; and yet for the Italian, color is the "greatest glory of painting," because it is most closely connected with pure vision, the representation of life, and even "the inward passions."[83] Haydocke would presumably have been receptive to all three values. On the other hand, general Protestant suspicions of Roman Catholic exuberance may also have compelled him to qualify the original text. His discussion of cosmetics raises important gender issues (for one, color itself is identified as feminine), but functionally it helps reframe color in terms of moral restraint. Honesty wins out over artificiality.

At the same time, however, as Michael Baxandall has argued, Haydocke never managed to grasp the full range of meanings of the Italian *disegno*, the crucial opposition of *colore*. He reached for a variety of English equivalents— "quantity delineated," "delineation," "portrait," "draught," "art of proportions," and even "picture"—but the multiplicity of terms dissipated the rich meaning of the original word, which in Italian united (1) the mental operation of a plan (2) with the graphic expression of a scheme (3) as expressed through particular linear representation.[84] For Haydocke, the English "*design* seemed blocked" by the French *desseing*, which was understood in England only as purpose, plot, determination, or the like. Haydocke never managed to combine this intellectual orientation with "a graphic sense" of the word.[85] It was a significant failure that would plague art theory in England for at least the next century, and it highlights both the central role of language for the discourse of art and the challenges of developing such linguistic structures.

Notwithstanding Haydocke's revisions and shortcomings, his insistence on practicality for working artists, the materiality of supplies, and the conflation of painting and personal adornment (art and health) would play an important role in subsequent English art texts, especially those by William Salmon, as discussed in chapter 3. Yet even in addition to these points of contact, Haydocke is useful for the relationship between physic and the visual arts, both for theoretical reasons and because he himself was an amateur artist.

Haydocke, no doubt, found much in Lomazzo that corresponded with his medical studies. The Milanese painter begins his preface with a description of the origins of various arts, and physic appears alongside such basic, ancient human enterprises as husbandry, weaving, navigation, and government. Lomazzo's insistence that painting be considered a liberal art (as, he notes, it was by Pliny) must have resonated with a young physician eager to distinguish his own professional aspirations from the "mechanical" work of others.[86] And similarly, the pride of place given to human anatomy in

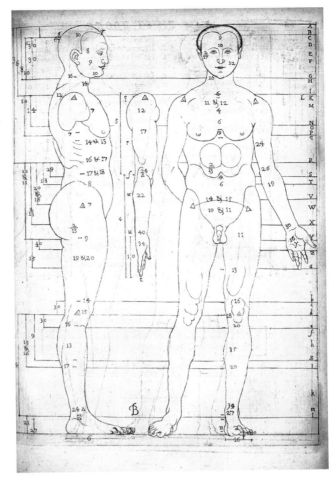

FIGURE 17 Richard
Haydocke, table B; from
Lomazzo, *A Tracte Containing
the Artes of Curious Paintinge,
Carvinge, and Buildinge,* trans.
Haydocke (Oxford, 1598).
Used by permission from Uni-
versity of Chicago Library,
Special Collections Research
Center.

the first book on proportion must have made perfect sense to Haydocke,
as did the second book's dependence on humors and astrology as a means
of explaining the movement of the passions. According to the human-
ist model of knowledge, painting and physic were both essentially about
the body.

In his address to the reader, Haydocke states he had been painting for
"mere pleasure and recreation" for seven years prior to the publication
of the *Tracte,* and his own engravings were used to illustrate the volume.
With guarded pride, he describes them as truthful in "delineation & propor-
tion," more skillfully executed than might "be expected from the inexperi-
enced hand of a student." In several cases, he—following Lomazzo—relies
on Dürer's *Vier Bücher von menschlicher Proportion* (figs. 17, 18); yet as Karl

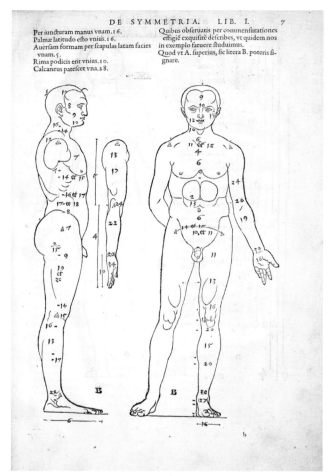

DE SYMMETRIA. LIB. I. 7

Per iuncturam manus vnam. 16.
Palmæ latitudo efto vnius. 16.
Auerfam formam per fcapulas latam facies vnam. 5.
Rima podicis erit vnius. 10.
Calcaneus patefcet vna. 28.

Quibus obferuatis per commenfurationes effigiē exquifitè defcribes, vt quidem nos in exemplo faruere ftuduimus.
Quod vt A. fuperius, fic litera B. poteris fignare.

FIGURE 18 Albrecht Dürer, table B; from *De symmetria partium humanorum* (Paris, 1557). Used by permission from University of Chicago Library, Special Collections Research Center.

Höltgen has suggested, Haydocke's graphic work is at its most interesting when derived from other sources. Table A (fig. 19), for instance, owes more to something like Thomas Geminus's edition of Vesalius (fig. 20) than the northern Renaissance master, and Haydocke's images of horses suggest a mannerist concern for motion, perhaps derived from Sebald Beham's *Proporcion der ross*.[87] John Pope-Hennessy stresses the way in which Lomazzo himself revises "Dürer's static anthropometry in terms of Leonardo's theory of movement."[88] When transplanted to England, Hilliard would use these revisions for the sake of expressing action and gesture, character and emotion; for Haydocke, they resonated with a physician's understanding of the body not as lifeless anatomy but as animated living flesh.

The title page (fig. 16) signals this congruence of art and medicine, as Haydocke identifies himself with only his initials and the descriptive phrase "Student of Physick." For anyone who failed to understand the association, in his note to the reader he explicitly answers the question of what business a man of medical learning has translating an art text. Likening himself to Archimedes, who was so preoccupied with his mathematical pursuits that he failed to give advice to the leaders of his native Syracuse as the enemy attacked (or even notice when the enemy penetrated the city's gates), Haydocke concedes that some might think his time better spent at "the College of Physicians, learning and counseling such remedies, as might make for the common health" rather than translating a text on "lines and lineaments, portraitures and proportions." Having posed this hypothetical critique, however, Haydocke turns again to Archimedes:

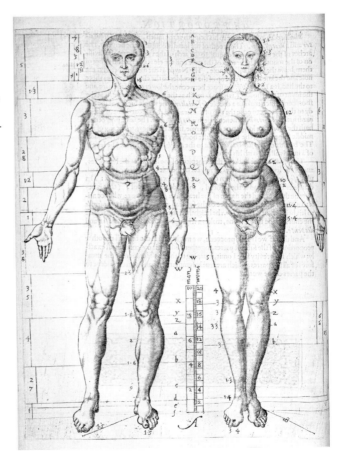

FIGURE 19 Richard Haydocke, table A; from Lomazzo, *A Tracte Containing the Artes of Curious Paintinge, Carvinge, and Buildinge,* trans. Haydocke (Oxford, 1598). Used by permission from University of Chicago Library, Special Collections Research Center.

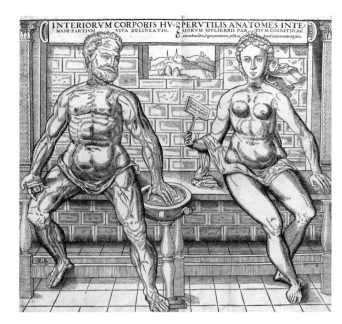

FIGURE 20 Thomas Geminus, anatomic plate; from *Compendiosa totius anatomie delineatio* (London, 1559). Used by permission from Wellcome Library, London.

How be it, as I find not him much taxed in the story, for this his diligent carelessness, because he was busied about matters, which were not only an ornament of peace, but also of good use in war: So my hope is (Ingenuous Reader) that my sedulous trifling, shall meet with thy friendliest interpretations: insomuch as the art I now deal in, shall be proved, not only a grace to health, but also a contentment and recreation unto sickness, and a kind of preservative against Death and Mortality: by a perpetual preserving of their shapes, whose substances Physic could not prolong, no not for a season.[89]

Haydocke paid careful attention to the poetics of this defense, but there is every reason to believe he was entirely serious when prescribing art as "a grace to health."

Henry Wotton, in the dedication of *The Elements of Architecture* to Charles I, similarly casts visual contemplation as a form of therapy. After describing his own bout with "a "miserable stopping in my breast and defluxion from my head," he characterizes the writing of the 1624 book—generally accepted as the first significant architectural treatise penned in English—as a useful "diversion of my mind from my infirmity."[90] Likewise, in the massive *Anatomy of Melancholy*, Robert Burton recommends the "learning of some art or science" to remedy ill health, and distempers linked to melancholy, in particular, were believed to benefit from the moderate pursuit of an

intellectual interest.[91] The criteria for judging art turns out to be not unlike that used to judge health (with a bodily derived conception of proportion and regularity dominating both), and finally the passage suggests, too, that Haydocke perhaps had not strayed as far from his Hippocrates as he had earlier intoned: it was, after all, the ancient medical writer who asserted that life is short and art long.

For a sense of the direction of Haydocke's future artistic production, the title page of the *Tracte* serves as a much better guide than the engravings used inside the book. Haydocke's handsome self-portrait at the bottom of the page balances that of Lomazzo at the top (drawn from the *Trattato*). Shown in a three-quarter view and wearing distinctly contemporary finery, Haydocke alone evokes the turn of the seventeenth century, in contrast to the other forms that suggest a vaguely antique world of symbolic meaning. The four corners show Juno as the goddess of light with her peacock and eye-crowned scepter; Athena with spiderwebs and drapery alluding to transformation and the arts of textiles; Prometheus, the archetypal sculptor and recipient of the gift of fire; and Daedalus, architect of the labyrinth (here looking more chivalric than classical). On the left side of the title cartouche is the shield of Oxford and on the right, that of New College. The ornamental scrollwork implies movement and emphasizes the works of the hands, a point made explicit by the reference from Ecclesiastes 9:19, "In the handes of the Skilfull shall the worke be approved."

Haydocke would go on to embrace the emblematic tradition, designing memorial brasses for Oxford divines and doctors that ranged from the predominately figurative, such as that of Henry Robinson (fig. 21), to the principally symbolic, such as that of Dr. Thomas Hopper (fig. 22). As explicated by Höltgen, the last example depends on the pentagram, emblematic of health and salvation, encircled by the eternal serpent, which holds in its mouth the forbidden fruit of the Tree of Life. To the side appears Moses holding a staff (understood both as Aaron's rod which became a serpent and the brass pole, topped by a serpent, by which the Israelites were saved from a divinely sanctioned plague). Across from the lawgiver is a female figure with a cornucopia, presumably either Hygieia or Salus (Health). The Corinthian order—marked with the four corners of the earth as well as *Theoria* and *Praxis*—frames the textual memorial, which dominates the center of the image; a marble surround includes additional mortality emblems.[92]

This emblematic language, structured by architecture, would appear again in Haydocke's designs for the title pages of Arthur Warwick's *Spare Minutes; or, Resolved Meditations and Pre-Meditated Resolutions* of 1635 (fig. 23). It also would surface in the picture Haydocke donated to New Col-

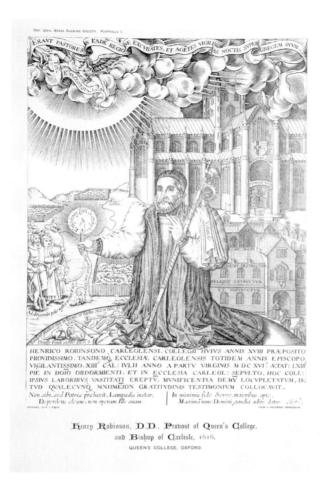

FIGURE 21 Etching of
Richard Haydocke's *Brass of
Henry Robinson,* 1616. Queen's
College, Oxford. From *The
Oxford Portfolio of Monumental
Brasses,* pt. 1 (London, 1898).
Used by permission from
the Society of Antiquaries,
London.

lege, Oxford, in 1630 to commemorate the twenty-fifth anniversary of the
failed Gunpowder Plot (fig. 24).[93] Painted by one J. P. of Salisbury (perhaps
John Percivall) but likely designed by Haydocke, the picture organizes his-
tory into the frames provided by a triumphal arch. In the first level Justice
disrupts the plans of the conspirators; in the second, the royal family retains
its place at the head of the state; and at the apex sits God Almighty, preserv-
ing the societal order.

The theme of divine salvation as expressed through the reign of King
James also carried a more personal meaning for Haydocke. For in 1605
he began claiming he was possessed of the curious ability to preach in his
sleep; the hoax soon spun out of control, and when it attracted the attention
of King James (ever watchful for intrusions of the supernatural), the doctor

was forced to admit his deceit. No serious consequences resulted from this bit of sensational knavery, but the benign resolution of the episode must have left Haydocke still feeling an enormous sense of relief twenty-five years later. Reformulating his own shame into a celebration of James's divine protection—with the architectural frame functioning as a memory theater of sorts—perhaps provided some propitiatory measure of closure.

Most striking about Haydocke's interests in medicine and art is the degree to which his own work departs from the Continental traditions with which he began. To whatever extent one sees Lomazzo's text as a mannerist revision of Renaissance theory moving toward systemization, Haydocke evinces at least the potentially vast gap between English visual culture and that of Italy. He demonstrates the English propensity for the emblematic, heavily textual use of images in the service of documenting and commemorating individuals, along with the expression of metaphysical ideas explicated in theological texts or hermetic processes better suited for alchemical experiments than the fine arts.

FIGURE 22 Richard Haydocke, *Brass of Dr. Thomas Hopper*, 1623. New College, Oxford. Used by permission from The Warden and Scholars of New College, Oxford / The Bridgeman Art Library International.

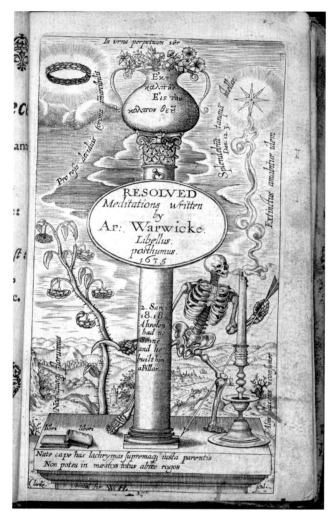

FIGURE 23 Richard Haydocke, frontispiece; from Arthur Warwick, *Spare Minutes* (London, 1635). Used by permission from the British Library, London.

Looking back over the shoulders of a Georgian connoisseur, one would be inclined to see Haydocke as a false start. Fair enough. And yet the point is that in England the discourse that would ultimately nurture the fine arts worked in tandem with this emblematic mode of engaging nature and pictures, a text and the body, knowledge of words and material forms. For better or worse, there is an intelligible thread connecting Haydocke with Hilliard, Mayerne, and their Restoration counterparts.

Even the more classicizing, antiquarian tradition embodied by Arundel, Harvey, and Jones intersects with the life of the Salisbury physician. Hay-

docke's son-in-law, Dr. Nathaniel Highmore, participated in the circle of natural philosophers centered on Harvey in the 1640s. Highmore's *Corporis humani disquisitio anatomica* of 1651 is dedicated to the doctor. His *History of Generation,* from the same period, was the first publication to be dedicated to Robert Boyle, and Highmore's atomism led him to revise Kenelm Digby's ideas on embryology as well as Digby's advocacy of the efficacy of sympathetic medicines that, through supposed laws of correspondence (heavily indebted to Paracelsian ideas), were widely believed to work on wounds if applied, for example, to the weapons that had inflicted the violence.[94]

And notwithstanding the limitations of Haydocke's own artistic output, his translation of Lomazzo proved important for the next century and a half of English art writers, including Peacham, Junius, Alexander Browne, Salmon, and Vertue.[95] William Hogarth refers to Lomazzo several times in his *Analysis of Beauty* (1753), and though, as Frederick Hard has noted, he is often critical of the Italian theorist, in the preface he draws on the text to

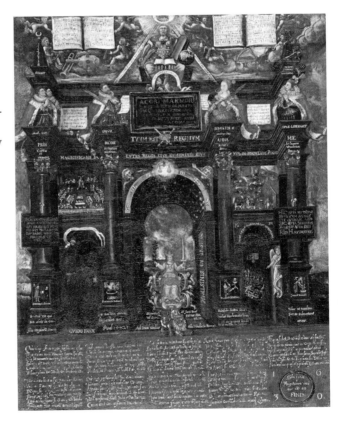

FIGURE 24 John Percivall, *An Allegory of the Guy Fawkes Plot,* 1630. Oil on canvas. Used by permission from The Warden and Scholars of New College, Oxford / The Bridgeman Art Library International. The composition likely originated with Haydocke.

support his fundamental notion of the serpentine line: Lomazzo's quotation of the directive from Michelangelo that an artist "should always make a figure pyramidal, serpentlike, and multiplied by one, two, and three."[96] For Hogarth, herein lies "the whole mystery of art";[97] and thus, despite his usual opposition to Italian prescriptions, here—through Haydocke—Hogarth presents himself not as antagonist but as rightful heir to the tradition.[98]

Even Haydocke's bizarre hoax introduces a cluster of themes that pulse throughout early modern medical history: trust, authenticity, quackery, and pretending. In the same way that both physic and art were erected on the foundation of the human body, each was constantly under pressure to establish its legitimacy, defining itself over and against charlatanism[99]—this despite the fact that the lines between the reputable and the dubious were rarely as well defined as those voicing the accusations would have us believe. From the pervasive chargers of quackery that echoed throughout the pamphlet debates of the Restoration and Georgian periods, to the unsettling case of Mary Toft, who claimed to have given birth to rabbits in 1726, to the contested character of taste in matters of artistic patronage, credibility was renegotiated at every turn.

The Virtuosi and Italian Humanism

These issues of legitimacy were closely connected with authority, and early modern physicians understood perfectly well the importance of establishing the validity of one's professional voice, even if approaches for doing so varied from doctor to doctor. The writings of the Ancients and the Book of Nature constituted a medical education, and the accomplished doctor was an expert reader of both. In this sense Haydocke's interest in translating Lomazzo's text should come as no surprise. Textual expertise was a prerequisite for studying physic in the first place, and already by the sixteenth century there was a well-established tradition of physicians looking to Italy in the midst of their education. Writing in 1780, John Aikin stressed this humanist model in his *Biographical Memoirs of Medicine in Great Britain from the Revival of Literature to the Time of Harvey*. Embracing a thoroughly Renaissance conceptual framework, he dates the earliest attempts to recover the ancient medical accomplishments of the Ancients to the fall of Constantinople in 1453. John Phreas is celebrated for mastering "both the learned languages" (Greek and Latin) and is even credited with writing "an epitaph for the tomb of Petrarch" to replace "a barbarous one before inscribed upon it." Amazingly, Aikin portrays Phreas the Englishman as stamping out bar-

barism in Italy! Likewise, he makes much of the fact that Thomas Linacre, the first president of the Royal College of Physicians, took his medical degree from Padua in 1496 and was said to have perfected his Greek in Florence while studying with the sons of Lorenzo de' Medici.[100]

Yet reading during the early modern period more often than not involved modes of looking that went far beyond seeing merely the words on a page—notwithstanding the curious fact that Lomazzo was blind by the time he wrote his *Trattato del arte*. The antiquarian tradition nurtured by the circle of scholars around the Medici during the fifteenth century could still inspire Harvey to sift through the soil at Stonehenge or to extend his advice in Rome regarding possible additions to the royal collection. Indeed, in some respects, a medical education was by definition an antiquarian project.[101] The examples set by all of these physicians challenge the view that the virtuosi were, until the mid-seventeenth century, interested principally in art and antiquarian matters and only then turned their attention to "scientific" concerns.[102] On the contrary, the virtuosi from the beginning eagerly embraced all sorts of knowledge, and physicians understood that cultural refinements ultimately worked to their professional advantage.

Far more than simple signs of intellectual status or sophistication, however, the early modern doctor's engagement with the arts and antiquarian objects was connected to the other essential ingredient for a successful career in physic: the ability to provide sound advice. As Harold Cook has shown, in an age in which physicians were working with the same basic medical tools as the corner quack, the doctor distinguished himself through a social process that depended on trust and consisted of dispensing counsel.[103] According to established humanist principles, the cultivation of the arts was one way to nurture these judgment instincts. Indeed, perhaps as much as Harvey's own interest in the arts, it was this trait that prompted Arundel to arrange for the physician's trip to Rome.

Italy not only provided textual, archaeological, and educational resources. As noted by Peacham when he introduced the *virtuoso* designation into English in 1634, this expansive outlook originated there as well, and the southern peninsula likewise provided examples of medical men engaged in wider intellectual pursuits. Take for instance the sixteenth-century doctor and courtier Paolo Giovio. Despite a successful career as physician to Giulio de' Medici (in his role as both cardinal and Pope Clement VII), Giovio really wanted to write history. Two of his treatises, *De romanis piscibus* (On Roman Fish) of 1524 and *De optima victus ratione* (On the Best Regimen of Diet) of 1527, demonstrate how medicine and antiquarian interests could be joined. The latter, written just as Rome was being ravaged by the troops of Charles V,

was a standard prescription of moderation drawn from Galen, but the former, as described by T. C. Price Zimmermann, was more unusual. Giovio analyzed forty different kinds of fish to be found in the Roman market according to ancient Latin references. Having established a common nomenclature—a challenge appreciated by anyone who has ever tried to order fish from a menu in a foreign country—he proceeded to offer advice on the medical and nutritional attributes of each type. Giovio became a bishop in 1527, abandoning medicine, partly out of frustration that physicians were so ineffectual in correctly diagnosing, much less curing, patients—though Zimmermann suggests that he never entirely forsook his medical outlook. Giovio assembled a widely influential collection of hundreds of portraits, but his art-historical significance is generally explained more simply: he offered initial and persistent encouragement in the 1540s for the first edition of Vasari's *Lives of the Artists*.[104]

In the second half of the century, Dr. Ulisse Aldrovandi gathered a vast array of plant and animal specimens in Bologna, the cataloguing of which kept the custodians of the collection busy for fifty years after his death in 1605. Aldrovandi's own attempt to convey the scope of the undertaking was daunting enough:

> Today in my microcosm, you can see more than 18,000 different things, among which 7000 plants in fifteen volumes, dried and pasted, 3000 of which I had painted as if alive. The rest—animals terrestrial, aerial and aquatic, and other subterranean things such as earths, petrified sap, stones, marbles, rocks, and metals—amount to as many pieces again. I have had paintings made of a further 5000 natural objects—such as plants, various sorts of animals, and stones—some of which have been made into woodcuts. These can be seen in fourteen cupboards, which I call the Pinacotheca.[105]

Meanwhile in Milan, Dr. Ludovico Settala assembled a collection of manuscripts, paintings, ancient artifacts, and curiosities, which continued to grow over the course of the seventeenth century under the direction of his son Manfredo, a cleric with strong interests in mechanics and natural philosophy—regarding which he corresponded with the Royal Society. In addition to serving as canon of the Basilica of SS. Apostoli, Manfredo headed up the city's art academy, and many of the objects from the Settala collection are still to be found in the Pinacotheca Ambroisana.[106]

Back in Rome, the Jesuit Athanasius Kircher presided over his famously eclectic museum, which aimed to encapsulate the whole of Creation—complete with fossils, shells, skeletons, paintings, marbles, mathematical

instruments, globes, and obelisks. In conjunction with his larger project to establish the essential unity of God's handiwork, Kircher published over forty books on topics ranging from astronomy to the subterranean world, from the Tower of Babel to the decipherment of Egyptian hieroglyphs, from spontaneous generation to the microorganisms responsible for the spread of plague.[107]

And finally there is the case of Dr. Giulio Mancini, the physician to Pope Urban VIII who assembled a reputable art collection and penned his own *Considerations on Painting* in the early 1620s. Carlo Ginzburg famously judged that Mancini fused the eye of the clinician with that of the connoisseur, and Mancini is best known to art historians for his dismissal of Caravaggio's *Death of the Virgin* as a blasphemous breach of decorum: it was Mancini who asserted that the artist had modeled the Madonna after a common prostitute.[108]

Giovan Pietro Bellori referenced Mancini's criticism in an address before the French Academy in the 1660s to support his contention that artists should look to classical traditions of Greece and Rome for their models. But as Todd Olson has argued, Mancini's position was not quite that espoused later by Bellori.[109] For the doctor was not simply opposing the ennobling ideal to the vulgar particular. Instead, Mancini was struggling with more profound questions about beauty, representation, and the challenge of ever finding an adequate referent for the presence of the divine; he likens, for example, Caravaggio's selection of a prostitute to a Byzantine artist who, having modeled an image of Christ on a statue of Zeus, had his hand cut off as punishment. The "material and historical specificity" of the prostitute's body paralleled the unsettling fact that early modern anatomic knowledge advanced thanks to dirty, poor, and criminal bodies. In short, Mancini was compelled to censure Caravaggio's painting not because it was so alien to his own working method but because it pointed to uncomfortable (and presumably unacknowledgable) similarities between himself and the artist. As Olson judges, Mancini had "backed himself into a corner."[110]

The case of Mancini usefully raises a number of themes relevant to the English context. First, the virtuosi were continually balancing universal and particular knowledge claims. If the latter category served as an endless source of cerebral stimulation, it was also far messier than was generally admitted and frequently complicated simple acceptance of previously unproblematic positions. Second, as a result of this tension, the virtuosi often found themselves in an impossible position, pinned between received theory and the evidence of one's own senses. As explored in the next two chapters, significant consequences followed in terms of their engagement with the arts. Society

Fellows typically embraced some form of academic classicism, and yet their empirical commitments routinely altered the theory they appropriated. It is all too easy to view the Royal Society's artistic ideals as a dim reflection of those promoted by the French Academy, especially since the majority of the texts produced by Society Fellows originated from across the Channel. But just as Bellori managed to employ Mancini's criticism of Caravaggio with none of the complications that besieged the physician, the virtuosi's use of Continental theory resulted in the reintroduction of epistemological dilemmas arising from the English empirical context. Third and finally, this forty-year lapse between Mancini's original criticism and Bellori's reference in front of the French Academy underscores the degree to which the passing of time necessarily entails change. The Restoration period—despite occasional contemporary rhetoric to the contrary—was in no way a seamless return to the early Stuart period. While these precedents still mattered immensely, the virtuoso tradition itself changed over time. The importance of Arundel's circle was not that it defined the essence of the English virtuoso but that it provided models for subsequent generations as they refashioned their own intellectual landscapes.

Similar points of incongruity existed between the Restoration virtuosi and their Italian predecessors. As described by Lorraine Daston and Katharine Park, the former melded curiosity and wonder in hopes of counteracting natural philosophy's traditional fascination with Aristotelian universals— "its lazy hankering for generalities." Daston and Park crucially observe that "the transition from a natural philosophy based on universals to one based on particulars required a new economy of attention and the senses."[111] Likewise, Paula Findlen notes that leading members of the Royal Society held reservations about the learned ambitions of Aldrovandi and even more suspicion for Kircher, who exuberantly advocated an analogic epistemology intended to advance the position of the Roman Catholic Church.[112] In response to Kircher's *Subterranean World,* Henry Oldenberg shared the following assessment with Robert Boyle: "I do much fear he gives us rather collections, as his custom is, of what is already extant and known, than any considerable new discoveries."[113]

Yet even as the Royal Society's commitment to new forms of knowledge served as the grounds for devaluing such work, a tinge of insecurity still rings around the edges. The legacy Bacon bequeathed to the society was itself, after all, keenly fixed on the amassing of data; and Evelyn, for one, had eagerly made the pilgrimage to Kircher's museum at the Roman College while abroad during the interregnum. On a Friday morning in November of 1644, he found the sweeping range of the Jesuit's collection perfectly exhila-

rating.[114] For all of their differences, Evelyn, like Kircher, nursed ambitions of understanding everything. Surveying the next sixty years of Evelyn's life, we might explain the expenditure of his intellectual energies, most of which played out in the context of the Royal Society, as the reframing of that ideal from an individual dream to a collective aspiration. For Evelyn and his colleagues, the Royal Society possessed the potential to succeed where Kircher ultimately had failed. That an issue of the 1668 *Philosophical Transactions* could, in a single review, accommodate books on chemistry, practical mathematics, zoology, and the fine arts must have been an encouraging sign.

From the "Applying of Colors" to "the Politer Parts of Learning"

Art and the Virtuosi after the Restoration

The execution of Charles I in 1649 attests to the Puritans' unflinching resolve and utter rejection of the royalist claim of divine sovereignty. It also marks the end of the first phase of English virtuosity. With the beheading staged on a scaffolding erected beside Inigo Jones's Banqueting House at Whitehall, the regicide entailed not only the violent suspension of the Stuart dynasty but also an attack on the larger court culture it had nurtured. Within the Banqueting House, Ben Jonson's masques had celebrated the Stuart reign, and ambassadors from across Europe were received under Rubens's painted ceiling, which likened the reign of James to that of Solomon. In addition to these performances of royal power, the sovereign also here dispensed the promise of health to those suffering from scrofula, or the "King's Evil," a tubercular illness believed to be cured by the ruler's touch—though how differently the Puritans would understand the phrase.[1]

In the 1640s, Lord Arundel and Countess Aletheia retreated to the Continent along with Queen Henrietta, her mother, Maria de' Medici, and her son, the future Charles II. By the mid-1650s, death had claimed England's first generation of virtuosi, and the royal collection had been scattered across Europe. Yet if the Commonwealth provides a convenient termination point for the early Stuart virtuosi, it also ushered in the second generation, which would take shape largely around the Royal Society.

John Evelyn, Medical Virtuosity, and Objects of Learning

John Evelyn (fig. 25), one of the principal figures of this next generation, spent much of the English Civil War across the Channel, observing palaces, pictures, antiquities, and all manner of curiosities.[2] As for art, the curator of Arundel's collection, Hendrick van der Borcht, wrote to Evelyn in Padua full of envy:

> I . . . do wish myself often times with you that we might together enjoy the sight of the rare Pictures in those Parts. I do not doubt of the increase of the Love and skill you have in Pictures and that you do exercise yourself in it. . . . [or that] you go often (at your being at Venice) unto the island of St. George to see the rare great picture of Veronese and the goodly pictures of Titian at Frari and other places likewise.[3]

At the same time, Evelyn avidly pursued an array of medical interests. His diary includes dozens of entries on hospitals, anatomic theaters, chemical lectures, and physic gardens. While in Rome in February of 1645, for

FIGURE 25 Robert Nanteuil, *John Evelyn,* 1650. Engraving. Used by permission from Wellcome Library, London.

instance, he visited the Isola Tiberina, noting the ruins of the Temple of Aesculapius (the Greco-Roman god of healing), the "stately hospital" of the Fatebenefratelli, and the adjacent church of San Bartolomeo, which houses "the body of that apostle."[4] Such juxtapositions of interests—in this case antiquity, medicine, and religion—occur throughout the diary, and one senses Evelyn discovered these connections largely because he expected to.

Several months later, in July, Evelyn matriculated at the University of Padua to study "Physic & Anatomie." The restrained tone of his diary gives way to enthusiasm as he notes the school's outstanding "Theater for Anatomies," and its renowned medical faculty.[5] During his year-long course of study, he attended anatomy lectures and visited the city's hospitals, observing cures executed by the "skillfulest Physitians" for "Men & Women; Whores & Virgins, Old & Young."[6] He also acquired several objects which seem wonderfully curious, even in the twenty-first century: a series of four anatomic tables consisting of actual human veins, arteries, and nerves.[7]

Apparently the first of their kind (only one other, later set is known to exist), they bear material witness to Evelyn's course of study in the 1640s, and yet the subsequent history of the panels, including their 1702 appearance in an article by William Cowper in *The Philosophical Transactions*, extends their significance beyond this initial moment of acquisition. In this broader context, the panels prove useful for probing the visualization of anatomy, the persistence of pre-Harveian conceptions of the arterial and venous systems, and above all, the economy of learned objects within the virtuosic world of the early Royal Society.

Mounted onto 2-foot by 5-foot wooden panels, the specimens were prepared by the surgeon Giovanni Leoni, assistant to the chair of anatomy Johan Vesling, and include

- the aorta and the distribution of the arteries (plate 4A),

- the spinal cord and the nerves of the trunk and extremities (plate 4B),

- the distribution of the veins (fig. 26),

- and—in three groups—the vagi with sympathetic nerves, the veins of the lungs, and the portal vein and its branches in the liver (fig. 27).

Writing in 1702, Evelyn recalled that Dr. George Rogers, then a student at Padua, negotiated the purchase, with Evelyn specifically requesting the

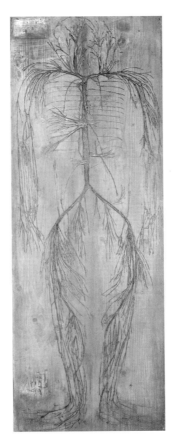

FIGURE 26 (LEFT)
Giovanni Leoni, *Distribution of the Veins,* ca. 1646. Used by permission from the Museum of the Royal College of Surgeons, London.

FIGURE 27 (RIGHT)
Giovanni Leoni, *The Vagi with Sympathetic Nerves, the Veins of the Lungs, and the Portal Vein and Its Branches in the Liver,* ca. 1646. Used by permission from the Museum of the Royal College of Surgeons, London. However unusual this fourth panel may now seem, it was specifically requested by Evelyn "to compleat" the series of panels he acquired in Padua. He donated the tables to the Royal Society in 1667 on his forty-seventh birthday.

fourth panel of the sympathetic nerves and veins of the liver and lungs, so as "to compleat" the series.[8]

Soon after the tables arrived in England, they garnered admiration from the medical community, and in 1652 Dr. Charles Scarburgh (fig. 8) approached Evelyn, imploring him to donate them to the College of Physicians.[9] Scarburgh pledged to use them to "celebrate" Evelyn's "curiosity, as having been the first who caused them to be completed in that manner, with that cost." But despite the offer—which interestingly promised to extend the curious character of the tablets to Evelyn himself for his role in acquiring them—Evelyn was not "willing yet to part with them" and agreed only to lend them for the college's anatomic lecture.[10]

Eventually, in October 1667, Evelyn did donate the panels, but to the Royal Society rather than to the College of Physicians. His loyalty to the society and its relatively recent attempts to establish a collection partly explain the decision.[11] But closer attention to the circumstances surrounding the gift

provides a more precise rationale for both the timing and Evelyn's recipient selection. Before pursuing this line of inquiry, however, we first need a fuller sense of Evelyn's medical interests.

His engagement with physic began soon after he abandoned his study of law. In 1641, during his first trip to the Continent, Evelyn recorded being impressed with Amsterdam's hospital for wounded soldiers, and at Leiden he "was much pleased" with the school's physic garden, museum, and anatomic theater.[12] His interest in medicine persisted throughout his life. He attended chemistry lectures by Nicolas Le Fèvre, the future apothecary to Charles II. His acquaintances included many of England's most respected doctors, including Christopher Merrett, Walter Charleton, Thomas Short, Richard Lower, Salusbury Cade, and Hans Sloane. He made regular appearances at the Royal College of Physicians, attended lectures there, and was even consulted about the relocation of the institution's library.[13] Above all, his appointment in 1664 as a commissioner for the care of sick and wounded seamen from the Dutch-Anglo War brought Evelyn in direct contact with England's health-care system, and he embraced these responsibilities with assiduous dedication. He provided enthusiastic support for the planning of Chelsea Hospital, and in 1696 he assisted Christopher Wren in laying the foundation stone of Greenwich Hospital.

Evelyn never practiced physic as a profession, and it would be a mistake to think of him as a doctor. Still, he likely understood the culture of seventeenth-century medicine as well as any of his peers. While his involvement with the Royal Society would have inevitably brought him in contact with London's medical community, his own interests in the field began as early as the 1640s and resulted in a lifelong engagement with medical matters that included research, practice, and the administration of care.[14]

This involvement with medicine was rarely if ever isolated from Evelyn's other intellectual concerns. Rather, these medical pursuits are important *because* they were fostered alongside his other interests. It is precisely Evelyn's inability to compartmentalize his medical pursuits that makes them so valuable, not only for the history of medicine but for the larger history of seventeenth-century virtuosity.

On August 1, just after Evelyn matriculated at the University of Padua, for instance, he accompanied Thomas Howard, Earl of Arundel—who had also settled in Padua after fleeing a war-torn England—to the Gardens of Mantoa and the Odeon and loggia of Giovanmaria Falconetto (included in book 7 of Serlio's *Architettura*).[15] After dinner he and Arundel proceeded to the remains of the ancient amphitheater (adjacent to the Scrovegni Chapel), which had been transformed into a menagerie; there they observed an as-

sortment of animals and birds: "two eagles, a crane, a Mauritanian Sheepe, a stag, and sundry foule." Several days later, Evelyn visited the Murano glassworks in Venice, not only purchasing an assortment of pieces but also observing the production process. And on the same visit he acquired, through an English captain, an Egyptian stone with hieroglyphs, a copy of which he sent to Athanasius Kircher, who included the text in his *Obeliscus Pamphilius* (fig. 5)—though, much to Evelyn's dissatisfaction, without acknowledgment of its provenance.[16]

This was a remarkable week even for Evelyn, but a similar pattern appears throughout the diary. The day before he visited Leiden's anatomy theater, he records seeing the grave of Joseph Scaliger in Pieterskerk, while several days later he notes his wonder at the decorative paintings of the royal hunting palace at Honselaarsdijk, which included the magisterial *Crowning of Diana* by Rubens and Frans Snijders (now in Potsdam), a painting appropriate for posthunt banquets but one that surely also appealed to Evelyn's fascination with the natural world.[17] Likewise, while in Paris in the spring of 1650 he described in consecutive entries a trip to the Château de Madrid in the Bois de Boulogne; a visit to the collection of the printmaker Stefano della Bella, where he purchased prints and met the artist Gabriel Pérelle; and his attendance at the public hospital, where he "saw the whole operation of Lithotomie" on a forty-year-old man who "had a stone taken out of him, bigger than a turkey's Egg"—after which Evelyn understandably gave "Almighty God hearty thanks" that he "had not been subject to this Infirmitie."[18] In this lively intellectual ferment, the interior wonder of the human body coexisted with works of art, chemical lectures, religious meditations, scholars (both living and deceased), palaces, glass factories, and gardens.

Evelyn's anatomic tables fit nicely within this polymathic milieu, and here a number of questions come to mind. What made the panels so special for seventeenth-century viewers? What sort of information were the tables seen to offer? What advantage did they have over printed anatomies? And how could they have still been so highly esteemed even as late as 1702?

Above all, the tables were seen as a curiosity. Scarburgh makes the point in his 1652 appeal to Evelyn, pledging to use them to "celebrate" Evelyn's own curiosity. And for two decades, the panels were unique in England. Scarburgh also alludes to their cost. In a letter to William Cowper (included in the *Transactions* article), Evelyn recalls paying 150 scudi—what Carlo Maratti was charging for full-length portraits, or five times as much as a normalsized easel picture.[19] In addition to the expense, the process of making them contributed to their curious character. Dr. Nehemiah Grew, for instance, in his *Musaeum Regalis Societatis; or, A Catalogue . . . of Rarities Belonging to*

the Royal Society, states that Evelyn "bought them at Padoa, where he saw them with great industry and exactness (according to the best method then used) taken out of the body of a Man, and very curiously spread upon four large TABLES."[20] An annotation in Evelyn's own copy of Grew's *Catalogue* again refers to the panels' cost while supplying additional information about their audience: "King Charles the 2nd saw them in my house at Deptford."[21]

Yet if the set were seen as a rarity, the anatomy visualized was not. The language employed in both Grew's description and the 1702 article emphasizes the degree to which the panels reinforced what was already known.[22] In the 1640s, however, European doctors were most definitely facing an anatomic issue that was new: William Harvey's explanation of the blood's circulation. The publication of his *Motu Cordis* in 1628 offered a profound revision of basic anatomic knowledge as received from Galen, even as it initially met with skepticism. Two decades later, Harvey's account had become increasingly difficult to argue against, though it still faced opposition.

Although Harvey was some forty years older than Evelyn, the two men could have met—especially since both were members of the Arundel circle. While Evelyn nowhere records such an introduction, at several points in his diary he refers to Harvey, and always with admiration.[23] Whatever Evelyn thought about the blood's circulation in the 1640s, there is no reason to think he ever later challenged it.

But the anatomic tables make the perfect case for a Galenic understanding of the human body wherein the veins and arteries are understood as separate, unconnected systems. Accordingly, the veins were believed to carry nutritive blood produced in the liver, while the arteries were considered part of the respiratory system transporting vivified blood from the lungs.[24] Evelyn's panels follow this division, displaying the veins, arteries, and nerves separately, with a fourth panel, which Evelyn specifically ordered, showing a central component for each system: the sympathetic nerves, the vessels of the liver, and the vessels of the lungs.

The 1702 article by William Cowper ignores these associations and, in fact, employs the tables to explain the movement of the blood from the arteries to the veins. It was this movement that Harvey was forced to accept on speculative grounds and that the tables can in no way be said to demonstrate.[25] An empirical understanding of the connection *between* the two systems instead rested on the application of two other imaging technologies, the microscope and the injection of wax into biological structures.[26] Cowper makes his case with reference to Antonie van Leeuwenhoek's microscopic work on fish and frogs. On the whole, he takes for granted the evidentiary potential of wax-injected specimens, a process pioneered by another Dutch-

man, Jan Swammerdam.[27] This "wet" model of anatomy runs exactly counter to Evelyn's panels, which depended on the extraction and drying of systems. Importantly, this fluid conception of the body serves as the foundation for Cowper's larger mechanistic understanding of anatomy, which was widely accepted throughout the first half of the eighteenth century and roughly corresponds with a Newtonian framework that described the body in terms of the push and pull of various physical forces. For his part, Cowper presents the veins and arteries as a vast system of pipes carefully arranged in terms of size and location to balance the effects of gravity and the weight of the blood.

But if Cowper's article demonstrates how much the field of anatomy had changed over the latter half of the seventeenth century, it also throws into relief the anatomic tables themselves. While Cowper's investigations addressed the very points of physiological convergence that the panels failed to show, they bring us back to the question of the tables' appeal. And at this point, consideration of the circumstances surrounding Evelyn's donation is in order.

By 1667, when he at last gave them up, another set of mounted anatomies had been imported from Padua (plate 5). Six in number, they include the same systems as Evelyn's with the addition of the arterial system of a woman (supplementing that of a man) and a dichotolydinus placenta from the miscarriage of twins. Appearing less carefully contoured and diagrammatically arranged than Evelyn's (and perhaps more monstrous as a result), these panels are more sophisticated in terms both of their technical production and of their correspondence with in-situ anatomic forms, though admittedly curiosity remains a key concern. These tables, which eventually ended up in the collection of the College of Physicians, initially belonged to the brother-in-law of Harvey's niece, Dr. John Finch, who also studied at Padua around 1650, taught anatomy at Pisa, and in 1661, upon returning to London, became an Extraordinary Fellow of the College of Physicians.[28] Edward Browne refers to Finch and his tables in a 1665 letter to his father, Dr. Thomas Browne, and thus they were known to at least a portion of London's medical community. That Evelyn's were no longer the only anatomic tables in England may, therefore, have contributed to his decision finally to let them go.

Still, other circumstances also deserve consideration. The month prior to his presenting the panels, Evelyn was busy sorting through the Arundelian collection of ancient marbles that he himself had convinced Henry Howard of Norfolk (Lord Arundel's grandson) to donate to the University of Oxford. Having been closely acquainted with the heir apparent since at least the mid-40s, when the two men were together in Padua, Evelyn had already in January of 1667 convinced Henry to donate the Arundel library to the Royal Society.[29] Henry himself was a Fellow of the society and had made Arun-

del House available for the society's meetings in the aftermath of the Great Fire.[30] In 1668, Evelyn dedicated his translation of Fréart's treatise on painting to Henry, acknowledging his donation of Greek and Latin inscriptions, "a greater gift than all the world can present," since "all the world cannot show such a collection of antiquities." He went on to encourage Henry to "cause the choicest of your statues, basse relievos, and other noble pieces of sculpture, standing in your galleries at Arundel House to be exquisitely designed by some sure hand, and engraven in copper."[31]

Following these efforts in brokering the philanthropy of the Howard family, on October 31, 1667, his forty-seventh birthday, Evelyn traveled to London, where he presented the Royal Society with his treasured anatomic tables, for which he "received the publique thanks of the Society." Concluding the day's entry, Evelyn writes, "I lay this night at Arundell house."[32]

For all the differences of scale between Evelyn's donation and the items from the Arundel collections, the timing of the former marks the gift as a gesture of emulation. Evelyn's decision finally to relinquish these objects on which he had placed such a high value for two decades should be seen within a larger context of gift giving that associatively connects these anatomic tables with other objects of erudition: ancient marbles, a library, and—through the dedication of Evelyn's translation of Fréart—the most esteemed collection of ancient statues then in England. This context also unites the intellectual and aesthetic accomplishments of Lord Arundel and his circle with the Royal Society, as one generation embraces the legitimacy offered by its illustrious forerunner. However modest, Evelyn's act of philanthropy signals a hopeful realization of the role the Royal Society could play in producing and preserving knowledge, an (arguably self-interested) admission of the shift in virtuosity from the private circle of the court and aristocracy to the "public" realm of learned societies.[33]

The language with which Evelyn describes the panels in 1702 is instructive. In contrast to Cowper, he shows no interest in the concept of anatomic movement but in fact just the opposite; he stresses the literal, static qualities of the mounted anatomies. They are valuable because they present the vascular systems in their "natural proportion and position." In contrast to printed atlases, the tables provide striking visual information about the size, scale, and textures of the anatomic forms on display. And yet Evelyn even believes the usefulness of these objects will survive the translation back into print. He gives his blessing to Cowper's publishing project, because he concurs they should "be accurately delineated, in order to their being engraven, as more correct than any that are yet to be found among the figures of those vessels in books of anatomy" (fig. 28).[34] For Evelyn the panels function as

FIGURE 28 *Arteries,* one of the four anatomic tables acquired by Evelyn in Padua. Engraving; from *Philosophical Transactions of the Royal Society* 23 (1702). Used by permission from University of Chicago Library, Special Collections Research Center. The *Transactions* engraving reappeared in John Harris's *Lexicon Technicum; or, An Universal English Dictionary of Arts and Sciences* (London, 1704).

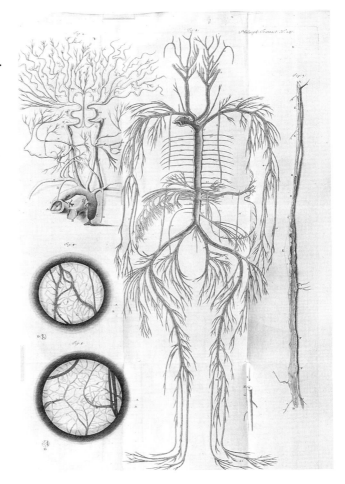

an unmediated picture of the various systems in question. The tables are simultaneously images and specimens. Literalness is presumed to guarantee accuracy. The emphasis is placed on material description rather than explanation, and this physicality links the tables with other kinds of learned objects. They are, for instance, analogous to the drawing of the relief panel from the Arch of Titus that Evelyn commissioned from Carlo Maratti in 1644 (fig. 29); in his diary, Evelyn describes it, too, as being copied "most exactly."[35] Likewise, the Arundelian marbles were important not only for their inscriptions but because of the physical connection they provided to the Ancients. Just as the marbles gave tangible form to texts thousands of years old, the anatomic tables gave physical substance to systems that were either unseen or, as a result of their organic nature, conspicuously temporal.

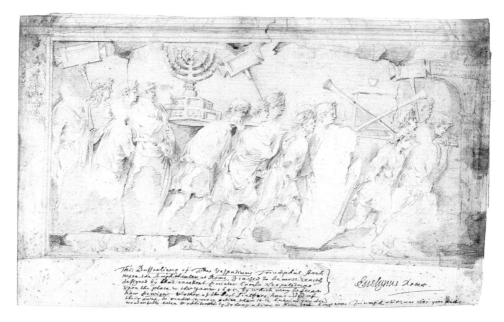

FIGURE 29 Carlo Maratti, *Relief of the Triumph of Vespasian from the Arch of Titus*, Rome, 1645.
Black chalk. © Copyright the Trustees of The British Museum. Used by permission from The
British Museum, London. One of Maratti's early patrons, Evelyn saw the depiction of the sack
of the Temple at Jerusalem as historical evidence of "holy history." In contrast to François
Perrier's etching in *Icones et segmata illustrium e marmore tabularum quae Romae adhuc extant*
(Rome, 1645), Marrati does not attempt to restore the relief.

Interestingly, the first entry in Grew's catalogue of the Royal Society col-
lection describes "an ÆGYPTIAN MUMMY given by the Illustrious Prince
Henry [Howard] Duke of Norfolk. . . . an entire one taken out of the Royal
Pyramids" and measuring roughly the same dimensions as Evelyn's pan-
els, which are described just two pages later. This additional intersection of
preserved bodies, Arundelian patronage, and Evelyn's tables raises the issue
of antiquarianism as well as obsolescence. The former could prove useful
methodologically as an antidote to Whiggish accounts of medical history
that have often been more interested in parsing "genuine" medicine from
polymathic virtuosity than exploring the wonderfully complicated interests
of these men of erudition. That Robert Boyle, writing in 1665, pointed to the
common use of mummies as an ingredient in medicine should encourage us
to widen, rather than restrict, the inquiry.[36] That Dr. Sloane's surviving col-
lection of *materia medica* includes a compartment of mummy fingers evinces
the broad connections that were made well into the eighteenth century.[37] As

for obsolescence, already by 1681 Grew was suggesting the declining value of Evelyn's tables, noting "the Nerves have been much more truly and fully represented to us of late by Dr. Richard Lower, in Dr. [Thomas] Willis [*Cerebri Anatome*]."[38] The comment points to the possibility that Cowper was fully aware of the disconnect between his article and the panels but included them on the grounds of the authority they once possessed, and perhaps even sought to realign them with a wholly Harveian mode of thinking.

In any event, a sense of conservatism pervades the entire history of Evelyn's tables. Even when described as a sign of anatomic progress, they are never presented as new.[39] The body serves as an absolute, linking past and present knowledge; and in the end Evelyn's tables show us no brave new world, but force us instead to marvel at the past.

Medicine, the Royal Society, and the Case of Christopher Wren

Evelyn's donation of the tables raises the more general issue of the Royal Society's relationship with the field of medicine and medical knowledge. As scholars have long noted, medical practitioners constituted the largest and most active occupational group in the society during its early history. Breaking the membership into scientific and nonscientific Fellows, Henry Lyons noted in the 1940s that medical men constituted over half of the former group during this period. Subsequent researchers have challenged this binary division of the Fellows on a variety of grounds, but even taking the whole society into account, one is left with medical men making up a fifth of the total membership, a trend that continued by and large throughout the eighteenth century.[40] As would be expected, many of these doctors also belonged to the College of Physicians, and there were proposals made in the planning of the Royal Society that the two bodies would work closely together, with the society even meeting at the college.[41] Apart from the substantial overlap of membership, however, the two groups retained their autonomy; in fact, as the College found its authority undermined in the wake of the 1665 plague and then the Great Fire the following year,[42] the Royal Society emerged as the center of progressive, experimental work in the areas of anatomy, physiology, pharmacology, organic chemistry, pathology, generation, climatology, and balneology.

In addition to publishing articles on these topics in the *Philosophical Transactions,* the Royal Society or, more precisely, its secretary maintained regular communication with physicians from the Continent. During his lengthy tenure, Henry Oldenburg corresponded with Sylvius and Swam-

merdam in the Netherlands, Olauf Rudbeck in Stockholm, and physicians
of the Academia Curiosorum in Germany. Ever curious about remedies from
other lands, Oldenburg wrote both to the East and to the West, from India
to Iceland, from Aleppo to Barbados.[43]

The case of Christopher Wren (1632–1723) further evinces the symbiotic
relationship between the Royal Society, the interests of its polymathic Fel-
lows, and contemporary physic.[44] Now remembered for his role as the Royal
Surveyor and architect of the new St. Paul's and the fifty-one churches of the
City built after the Great Fire, Wren spent the first decade of his professional
life as an astronomy professor, admired for his mathematical and geometric
proficiency. Born into a staunchly Royalist family, he attended Westmin-
ster School, where, like his contemporaries John Dryden and John Locke,
he studied Latin and Greek under the stern pedagogue Richard Busby. In
the late 1640s he moved to Oxford, where he came under the tutelage of
Dr. Scarburgh, whom he assisted with dissections and the construction of
anatomic models. In the summer of 1654 Evelyn recorded visiting this "mir-
acle of a Youth, Mr. Christopher Wren," and over the course of the next
several decades, the two became close friends.[45] At Oxford Wren also met
Robert Boyle, John Wallis, Seth Ward, and Dr. Willis, all of whom would
become leading members of the Royal Society.[46]

Wren's anatomic training under Scarburgh, a friend and admirer of Har-
vey's as seen in the previous chapter, led to his own experiments with intra-
venous injections. The topic appears regularly in the early volumes of the
Transactions as the Restoration generation probed the implications of Har-
vey's discovery of the blood's circulation, though both Boyle and Oldenburg
credited Wren with initiating these experiments. Thomas Sprat concurred,
writing in his *History of the Royal Society* of 1667 that Wren "was the first
Author of the Noble Anatomical Experiment of Injecting Liquors into the
Veins of Animals. An Experiment now vulgarly known, but long since ex-
hibited to the Meetings at Oxford."[47] The medical aims of these experiments
emerge in a letter to William Petty in which Wren insists his findings "will
give great light both to the Theory and Practice of Physick."[48] Along with
Dr. Lower and Dr. Thomas Millington (the future president of the College of
Physicians), Wren also assisted Dr. Willis with his research on the anatomy
of the brain in 1663, producing the illustrations for the *Cerebri Anatome,* pub-
lished the next year.[49] Moreover, in addition to his professional telescopic
studies (which he also understood to have medical implications), Wren was
intrigued with microscopy. In the preface of Robert Hooke's *Micrographia*
of 1665, he is praised as a pioneer of the field, and two decades later he was

still corresponding with Leeuwenhoek over the otherwise invisible details of "the wings of a gnat."[50]

To a large extent Hooke has lived in the historiographical shadows of Wren. Distinguishing the individual accomplishments of the two men is often difficult, and judgment is complicated by the fact that many of Hooke's most important buildings no longer survive.[51] Originally on course to become a painter, Hooke was apprenticed to the portraitist Peter Lely, but he abandoned the studio for a spot at Westminster School (also studying under Busby) before advancing to Oxford. There his abilities were recognized by Willis and Boyle, whose favor resulted in his 1662 appointment as curator of experiments for the Royal Society.[52] Like Wren, Hooke obtained a professorship at Gresham College (teaching geometry), and also like Wren, he became increasingly active as an architect from the mid-1660s. He was, for instance, responsible for rebuilding a number of medical structures, including Bethlehem Hospital, Bridewell Hospital, and the Royal College of Physicians Building in Warwick Lane (fig. 30).[53] As one of several surveyors

FIGURE 30 Robert Hooke, Royal College of Physicians at Warwick Lane, completed in 1679. Engraving by J. Mynde, 1746. Used by permission from Wellcome Library, London.

appointed to oversee the reconstruction of the City, he worked closely with Wren over the next thirty years.[54] Alongside these projects, Hooke continued to fulfill his curatorial duties at the Royal Society, and following the death of Oldenburg in September of 1677, he served as the society's secretary, until 1682.

During this period, Wren was elected president of the society, serving from 1681 to 1683, timing which belies any sharp chronological partitions between his interests in natural philosophy and architecture.[55] In fact, when he first turned to building design, he exhibited a model of the Sheldonian Theatre at a weekly Wednesday meeting of the Royal Society in April of 1663. As a synthesis of ancient Roman precedent (specifically the Theater of Marcellus as depicted by Serlio) and a modern roofing design (the trussing of which eliminated the need for internal supports), the Oxford building (fig. 31) visualizes the larger dialogue between the Ancients and the Moderns then taking place in England.[56] Although expenses seem to have curtailed

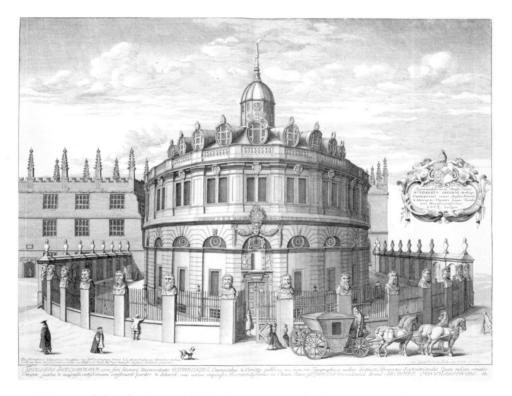

FIGURE 31 Christopher Wren's Sheldonian Theatre, Oxford. Engraving by David Loggan; from *Oxonia Illustrata* (published 1675). Private Collection. Used by permission from The Stapleton Collection / The Bridgeman Art Library.

FIGURE 32 John Webb, after Inigo Jones, Barber Surgeons' Anatomy Theater, 1636. Pen. Used by permission from The Provost and Fellows of Worcester College, Oxford.

the idea, early building plans included provisions for anatomy lessons. Society Fellows who had seen Wren's model expected the theater to be used not only for convocations but also for the "dissection of bodies and acting of plays," and while the pairing perhaps simply signals the mixed-use character of the project as understood in an early phase, the juxtaposition also suggests the performative nature of anatomic lessons that instilled in early modern audiences the same measure of drama as Shakespeare or Dryden.[57]

The oval plan also calls to mind a building in London that would have been obvious to Restoration virtuosi but which has now been largely forgotten: Inigo Jones's anatomy theater for the Barber Surgeons from 1636 (fig. 32). Richard Boyle, third Earl of Burlington, admired it enough to pay for its restoration in 1730, and Horace Walpole considered it Jones's most accomplished work.[58] Irrespective of the alterations of the Sheldonian plans, the early proposal is intriguing given that the building was begun the same year Wren's depictions of the anatomy of the brain appeared—a

connection reinforced by Robert Streeter's ceiling painting, *Truth Descending upon the Arts and Sciences,* which includes physic and the related fields of botany, chemistry, and surgery; as described by Robert Plot, Chyrurgery prepares "to finish the dissecting of a head, which hath the brain already opened."[59]

Compounding the virtuosic significance of the site is the fact that the walls flanking the sides of the building contained more than a hundred ancient marbles of Greek and Roman origin, most of which had been part of the Arundel collection that Henry Howard donated to Oxford. Wren likely designed or approved the installation, and Evelyn—having facilitated the gift—kept tabs on the condition of the inscriptions and sculpture.[60] In light of the juxtaposition of antiquity and virtuosity, it was appropriate that in 1715 Edmund Halley, the astronomer now known for the comet that bears his name, should have been the one to relocate the marbles inside the library to the Bodleian museum.

And just as this "garden of antiquities" reinforces Wren's polymathic milieu, we should be reluctant to frame his trip to France in 1665 strictly as an architectural excursion. Although his well-known meeting with Bernini may have been one of the more influential events of the trip, Wren spent a considerable amount of time with prominent *curieux,* discussing the state of natural philosophy in and around Paris.[61] A letter from the Huguenot Henri Justel, dated August 24, 1665, notes, for instance, that Wren had recently been introduced to the astronomer and mathematician Adrien Auzout, the astronomer and physician Pierre Petit, and the Royal Librarian Melchisédech Thévenot.[62] Justel, who later reports seeing Wren "presque tous les jours," also escorted his English guest to a meeting at the home of Abbé Bourdelot (physician to the Prince of Condy), where "on dit quantité de belles choses," including a report on a deaf and mute man who could dance to the beat of music and a lecture by the queen of Poland's physician regarding a hair condition said to affect only Poles and Cossacks! Justel observes that the proceedings earned Wren's approval, though "il souhaitoit, qu'on fit des experiences," an appropriate response from one credited with helping to formulate an empirical foundation for the new mechanical philosophy.[63]

In September, Wren spent several days traveling with his countryman and soon-to-be FRS Dr. Edward Browne. The latter, in a letter to his father (written six months after that which references Finch's anatomic tables), expresses his regret at having missed Bourdelot at Chantilly but proceeds to enumerate an itinerary of houses, gardens, waterworks, churches, and a hospital. Significantly, the one architectural project Browne records Wren to have singled out belongs within an engineering tradition: the massive Quays

along the Seine, "built with so vast expense and such great quantity of materials, that it exceeded . . . [even] the two greatest pyramids of Egypt."[64]

As we begin to glimpse in this report, Wren was, in general, eager to observe whatever he could in regard to French arts and trades. That his promised "Observations on the present State of Architecture, Arts, and Manufactures in France" never appeared should not cause us to question Wren's interest in these broader topics, and, in fact, the same letter that describes the "few Minutes" he spent greedily glancing over Bernini's designs for the Louvre also provides an outline of key architects, sculptors, plasterers, engravers, painters, weavers, and gardeners then active in France. Moreover, according to Lisa Jardine, it was addressed to Evelyn.[65] That Wren never completed the document not only is consistent with his own reluctance to produce finished texts but also is in keeping with most of the History of Trades projects that the Royal Society sponsored or encouraged.

The History of Trades Project

Unfulfilled aspirations tend to be the rule in regard to these endeavors, though this is not to say that such ambitions were unimportant or inconsequential.[66] The notion that the pursuit of knowledge should interact with real-life industries depends on a number of sources, though no one deserves more credit than Francis Bacon. With his insistence that learning could continue to advance only by replacing Aristotelian deduction with more empirical, inductive approaches to knowledge, Bacon had placed natural history—broadly conceived to include "Nature altered" as well as the history of "Prodigies" and "Arts"—at the center of his epistemological prescriptions.[67] His *New Organon* of 1620 (an explicit challenge to Aristotle's logic as outlined in the *Organon*, or "Instrument" for rational thought) included an "Outline of a Natural and Experimental History, adequate to serve as the basis and foundation of True Philosophy."[68] The text consists of ten sections of aphorisms followed by a catalogue of 130 histories Bacon proposed as desirable lines of inquiry: histories of rainbows, precipitation, geography, fire, air, earth, water, fossils, plants, vegetables, snakes, physiognomy, anatomy, human fluids, human motion, sleep and dreams, human generation, pharmaceutical history, surgical history, optics, painting, sculpture, music, sex, wine, food, perfumes, weaving, dyeing, tanning, glass-making, architecture, the naval arts, even "Jugglers and Clowns"—to give only a sample of the myriad subjects sketched. Bacon appended the "Outline" to the *New Organon* largely as a recruiting device, admitting that the project

is a massive thing which would take great pains and expense to complete; it requires the efforts of many men, and as we have said before, is in some sense a royal task. It occurs to me therefore that it would be appropriate to see whether there may be others able to take up this challenge.[69]

And indeed, others did. Samuel Hartlib, Boyle, and Evelyn all embraced the project even before the founding of the Royal Society, and after 1660 the History of Trades project became a persistent theme on the society's agenda. At an early meeting, Dr. Christopher Merrett was placed in charge of organizing the program, and in October 1664 he presented his catalogue outlining the structure of the project. Similar lists came from Dr. William Petty, Evelyn, and Hooke, and a number of histories were begun straightaway.

Whereas conviction of the project's value was widely shared, there was less agreement about the precise relationship between natural philosophy and the practice of specific arts and skills. Bacon had understood that improvements in the former would eventually lead to improvements in the latter, but he also had clearly affirmed that practice should remain subservient to philosophy, arguing it would be a mistake

> to think that our plan is being followed if experiments of art are collected with the sole aim of improving the individual arts. For although in many cases we do not altogether condemn this . . . the streams of all mechanical experiments should run from all directions into the sea of philosophy.[70]

In contrast, Hartlib emphasized the other half of the equation, espousing a gospel of improvement and social reform in trades and agriculture tied to pronounced millennial expectations. And though his ideas may represent an extreme form of Protestant thinking, most of his Royal Society successors were shaped by these ideas, and their understanding of the Trades program falls somewhere between his religiously guided pragmatism and Bacon's posture of pure philosophy.

Boyle, for instance, in arguing for the usefulness of natural philosophy to physic, confessed, "I shall not dare to think my self a true naturalist till my skill can make my garden yield better herbs and flowers, or my orchard better fruit, or my field better corn, or my dairy better cheese, than theirs that are strangers to physiology."[71] If the garden or workshop was expected to serve as laboratory space for Royal Society investigations, the proof of the success of those studies was expected to be apparent in the produce or goods that the garden or workshop yielded.

Using this balance between practical application and improvement of knowledge as her criteria, Marie Boas Hall singles out Dr. Merrett's 1668 *Art of Glass,* an expanded translation of Antonio Neri's *L'Arte Vetraria,* as a model of the successful Trade history.[72] Not only does it explain Venetian workshop practices (recalling Evelyn's interests in the subject during his time in Padua) with additions on English techniques, it also includes a commentary on the chemical dimensions of glass-making as explained by Neri. Furthermore, in regard to Boyle's test of validity, Kathleen Ochs suggests Merrett's additions may have contributed to George Ravenscroft's development of English flint glass.[73]

Other areas pursued by members of the Royal Society included distillation of cider and wine, leather production, dyeing, varnishing, carriage design, vinegar and salt production, silk making, and shipbuilding.[74] Francis Willughby, another member of the society's Committee on Trades, compiled a Book of Games.[75] Evelyn, by himself, addressed an array of topics ranging from the marbling of paper, to forestry, to engraving, to architecture. And while there is danger in imposing too forcefully on these texts a false sense of unity (grouped together, they point to the project's failures as much as its successes), the texts provide, as Walter Houghton observes, a focal point to Evelyn's "endless" virtuosity.[76]

Evelyn's interest in the project dates to the 1650s and coincides with his earliest publications, including his verse translation of the first book of Lucretius's *De rerum natura* (fig. 33), which helped establish the neo-Epicurean foundations of the emerging New Philosophy (with a decorative title page designed by Mary Evelyn and etched by Wenceslaus Hollar, it also points back to Arundel).[77] Early in the decade, Evelyn had begun keeping a notebook entitled "Trades. Seacrets & Receipts Mechanical," in which he planned to address dozens of various topics.[78] These early aspirations soon waned, however, under the weight of the practical difficulties; and though the volume includes descriptions for making marbled paper and gilt varnish, mixing paint pigments, enameling, and casting of statues, by Michael Hunter's count, fewer than 50 of the notebook's 605 pages include anything more than a section heading.[79] All the same, the topics that are covered generally found related expression in print during the following decade, and thus this early foray into the Trades project should be borne in mind when considering Evelyn's *Sculptura* and his translations of Fréart. Evelyn's notebook also calls to mind those of Dr. Turquet de Mayerne. Evelyn embarked on the project in response to Bacon's challenge but ended up producing a collection of notes more in line with the work of the Paracelsian physician,

FIGURE 33 Wenceslaus Hollar, after Mary Evelyn, title page; from Lucretius, *De rerum natura,* bk. 1, trans. John Evelyn (London, 1656). Used by permission from the Thomas Fisher Rare Book Library, University of Toronto.

whose own work was conceivably itself a response to Bacon's prescriptions, though far less sweeping in scope.

Evelyn's frustrations with the project appear in two letters addressed to Boyle. The first, from May 9, 1657, evinces Evelyn's general dissatisfaction with the Commonwealth while also raising the issue of who has a legitimate claim to the kind of knowledge the Trades project aimed to compile. He writes,

> I have since been put off from that design, not knowing whether I should do well to gratify so barbarous an age (as I fear is approaching) with curiosities of that nature, delivered with so much integrity as I intended them; and lest

by it I should disoblige some, who made those professions their living; or, at least, debase much of their esteem by prostituting them to the vulgar.[80]

Evelyn goes on to propose that responsibility for this proprietary knowledge should rest with a body of intellectuals, who would occasionally pass information on to the public "for the reputation of learning and benefit of the nation"; here it is easy to see how Evelyn's interests in the Trades project were reinvigorated by the founding of the Royal Society.[81]

The second letter, from August 9, 1659, suggests the project retained a place in Evelyn's thoughts throughout the decade, though by this point he was even more discouraged. He reports that his work on the History of Trades

> [has] not advanced a step; finding (to my infinite grief) my great imperfections for the attempt, and the many subjections, which I cannot support, of conversing with mechanical capricious persons, and several other discouragements; so that, giving over a design of that magnitude, I am ready to acknowledge my fault.[82]

Covering his bases, Evelyn attributes his stalled progress both to a concern over debasing the status of trades and to the difficulties of having to actually speak to the "capricious" craftsmen who practice the trades in the first place.

Despite his misgivings, Evelyn's early involvement in the Trades project underscores issues that characterize the program as a whole. In order for the project to have any hopes of succeeding, a series of relations had to be carefully navigated: secrecy versus the free flow of knowledge, men of learning versus men of trades, national interests versus the ideals of the Republic of Learning, manageable divisions of knowledge versus comprehensive compilations. And however bleak the program's prospects may have seemed to Evelyn in 1659, the Trades project as taken up by the Royal Society did prove important, even as it highlights larger tensions within the society's intellectual foundations.[83]

In the context of the New Philosophy, vast schemes for gathering knowledge quickly proliferated far beyond the limitations of practical constraints. As Bacon scholars have long noted, the so-called father of modern science, in fact, held a rather dim view of the notion of a hypothesis, emphasizing instead the amassing of information, as if at some point, knowledge would simply emerge by its own accord as indisputable fact from these glaciers of data.[84] As Society Fellows quickly discovered, however, it was much easier to assemble catalogues outlining projects than it was to complete them. For

all the hermeneutical challenges facing the Royal Society (nowhere seen more clearly than in its attempts to refine language into "pure" communication), problems surrounding the interpretation of information remained. As already suggested, the Trades project also throws into relief the uneasy relationship between utility and knowledge, given that the society was continually satirized for collecting utterly useless bits of information. At the same time, pressures to maintain the superiority of abstract knowledge over practical application continued to fuel the society's intellectual ambitions, and similar tensions pervaded both medicine and antiquarianism as each struggled to manage the relationship between empirical data and rational explanation, between particulars and holistic narratives. But for all the difficulties of the Trades program and even despite Evelyn's misgivings about interacting with persons "mechanical," the project did make strides in chipping away the partition between gentlemanly scholars and craftsmen; and the English-language art texts that were published in the latter half of the seventeenth century owe their success, at least in part, to this newly negotiated relationship.

Evelyn's Sculptura and His Translations of Fréart

On June 10, 1662, Evelyn presented the Royal Society with a copy of his newly published treatise on the history of printmaking, the first monograph of its kind to appear in any language.[85] Originally, *Sculptura; or, The History and Art of Chalcography*—the title of which emphasizes the essential role of the incised plate in the printing process—was to have included not only historical materials but also a section on technique, adapted from Abraham Bosse's *Traicté des Manières de Graver en Taille Douce sur l'airin*. An advertisement at the end of *Sculptura* notes Evelyn had prepared this section at the request of the Royal Society but had refrained from publishing it out of deference to William Faithorne, who had also recently translated part of Bosse's text.[86] Regardless, the original conception connects the origins of *Sculptura* to the History of Trades project, the importance of which Evelyn goes on to assert: "I could wish with all my heart, that more of our Workmen, would ... impart to us what they know of their several Trades, and Manufactures, with as much Candor and integrity as Monsieur Boss has done."[87]

Yet one hardly must look to the end of the text to discover Evelyn's purpose. He dedicates the book to Boyle, who as noted earlier corresponded with Evelyn about the Trades program, and commits himself to following Boyle's example "of cultivating the Sciences" and the "advancing of useful

knowledge." Next, there appears an account of the life of Giacomo Maria Favi, a seemingly arbitrary inclusion until we learn that Favi was himself intending "to compile and publish a Compleat Cycle and Hystory of Trades."[88] Despite his obscurity, Favi exemplifies the virtuoso for Evelyn. This Bolognese intellectual is depicted as the model traveler, driven across Europe by the pursuit of knowledge. In the course of visiting Spain, the German States, Poland, Sweden, Denmark, Holland, France, and England, he collected

> the Crayons, Prints, Designs, Models, and faithful Copies of whatsoever could be encountered through the whole Circle of the Arts and Sciences. . . . He Design'd excellently well, understood the Mathematicks; had penetrated into the most curious part of Medecine, and was yet so far from the least pedantry, that he would (when so disposed) play the Gallant as handsomely as any man.

Favi's life here looks remarkably like that to which Evelyn aspired—and largely attained. The acquisition of visual forms of knowledge based on mimesis, the abstract certainty of mathematics, and a general grasp of medicine are singled out as indispensable attributes of learning, though the true gentleman possessed of such knowledge must never allow himself to be seen as a pedant who, lost in the details of learning, neglects his public responsibilities to genteel society. Once again, the familiar tension between part and whole rears its head as the true scholar is defined over and against inappropriate kinds of learning.

Just as this biographical sketch credits Favi with the art of "designing," Evelyn was himself an amateur draftsman and printmaker.[89] In the 1640s he produced at least thirteen etchings, which Antony Griffiths has judged to be "the first landscape prints made by an Englishman" and the first prints of any kind by an English amateur.[90] Equally remarkable, at least eleven of Evelyn's etchings were published for public consumption. Despite his moments of vague disdain for "workers" and "mechanics," Evelyn possessed no qualms about using his own hands and was not above selling the fruit of his own labors. He, of course, would have maintained the intellectual dimensions of these endeavors; yet in a sense, this is the point: the History of Trades project tended to blur the boundaries between the work of the mind and the work of the hands.

As already noted, Evelyn sought out printmakers and print collections during his time on the Continent, and by 1662 he had already formed the bulk of his own substantial collection.[91] His placement in society could not have been more advantageous for nurturing his interests in printmaking, as

illustrated by his presence before the king in January 1662. While Charles II sat for Samuel Cooper, the miniaturist responsible for the portrait that would appear on the nation's new coins, Evelyn held the candle and spoke with "his Majestie . . . about severall things relating to Painting & Graving &c."[92] Evelyn thus benefited from a nearly limitless degree of access to pertinent sources on printmaking, and thus notwithstanding the dismal reception *Sculptura* received in the twentieth century, we should not underestimate his qualifications.[93]

Admittedly, however, the work presents challenges to present-day readers. Ever the meticulous antiquary, Evelyn rarely passes an opportunity to explicate etymologies and enumerate ancient references. In his discussion of the origins "of sculpture in general," he is skeptical of Trismegistus's claim to have discovered books produced by the progenitor of all humanity, Adam himself, but then goes on to affirm "that Letters, and consequently Sculpture, was long before the Flood." Referencing next the sons of Noah, Zoroaster, Melchior, and Egyptian obelisks, Evelyn's foray into origins climaxes with the tablets of stone given to Moses, "engraven by the Finger of God himself" and in turn prohibiting the worship of sculpture—evidence of the "greater antiquity" of both idolatry and engraving.[94] For all the peculiarities of this history, at the heart of Evelyn's understanding of the topic is the intricate relationship between texts and sculpture as one bleeds into the other, even as words ultimately are expected to hold objects in check.

Evelyn goes on to trace the subject through ancient Greek and Roman sources, quickly skips over the "horrid devastations" of the medieval period, and finally alights upon more solid ground in the fifteenth century, with Gutenberg's invention of "Typography" and the appearance of copper engravings (again, Evelyn is careful to privilege word over image). From here he surveys the major printmakers of the next century and a half, generally arranged according to region and including, from (1) Italy: Maso Finiguerra, Marcantonio Raimondi, Ugo da Carpi, Parmegianino, Titian, Andrea Mantegna, Properzia de Rossi ("the glory of the [female] Sex"), the Caracci, and Stefano della Bella; from (2) the Germanic states and the Netherlands: Dürer, Lucas van Leyden, Hieronymus Cock, Frans Floris, Aegidius Sadeler, Hendrick Goltzius, Anthony Van Dyck, Cornelis Visscher, Anna Maria van Schurman, and the Brueghels; and from (3) France: François Perrier, Gabriel Pérelle, Israel Silvestre, Robert Nanteuil, Abraham Bosse, and Jacques Callot. Biographical information is interspersed with references to the printmakers' most important works, and finally, *Sculptura* concludes with some general observations about the importance and uses of prints, along with a brief description of Prince Rupert's method of mezzotint printing.

Evelyn's narrative buckles under the massive weight of information, and most of the work's shortcomings result from this imbalance. These problems should not, however, cause us to lose sight of *Sculptura*'s importance as a starting point in the literature of prints, and it continues to serve as a valuable, though largely untapped, guide to the state of print collecting in the mid-seventeenth century. Furthermore, the book provided for its original readers not only an introduction to prints but a framework for understanding the history of European art more generally. Evelyn's assessment of Marcantonio is, to a large extent, an assessment of Raphael. His chronological trajectory, which—following Vasari—begins in fifteenth-century Florence establishes for English readers the dominant evolutionary model of art history that has only begun to be seriously challenged over the last few decades. This particular case is all the more striking given that whatever truth this standard chronology may hold for the history of painting, it completely misrepresents the history of printmaking, which owes its modern origins to artists working in the north. Yet Evelyn's conception of prints and paintings as closely interwoven serves as a reminder of the extent to which seventeenth-century British virtuosi understood the latter through the mediation of the former, as well as the extent to which this mediation was itself understood and appreciated.[95] It was simply an essential component of being interested in art, and thus rather than an obscure specialty study, *Sculptura* should be regarded as an entirely logical starting point for English art-historical writing in general.

In 1664, two years after the publication of *Sculptura*, Evelyn turned his profuse attention to the field of architecture, translating Fréart's *Parallèle de l'Architecture antique et de la moderne*.[96] In the dedication to Charles II, Evelyn himself connects his text to the Trades program by suggesting it represents a "proper and natural consequent" from his *Sylva*, which "endeavour'd the improvement of Timber, and the planting of Trees," undertaken at "the commands of the Royal Society." In his second dedication, to Sir John Denham, the Royal Surveyor, Evelyn states that he had been working on the translation for a decade and had finally completed it at the encouragement of his friend, the architect Hugh May, for "our Workmen" who have "few assistances . . . of this nature (compar'd to what are extant, in other Countries)."[97] A similar reference to this intended audience appears on the title page, as Fréart's text is said to have been "Made English for the Benefit of Builders." Considering *A Parallel of the Antient Architecture with the Modern* within the context of the Trades program has its limits, and the influence of the translation extended well beyond these builders Evelyn posits as his ideal readers.[98] Still, Evelyn uses these pragmatic terms to frame his text, and at least rhetorically, it becomes the rationale for publication.

The *Parallel* itself provides a point of entry into the major authors to have written on architecture. Comparative in design, the book takes its structure from the five orders, beginning with the Doric, Ionic, and Corinthian, turning then to the Tuscan and Composite (both of which are dismissed as poor "Latine" additions), and concluding with Evelyn's own twenty-eight-page "Account of Architects and Architecture, together with an Historical and Etymological Explanation of certain Tearms particularly affected by Architects." Examples from ancient sites, including the Theater of Marcellus, Trajan's Column, the Baths of Diocletian, and the Temple of Fortuna Virilis, are shown alongside modern samples from the likes of Alberti, Palladio, Serlio, and Vignola. While simple in conception, the arrangement implies systematic comprehensiveness; here in a single, illustrated volume Evelyn offers the means for what he hopes will lead to "a miraculous improvement" in England's buildings, which for too long have been characterized by "asymmetrie" and a neglect of the "Principles of Geometrie" and "the Rudiments of Perspective."[99]

This opposition between architectural decorum and deformity soon reveals itself as a political issue as Evelyn champions the newly restored Stuart monarchy. In his address to the king, he asserts that "Your Majesty has already Built and Repair'd more in three or four Years . . . than all Your Enemies have destroy'd in Twenty; nay than all Your Majestie's Predecessors have advanc'd in an Hundred." And in a moment of absurd exaggeration in the epistle to Denham, Evelyn boasts "that more has been done for the Ornament and Benefit of the Publick in two years time . . . than in five hundred before," even as he still considers the city of London a "monstrous Body" in dire need of improvement. Employing medical language, Evelyn describes the "want of decorum and proportion in our Houses" as indices of "the irregularity of our humors and affections," all of which His Majesty stands to correct. Lurking beneath the surface throughout is the bugbear of the interregnum and the chaos it presented to all components of Evelyn's ideal, ordered society.

Significantly, Fréart's text first appeared in France at a comparable moment of disorder, at the height of the Fronde in 1650, as the royal family had recently fled Paris and Cardinal Mazarin would be forced to retreat the following year. The French and English conflicts were quite different, as the *parlementaires* bore little resemblance to the Puritans, but it is interesting to see how Evelyn in introducing the text to an English audience maintains and adapts this context of conflict for his own purposes.

He keeps the original dedication, nominally addressed to Chambray's two brothers, Jean and Paul Fréart. In fact, this dedication serves as a tribute to

the memory of their uncle, François Sublet de Noyers, an accomplished administrator of the arts who in 1643 at the death of Louis XIII was disgraced and forced out of his position of *secrétaire d'Etat* by the ascension of Cardinal Mazarin. As stressed by Todd Olson, Sublet was largely responsible for luring Poussin back to Paris in 1640, after sixteen years of living in Rome.[100] As *premier peintre,* responsible for the oversight of all royal commissions, Poussin immediately began working on designs for the renovation of the Grand Galerie of the Louvre, conceiving this "manifest symbol of Bourbon authority" as "an historical archive," replete with classical references, many of which, including Trajan's Column, had already come to play an important role in French humanism and the visual culture it spawned.[101] Although work on the project never began, and Poussin returned to Rome in 1642, the renovation project nonetheless underscores the vital role that the Louvre as a site of artistic activity played throughout the mid-seventeenth century. Evelyn had been impressed by the Grand Galerie since first seeing it in 1644, and Wren made frequent visits in the mid-60s, when Bernini's plans were still expected to be executed.

In the midst of the Fronde, the memory of the recently deceased Sublet became a rallying point for those who opposed Mazarin, and Fréart's panegyric to the former secretary of state, reinforced by the frontispiece portrait (fig. 34), casts the *Parallèle* as a blatant political, pro-*parlementairian* text.[102] These implications could hardly have eluded Evelyn, who was living in Paris during the Fronde. Indeed, his diary entry for February 9, 1651, recorded the proscription of Mazarin and the "great commotions" it ignited.[103] Yet Evelyn remained remarkably aloof from political judgments and speaks of Mazarin only in neutral or honorific terms, as when, for instance, he notes the death of "the great Minister & Polititian" in the spring of 1661.[104] Perhaps also relevant is the pride Evelyn took in the portrait of himself executed by the engraver Robert Nanteuil (fig. 25), who earned official recognition in 1652 for his portrait of Mazarin, the first of several prints he would produce for the cardinal.[105] The political divisions that polarized French society thus failed to bind Evelyn's own aesthetic loyalties. While his general abhorrence of challenges to royal authority, particularly so soon after the execution of Charles I, would have made it impossible for him categorically to side with the *parlementaires,* he could nonetheless embrace the artistic circle of Fréart and Poussin and its support of Sublet, even maintaining Sublet's portrait for his frontispiece. Or more precisely, he could, through the inclusion of his own dedications, recast the conflict presented in Fréart's eulogy of Sublet (which conveniently never mentions Mazarin by name) in terms suitable for the English, Restoration context. Addressing the book to King Charles and

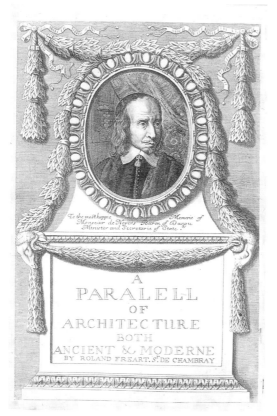

FIGURE 34 Frontispiece portrait of François Sublet de Noyers; from Roland Fréart, Sieur de Chambray, *A Parallel of the Antient Architecture with the Modern,* trans. John Evelyn, 2nd ed. (London, 1707). Used by permission from University of Chicago Library, Special Collections Research Center.

his Royal Surveyor infused the lament over Sublet's fate with new meaning; the fact that the *secrétaire* was forced "to conclude his dayes in the Country like an Exile" would have resonated with Royalists who, like Evelyn himself, were forced into exile by the English Civil War. From Evelyn's point of view, the description could as easily have been applied to any number of Englishmen (Lord Arundel particularly comes to mind). Above all, Charles's own fate took shape around the theme of exile—though of course the Stuart king, at the will of "the Divine Architect," returned to power, restoring the arts and sciences. The injustice enacted against Sublet at last finds restitution in Charles's triumph.

At the end of the *Parallel,* Evelyn appends his translation of Alberti's *Of Statues.* In his note to the reader, he justifies the addition on the grounds that Alberti numbers among those included in the volume on architecture. Arguing that the two discourses by the "Florentine Gentleman . . . cannot well be separated," Evelyn describes the nineteen-page treatise on sculpture as "the

very first of the kind which ever spake our Language," and again suggests
its usefulness for "our Workmen." Theoretically, the text articulates an aes-
thetic of imitation governed by rules and grounded on the principle of pro-
portion, while practically the text suggests a number of strategies for mea-
suring angles, mass, and lengths of figures as the artist moves from model
to statue. Alberti classifies work in wax, plaster, or clay as involving both
"adding to, and taking away from the Material," work in marble as entirely
subtractive, and silversmithing as entirely additive. Yet beyond these intro-
ductory remarks, little attention is paid to materials or specific technique
as the emphasis quickly shifts to ideal forms. The text culminates in a chart
providing feet, degrees, and minutes for dozens of bodily measurements
("thickness of the Wast," "height up to the Buttocks and Testicles," "length
from the great Toe to the Heel," "From the Forehead to the hole of the Ear,"
"thickness of the Shoulders," etc.). Not surprisingly, Alberti recommends
anatomic "inspection into those parts which are not outwardly expos'd to
sight," and the prescription quickly leads into a final discussion of shading
and perspective, though he admits these matters "belong more properly to the
Painter than the Sculptor," promising to address them "in that capacity . . .
more largely elsewhere."

The pledge could just as well have been made by Evelyn, who in 1668
published his translation of Fréart's *Idée de la perfection de la peinture*. In a
note to his English readers, he states that he "did once think, and absolutely
resolve[d]" to be "for ever done with the drudgery of Translating of Books."
Yet arguing it is better "to be still digging in that mine, than to multiply the
number of ill ones, by production of my own," he cites his fondness for
Fréart, reiterates his claim that the earlier translation was made for "the
assistance and encouragement of builders," and expresses his hope that the
current work will be of "service . . . to our painters." Referencing his own
Sculptura, he states that these three texts together "perfectly consummate"
his plan "of recommending to our country, and especially to the nobles,
those three illustrious and magnificent arts, which are so dependent upon
each other."

Fréart's *Idée* has long been recognized as a pivotal volume for the his-
tory of art writing. Thomas Crow describes it as "arguably the first work of
pictorial aesthetics published in France," while Louis Olivier uses it to sup-
port his identification of the 1660s as the moment when one can first "truly
speak of [French] works of esthetics centred on the visual arts."[106] Stressing
the polemical character of the text, Donald Posner employs it as evidence
for the claim that the '60s mark a turning point for French art, when col-
lecting and painterly knowledge increasingly became "fashionable marks of

cultivated people."[107] Posner underscores the division among this nascent art audience, which included not only advocates of Fréart's classical guidelines but also the *curieux* who prized "mechanical" and "painterly" work. An unfounded reliance on textual evidence has caused scholars to neglect these latter aesthetic concerns; yet the oversight further attests to the *Idée*'s importance. The polemics are easily missed, in part, because they were so effective at establishing a benchmark for French art theory.

The point is that the emergence of an "art public" in France occurred only in the mid-seventeenth century amid conflicting attitudes, and that one of the central texts for this cultural shift appeared in English within six years of its original French publication. While it would soon became a commonplace to bemoan the state of the arts in Britain relative to that of France (and to some extent the anxiety already drives Evelyn's project), the *Idea of the Perfection of Painting* suggests that the distance between the two countries in the 1660s in terms of an art public may not have been as vast as the judgment of subsequent decades would imply. Moreover, in the absence of an art academy (the establishment of which in France was significantly also bound up with political conflicts related to the Fronde), this importation of French aesthetic theory occurs through the channels of the Royal Society and its virtuosi members—a point emphasized, again, by the dedication to Henry Howard that explicitly acknowledges his support of the society. To denigrate the society's aesthetics while championing the French academicians of the 1660s and '70s is to accept a double standard. This is in no way to minimize the differences between England and France, but only to note the similar theoretical underpinning of each nation's art writing.[108]

In his own comments on Fréart's text, Evelyn highlights the importance of "decorum," a term covering a broad range of content concerns, including one's *attitude* toward content. Evelyn sees it as a means of countering cultural productions that grow "daily more licentious . . . ridiculous, and intolerable." The specific violations he cites, however, deal with anachronisms and pictorial license that, for Evelyn, disrupt a picture's historical integrity. Exemplifying the problem is Bassano, "who would be ever bringing in his wife, children, and servants, his dog, and his cat and very kitchen-stuff, after the Paduan model," though even "the great Titian" and the "excellent and learned painter Rubens" were guilty of the same general mistake.[109]

Evelyn moderates Fréart's harsh evaluation of Michelangelo, and stresses his accomplishments as a sculptor and architect—his ability to work across trades, as it were. Moving on to the topic of linear perspective, Evelyn reinforces Fréart's emphasis on the construction of coherent compositions that do not bring "more into history, than is justifiable upon one aspect," while

arguing that even Fréart fails to recognize the multiplicity of viewpoints in Raphael's *Judgment of Paris*. Here he cites Abraham Bosse and notes that other violations of decorum include "those landscapes, grotesques, figures, &c which we frequently find . . . painted horizontally or vertically on the vaults and ceilings of cupolas." Evelyn's rejection, in principle, of such illusionary images challenges the caricature of him as a dullard fascinated by every *trompe l'oeil* he came across. In fact, he anticipates the neoclassical rejection of such decorative programs, basing the claim on the authority of "the ancients."

Evelyn similarly appeals to classical authority to anchor his claim regarding the respectability of the artist, or at least *certain* artists, those who "were learned men, good historians, and generally skilled in the best antiquities," men such as Raphael, Alberti, and Rubens.[110] Turning to the context from which Fréart's text originates, Evelyn cites Poussin and Bernini (again, both of whom produced unexecuted plans for the Louvre) and then caps the list with Christopher Wren, whom he presents as Bernini's successor. Concluding these thoughts on the education of his ideal artist, Evelyn, again following Fréart, ranks "the tempering and applying of colors" behind the "politer parts of learning," such as oratory, classical architecture, history, optics, and anatomy.

As for Fréart's text itself, the innovation lies in his application of categories derived from Franciscus Junius to specific images by Leonardo, Raphael, Michelangelo, Romano, and Poussin. Through Lord Arundel's former librarian (fig. 11) and his *De pictura veterum* of 1637, we are drawn back once more to the earl and his circle. Junius was, at the time of the *Idée*'s publication, living in Amsterdam, though in 1675 he would return at the age of eighty-four to England, where he would live out the remaining two years of his life amid the treasures of the Cottonian Library in London and the Bodleian in Oxford.[111] The lineage of these categories of invention, proportion, color, expression, and disposition thus can be traced back to early Stuart England; they were incorporated into the foundation of French academic theory through Fréart; and finally, they were reintroduced to England via Evelyn's translation.

Addressing the perennial early modern problem of how to secure a place for painting and sculpture within the realm of the fine arts, Fréart draws a sharp line between the rational and "mechanical" components of image making.[112] As already noted, Evelyn reinforces the point in his own note to the reader. But here the issue becomes problematic given that Evelyn has framed *Sculptura*, the *Parallel*, the treatise "On Statues," and the *Idea* all in terms of the History of Trades project. Over and over, he expresses

his hope that these publications will benefit the nation's "workers." With the last text, he admits that members of the aristocracy number among his intended audience, but the extent to which this is the case becomes clear only with the last paragraph of Evelyn's note; making various excuses for why no engravings accompany the text, he judges that it will be "of most use to the virtuosi" and assumes "that such as are curious must . . . already be furnished with them."

The fundamental tension regarding the status of objects resurfaces as an insurmountable difficulty for the History of Trades project. The inherent mechanical dimension of the scheme is both attractive and repellant to Evelyn and his circle. For the conflict over the Trades project, in fact, stems from a larger tension within the Royal Society's agenda: how can the group maintain its intellectual credibility, founded on the gentlemanly status of its members, while simultaneously embracing an epistemological model based on the notion that the entire domains of natural philosophy and natural history operate according to a basic set of *mechanical* principles? How does one negotiate the relationship between the mechanics employed by Newton and those applied by a commercial glassmaker? The need to partition the two stands behind the English reception of French academic art theory as channeled through the Royal Society. Raphael was not simply a face painter, just as the Society Fellows were involved in something essentially different than the dime-a-dozen limners they would pass on their way to Arundel House. And if the mechanical does not exactly correspond to the empirical, the two are closely related. The mechanical philosophy rested on the assumption that the given system of forces in motion could be observed, even if, as in the case of Cowper's use of Evelyn's anatomic tables, the empirical evidence simply demonstrated what could not be pictured.

It is telling that Hooke, who so successfully managed to exchange his apprenticeship under Lely for a career in experimental natural philosophy, was never completely accepted as an equal by his fellow members, in part because of the responsibilities he bore to prepare and often perform experiments (for which he received a salary). In this role, Hooke provided a crucial point of contact between the Royal Society's mechanically based theory of knowledge and actual hands-on mechanical demonstrations. As such, he was necessary, even as he was never afforded the same status as other Fellows.[113] This is not to say that more respected members never carried out experiments themselves. They clearly did. It was important, however, that they be perceived as doing something greater than performing a mechanical act, just as Evelyn's ideal artist is not constrained by the mere "applying of colors." Wren, for one, succeeded in toeing the fine line between actual

mechanical expertise and intellectual mastery over the mechanized world of nature. It is the latter that Evelyn has in mind when he boasts of his friend's "many admirable advantages" by which he might someday surpass even Poussin and Bernini.[114]

As we shall see in the next chapter, the tension between hands-on experience and a more abstract notion of mechanics also appears in the field of medicine. To bring physic back in even at this point, however, several connections are worth noting. First, late in life Wren is said to have regretted not pursuing his medical studies further, reasoning that "the Profession of Physick" would have provided a more comfortable standard of living.[115] Wren's position amid the most innovative members of England's medical profession in the 1650s and '60s cautions against dismissing the claim as empty speculation born of ignorance. Second-guessing it may be, but it is the second-guessing of one in a fine position to envision his life as it might have been, had he become a medical doctor. The claim, even if motivated by economic envy, suggests that physic remained in the back of Wren's mind throughout his life.

Notably, he employs the language of medicine in an analogy to describe his work at St. Paul's. In a letter to Dean Sancroft he likens his intention of retaining the west end of the old structure to "the rationall attempt of a Physician in a desperate disease," explainable only "by the anatomist after the dissolution."[116] The passage raises the intriguing possibility that in some way Wren approached architecture as a physician approaches a patient, as an anatomist approaches a cadaver. The analogy's currency seems to extend beyond the function of rhetoric to include the strategies Wren made practical use of as a builder.[117]

Medical and anatomic studies figured into the intellectual development of many of England's finest scholars who came of age during the interregnum. Evelyn and Wren were exemplary in this regard, not exceptional. Nor did the trend go unnoticed at the time. Dr. Walter Charleton, for instance, judged that the "late Warrs and Schisms" turned students away from theology and law but encouraged "young Schollers in our Universities" to "addict themselves to Physick."[118] In the 1660s, then, the Royal Society emerged as the site that would provide an intellectual forum for these interests amid an engagement with natural philosophy more generally. Thanks largely to Bacon, the society's philosophical agenda gave unprecedented attention to the production of natural histories, including arts and trades. Through this context there first emerged in English a body of literature addressing printmaking, architecture, sculpture, and painting. The status of the fine arts remained an open question, just as the entire History of Trades project was

plagued with tensions regarding the relationship between utility and abstract knowledge. An aesthetics of mimesis, optical fidelity, and decorum dominated the Royal Society's artistic expectations. Yet to dismiss these interests out of hand as unsophisticated or base is unfair to this lively and crucial period, which serves as a bridge between the artistic accomplishments of the early Stuarts and the development of an internationally significant British art tradition in the eighteenth century.

In her study of the painter Samuel Van Hoogstraten, Celeste Brusati suggests the Royal Society and the potential patronage its Fellows represented could appear attractive even to artists across the Channel. Having lived "in Vienna in the 1650s, when Ferdinand III's support of the experimental arts and sciences was at its height," Van Hoogstraten was eager to find another, similar milieu of support.[119] He arrived in London in 1662 and soon succeeded in attracting the attention of Thomas Povey, a civil servant and Fellow of the Royal Society. Povey owned two perspective scenes by Van Hoogstraten and on at least one occasion had the artist for dinner at his home in Lincoln's Inn Fields, along with several gentlemen from the Royal Society.[120] Povey's interest in the Dutch painter was consistent both with his enthusiasm for the visual arts and his interactions with other painters. He twice addressed the society on the topic of painting, and in December 1667 he called for the group to sponsor the production of "an entire history" of painting as well as to form a committee of members to meet with London artists, including Peter Lely, Samuel Cooper, and Robert Streeter, all of whom had "already declared their willingness to serve the society" any way they could "concerning the curiosities in the art of painting."[121] As Brusati rightly observes, painting was for these virtuosi "an art of experiment."[122] Povey, in describing the mixing of pigments, stresses his own role as an eyewitness; as a gentleman he vouches for the validity of the results in accordance with the overarching pattern employed by the Royal Society for advancing truth claims.[123] Similarly, he proposes that Hooke accompany him just as Hooke would, as curator of experiments, be present at demonstrations involving air pumps, magnets, or pendulums (that Hooke was "ordered to attend" again signals the curator's inferior status).[124] Finally, painting as experimentation stands at the bottom of Povey's assertion that this art, in fact, deserves the society's "care and research."[125] Evidence from Evelyn, Wren, and their Royal Society colleagues suggests we would do well to pay more attention not only to the results of these experiments but also the method and energy with which they were undertaken.

"The Extream Delight"
Taken "in Pictures"
Physicians, Quackery, and Art Writing

At the meeting of the Royal Society on October 31, 1667, the same day John Evelyn turned over his prized anatomic tables, Sir Anthony Morgan proposed a new candidate for membership in the learned body. The nominee, Dr. William Aglionby (ca. 1640–1705), was elected the following week and officially admitted on November 14.[1] Like Evelyn, Aglionby made several forays into the field of translation, producing texts on various topics, including chemistry, papal history, theater, and the Venetian government. In addition, he authored the first original English text to propound a humanist art theory based on the primacy of Italian history painting. His *Painting Illustrated in Three Diallogues* appeared in December 1685.[2] In 1921, Tancred Borenius described it as "apparently the first systematic treatise on the history and criticism of painting in English," while more recently Carol Gibson-Wood has drawn attention to the precedent it set for Jonathan Richardson's *Theory of Painting* (1715) and *Two Discourses* (1719).[3] Yet Aglionby's text has largely been neglected, and little attention has been given to the fact that it was produced by a physician. Redressing both oversights, the first part of this chapter places Aglionby within the virtuosic circle of the Royal Society, summarizes the structure and argument of *Painting Illustrated,* and finally explains why it is, when contextualized within the 1680s, a more interesting text than has thus far been allowed.

By 1685, however, another book on art, of a more practical bent but also written by a man of medical ambitions, had already proved itself a best-seller. William Salmon's *Polygraphice* was then in its fifth edition, having first ap-

peared in 1672. Like Aglionby, Salmon produced a number of books, though strictly speaking he borrowed and compiled far more than he authored. Despite presenting himself as a learned physician, he was not a doctor: he held no medical degree and practiced without the sanction of the Royal College of Physicians. He was, in his own lifetime, regarded as a quack. Because of this heterodox approach to medicine, *Polygraphice* is useful for considering how the wide-ranging interests of the virtuosi played out in English society and the extent to which early modern art and medicine navigated the same market context.

After addressing the points of intersection between the careers and artistic interests of Aglionby and Salmon, the chapter approaches the problem from the other side, as it were, by examining a handful of medical texts that employ references or metaphors drawn from the visual arts—reinforcing the degree to which issues of empiricism, rationalism, the particular versus the general, and the locus of authority pervaded the fields of painting and medicine during the Restoration and early eighteenth century.

Dr. William Aglionby and His Painting Illustrated

The names of Evelyn and Aglionby appear together not only in the record for the Royal Society meeting of October 31, 1667; coincidentally, both are also mentioned in a diplomatic letter from February 8, 1698.[4] Reporting on Peter the Great's visit to England, John Ellis notes the czar's decision to sublet Evelyn's residence at Deptford, Sayes Court.[5] In the next paragraph, Ellis writes that Aglionby had just arrived in London from Calais "without having settled the post-office," a reference to the postal treaty Aglionby had been trying to negotiate with the French. The juxtaposition underscores the political world Evelyn and Aglionby each inhabited and introduces Aglionby in the role by which he is best known to historians (if at all), that is, as a minor diplomat.

Little is known of Aglionby's early life, and estimates of his date of birth range from the late 1630s to the mid-'40s.[6] A reference in the dedication of *Painting Illustrated,* however, provides one vital piece of information about his childhood that has thus far gone unnoticed. Addressing his contemporary William Cavendish, the fourth Earl of Devonshire, Aglionby expresses his gratitude to the earl's "Noble Family" for the kindness and favors they bestowed upon him, "not only in my Infancy, but even some days after my Birth; and so generously contrived, that they are like to last as long as I live." Raising as many questions as it answers, the passage nonetheless provides

an interesting link to the Cavendish family, famous not only for their estates at Hardwick Hall and Chatsworth but also for their support of Thomas Hobbes.[7] The family employed one George Aglionby, who served as a tutor for the third Earl beginning in 1629. That November George wrote to Hobbes, detailing the latest news from the Cavendish household, and John Aubrey would later describe him as a "great acquaintance" of the philosopher.[8] George received his DD from Oxford in 1635 and that same year married Sibella Smith of London. He died at Oxford in 1643 "of the epidemique disease then raging" and was buried in Christ Church Cathedral.[9] Twelve years later, the Hardwick accounts record a half-yearly payment of £10 for "Mrs. Aglionby."[10] William was presumably the couple's son, and the 1655 annuity must have been the sort of support he alludes to in *Painting Illustrated*. The third Earl died in 1684 just prior to the book's publication, and one senses that the dedication to the new earl (later first Duke of Devonshire) was meant to celebrate his ascendancy and to honor the memory of his recently deceased father. Significantly, both were members of the Royal Society.[11]

Aglionby's own nomination for society membership in 1667 is the first point in the doctor's life that can be precisely dated. A letter penned ten years later by the Duke of Ormonde, chancellor of the University of Oxford, sheds light on the MD Aglionby is credited with at his election. Ormonde writes to the vice chancellor on behalf of Aglionby, who is "recommended highly by Lord Longford, and, as may be seen from his diploma, a Doctor in Physic at Bordeaux."[12] Presumably, Aglionby received his degree in the late '50s or '60s.

Immediately after his election as FRS, the doctor turned to publishing. In 1668 he translated Pierre Thibaut's *Cours de Chymie* as the *Art of Chymistry: As it is Now Practiced* (contextualizing chemistry as an adjunct to medicine in the preface), and the next year he translated Gregorio Leti's *Il Nipotismo di Roma; or, The History of the Popes' Nephews*.[13] 1669 also saw the appearance of Aglionby's study of the Netherlands, which depends heavily on Jean de Parival's 1651 *Les Délices de la Hollande*.[14] It is currently impossible to place Aglionby's residence during this period, though he was perhaps again abroad given that, without explanation, he was exempted from his Royal Society dues.[15]

Ormonde's 1678 letter was occasioned by Aglionby's desire "to take the same degree at Oxford," a standard practice for Continentally trained physicians looking to establish their practice in England.[16] Whatever his intentions (and no evidence exists to confirm the request was granted), Aglionby was by the following summer in The Hague serving as secretary to Sir William

Temple, then ambassador to Holland.[17] Temple himself had written on the Netherlands, and his *Observations upon the United Provinces* largely replaced Aglionby's book. Both texts serve as a reminder of the extent to which travel and travel writing were viewed as matters of state, a point Francis Bacon makes when he recommends that travelers seek out the company of ambassadors and their secretaries.[18]

In the 1680s, Aglionby returned to London and began pursuing the path of the fashionable physician, taking up residence at Broad Street near Bishopsgate. He at last became an active member of the Royal Society, serving on the Council twice toward the middle of the decade. In February 1684 he was asked by the group "to peruse" Robert Boyle's *Memoirs for the Natural History of the Humane Blood,* and in August he promised to give an account of Boyle's *Experiments and Considerations about the Porosity of Bodies.* Aglionby's own empiricist sensibilities are evinced by his report to the society on Ludovicus von Hammen's *De herniis:* "there was a great deal of reading in it, but little experiment."[19] In 1687 Aglionby was listed as a Licentiate of the Royal College of Physicians, a legal qualification required of anyone practicing within the London area who had not received his degree from Oxford or Cambridge.[20] And during this period when he was most active within London's medical and natural philosophy circles, Aglionby published two works on the arts: his 1684 translation of François Hedelin's *Whole Art of the Stage* and his own *Painting Illustrated* of 1685.[21]

For unknown reasons, these plans to establish himself in London were abandoned by the end of the decade, and by 1689 Aglionby was back in The Hague negotiating a postal agreement whereby the Dutch would rely on the British rather than the French for postal services to Italy and Spain. When these talks proved fruitless, he traveled to Spain in 1692 to pursue the matter at the other end.[22] The next spring he was appointed envoy extraordinary to the Duke of Savoy, but the ill-fated promotion got off to a portentous beginning as Aglionby's ship wrecked off the coast of Corsica on the way to Turin; in all, he spent less than a year in the position.[23]

Still, Aglionby continued to fill various diplomatic roles, and in 1702 he was appointed envoy extraordinary to Switzerland under the newly reappointed secretary of state, Daniel Finch, second Earl of Nottingham.[24] In July payment was authorized in the amount of £500 "for his equipage" and £5 a day "as salary" in addition to "his allowed expenses for extraordinaries."[25] But success again proved fleeting, and Aglionby was recalled in the fall of 1704, shortly after Nottingham's own resignation. In a letter to his patron, Aglionby defends his diplomatic record and asserts that he was unfairly dismissed because of the false accusations of two enemies. Specifically,

he was alleged to be a papist.[26] In the spring of 1705, the worn and aged Aglionby returned to England for the last time. He died on December 7.[27]

Despite the steps Aglionby took to establish himself as a physician in London—applying for a medical degree from Oxford in 1677 and then becoming a Licentiate of the College of Physicians in 1687—there is nothing to show the scope of his medical practice. We should, however, be careful to avoid reading the diplomatic achievements of the last fifteen years of his life back into the 1680s, the most relevant decade for Aglionby's contribution to British art history. Having served a brief stint as secretary to Sir William Temple in The Hague, Aglionby was at this point an active member of the Royal Society, a translator, a writer on art, and a licensed physician. As we consider *Painting Illustrated,* this picture of Aglionby must be borne in mind.

Nevertheless, it is worth noting that Aglionby corresponded with Dr. Hans Sloane throughout the 1690s and into the next century. Writing from Madrid, for instance, in April 1693, Aglionby commented on the health of the Spanish king, stating he had recently been bled—twice, in fact, since the royal physicians "never bleed once."[28] In the same letter, he recommended Gabriel Alonso de Herrera's book on agriculture and inquired about the opposition Thomas Burnet's *Sacred Theory of the Earth* faced in England, noting he himself longed to see it, though he knew it would never get past the Inquisition officers.[29] In a letter from the previous June, Aglionby commented on a library in Madrid, and as late as January 1705 he wrote to Sloane to introduce two sons of the Swiss physician Dr. Lavater who had settled in London and "applied themselves to their father's profession."[30] Aglionby suggested that Sloane might "introduce them to ye. [Royal] Society meeting and to some hospitals and also the College of Physicians' laboratory." Other letters include mention of an appointment to visit Sloane's bookseller together and the recommendation of a feverish patient.[31] Though fragmented and impressionistic, this handful of personal notes shows us what the dozens of official diplomatic dispatches do not. Discussing books and their reception, medical practices of foreign doctors, and the health of monarchs, along with asking favors and offering introductions on behalf of other men of learning, these letters—from one physician to another—attest to Aglionby's citizenship in the Republic of Letters, that Pan-European network of intellectuals united by knowledge and correspondence.

Aglionby's acquaintance with Sloane dates at least to 1685, when Sloane was elected Fellow of the Royal Society, having recently completed his medical education in France. The 1680s marked a decisive upturn for the society's well-being after a dozen or so years of difficulty following the plague.[32]

Christopher Wren's two years as president (1682–83) helped usher in this period, which brought with it an improvement in the society's finances thanks to King Charles's payment of £1300 for the land at Chelsea College, the future site of Wren's hospital.[33] To reiterate: it is at this time that Aglionby finally became an active member and at this time that he published his *Painting Illustrated*.

As demonstrated in the previous chapter, the early Royal Society regularly addressed the fine arts, at least partly in conjunction with the larger History of Trades project. John Evelyn's own *Sculptura* and his translations of Fréart de Chambray's *Parallel of the Antient Architecture with the Modern* and *The Idea of the Perfection of Painting* are all contextualized against the backdrop of the society through their prefatory remarks. The last work was briefly reviewed in *The Philosophical Transactions*, as were Charles Le Brun's *Conferences* and André Félibien's *Entriens sur les Vies et sur les Ouvrages des plus excellens Peintres, Anciens et Modernes*.[34] Gentlemen such as Thomas Povey encouraged the inclusion of artistic topics within the group's agenda and personally consulted painters in regard to technical questions about their art. In short, the Royal Society served as the institutional focal point for the reception of the fine arts in England during the Restoration period.

Therefore, reference to "the extream delight" taken "in Pictures," which opens the first dialogue of *Painting Illustrated,* would not have been at all peculiar to Aglionby's fellow Royal Society members. Delight in art they did—though importantly, in the text the origins of this "Pleasure" are ascribed to the character's experience abroad. Sharing his "Knowledge of the first Principles of the Art" of painting with a "Friend," the instructor-figure in the dialogues is cast as the Traveller. He admits that before his exposure to foreign lands, he, too, had believed "all Pictures were alike" and had laughed "at the distinction that some . . . did use to make of the Pieces of this and the other Master." Now, however, the Traveller assures his Friend (and the reader) that "if he undertake[s] this Task with Order and Method, it will prove extream[ly] easie."[35]

This opening scene reinforces Aglionby's remarks from the preface, where he declares England's inferiority in the field of painting, vis-à-vis the Continent, as a matter of fact. In an oft-quoted passage he marvels that despite "how much all [the] *Arts* and *Sciences* are Improved in these *Northern* Parts, and particularly with us, . . . we have never produced an *Historical Painter*, Native of our own *Soyl*." He offers a number of examples of Englishmen who have excelled in their fields: Inigo Jones in architecture, Grinling Gibbons in sculpture, and a number of portrait painters, including Isaac Oliver, Samuel Cooper, William Dobson, Robert Walker, and John Riley.

He suggests England's *"Genius . . .* particularly leads them to affect *Face-Painting,"* and blames the absence of a native school of history painting on "the little Incouragement it meets with in this Nation." And so he writes in order

> to Remedy this. . . . The Design . . . [being] to make Painting Familiar and Easie to the *Nobility* and *Gentry* of this Nation, and to enter them so far in the *Knowledge* and *Acquaintance* of the *Italian Painters,* that they may converse with their Works, and understand their different Characters.[36]

Aglionby's Italian bias is here stated explicitly, but the three dialogues survey the classical tradition more generally, including ancient artists of Greece and Rome along with the occasional northern European painter.

Echoing Aglionby's complaint that England lacked a native history painter, twentieth-century writers have, in a strange historiographical turnabout, faulted *Painting Illustrated* on similar grounds. Stressing its dependence on Charles-Alphonse Dufresnoy's *De arte graphica* and Roger De Piles's commentary on the poem, Luigi Salerno denounced it as "a complete plagiarism," asserting it "does not really reflect English taste, but . . . foreign influence."[37] Lawrence Lipking likewise sees Aglionby as "a snob . . . [who] directs his snobbery against English painting and English ideas about art." Disgruntled by the casting of the Traveller as the connoisseur, Lipking quips that "Aglionby travels too," having taken "his ideas from Dufresnoy and eleven lives from Vasari."[38]

These criticisms, however, fail to explain what *is* unique about *Painting Illustrated.* That *De arte graphica* serves as the principal source for the dialogues should be a starting point into the material, not grounds to ignore it. For all of the debts Aglionby owes Dufresnoy and De Piles, he supplies no straightforward translation of the poem or the commentary that accompanies it. His formal and structural revisions (indeed his recasting of the text from one genre to another) instead facilitate innovations of meaning and purpose. Connecting Aglionby's text and his involvement in the Royal Society allows us, moreover, to reconsider the national dynamic at play in the text, though first a more complete description of the volume is long overdue.

Following the dedication and the preface, "An Explanation of Some Terms of the Art of Painting" defines twenty-seven key words, starting with *air* and concluding with *tinto.* Many are featured in the glossaries of today's introductory texts: *chiaroscuro, contour, design, fresco, print, relievo,* and [*fore*]*shortening,* while others such as *aptitude, gruppo,* and *schizzo* no

longer seem so crucial. *Festoon* and *grotesk* point to the ornamental arts, but
the focus rests squarely on narrative painting, with *antique, cartoon, drapery,
figure, history, manner, model,* and *nudity* receiving the most attention.[39]

Precedent for the "Explanation" comes from Evelyn, who attached a
glossary of architectural terms to his translation of Fréart's *Parallel of the
Antient Architecture with the Modern.* Likewise, in the "Advertisement" for
An Idea of the Perfection of Painting, Evelyn notes he did his best "to render
things as clear and intelligible to the Reader as possible," avoiding "obscure
Italian terms" when he could, though in the end he felt compelled to retain
those "which really are proper terms of art."[40]

Hence Evelyn, in the 1660s, and Aglionby, in the 1680s, struggled with
the same dilemma of how to adapt the language of art, which had developed
in Italy, for English readers. The Royal Society's commitment to the notion
that language should be as precise, as simple, and as "neutral" as possible
compounded the problem. How does one balance the competing values of
clarity and simplicity when the former demands English and the latter Ital-
ian? For both writers, the answer was education. Since precise words al-
ready existed to convey specific artistic ideas, these words must be made
familiar to English readers.[41]

The first dialogue provides an introduction to basic pictorial concepts
and media. Through the conversation format, Aglionby explains pain-
ting as

> the Art of Representing any Object by Lines drawn upon a flat Superficies,
> which Lines are afterwards covered with Colours, and those Colours applied
> with a certain just distribution of Lights and Shades, with a regard to the
> Rules of Symmetry and Perspective; the whole producing a Likeness, or true
> Idea of the Subject intended.[42]

The rest of the dialogue then consists of the Traveller expanding on this
initial, emphatically mimetic definition.

Design, in the sense of drawing, is treated as the basis of painting, and
this leads to a discussion of the merits of basing one's designs either on the
antique or on nature.[43] Perugino is faulted for adhering too closely to the
former and Caravaggio for erring on the side of the latter (merely imitating
"Nature as he found her, without any correction of Forms").[44] The Travel-
ler employs the perennial tale of Zeuxis's composite Venus to explain how
it can be "possible to erre in imitating Nature" and why one should study
ancient sculpture, which provides the proper rules of proportion.[45] Fore-
shortening is presented as the ultimate achievement in design, requiring "a

great Knowledge of the Muscles and Bones," and Michelangelo is credited with being "the greatest Master in that kind" among the Moderns.[46]

The Traveller spends the rest of the first dialogue discussing color, the "Life and Soul" of the painter's art that enables pictures to "deceive the Eye."[47] Zeuxis is credited with fooling birds with his painted grapes, Apelles with causing actual horses to neigh at pictures of horses, and Jacopo Bassano with leading Annibale Carracci to mistake a painted bookshelf for a real one. Responding to his Friend's questions, the Traveller addresses the mixing of colors, depictions of flesh and drapery, kinds of pigments including tempera and oil, and chiaroscuro.[48] Finally, the Friend compliments the Traveller on his ability to explain the art of painting with clarity and ease and asks to hear more about "the History of Painting, that is of its Rise, Progress, Perfection, and Decay" among the Ancients and the Moderns.[49]

Aglionby structures the text so that this introduction to design and color seems naturally to raise the question of painting's history, which he addresses in the second dialogue. The Traveller's survey of the Ancients centers on "the four Famous Painters of Graece": Zeuxis, Parrhasius, Apelles, and Protogenes, though he mentions another dozen.[50] He uses the example of Polygnotus, who "Painted the Temple at Delphos, and the great Portico at Athens," without charge, to suggest that the painter fulfills a public, noble function—a point reinforced several pages later when the Traveller states that the practice of art was for only "Ingenious Minds and free Spirits" and that "Slaves and Inferiour Persons were forbid by the Laws to apply themselves to it."[51] The elevated status of the artist is further demonstrated by the example of Apelles, to whom Alexander the Great presented one of his mistresses when it became clear the painter had been unable to "defend his Heart against" her beauty and "Charms." Pursuing this rhetorical strategy of sexual appeal and potency, Aglionby interjects the claim that "great Painters have generally either Handsome Wives or Beautiful Mistresses, and . . . are for the most part, extreamly sensible to Beauty."[52] The Traveller spends less time on Roman painters, but notes there were a number of "very famous Ones."[53] Principally here, he praises "all the Great Men" of Rome who "purchased the Works of the Greek Painters and Statuaries at any Rate; insomuch that Graecia and Asia were almost deprived of all the best Originals"—thus connecting the Romans with his English readers by way of a desideratum, the observation having already been made that England lacks the kinds of models that are to be found in Italy. The implication is clear: the English nobility and gentry should not only work to foster a native school of history painting but also devote themselves to the collecting of older masterpieces that could serve as examples for contemporary artists.

While the "Barbarous" Middle Ages receive a meager two pages, the end of this period "of Oblivion" results in a rebirth of painting, a recovery of the "perfection in the art, which perhaps would astonish those Antient Artists themselves."[54] Following Vasari, the Traveller proceeds to sketch the familiar tale of the Renaissance from Cimabue, Giotto, and Masaccio; through Brunelleschi, Ghiberti, and Donatello; and up to the Florentines of mid-century, including Castagno, Piero della Francesca, Ghirlandaio, and Botticelli. After commenting on the Bellini brothers, Francesco del Cossa, and Ercole de Roberti, he turns his attention to the High Renaissance, which he describes as the "Third Age, . . . the Virility or Manhood of Painting."[55] Leonardo is presented as the father of this new era that produced such "rare Painters" as Giorgione, Andrea del Sarto, Raphael, Correggio, Parmigianino, Polidoro, Romano, and Michelangelo. For more detailed accounts, the Traveller refers his Friend to Vasari (excerpted at the end of the volume), but goes on to provide sketches of these "famous Names." Raphael is singled out as "the greatest Painter that ever was" and Michelangelo "the greatest designer."[56] The latter is again praised for his mastery of "the Contorsions of Members, and Convulsions of the Muscles, Contractions of the Nerves, &c.," though his painting is, on the whole, judged "less agreeable." Cavaliere d'Arpino and Caravaggio are used to characterize the subsequent period that promised certain decay, until Agostino and Annibale Carracci succeeded in renewing "Raphael's manner."[57] Within this trajectory, the Traveller includes Guido Reni, Domenichino, Lanfranco, and Cortona. Closing the dialogue is a brief discussion of Titian, Tintoretto, Veronese, and Bassano, along with a handful of notable German and Flemish painters.[58]

The third dialogue addresses the qualitative concerns associated with "How to Know Good Pictures," a crucial component of Aglionby's goal of raising support for the arts among the nobles and gentry. Building on his discussion of design and color from the first dialogue, the Traveller concentrates on invention, here described as the third part of painting.[59] Under invention, he places disposition (or order) and decorum. Above all, for Aglionby, proper invention stems from unity of form, tone, and narration. The mimetic achievements of color and design can be maintained only through careful attention to consistency of invention. He judges "the Expression of the Passions" to be "the most difficult part" of invention, the ultimate test of an artist's abilities as well as the source of his style.[60] Finally, the Traveller concludes by suggesting a list of those "fittest to be Studied," with the genealogical line of descent from Raphael to the Carracci again receiving top honors, even as reservations are voiced about three remarkable painters. Leonardo, celebrated earlier as the father of the High Renaissance,

is excluded from this list of "Patterns" on the grounds that too few of his works survive, while Michelangelo is faulted for failing to produce paintings worthy of his own designs.[61] Yet the most significant criticism is directed toward the artistic cornerstone of the French Academy: Poussin. Reconciling these complaints forces us to consider not only the similarities but also the important differences between *De arte graphica* and *Painting Illustrated*.

As a starting point, we should examine the three parts of painting that both writers employ. As noted in chapter 2, Lord Arundel's librarian, Franciscus Junius, had divided painting into five parts: invention, design, color, expression (including action and the passions), and disposition (or order). Fréart adopted these for his *Idée de la perfection de la peinture* of 1662, and the categories were reintroduced to English readers through Evelyn's translation of the work, published in 1668. Nodding toward these sources, De Piles admits that "Many Authors who have written of Painting, multiply the parts according to their pleasure," but he defends Dufresnoy's classification on the grounds "that all the parts of Painting which others have named, are reducible into these three."[62] The simplification of prior schemes into a more manageable trio must have appealed to Aglionby, though importantly the English physician altered the order. For Dufresnoy, invention is *first*: "a kind of Muse, which being possess'd of the other advantages common to her Sisters, and being Warm'd by the fire of Apollo, is rais'd higher than the rest, and shines with a more glorious, and brighter flame."[63] While equally important for Aglionby, invention is described as the *third* part of painting in the dialogues and discussed only in the final section.

However minor the change, it points to larger differences between the two writers' purposes and audiences. Dufresnoy's *De arte graphica* was intended as a modern, painterly equivalent of Horace's *De arte poetica*.[64] The ambitious character of the project is perhaps diminished as Dufresnoy's Latin is translated into the vernacular and certainly obscured by a prose translation such as that made in 1695 by John Dryden, himself a student of medicine. But we should not lose sight of the degree to which Dufresnoy, the artist, was attempting to provide an authoritative text that would govern painting, a work for both connoisseurs and learned painters. Aglionby, by contrast, was aiming to introduce members of the English elite to the classical tradition of history painting as it had developed in Italy. Over and over, he stresses that an understanding of painting can be learned, even that it's easy. He begins with elementary concepts and pays close attention to definitions. He assumes little knowledge from his reader and includes a history of painting that focuses on origins and student-master relations—a significant departure from Dufresnoy.[65] When Aglionby finally tackles the more sub-

stantive issue of invention, he does so within the overtly pragmatic context of "How to Know Good Pictures," and even here he invokes the "Rules of Common Sense."[66] Twentieth-century scholars are correct in noting that Aglionby advances no theoretical innovations; yet because of this fixation on the new, they failed to see what Aglionby *does* accomplish, namely the recasting of an authoritative didactic poem on painting into an art history primer for the English well-to-do.

From a pragmatic standpoint, the dialogic form of *Painting Illustrated* allowed Aglionby to glean from *De arte graphica* with few of the complications involved with a direct translation (the difficulty of which is evinced by the multiple versions that appeared over the course of the eighteenth century).[67] Aglionby's recasting of Dufresnoy's content into a new form with a new purpose, however, results in several peculiar shifts in meaning. Dufresnoy, for instance, devotes several lines to the subject of portraiture in the midst of a larger section on color and tonal variations, while De Piles's commentary emphasizes the issue of verisimilitude and the importance of expressing the sitter's "true temper."[68] Synthesizing the two texts, Aglionby places his discussion of portraiture in the third dialogue as a final note on color before he moves on to invention. The disjunction comes in the fact that Aglionby is not addressing painting in general but specifically history painting (he has, after all, already faulted England in the preface for producing too many portraitists). In order to fit these comments into the context he has constructed, he sets up a contrast between portraiture and more noble genres. Departing from *De arte graphica,* he emphasizes what differentiates these modes of painting: "Face-Painting alone . . . is to be managed another way."[69] In the same section of De Piles's notes, the French commentator relates the ancient tale of how

> Apelles made his Pictures so very like [their subjects] that a certain Physiognomist and Fortune-teller . . . foretold by looking on them the very time of their Deaths, whom those Pictures represented, or at what time their Death happen'd if such persons were already dead.[70]

Aglionby recycles the tale but moves it to the second dialogue, where he discusses Apelles.[71] The anecdote becomes proof of Apelles's mastery of nature in general rather than a direct lesson about portraiture.

Other, more substantial alterations result from this process of adaptation as well, one of which turns on the issue of health. Near the end of the poem, Dufresnoy states that "Wine and good Cheer are no great Friends to painting," and De Piles supports the maxim with three temperance tales involv-

ing Protogenes, Michelangelo, and Vasari.[72] Since *Painting Illustrated* was
not aimed at artists, one might expect this admonition to be omitted. In fact,
Aglionby simply reformulates it for his aristocratic audience:

> under the specious names of Society and Hospitality, we Countenance the
> most Profuse Gluttony and Exorbitant Drunkenness that the Sun sees: I
> might tell Gentlemen, That the Loss of Time, the Ruine of their Fortunes,
> the Destruction of their Health, the Various Tragical Accidents that attend
> Men who once a day lose their Reason are all things worthy their serious Re-
> flection; and from which the Love of the Politer Arts would reclaim them.[73]

The sentiment is echoed by the Friend in the second dialogue. Painting,
sculpture, architecture, music, gardening, and polite conversation are all
described as "ravishing Entertainments, and infinitely to be preferr'd be-
fore our other sensual Delights, which destroy our Health, and dull our
Minds."[74] Painting, because of its association with politeness, becomes an
antidote for heavy drinking.

These passages recall Richard Haydocke's hope that art might be "not
only a grace to health, but also a contentment and recreation unto sickness,
and a kind of preservative against Death and Mortality."[75] According to this
logic, the fine arts are not only ennobling; they're also good for you.

On the other hand, Aglionby's redirecting of the text leads him to recon-
struct the character of the ideal artist. The section from *De arte graphica* that
deals with temperance fits into a larger discussion aimed at establishing a
strict work ethic for painters. Diligence of thought and action is praised.
As are mornings. "Silence and Solitude" are prescribed as conducive to "a
greater Application to work and study."[76] Neither art nor the tablet should
ever be far from the painter's mind, and in general pleasure is seen as a du-
bious distraction. None of this appears in *Painting Illustrated*. Rather than
hard work, Aglionby lauds the artist's capacity for beauty, his status as a
respected servant of kings and emperors, his sexual prowess among women.
The learned courtier becomes the new model. While Dufresnoy himself is
keen to elevate the status of the artist, his strategy accords with the regi-
mented system of the academy. Not only is this not an option for Aglionby
(given that there was no academy in England to speak of at the time), rhe-
torically it also misses the mark.[77] While writing about the history of great
artists, Aglionby is, in fact, trying to persuade his readers to become collec-
tors and patrons. The implication of his characterization of the painter is
that artistic production itself reifies these ideals. To be a virtuoso is to claim
these attributes of social accomplishment and virility.

Aglionby's specific English context is another factor affecting the way the ideas from *De arte graphica* are revised in *Painting Illustrated*. Dufresnoy, like Poussin, spent much of his life in Rome. This experience, coupled with his poetic encapsulation of academic theory, implied a historical trajectory positing France as the heir to the Italian classical tradition. That additional commentary was supplied by De Piles, an important theoretician for the Académie royale, reinforced the view. Within this model, Poussin emerges as the hero of modern painting. But Aglionby will have none of it. His chilly dismissal of the French painter brings the dialogues to a curt conclusion:

> As for Poussin, the so much Admired Frenchman, his way was in Little for the most part; and some are of Opinion he could not do in Great; or at least, he did not delight in it. . . . He had a Talent for Expressing the PASSIONS: which was most admirable. . . . Take him altogether in his Way, he is a Great MAN, but not of that first Rank of PAINTERS, whom all ARTISTS must look upon as the Great Originals that Heaven hath given to Mankind to Imitate.[78]

Highlighting the rejection is the fact that it comes right after Aglionby's comments on Michelangelo and Leonardo, which are taken directly from Dufresnoy.[79] While it is difficult to complain about sharing the second-string bench with these Renaissance giants, both Italians fare much better in other parts of *Painting Illustrated*. This, however, is the only reference to Poussin, and nowhere in the text are other French artists given a role to play in the story of painting's progress. In the few passages that discuss artists from outside Italy, Aglionby focuses instead on Dürer, Holbein, Rubens, and Van Dyck.

All four of these painters were represented in English collections, and Rubens and Van Dyck both spent time in London. Through these northern European artists, Aglionby opens the door to the possibility that the English might produce a serious school of painting that would build on the groundwork laid by the Italians. The question of whether the arts are in decline, for instance, goes unresolved in *Painting Illustrated*. Whereas De Piles asserts that art is on the upswing—"thanks to the zeal of our Great Monarch, and to the care of his first Minister, Monsieur Colbert, we may shortly behold it more flourishing than ever"—Aglionby describes a scenario of improvement that has begun to come to "a stand" and appears likely to "Decay . . . for want of Encouragement."[80] Thus, even in predicting a dim future, Aglionby interjects the importance of patronage, hinting that it may not yet be too late to provide the needed investment. He may also have in mind the iconoclasm of the interregnum, which he denounces in the preface:

had not the Bloody-Principled Zealots, who are Enemies to all the Innocent
Pleasures of Life, under the pretext of a Reformed Sanctity, destroyed both
the Best of Kings, and the Noblest of Courts, we might to this day have seen
these Arts flourish amongst us: and particularly this of Painting.

In the historical survey sketched in the second dialogue, Aglionby expands
this line of attack, analogically tying the Puritans with late antique icono-
clasts; what begins as a discussion of the medieval period quickly becomes
a rant against the "Blind Zeal"[81] of rabid, misguided Christians—a refer-
ence that in the 1680s could not help but call to mind the excesses of the
Civil War. The reversal of the decay in the arts in Aglionby's own time is
consequently linked to the Restoration of the monarchy. For Aglionby the
progress of one depended on that of the other, and the aristocracy's support
is understood as vital for both.

In his preface, Aglionby notes that he planned to publish "a Second Part;
which, besides some more refined Observations upon the Art itself, will con-
tain the Lives of all the Modern Painters of any Note." This second volume
never appeared, but a manuscript in Aglionby's hand clarifies his intentions.
The text is a translation of the dozen lives of Giovan Pietro Bellori's *Le vite
de' pittori, scultori et architetti moderni* (1672), along with an English version
of the text's preface, "L'Idea del pittore, dello scultore e dell'architetto."[82]
That the collection of lives concludes with an account of Poussin complicates
the doctor's assessment of the French painter.[83] Yet the argument sketched
here is not drastically affected, for in *Painting Illustrated* Aglionby attempts
not to provide a critical evaluation of Poussin but to place him within—or,
more precisely, to displace him from—a larger trajectory of European paint-
ing. In order to reserve a spot for an emergent English school of painting,
Aglionby makes a profound revision of Dufresnoy, denying Poussin's role
as the model painter. Ultimately, this has little to do with what he thinks of
Poussin and everything to do with his attempt to construct a history that
might still culminate with an English artist.

This revisionist displacement of Poussin leads us back to the Royal So-
ciety. As in France, where the works of Dufresnoy and De Piles, Fréart and
Félibien belong within the context of the French Academy, Aglionby's *Paint-
ing Illustrated* should be viewed in relation to the Royal Society. The doctor
produced the text during the brief period when he was active within the
group and dedicated it to a fellow member, whose recently deceased father
had also belonged to the body. By recasting Dufresnoy's ideas in the form of
three dialogues between a knowledgeable traveler and his friend who is ea-
ger to learn, Aglionby—far from committing an act of snobbery—employs

a series of conventions perfectly consistent with the Royal Society's own social dynamics, which privileged travel, the sharing of information across the Republic of Letters, and the authority of civility.[84] While nationalist ambitions are central to the text, to take offense at Aglionby's criticisms of English artists is to misunderstand his ambitions. When Aglionby expresses his hopes for a native school of history painting, he is burdened by none of the concerns that would surface in the eighteenth century of what a distinctively English mode of painting might look like. Instead, he simply assumes it will in some way be an extension of Italian classicism.[85] And like a good Society Fellow, he treats the subject as a body of knowledge grounded in nature and man's relationship to it, vis-à-vis mimesis.

The cursory attention paid to *Painting Illustrated* not only has obscured the ways in which Aglionby created a distinctly new text through his appropriations of Dufresnoy; it also has clouded the similarities between the two writers. The son of a successful apothecary, Dufresnoy was expected to pursue a career in medicine, and the education he received, which included classical languages, geometry, and anatomy, was designed toward this end. These same skills provided the intellectual basis for his life as a learned painter, and *De arte graphica* is unthinkable without this medical education in classics. In the early 1630s, when he first turned to painting, Dufresnoy's social position had yet to be secured, and his life as an artist and writer rehearses the plea for the respectability of the visual arts that his didactic poem expresses so eloquently. Aglionby's life of continual aspiration and gradual social advancement parallels the Frenchman in this regard. Aglionby would eventually abandon his medical education for a career as a diplomat, but in the mid 1680s, he believed advancement would come through a career as a learned physician and an active member of the Royal Society. Reworking *De arte graphica* for his English audience fit perfectly within this strategy.[86]

William Salmon and His Polygraphice

While Aglionby carefully set about navigating the proper channels to secure his place in the London medical establishment, William Salmon (1644–1713) was busy building a career upon his own invented credentials.[87] At the age of twenty-seven, he first ventured into publishing with *Synopsis Medicinae; or, A Compendium of Astrological, Galenical, and Chymical Physick,* in three books. He dedicated this debut to the physician Dr. Peter Salmon and Thomas Salmon, Esq., of Hackney, implying a familial connection, where in all likelihood there was none. The book is typical of Salmon's prolific career as an

author and essentially depends on the work and prestige of others—many others. He notes that

> we have scrutinized the best Authors, to many of which we have been very much beholden. Among the Mathematical Tribe, we advised with Hermes, Ptolomeus, Æscuides, Junctinus, Naibod, Gauricus, Regiomontanus, Argollus, Duretus, Kepler, Lilly, Morinus, and others. Among the Anatomists, we applied Ourselves chiefly to Fallopius, Vesalius, Kyperus, Folius, Laurentius, Spigelius, Bauhinus, Malpighius, Willis, Veslingus, Riolanus, the most famous Bartholine and some few more. Among the Chyrurick Tribe, we sought to Celsus, Ægineta, Arnoldus de Villa Nova, Aquapendens, Paraeus, Severinus, Sennertus, Valeriola, Hildanus, Pigraeus, Scultetus, Barbettus, and some others. Among the Medical Tribe, we consulted Hippocrates, Galen, Avicen, Dioscorides, Capivaccius, Fernelius, Matthiolus, Erastus, Fracastorius, Septalius, Zacutus, Forestus, Rudius, Petraeus, Joel, Regius, Zecchius, Platerus, Sennertus, Riverius, Sylvius, etc. Among the chymists we made use of Paracelsus, Crollius, Hartman, Faber, Quercetan, Mynsicht, Untzer, Sala, Mylius, Horstius, Porterius, Schroeder, Zwelfer, Beguinus, Grulingius, Clossaeus, together with a multitude of others, whose Names shall live in an Honourable esteem through all succeeding Generations.[88]

The catalogue underscores the competition between schools of medical thought in the early modern period. Rather than taking sides, however, Salmon just includes them all! As established practitioners aligned themselves with the mathematical or chemical camps, with the modern Paracelsians or the ancient Galenists, with close attention to anatomy or careful allegiance to astrology, Salmon provided for his English readers a compendium of everything.

Thanks in part to such absurd rhetoric, Salmon generally surfaces in the literature of the history of medicine only within quaint accounts of the history of quackery, a picturesque comic tradition running alongside the serious business of accounting for the accomplishments of orthodox medicine. Eschewing "the eternal dialectic of knaves and fools," Roy Porter, however, has shown the histories of orthodox medicine and quackery to be inextricably intertwined.[89] The key issues are economic and rhetorical, since medical practitioners of all sorts succeeded or failed on the basis of their reputations and their marketing abilities.

Moreover, as Porter observes, "most of the litmus tests that might be proposed to divide quacks from pukka doctors . . . confuse rather than clarify."[90] Defining quacks on the basis of motives, education, the selling of nostrums,

or even the efficacy of their treatments proves impossible, and any rules are constantly to be confounded by the exceptions. As for intent, how would one begin to pursue the matter? The desire for profits characterized the practice of all forms of medicine, and purposeful deception can rarely be established with any certainty. Likewise, Salmon was undoubtedly educated, regardless of whether or not he possessed an MD. He owned a large library, complete with two microscopes; he could read Latin and was familiar with the medical literature of his day. As for the selling of remedies (Salmon's Pills could be purchased even on the Isle of Wight), respected physicians such as Hans Sloane and Richard Mead also attached their names to mass-marketed products. And finally as for efficacy, one was as likely to recover in the care of an irregular practitioner as under the scrutiny of an overzealous doctor set on bleeding and purging.[91]

Yet if the lines between the physician and the quack should be drawn lightly, in pencil rather than pen, value in the distinction remains, precisely because it figured so prominently in the discourse of the period. And while we should be wary of essentialist definitions, descriptive and functional approaches are useful; and here, too, I depend on Porter, who distinguishes the regular doctors' tendency "to consolidate stable practices with familiar clients" from the quacks' interest in "the anonymous customer — the faceless crowd, the nameless reader."[92]

Although Salmon himself is absent from Porter's study, this model for thinking about quacks provides a useful framework for reconsidering the self-styled "professor of medicine" who clearly understood the importance of England's rising literacy rates. During the course of nearly five decades, Salmon copied, translated, abridged, enlarged, and compiled from the texts of others, publishing over two dozen works bearing his own name, many of which appeared in multiple editions. Nearly everything known about Salmon's life, in fact, comes from his own books. With an acute appreciation for the public's appetite for medical advice, he produced popular works on pharmacology, anatomy, alchemy, surgery, case studies, and treatments for specific diseases, including smallpox, measles, and syphilis. He wrote on astrology and produced an almanac that aimed to coordinate its readers' health with the heavens.[93] He published on botany and cookery and seems to have played a role in the most influential sexual primer of the early modern period, *Aristotle's Master-Piece*.[94] On three occasions he penned religious tracts.[95] And yet perhaps his most successful text dealt with art.

His *Polygraphice, the Art of Drawing, Engraving, Etching, Limning, Painting, Washing, Varnishing, Colouring, and Dyeing* first appeared in 1672 and remained a reliable seller for the next thirty years, going through eight edi-

tions.[96] In the preface of the final edition, from 1701, Salmon boasted that fifteenth thousand copies of the book had already been sold; and while it is difficult to take him at his word given his propensity for self-aggrandizement, Mansfield Kirby Talley, who tends to be hard on Salmon, suggests that in a period when the Stationer's Company limited print runs to two thousand copies, a count of fifteen thousand may not be grossly inflated.[97]

Like most of Salmon's publications, little of the text can be said to have originated with him, and he stretches even the loosest definitions of early modern authorship. For Talley, the "book is an encyclopaedic tour de force of piracy . . . little more than wholesale thievery."[98] Salmon freely draws upon Henry Peacham, Junius, Edward Norgate, William Sanderson, Alexander Browne, Robert Boyle, and John Smith, and openly admits in the preface to having "made use of the best Authors" he "could possibly procure."[99] But to disregard Salmon and his text for his lack of originality is to ignore one of the most widely available art books of the seventeenth century and to misunderstand its importance for the dissemination of the sources on which it depends.

The biggest misconception about *Polygraphice* is that it constitutes a single discrete text. In fact, it evolved profoundly over its lengthy publishing history, and its eight-edition lifespan encompassed five different versions. Simply comparing the number of pages renders the point obvious: the final edition of 1701 weighs in at 939 pages, three times the size of the first edition of 1672. Mapping this progression not only provides a more informed understanding of *Polygraphice* but also serves as an index of the rising demand for increasingly sophisticated art books in England over this thirty-year period.

The first-edition frontispiece pictures Salmon's initial, pragmatic aims (fig. 35).[100] The coarse engraving by Phillip Holmes shows four different scenes of a gentleman, or at least a member of the middling ranks, engaged in various artistic activities: etching, engraving, varnishing or coloring two spheres of a globe, and painting at an easel. With this initial venture into art publishing (only his second publication of any sort), Salmon—here styled simply "W. S. a Lover of Art"—aims to provide a practical how-to manual for his readers. In the preface he stresses the novelty of the work, which aims to make "*things uncertain,* . . . limited and reduced: *things obscure,* . . . plain: *things tedious,* . . . short: *things erroneous,* . . . rectified and corrected: *things hard,* . . . facil and easy." For all the intellectual resonance Salmon sought in "that Greek Compound POLYGRAPHICE," the term's attraction lies in its comprehensiveness. In contrast to *painting,* which is "not only too singular; but also too short or narrow," the term *polygraphice* includes "Drawing, En-

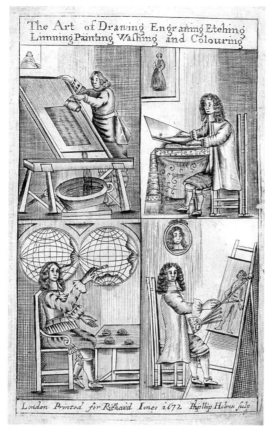

The Art of Drawing Engraving Etching
Limning Painting Washing and Colouring

London Printed for Richard Janes 1672 Phillip Holms fulp

FIGURE 35 Phillip Holmes, frontis-
piece; from William Salmon, *Polygraphice,
the Art of Drawing, Engraving, Etching,
Limning, Painting, Washing, Varnishing,
Colouring, and Dyeing* (London, 1672).
Used by permission from University of
Chicago Library, Special Collections
Research Center.

graving, Etching, Limning, Washing, Colouring, and Dyeing," and the first
edition offers a straightforward guide to these pursuits.

Comprised of hundreds of brief chapters on disparate topics, the form of
the text runs exactly counter to that of a theoretical treatise like Aglionby's.
Book 1 addresses drawing, with instructions on a range of topics includ-
ing different sorts of media, figure drawing, shading, proportion, landscape,
perspective, copying, and various iconographic conventions (virtues and
vices, the muses, the four winds, and so on). Book 2 explains techniques
for engraving, etching, and limning (how, for instance, to hold the graver,
handle aqua fortis, and prepare pigments), while book 3 covers oil paint-
ing along with an array of activities such as cleaning old pictures, painting
on glass, varnishing, and dyeing different materials—"Cloth, Silks, Bones,
Wood, Glass-Stones, and Metals."

As Carol Gibson-Wood argues, Salmon's project can be seen as an "opportunistic" manifestation of Bacon's History of Trades program, which the Royal Society embraced so enthusiastically. As the author of "this compendium of information," Salmon remains oblivious to Continental notions "about the humanistic aims of painting . . . that would have prohibited his egalitarian depiction of both vegetables and Roman virtues."[101] While Aglionby aimed to introduce English readers to connoisseurship and classical art theory, Salmon was adapting the Royal Society's thirst for practical production skills to an even larger audience, one that Gibson-Wood has, in another context, characterized as far more interested in art, at least at a popular level of consumption, than has generally been admitted.[102]

Although *Polygraphice* remained throughout its publishing history an odd collection of disjointed material dominated by practical instruction and recipes (with the three books of the first edition swelling to eleven books by 1701), it is informative to see how later editions adapted to an expanding art market and emulated elite forms of consumption and virtuosity. The evolution of the eight editions can be summarized as follows:

A. *1672*

293 pages; no plates other than the frontispiece; dedicated to Peter Stanley.

B. *1673*

352 + pages; the 1672 frontispiece replaced with a portrait of Salmon and a decorative half-title page picturing Zeuxis and Apelles; fourteen other plates added; dedicated to Henry Howard.

C. *1675, 1678, 1679, 1681*

407 + pages; two plates of nude figures from the 1673 edition are replaced; a standing écorché figure and a diagram for palmistry are added; in all there are now twenty plates; material on perspective is enlarged; discourse on chiromancy added along with discussion of alchemy, metals, and hermetic philosophy; still dedicated to Henry Howard.

D. *1685*

509 + pages; the previous images are retained and five more added (four landscapes and another chiromancy diagram); there are now twenty-five plates; additional material on alchemy and material on medicine added; dedicated to Wortley Whorwood.

E. *1701*

939 + pages; a new portrait of Salmon substituted and the decorative half-title page omitted; twenty-four plates in all (despite the claim on the title page to XXV); expanded throughout; dedicated to Godfrey Kneller.

With few exceptions, the versions change over time not through substitutions but by additions. Plates, for example, are included for the first time in 1673, and versions C and D likewise add images. The same preface is used in versions A, B, and C. It is expanded twice and then retained again in both 1685 and 1701. Even as dedicatees change, the dedications themselves remain mostly the same. In regard to content, each subsequent version contains larger sections on cosmetics, perfumes, medical treatments, alchemy, and chiromancy as the space allotted the pictorial arts proper also increased.

To say that *Polygraphice*—even judging from the earliest versions—is entirely devoid of theory is misleading. While never a priority, theory still seeps into the mix, since Salmon's sources articulate theoretical positions. There is, in other words, a kind of theoretical residue that appears throughout *Polygraphice,* and again, it becomes more pronounced over the thirty-year history, just as the text (to our eyes) looks less and less like an art book thanks to the various hermetic and medical inclusions.

The first chapter of book 1 defines *polygraphice* as an essentially mimetic art, the aim of which is "imitating Nature . . . [in order] to represent to the life (and that in plano) the forms of corporeal things, with their respective passions." This entirely commonplace understanding of art serves as the baseline. In his discussion "Of a Picture in general," Salmon similarly looks to current academic theory and identifies "four principal considerations": invention, proportion, color, and life. Beginning in 1675, book 3 receives a comparable introductory chapter, and Salmon identifies three key categories: design, proportion, and color—which curiously he connects to "three sorts of Painting, viz. Landskip, History, and Life." The chapter includes a number of aphoristic remarks from Dufresnoy, concluding with the admonition that one's thoughts should always drive one's work and that all one's "endeavors . . . [should be] assisted by an intellectual energy."[103] That the following chapter applies the guidelines for evaluating pictures to the specific task of selecting appropriate paintings to copy underscores the differences between the text and its theoretical antecedents. The point is that Salmon unabashedly juxtaposes the two.

One of the most substantive shifts appears between versions A and B. Published a year after the first edition, the 1673 text adds only fifty pages

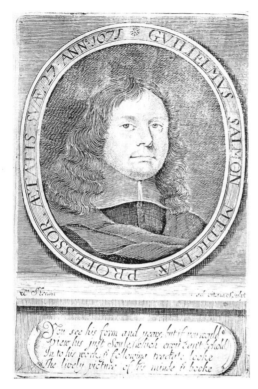

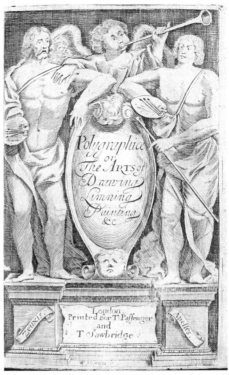

FIGURE 36 William Sherwin, frontispiece portrait of William Salmon; from Salmon, *Polygraphice* (London, 1685). Used by permission from University of Chicago Library, Special Collections Research Center.

FIGURE 37 William Sherwin, half-title page; from Salmon, *Polygraphice* (London, 1685). Used by permission from University of Chicago Library, Special Collections Research Center.

and generally contains the same content, but the alterations are important. In place of the previous frontispiece, which showed some of the techniques described within the book, there is now a portrait of Salmon (fig. 36) and a decorative title page depicting Zeuxis and Apelles (fig. 37). Whereas the first edition was attributed merely to "W. S.," this and each subsequent edition would be presented as a product of Salmon's intellectual activity, complete with his medical credentials. The inclusion of the nude figures of Zeuxis and Apelles similarly attempts to provide the book with an ancient, noble disposition—a striking contrast to the earlier image of a contemporary actually engaged in art. Not surprisingly, it was at this point that William Sherwin's plates were added in the body of the text. Finally, the dedication is reallocated to Henry Howard, Lord Arundel's grandson. Five years after Evelyn dedicated his translation of Fréart's *Idea of the Perfection of Painting* to

the Norfolk Duke, Salmon followed suit, hoping to recast *Polygraphice* in a more prestigious light than had attended the first edition.

The Howard connection—even if more imagined than real—calls to mind once more the Royal Society, and the polymathic character of *Polygraphice* can be seen as a reverberation of the group's own eclectic range of interests. While aimed at a wider audience, Salmon's text suggests the degree to which expansive curiosity was not limited to the virtuosic elite but pervaded English culture.

This would in part account for the major additions of medical, cosmetic, and alchemical materials that appear in the later editions. The sections on cosmetics and hygiene are especially interesting because of the way they foreground issues of artifice. To those who would wonder why he "should meddle with such a subject as this, in this place," Salmon responds,

> the Painting of a deformed Face, and the licking over of an old, withered, wrinkled, and weather-beaten skin, are as proper appendices to a Painter, as the rectification of his Errors in a piece of Canvase: Nor is there any reason, but that the Artist should shew his care in the one, as well as to expose his skill in the other, since a single deformity in the body, begets a complication of miseries in the mind, and a unity of defects a multiplication of Evils.[104]

Salmon gestures to the Neoplatonic notion that outward appearances provide a reliable guide to inward states of being. Yet as already noted with Haydocke, according to this tradition cosmetics were an anathema precisely because of the threat they posed to the visible world's otherwise "natural" legibility. If appearances could be altered, they could no longer serve as indices of truth. On this basis, line was privileged above color by most academic theorists, and any attempts to define color as the essence of art were met with fierce resistance.[105]

Breaking with this tradition, Salmon singles out the sections on cosmetics in his 1685 preface and describes the value of these "various ways of Painting, Beautifying, and Adorning the Face and Skin, so artificial as it shall be imperceptible to the scrutiny of the most curious and piercing eye." He presents the *artificial* as a remedy to nature's defects, though visually the two are indistinguishable. Nor is the medical language that Salmon employs—*disease, deformity,* and *death*—to be taken lightly.[106] In the same way that a woman's face can be likened to a canvas, diagnosing a patient's health is seen as analogous to judging pictures. The slippage comes in the

FIGURE 38 Diagram of chiromantical sig-
natures; from Salmon, *Polygraphice* (London,
1685). Used by permission from University of
Chicago Library, Special Collections Research
Center.

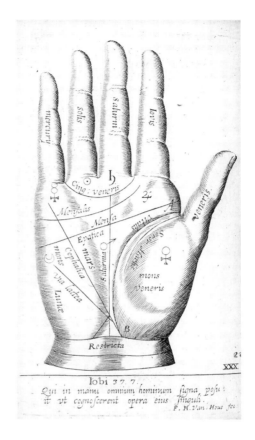

fact that treating appearances becomes a way of treating the source of prob-
lems, too. Salmon understood his audience well enough to appreciate the
appeal of such logic.

This connection also provides the context for understanding Salmon's
fascination with chiromancy (fig. 38). In his chapter entitled "A Rational
Demonstration of Chiromantical Signatures," he explains its ancient associ-
ations, which can then be coordinated with the heavenly spheres (Mercury,
the Sun, Saturn, Jupiter, and Venus all are assigned a finger). The hand be-
comes a physiognomic puzzle holding the secrets of one's life as attested and
affirmed by the cosmos at large. However strange the inclusion may seem
in the context of an art text, it is worth recalling that De Piles cites the an-
cient tale of a fortune-teller's success as proof of Apelles's mastery of nature,
and this just four years prior to the first edition of *Polygraphice*. Or from a
medical perspective, one could point to no less of an authority than the Hip-

pocratic author of the *Prognostic* who held "that it is an excellent thing for a physician to practice forecasting" in regard to patients' health.[107]

Salmon's detractors pointed, of course, to these admittedly unorthodox interests as proof of his being a quack, and perhaps even more damning than his dabbling in alchemy and fortune-telling were his forays into theology. If his *Discourse against Transubstantiation* rehearsed a routine Protestant argument, his tracts on baptism and communion isolated him from nearly every branch of the Christian faith. In the former he argued that Jesus's directive to baptize expired with the death of the apostles, while in the latter he maintained that Christ never intended to instigate a religious observance the night before his death but was simply eating the Passover meal.

Around 1700, Sebastian Smith took Salmon to task, publishing *The Religious Impostor; or, The Life of Alexander, A Sham-Prophet, Doctor, and Fortune-Teller . . . Dedicated to Doctor S-lm-n.* Despite the usual difficulties of using combative, satirical texts as evidence, the pamphlet provides one instance of Salmon's reception. Cast as Alexander, he is faulted for producing almanacs intended "to direct the taking of medicines," hawking recipes for his own "dispensatory" of cures, calculating nativities, and telling fortunes.[108] There is no mention of *Polygraphice*, though interestingly, a copperplate sets Alexander's scheme in motion:

> after some debate resolved upon, they privately hid a copper-plate in the old Temple of Apollo at Chalcedon, whereon was written, *That Aesculapius with his Father Apollo would shortly come and fix his Habitation at Abonoteichos.* After this, they so contrived matters, that the Plate was found bearing this wonderful inscription, the news whereof immediately spread itself.[109]

In making the case for Salmon's deception, Smith sets his tale of duplicity in antiquity. A related accusation is made near the end of the text, as the narrator asks, "who can ever forgive a scoundrel of his infamous character, for ordering medals to be stampt, bearing the figure of a serpent on one side, and his own on the reverse, with the arms of Aesculapius?"[110] The question underscores the self-serving ends that antiquarianism could be forced to serve, and though no medals of Salmon seem to have survived, the charge could as easily refer to the elaborate portraits that usually accompanied his publications and announced his medical expertise, taking their cue from ancient gems and cameos.

Writing several years after Salmon's death, the surgeon Daniel Turner in *The Modern Quack; or, The Physical Imposter Detected* describes Salmon as the "Ring Leader, or King of the Quacks."[111] The reference suggests not only the

established medical community's opinion of Salmon but also the extent to which he pervaded the London marketplace. Yet with these accusations we return to the problem of how to approach quacks fairly, acknowledging the ways in which they looked far more like their regular counterparts than the latter would have ever admitted while at the same time not dismissing important distinctions. Turner, for instance, in implying he himself was a Fellow of the Royal Society when he was not, could certainly stoop to a similar level of "impostering" as that with which he charged Salmon.[112] And when we see who owned copies of Salmon's books, we have a more difficult time dismissing him outright. Isaac Newton, Daniel Defoe, William Congreve, and Samuel Johnson hardly can be seen as simple-minded knaves.[113] Likewise, Horace Walpole owned a copy of both *Seplasium; The Compleat English Physician* and the 1701 edition of *Polygraphice.*[114]

As explored further in the next chapter, one major methodological distinction between quacks and physicians proper hinged on the issue of theory. The physician's calling was to explain health and custom-tailor treatment for an individual's well-being. It was the quack's job to treat symptoms, often with universal cures. To the extent that Salmon belonged within this latter camp, *Polygraphice* serves as a nice pendant to the art texts that received the Royal Society's recognition and support. Whereas Evelyn's translations of Fréart and Aglionby's *Painting Illustrated* attempted to endow the nascent English appreciation for the classical tradition with a theoretical foundation, Salmon hoped to capitalize on the growing interest in art more broadly. All of these boundaries, however, prove more permeable than they first appear. Just as the Royal Society's interests in the fine arts can be linked to the practical agenda of the History of Trades program, Salmon's *Polygraphice* helped disseminate glimpses of theory to an increasingly literate and artistically inclined English public. The degree to which Salmon provides an echo of the erudition of his Royal Society counterparts is nowhere more apparent than in the sale of his collections. Soon after his death in 1713, Thomas Ballard produced a catalogue of the library of the "Learned William Salmon, M.D." that included thousands of books in Latin and Greek as well as English, along with dozens of various "mathematical instruments," artifacts from the West Indies, forty-six "books of cuts in folio," loose prints, and seventy-six paintings.[115] Even if Ballard used the opportunity to stuff the sale with books and objects that Salmon never owned, the collection must still have been representative of what he did possess.[116]

The final edition of *Polygraphice* from 1701 reinforces Salmon's ability to respond to readers' expectations. The earlier frontispiece portrait is replaced with an updated engraving (fig. 39) that substitutes an elegant scarf for the

FIGURE 39 Michael Vandergucht, after Robert White, frontispiece portrait of William Salmon; from Salmon, *Polygraphice* (London, 1701). Used by permission from Yale Center for British Art, Paul Mellon Collection.

older Restoration collar.[117] In place of the now tired epitaph, an architectural base anchors the oval frame while ornamental ribbons cap the image, echoing the curls of Salmon's periwig. In contrast to the frontal pose used in the previous edition, the new emphasis on Salmon's shoulder fleshes out a three-quarter image that makes him appear simultaneously more accessible and more dignified. The decorative half title page is omitted completely, and the full title page is made more legible thanks to the removal of the occasional gothic type and the insertion of chapter headings to order the previously chaotic list of contents. Past dedications honored supporters of the arts (or in the case of the 1685 edition, to Wortley Whorwood, a supporter of alchemy), whereas the approbation this time was awarded to Sir Godfrey Kneller, whose position as the nation's leading painter was easily grasped by all segments of English society having any art interests at all.

Salmon was never one to waste a marketing opportunity, so advertisements for his Family Pills and other medicines appear throughout his publi-

cations. Mixing basic art instruction, explanations of techniques and media, medical advice, and hermetic wisdom, *Polygraphice* underscores the degree to which early modern art and medicine took shape within the same market environment.[118] Not only were the two closely aligned at the upper levels of elite culture—where authoring an art book could be used as a strategy for establishing oneself as a fashionable physician, as seen with Aglionby—but at the more popular level, where art and medicine looked to the same audience for support and competed for the same shillings.[119] A book that managed to combine the two disciplines proved a profitable venture for Salmon and helped establish himself as a household name.

Medical Texts and Art Metaphors

As physician to Frederick, Prince of Wales, and a Fellow of both the Royal Society and the Royal College of Physicians, Francis Clifton was eager to defend the boundaries of medicine from practitioners like Salmon. At the same time, Clifton was persuaded by the new emphasis on empirical observation and believed only through such means would physic ever improve. Unwilling to criticize the Ancients, however, he cast Hippocrates as an early Newtonian, and in a turnabout of the standard historiography, faulted the Moderns for their ineptitude in systematic observation. He attributed to the Ancients superior medical knowledge and even dismissed Harvey's explanation of the blood's circulation as having little effect on medical practice. As a corrective, he proposed a scheme for advancing medical knowledge through comprehensive documentation of patient case histories.[120] He targets "philosophy" as the obstacle to future progress and stresses the importance of "facts." Yet here Clifton must toe a fine line. Once he has castigated theory and supplanted it with observation, what is there to distinguish his notion of medicine from that of the empirics, those unlearned practitioners who treat symptoms with little concern for deeper causes of health?[121] Clifton understands his precarious position and is careful to articulate the physician's importance. He argues that only the university-educated doctor is qualified to process the data responsibly and thus "to know what is proper to be observed, and to [ar]range, one's observations in the best and easiest manner." To emphasize the point, Clifton contrasts the arts of medicine and painting:

> There's a great difference between the practice of Physick, and the practice
> of other Arts. A man may be ignorant or negligent in the noble Art of *Paint-*

ing, for instance, and yet paint on, without injuring anybody but himself. But the case is quite otherwise in Physick. If a man undertakes the cure of diseases, without knowing their nature, their appearances, and their consequences, together with the best remedies in use; or if he knows these things, and yet neglects to observe the case as he ought, 'tis a very great chance, if he does not injure every body but himself.[122]

The analogy is not original to Clifton. A variation of it dates at least to the sixteenth century, and in the 1602 text *The Anatomyes of the True Physition, and Counterfeit Mounte-banke*, physic is contrasted with the arts of the tailor and the potter, the point being that a ruined article of clothing or a broken pot can hardly be likened to a damaged body.[123] In choosing painting for the example, Clifton speaks to the growing interest in the fine arts. At the same time, he uses the analogy to distance physick from picture making (and by extension other forms of "manual" labor) and to elevate the status of the health-care provider, in part through simple scare tactics. As it becomes increasingly difficult to distinguish the methodological underpinnings of orthodox and irregular medicine, contrasting the former with painting serves to separate the different kinds of attention paid to appearances. Implicitly, Clifton associates painting with the empiric.

Writing in 1667, George Castle similarly aimed to demarcate medical practice proper from that of the mountebank. While admitting the latter occasionally met with "accidental success," Castle stressed he could not routinely promise such results: "there can be expected no better performances in Physick from this man's unskillful administration, than in Limning from a hand altogether rude, though armed with the pencils and colors of Vandike."[124] The comparison is kinder to art than those made by Clifton, even as its logic falters upon closer inspection. Does Castle really mean to suggest that an untrained artist might "accidentally" produce a first-rate painting? In any case, the point is to reinforce the differences in expertise, and painting again is used as a fundamentally negative example.[125]

In contrast to Clifton and Castle, Dr. Bernard Mandeville was far less wary of the *empiric* label and employed metaphors that transcended simple issues of craft or training. No stranger to eighteenth-century controversy, the Dutch-born physician rattled English society with his *Fable of the Bees*, which explicitly advocated the pursuit of luxury just as anxieties over the issue ran high. In his *Treatise of the Hypochondriack and Hysterick Diseases in Three Dialogues*, Mandeville likewise unabashedly argued for the importance of observation, with little of the trepidation shown by Clifton and no compulsion to honor the Ancients. In the text, it is the hypochondriacal

patient, Misomedon, who describes himself as a "Lover of Antiquity." Not only does he own an impressive library and collection of medals, but he has studied physic himself. He has read both the Ancients and the Moderns and attended dissections. He takes the fact that he is still not well as proof of the inherent shortcomings of the "art of physick." Philopirio, the foreign physician, on the other hand, faults the arrogance of his medical colleagues and pleads for a practical approach based on the observation of the patient's symptoms. But if Mandeville shares this emphasis with Clifton, he shows none of the latter's fear of being mistaken for an empiric. When Misomedon asks Philopirio point blank, "What! are you an Empyrick?" Philopirio traces the word back to its ancient origins, to Heraclion and his followers, and declares that so far as "the art of physick consisted in downright observation . . . I am an Empyrick."[126]

Given this favorable disposition to the empiric camp, it is interesting to see how Mandeville employs artistic metaphors. In criticizing the traditional medical curriculum comprising "the usual stages of logick, natural philosophy, anatomy, botany, and perhaps chemistry," Philopirio notes the degree to which a newly graduated doctor is still entirely unprepared to treat patients.

> Such a one is no more capable of discharging the weighty office of a physician, than a Man that should study opticks, proportions, and read of painting and mixing of colours for as many years would, without having ever touched a pencil, be able to perform the part of a good history painter.[127]

Here is the other side of Castle's analogy, and in contrast to Clifton, the comparison reinforces the *similarity* between physic and painting. Both are presented as having an intellectual foundation, though ultimately practice assures the effectiveness of each.

Several pages later, Mandeville employs the model of connoisseurship to argue for the primacy of images over language and the importance of knowledge acquired through close observation, even the extent to which this knowledge cannot be conveyed to the novice viewer. Philopirio argues that

> the practical knowledge of a physician, or at least the most considerable part of it, is the result of a large collection of observations, that have been made not only on the *Minutiae* of things in human bodies both in health and sickness, but likewise on such changes and differences in those *Minutiae*, as no language can express. . . . As for example: whilst your servant went to tell

you I was come, I saw in your parlour a Head of *Van Dike's,* which I would swear is an Original. But should anybody, especially one that had no skill in Painting, ask me why I would be so positive when it might be a Copy that was very well done and like it, and I was either to give him an intelligible Reason why I knew this from any Copy that could be made (which yet is very true) or else to be hang'd, I must die like a Fool.[128]

As with Castle, Van Dyck appears once more, though in this case Mandeville employs the comparison to demonstrate his commitment to appearances and images. He establishes the physician's credibility not by contrasting the doctor and artist but by endowing the former with the ability to judge the latter's work accurately. The physician's expertise lies in his ability to identify the original. That this sensory perception exists apart from language undercuts the logocentric tradition of medical education and must have been as disturbing to most eighteenth-century physicians as Mandeville's praise of luxury. Seen in this light, it is perfectly fitting that Dr. Mandeville was one of the earliest writers to use the word *connoisseur* in English.[129]

This troublesome relationship between the new empirical foundations of knowledge and the traditional, rational basis of medical authority is explored further in the following chapter. In closing here, however, it is worth noting two other medical texts that employ art analogies, specifically in regard to mimetic fidelity to nature.

The first comes from the preface of Thomas Willis's *Anatomy of the Brain and Nerves.* Willis states that at the start of the project he had formed "some rational Arguments" for explaining his subject. Yet he recounts that when these explanations were put

to a severer test, I seemed to myself, like a painter, that had delineated the head of a man, not after the form of a master, but at the will of a bold fancy and pencil, and had followed not that which was most true, but what was most convenient, and what was rather desired than what was known.[130]

As with the previous examples, the simile hinges on the discrepancy between a master and an inferior artist driven by "bold fancy" and convenience. The analogy, at first, seems to impugn painting with the familiar characterization of image making as an unreliable art of shadows. Painting is evoked to suggest what *not* to do. Yet the rest of the passage shows Willis to have something else entirely in mind. When he "determined . . . to enter presently upon a new course, and to rely on this one thing . . . to believe nature and ocular demonstration," he was setting out to be a master anatomist

comparable to the master painter just invoked. Confirmation comes from the thanks he extends to Christopher Wren in the following paragraph. Wren, who was "frequently" present at the dissections, conferred over anatomic questions and "was pleased . . . to delineate with his own most skillful hands many figures of the brain and skull whereby the work might be more exact."[131] While its mimetic function is taken for granted, depiction itself is not seen as an inherently false. For Willis, the painter's art is implicitly akin to the medical anatomists. Both pursue nature.

In the mid-eighteenth century, John Barker advanced a related argument. In *An Essay on the Agreement betwixt Ancient and Modern Physicians,* he writes that "the Arts of Painting and Statuary, as well as Medicine, are only imitative Arts."[132] For Barker, it only makes sense that painting would have its Apelles, sculpture its Phidias, and medicine its Hippocrates. But why, he asks, are none of these Ancients rivaled in the modern era? Arguing that to rule out the possibility "would be impeaching Nature," he concludes "that it is only for want of Industry and Application."[133] Barker, like Clifton and Castle, has an axe to grind with the empirics and lobbies instead for a marriage of reason and observation.

In short, members of the medical community—from the conservative to the more progressive—found themselves wrestling with the same issues at play in the visual arts. The ways in which physicians employed analogies based on these similarities provide a glimpse of how closely aligned art and medicine were during the period, even as most physicians sought to distinguish their own practice from that of the image makers. The methodological problems of mimesis in an age of empiricism were hardly confined to the visual arts. William Aglionby's attempt to provide his English readers with a theoretical basis for art consumption was simply the other side of the coin from William Salmon's practical compendium of art and medical knowledge, which itself can be seen as a popular reverberation of the Royal Society's polymathic virtuosity. Dominating all of these overlapping discourses was a fascination with nature as both a rational idea and an endless source of empirical sensation.

"Assuming Empirick" and "Arrant Quack"

Antiquarianism and the Empirical

Legacy of Don Quixote

During the Restoration and the early eighteenth century, negotiating the relationship between looking and reading was the single most important issue for what it meant to be a physician. Publication, even when dealing with nonmedical topics, helped establish credibility and name recognition. As a doctor and a Fellow of the Royal Society, William Aglionby responded to this pressure, as did his quack counterpart William Salmon. Central to the enterprise of textual output lay expectations about the potential of rational medical theory. Simultaneously, however, observation was lauded as the path to progress, with Francis Bacon and John Locke enshrined as the prophets of a new age. At stake in the methodological strain was the authority of the medical community itself, and proponents of empiricism understood the dangers. From this strain comes one of the most extraordinary anecdotes in medical history.

When faced near the end of his career with a student's request for a reading list of medical essentials, Dr. Thomas Sydenham looked neither to the perennial authorities of ancient medicine nor to the influential physicians of his own period. Instead, he singled out a different kind of text altogether, and his prescription still startles today: "Read *Don Quixote*. It is a very good book; I read it still."[1]

What seems to be a dismissal of medical theory by the so-called English Hippocrates, celebrated for his emphasis on clinical observation and treatment, poignantly challenges the long-standing textual basis of physic. Not only does Sydenham avoid listing medical books, the one book he suggests

addresses the ill effects of at least certain kinds of reading. The reference equates dependence on the medical canon with Don Quixote's blind obsession with romances and thereby cautions against the application of outdated modes of writing to the present. At the same time, Sydenham's remark has a jarring effect, and the unexpected nature of the answer is itself strangely quixotic. The incongruity between the question and the answer echoes the Man of La Mancha's inability to distinguish a barber-surgeon's basin from a noble's helmet. Might, therefore, the advice be understood as an ironic call for more careful reading? Samuel Johnson argued that Sydenham was hardly denying the value of all medical texts, since he himself wrote such treatises.[2] That the physician replies with a humorous title may also be relevant. Given the range of early modern meanings for the word *humor,* Sydenham perhaps deliberately confuses genres to underscore his distrust of medical theory. The physiological meaning referring to the four principal fluids that determine temperament and regulate health was the older, well-established one, but it was at about this time that the word began to be used in reference to the comic or that which amuses.[3] That *Don Quixote* is itself full of generic ambiguities reinforces the possibility. In any case, the story was seen in the eighteenth century to encapsulate Sydenham's accomplishments, and it still regularly figures in medical histories.[4] Retrospectively, the anecdote also resonates within the context of debates between the Ancients and Moderns, since the central dilemma in Cervantes's story stems from Don Quixote's attempts to square his pursuit of history (however romanticized) with contemporary life. Sydenham's directive is ultimately clever not because it allows him to evade the question but because the very problem the question presupposes plays an essential role within the book he recommends.

The competing gravitational attractions of reading and experience are effectively pictured in John Vanderbank's design for a print, engraved by George Vertue, *Alonso Quijano in His Study* (fig. 40). We glimpse the future Don Quixote, caught in the grip of his own "memory and imagination," as he abandons himself to the obsession Cervantes describes as "the strangest notion any madman ever conceived . . . to turn himself into a knight errant traveling all over the world with his horse and weapons, seeking adventures and doing everything that, *according to his books,* earlier knights had done."[5] Vanderbank's image, included in the 1742 translation undertaken by the Irish portrait painter Charles Jervas, shows the protagonist torn between text and the material world. He fingers the pages of an open book with his right hand while his eyes remain fixed to the breastplate above the chimney piece. The strong diagonal line of his body divides the picture into the world of books and the world of things, a split reinforced by the open shutters

FIGURE 40 George Vertue, after John Vanderbank, *Alonso Quijano in His Study*, before 1730. Engraving; from Miguel de Cervantes, *The Life and Exploits of the Ingenious Gentleman Don Quixote De La Mancha*, trans. Charles Jervas (London, 1742). Courtesy The Newberry Library, Chicago.

on the room's left side and the closed shutters on the right. Don Quixote's madness results from the uneasy collision of these two worlds. The figure's crossed legs echo the crossed weapons on the wall, and his twisted torso underscores both the intensity and the difficulty of his relationship with texts and objects, his utter inability to negotiate the two.

Sydenham's directive raises once more the issue of quackery and textual authority, but the quandary also allows us to probe the points of overlap between the discourses of medical legitimacy and antiquarianism. *Don Quixote* supplies a lens for thinking about the vital role sensory perception played for each.[6] For even as empiricism was widely seen as the surest path to intellectual advancement, it also posed epistemological challenges for physic and antiquarianism. Having fought for centuries to distinguish themselves from result-based practitioners, orthodox doctors remained wary of the rhetoric of observation, and to describe a physician as "empirical" was, for most, to invoke the language of insult rather than praise. Similarly, antiquaries were satirized for their inability to connect discrete and often disparate objects

with larger arguments or meanings, their inability to move from the detail to the whole, from material evidence to abstract explanation. Eighteenth-century references to *Don Quixote* highlight these methodological difficulties, and the satire provides a means of engaging the fields of medicine and antiquarianism together. With each shouldering similar liabilities, the satirical challenges to quackery were analogous to those launched against antiquarian studies.

The Reception of Don Quixote *in England*

Perhaps as remarkable as Sydenham's recommendation is the extent to which other physicians shared his opinion of the book.[7] In 1698, at the age of twenty-three, Dr. James Douglas compiled a list of his library, which then numbered ninety-seven volumes. The catalogue includes typical medical works (Francis Glisson's treatise on rickets, William Harvey on circulation and generation), grammars and dictionaries (Greek, French, and Dutch), and a single work of fiction—in K. Bryn Thomas's words—just one "concession to the imagination": *Les quatres premiers tomes de Don Quixhot* (Amsterdam, 1695).[8]

But if Douglas's book buying most neatly bears out Sydenham's directive, the text was equally familiar to his colleagues. Writing in regard to Dr. George Cheyne, Alexander Pope, in a 1739 letter, noted his affection for the physician and paralleled it to Cheyne's own feelings for Cervantes's creation: "I love him as he loves Don Quixote."[9] The reference, of course, allows Pope to poke fun at the doctor—who is here implicitly likened to the object of his own affection—but the rhetoric makes sense only if Cheyne's admiration is real. Likewise, the multiple editions and translations of the text in other doctors' libraries echo this appreciation. Dr. Mead owned at least two copies, including a 1605 Spanish first edition of book 1.[10]

This interest in the text on the part of physicians was hardly unique and comes as no surprise, since *Don Quixote* pervaded much of Britain's cultural landscape. The first translation of the story, into any language, was made by Thomas Shelton in the early seventeenth century, less than a decade after it appeared in Spain; and by 1701, three other English translations had been published.[11] Thomas D'Urfey's *Comical History of Don Quixote* opened onstage in 1694/95 and could still be seen as late as the 1730s when it was succeeded by Henry Fielding's anglicized adaptation *Don Quixote in England.* Turning from the theater to the novel, Fielding followed up this piece in 1742 with *Joseph Andrews,* acknowledging his debt to Cervantes on the

novel's title page ("Written in Imitation of the Manner of Cervantes"); and talk of Cervantes's text would have been heard in London coffeehouses as references appeared in popular periodicals including the *Spectator*, the *Tatler*, and the *Rambler*.

As shown by Stuart Tave, *Don Quixote* helped facilitate the development of an "amiable humor" as the caustic satire of the Restoration came to be replaced by works that looked to delight rather than expose. Don Quixote himself was transformed from an object of ridicule and scorn into a good-hearted, even lovable, protagonist. Increasingly from the 1740s, audiences were persuaded to laugh *with* him rather than simply *at* him, and as morality was relocated from the realm of actions to the intentions of the heart, Don Quixote's intentions were difficult to fault. By 1750 Samuel Johnson could write that "when we pity him, we reflect on our own disappointments; and when we laugh, our hearts inform us that he is not more ridiculous than ourselves."[12]

More recently, Ronald Paulson has stressed the political dimensions of the English reception. Judging *Don Quixote* one of the books that most "profoundly shaped English writing of the eighteenth century," Paulson connects it to Joseph Addison's efforts to aestheticize satire, indeed laughter itself.[13] Cervantes's text provided a means of tempering the genre and alleviating its ill-natured aspects, a way of bringing satire in line with the prescriptions of polite society as defined by Whig ideology, though as Paulson notes, disinterestedness—in both aesthetic and satiric matters—was a "pose" if not "self-delusion": "what began as the castigation of satire ends as a more refined but more potent satire . . . [useful] for the purposes of politics."[14]

The appeal of *Don Quixote*, therefore, lay in the fluidity of the text itself. Replete with outrageous debacles resulting from the protagonist's inability to understand even the most obvious empirical data, it could, under various circumstances, be put to various uses and the satirical tone modulated accordingly. The early modern visual record evinces the same potential for variation. At one extreme are broadsheets that invoked Don Quixote for purposes of ridicule. While more common on the Continent, such imagery also appeared in Britain. In 1660, for instance, the Puritan Hugh Peter, on the day of his execution, was satirized with a windmill atop his head and the devil whispering in his ear; the caption identified him as "Don Pedro de Quixot, or in English the Right Reverend Hugh Peters."[15]

At the opposite extreme, we find the designs of Charles Antoine Coypel, who produced two sets of cartoons for the Gobelins tapestry factory, most of which were finished by 1727. Many of these images circulated as prints, both

FIGURE 41 Gerard Vandergucht, after Charles Antoine Coypel, *Don Quixote Takes the Puppets to Be Turks and Attacks Them to Rescue Two Flying Lovers,* ca. 1723–25. Engraving. © Copyright the Trustees of The British Museum. Used by permission from The British Museum, London.

as fine art engravings and as more modest book illustrations. In London, Gerard Vandergucht produced plates for both sorts of pictures, and thus, by the mid-1720s, Coypel's work was widely known within English art circles (fig. 41).[16] As Katie Scott has argued, the tapestries hanging in the *hôtels* of France's most powerful families eschewed the "monstrously insane" image of Don Quixote (which had often been applied to Louis XIV in broadsheets) in favor of "a picaresque antihero" whose actions produced both "spectacular catastrophe" and "public delight." Formally, the images internalized "the conflictual dialogue . . . between history painting and the grotesque" as well as the whole and the discrete part, offering an alternative to earlier baroque conventions.[17] Akin to the *fête galante* of Jean-Antoine Watteau, the scenes

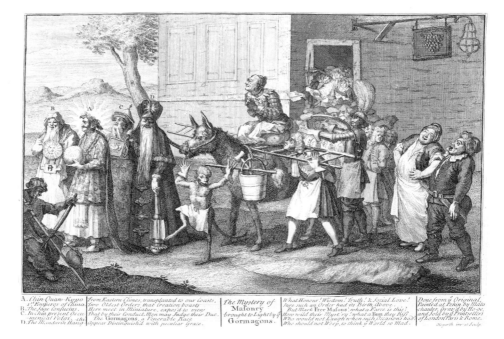

FIGURE 42 William Hogarth, *The Mystery of Masonry Brought to Light by the Gormagons*, 1724. Engraving. © Copyright the Trustees of The British Museum. Used by permission from The British Museum, London.

visualize a French aristocratic version of Tave's "amiable humor," preceding its British textual counterpart by a decade or so.[18]

William Hogarth, however, could use even these images of feminine gentility for coarser ends. As shown by Mark Hallett, his 1724 print *The Mystery of Masonry brought to Light by the Gormagons* (fig. 42) borrows from at least four of Coypel's illustrations.[19] Advertisements described it as a "curious print, engraved on a copper plate, by Ho-ge, taken from an original painting of Malanchantes, by order of the Mandarin Hang-chi, graved at Peking, and a number of them brought over from Rome, by a merchant in the ship Cambridge, and by him left to be disposed of at 12d each."[20] The image demonstrates Hogarth's knowledge of contemporary Continental prints and his ability to integrate their forms into his own work. But the sources also allow him to compound meaning through visual associations he realized would be familiar to many in his audience. The text below the image implicitly calls *Don Quixote* to mind:

> But Mark Free Masons! what a Farce is this!
> How wild their Myst'ry! what a Bum they Kiss

Who would not Laugh when such Occasion's had!
Who should not Weep to think y^e World so Mad.

By evoking the language of farce and madness in conjunction with charac-
ters directly drawn from Coypel's illustrations, Hogarth supports his own
satiric assault on Freemasonry with Cervantes's well-established attack on
archaic chivalry. Don Quixote himself is cast as simply one of several outra-
geous figures in the procession, but his presence reinforces the absurdity
of misguided erudition and fools' learning. The print depends on the same
sort of excavation and appropriation of previous cultural products as that
employed by the overly enthusiastic antiquary. In addition to commenting
on Freemasonry, the image thus fits within a discourse of antiquarian satire
that opens onto a much wider field of imagery. Before pursuing this theme,
however, we need first consider how physicians employed Don Quixote for
their own rhetorical ends.

Dr. Christopher Merrett, Sir Richard Blackmore, and the Physician's Study

Although Sydenham's reference to Cervantes's text has been the one most
frequently cited, another, less well-known, example from the same period
offers an instructive contrast. In *The Character of a Compleat Physician, or
Naturalist,* Christopher Merrett provides a more orthodox set of prescrip-
tions for the ideal doctor.[21] Such a physician should be "furnished with a
good library" full of books not only treating anatomy but also the entire
natural world of plants, chemistry, minerals, animals, insects, fish, and the
earth in general. "His morality is sober, grave, continent, pitiful to, and care-
ful of his patients." In contrast to physicians who prosper by flaunting their
own wealth and appearance with "a neat and well-furnished house, a coach
and horses, a velvet coat, a fine periwig, a curiously headed cane," Merrett's
man is

> Wise and prudent, mild and modest. . . . He laughs out-right at those who
> spend their precious time in hearing and hunting after news, and carry-
> ing it from house to house, and those who read lectures on chairs, beds,
> rooms, and hangings, or on *Don Quixot.* He thinks the usual aucupium of
> entertainments: telling of shows, misspent time, and judgeth not these any
> part of his profession. . . . And at all spare times you shall find him in his
> study.[22]

A member of Harvey's circle at Oxford, the curator of the Harverian Museum at the Royal College of Physicians, and a founding Fellow of the Royal Society, Merrett offers a vision of the perfectly sober, respectable physician. And to Merrett's thinking, *Don Quixote*—especially *Don Quixote*—was exactly the wrong kind of book for a diligent doctor. One can only imagine what he would have made of Vanderbank's image, which presents the study as the initial impetus behind Don Quixote's madness!

Merrett's mention of the title makes it tempting to interpret the 1680 inclusion as a response to Sydenham's reference, or vice versa, to understand Sydenham's remark as originating from his reading of Merrett's prescriptions. Sydenham's comment must have been made in the late 1670s or early '80s, but I know of no way to date it more precisely. This uncertainty is itself important, however. For it leads us some forty or fifty years forward, into the eighteenth century, when Sydenham's remark finally moved from the collective oral memory of British physicians to the relative stability of print. This historiographical dimension of Sydenham's remark frames it as an eighteenth-century issue that says as much about the early Georgian context as it does about Sydenham's Restoration practice.[23]

The most commonly cited source for the story comes from the poet and physician Sir Richard Blackmore, who recounts in the preface of his 1723 *Treatise upon Small-Pox* that he himself was the student who posed the question to Sydenham. He uses the anecdote as proof that "a man of good sense, vivacity, and spirit . . . [even] without the assistance of great erudition and the knowledge of books" will make a much better physician than the "student who deals in empty speculations and scholastic chimeras." Merrett's diligent reading in the library is here disparaged as "the idle labour of the closet" which produces "precarious and extravagant systems . . . castles of philosophy in the air." While admitting the challenges of physic, Blackmore goes on—again contra Merrett—to suggest that "the learning required for this profession, is not perhaps so various, extensive, and difficult as some imagine, or are willing that others should believe." Above all, one should have a general knowledge of anatomy, chemistry, and botany (avoiding "the minute recesses of nature") and the ability to experiment and grasp cause and effect connections. Blackmore rejects Hippocrates (a regular authority in contemporary smallpox debates) and concludes the preface with the claim that he has "advanced no notions" except those based on "long observations and experience."[24]

Here Blackmore raises the familiar specter of empiric medicine, the thorny legacy of the Restoration. Virtuosi physicians looked to the new phi-

losophy of the Royal Society but struggled to distance themselves from their result-oriented counterparts who relied on experienced observation rather than theoretical explanations. How could one depend on the immediate evidence of the senses and not become an empiric?

Merrett was well aware of the problem and applied the "ignominous title" to those who have "the fewest . . . requisites of a compleat physician."[25] An empiric was everything a doctor was not, and Merrett was determined to show the formidability of the physician's knowledge. But Merrett was himself an advocate of the new science (his *Art of Glass* advanced the History of Trades program), and he even argued the ideal doctor "takes nothing upon trust, but consults his own senses."[26] The motivation for his eagerness to distance the physician from the empiric here reveals itself; as the line between the two became increasingly difficult to discern, especially in terms of practice, Merrett's protecting it became all the more important. Although he railed against physicians' adopting ostentatious appearances to establish their authority, the persona he prescribes is equally conscious of appearances. In a competitive health-care market, the physician should present himself with a gravity consistent with his vast learning.

Ultimately, Blackmore worked to maintain boundaries, too. For all of his commonsense pragmatism, he recoiled at the taint of anti-intellectualism. As much as he relished the Don Quixote recommendation, he finally judged that Sydenham "carried the matter too far, by vilifying learning."[27] Rhetorically, the story marks the edge: proof of the validity of Blackmore's reliance on observation and reassurance that he had not gone too far.

Don Quixote *and Medical Satire: The Mead-Woodward Quarrel*

Establishing the legitimate role of the visual was therefore an issue that impacted all of early modern medicine, and physicians proved no less astute at managing appearances than their empiric counterparts. Merrett had understood the threat of an "empirical" set of aesthetics and tried to counter it with a respectably orthodox one.[28] By the eighteenth century, however, this persona had become less compelling, even as an ideal. Roy Porter notes that Georgian physicians publicly flaunted "themselves as men behaving badly," and even "leading doctors positively reveled in washing their dirty professional linen in public."[29] Among the examples Porter cites is the pamphlet war between Drs. Richard Mead and John Woodward. Since the publication of Joseph Levine's 1977 book *Dr. Woodward's Shield,* the quarrel has

been reasonably familiar to students of the eighteenth century, yet the references to *Don Quixote* made throughout the debate have consistently been overlooked.[30]

Predating Blackmore's treatise on the subject by several years, the dispute began over conflicting opinions regarding the treatment of smallpox. Dr. John Freind argued, in his *Hippocrates de morbis popularibus liber primus et tertius* of 1717, for the use of purging in certain instances upon the return of a fever. He supported his claim with ancient and contemporary cases and a letter from Mead. The following year Woodward published his *State of Physick*, in which he identified the stomach as the seat of health (crucial for holding in check the "biliose salts" there produced) and rejected Freind's opinions on purging. The battle lines were quickly drawn.

An antiquary and avid collector, particularly of fossils, Woodward had, a decade earlier, attracted criticism for his attempts to explain the relationship between the biblical flood and geologic fact. He had been embroiled in disputes with Dr. Hans Sloane, then the secretary of the Royal Society, over the latter's management of the group's journal, the *Philosophical Transactions*, and as recently as 1717 he had been satirized on the London stage in *Three Hours after Marriage* thanks to the Scriblerians: Alexander Pope, John Gay, and Dr. John Arbuthnot. On the whole, Woodward was regarded as an abrasive character—at best eccentrically learned and at worst ridiculously foolish.

Freind responded to *The State of Physick* with *A Letter to the Learned Dr. Woodward*, which he signed "Dr. Byfield."[31] The pamphlet ridicules Woodward's writing and, by extension, his reasoning in general. Woodward's camp replied with *A Letter to the Fatal Triumvirate: In Answer to that Pretended to be Written by Dr. Byfield*, which defends Woodward's content (if not his style), points to Freind, Mead, and Dr. Salusbury Cade as the trio behind the attack, and likens Mead's publishing to that of Cervantes, referring to the doctor as "Don Pedantio Amichi" and his writing

> the strange and wonderful adventures of a second Don Quixote; wherein he has outdone the very soul and spirit of all Romantic lying and feigning; nay, so much outdone even himself, that, though another volume of adventures was begun, and several sheets actually printed off, it was suppressed because it did not come up to the perfection of falsity which shone in the former.

The text proceeds to deride Mead's artistic interests, satirizing his penchant for buying "gawdy prints and drawings."[32]

This was just the beginning. Punning the privileged position Woodward

grants the stomach, one "Andrew Tripe" submitted a *Letter . . . to . . . the Profound Greshamite, Shewing that the Scribendi Cacoethes is a Distemper arising from a Redundancy of Biliose Salts*. Fueling an already belligerent quarrel, "Tripe," in a tone of mock helpfulness, notes that Woodward's hypothesis regarding bile's ill effects would account for those who "write much without thinking," those whom the Prussians call "ink shiters."[33]

Woodward's camp hit back with *The Two Sosias; or, The True Dr. Byfield at the Rainbow Coffee-House, to the Pretender in Jermyn Street*.[34] The idea comes from John Dryden's *Amphitryon; or, The Two Sosias*, an ancient Roman comedy revived in France by Molière, in which Mercuy, at the wish of Jupiter, assumes the form of Sosia, slave of the Theban general Amphitryon, so as to facilitate Jupiter's conjugal dalliance with the general's wife.[35] Turning the "Byfield" pseudonym against Freind, the pamphlet writer decries him as a "pretender," the kind of sham one would see in the theater. He goes on to fault Freind for busying himself with the "writing of feats of Chivalry, and setting forth what all judged nothing better than a foil to Miguel de Cervantes."[36] Finally, he suggests Freind's Spanish is as bad as his Greek.

Although Woodward's side introduced the theater into the quarrel, his enemies used it more effectively, employing the stock characters of the commedia dell'arte tradition, familiar roles for mountebanks eager to drum up business.[37] In *A Serious Conference between Scaramouch and Harlequin, Concerning Three and One*, Scaramouch recites passages from the *Letter to the Fatal Triumvirate* while Harlequin provides the cross examination. The latter is particularly eager to counter the Don Quixote reference:

Harl. Don Pedantio Amichi! Who the Devil's he? Surely thou hast the worst knack in the world at adapting of names to persons thou wouldst abuse: Amichi, what language is this?

Scar. I suppose then that you don't understand Italian?

Harl. Italian! Why, I thought you was speaking Spanish, with your Don's: But, pray how do you spell Amichi?

Scar. So: I have a fine task imposed upon me; why thus, A-M-I-C-H-I.

Harl. Very well, faith, Scarré, but I'm an oyster if I ever heard of such a word in my life: by Don Pedantio, I presume you understand somebody skillful in Greek and Latin, your abomination: but whoever he is, I may fairly conclude from what you said, that he has wrote a book, and that so

well, that malice itself could not hinder your comparing of it to *Don Quixote,* the best of its Nature that ever was penned.[38]

Simple derision here evolves into something more complex as a range of contested issues are layered into the Don Quixote analogy. From Mead's point of view, Woodward is continually mixing materials inappropriately; confusing a joke about Don Quixote with an Italian reference is merely symptomatic of his inability to make a coherent argument. That Woodward's Italian is barely adequate to make the joke in the first place only worsens the matter. In fairness to Woodward, he may be introducing Italian (and purposely mangling it) to denigrate the medical training of Mead and Freind, both of whom took their degrees at Padua.[39] Or he may be satirizing Mead's larger cultural aspirations heavily guided by Italian precedents; in other words, *this is what we should expect from a friend of Italian pedants.* Harlequin's defense of Mead's artistic interests would support such a reading:

Scar. Or that he don't know how to buy gawdy prints or drawings . . .

Harl. Now thou art got into thy wild note again; why shouldst thou take so much pains to expose thy ignorance in pictures? We were very well satisfied before . . . of thy taste; and that a Dutch piece of a Mountebank, with all his grimaces, and apish gestures, would give thee more pleasure than the best Antique Bust of an Hippocrates, or a Galen; or a Kneller's portrait of a Radcliffe, a Mead, or a Freind.[40]

Woodward's medical shortcomings are tied to his alleged aesthetic preferences as taste is presented as a marker of one's medical abilities. For the satirist, a comic picture of a mountebank serves as a mirror, and the pleasure Woodward derives from the "reflection" only confirms his juvenile fascination with surface appearances, his preference of caricature over character. In contrast to Mead, he fails to appreciate the nobility of antique forms or the dignity of a formal portrait. While Mead is associated with the best artistic and medical traditions of both antiquity and the present, Woodward's deficient taste is used as proof of his failings as a physician.

With *An Account of a Strange and Wonderful Dream Dedicated to Dr. M——d,* the Woodward camp retaliated once more, casting Mead as "the sublime Muslo, Historiographer to the Republic of Vipers, Spiders Scolopendras, Scorpions, Bees, Wasps, Tarantulas, Mad Dogs, &c.," thus alluding to Mead's poison studies as well as his "venomous" role in the quarrel. Represented as the "Hermetical Knight of the Crucible" Don Amigo (note the spelling alter-

ation), Freind plays the faithful companion, and together the two conspire to ruin the character of the man who challenges their "method of cure." In a series of letters, they hatch their scheme to expose "the Professor, under the ignominious title of the most contemptible Quack in town."[41] Mead is described as a cuckold reduced by his excessive spending to quackery and restored only by the patronage of another, respected physician (Mead did, in fact, benefit greatly from John Radcliffe's support and acquired many of his patients at Radcliffe's death). While the text contains no explicit references to Don Quixote, the dream appropriates the general setting of an absurd Spain characterized by arrogance and misperception.

Determining which side had the last word may be impossible, and the fact that Woodward and Mead eventually resorted to swordplay presented both men in a questionable light before much of the British public. Nonetheless, the Don Quixote barbs reached an appropriate culmination with *The Life and Adventures of Don Bilioso de L'Estomac.*[42] Metaphors and similes are swept aside as the author propels the rhetoric to a different level altogether: with a perfectly straight face, he attributes *The State of Physick* to Cervantes! Like a good antiquary, he bases his argument on the evidence of a rare manuscript, a French translation of the original Spanish. He chastises Woodward not for conceiving ridiculous medical notions but for plagiarizing the work of another and passing the romance off as a treatise on physic. Perplexed, he asks why one would do such a thing "unless he designed to banish this Science out of England, as Cervantes did Knight Errantry out of Spain?" He can imagine only that Woodward fell under the influence of the biliose salts and "neglected all other books but romances," and bemoans "how these hellish salts impose on the organs of sense, produce lusory visions, and represent actions, persons, and things, that nowhere exist but in the delusive operations and impositions."[43]

The Life and Adventures of Don Bilioso twice refers to Sydenham's advice to read *Don Quixote,* and this, four years prior to Blackmore's recounting the story as an autobiographical detail. That the satirist takes for granted his readers' knowledge of the anecdote suggests it was already in circulation by this point. Still, it appears in print only circa 1720 in the context of smallpox. The timing is consistent with the general reception of Cervantes's text in England, though the manner in which these physicians used the text countered the larger cultural tendency, which concerned the *softening* of raillery. The disconnect returns us to Porter's argument about the prevalence of doctors' "transgressive behavior." In response to why so many physicians rejected established codes of conduct and professional honor, Porter points to a rapidly deteriorating institutional base and a changing economic

environment in which "physicians had to sink or swim as individuals." Collectively, the medical establishment faced serious threats, and though the potential for wealth and esteem was higher than ever, these prizes would go to particular doctors who most effectively navigated various social systems — or alternatively, defied established systems and invented new ones.[44]

Don Quixote provided a rhetorical framework that proved remarkably flexible, accommodating a variety of insinuations and strategies for discrediting one's rival. Comparing a text to that of Cervantes and thereby dismissing it as "romantic lying" was the most obvious option, but the reference also allowed the satirist to make more nuanced quips about one's language skills, reading preferences, or collecting interests. With the perennial theme of quackery running throughout the tracts, the Don Quixote analogy finally provided a vehicle for criticizing an opponent's senses. What began as a medical dispute over theoretical commitments came down to appearances in the end.

To Quack in Antiquities

Just as there existed well-established conventions for denouncing medical quacks, satirists had been lampooning British antiquaries for decades. As early as 1628, John Earle singled out the antiquary as an identifiable character type as ripe for ridicule as a divine, a surgeon, or an attorney.[45] Throughout the early modern period, the antiquary was conflated with the objects of his study and thereby provided the punch line for myriad jokes about rust and dust, death and decay.

Despite its initial ambivalence toward antiquities, the Royal Society became an institutional focal point for much of Britain's antiquarian activity. With doctors making up a large portion of the society's membership, natural philosophy, natural history, and the material traces of human history were integrated into a single (if at times multiheaded) intellectual beast. An ancient burial site, for instance, could be of interest for medical, anatomic, geologic, social historical, or theological reasons. Consequently, the *Urne-Buriall* of Sir Thomas Browne, a physician and Fellow of the Royal Society, may be unique for its quality of writing but not for its subject matter.[46] This panoramic scope of the virtuosi's intellectual agenda only fuelled the satirists' fires, however. Whether at the theater or in print, Londoners were dished up a regular diet of these characters, typically physicians surrounded by fossils, mummies, coins, and other souvenirs of the past. These satires relied on the dissonance between empirical intentions and speculative out-

comes based on rational or a priori reasoning. The direct observation of material evidence seemed inevitably to result in an epistemological cacophony that rendered even the most straightforward intellectual pursuits absurdly comical.

The same confusion pervades *Don Quixote*. Stranded between the textual world of romance and the actual world he inhabits, the knight of La Mancha is forever misunderstanding. His foibles exemplify the blind application of texts to life. When confronted with a crowd of silk merchants, he immediately envisions a new adventure, "one that seemed ready-made for imitating as closely as he possibly could the adventures he'd read about." Without flinching or questioning, Don Quixote accepts his books of romance as scripts for life. The value of empirical evidence is further discounted when, in the same encounter, he demands that the merchants acknowledge Dulcinea to be the world's most beautiful damsel. As they protest that they have never seen Dulcinea, Don Quixote declares, "What's important is that you believe without seeing."[47]

On the one hand, *Don Quixote* indicts rationalist approaches to knowledge that begin with texts. Taken to extremes, they lead to delusions of epic proportion, transforming whores into noble virgins and windmills into giants. At the same time, however, there is something deeply disconcerting in the book regarding the implications of vision for the construction of knowledge. Again and again, Cervantes demonstrates the plethora of opportunities for misunderstanding the material world. And although these are attributed only to a madman, they open the door for at least the possibility of skepticism more generally.

The manner in which Cervantes ridicules such interpretive shortcomings links the work to subsequent texts that satirize the virtuoso; indeed *Don Quixote* can be seen as their progenitor. Still, the structure of the book is predicated upon antiquarian conventions. The narrator, for example, presents himself as not only an author but also an editor reliant on others' texts, particularly that of the Arab historian Sidi Hamid Benengeli, whose work he claims to have found in the Toledo marketplace by happenstance. The notion of historical recovery runs throughout the text, and as Bruce Wardropper has noted, the book's framework depends on a related paradox: it is "a story masquerading as history."[48] Moreover, in the prologue, the narrator bemoans his lack of erudite commentary and the paucity of his classical references. These tongue-in-check apologies reinforce a central theme of the book—the constrictive character of texts in general—but we deceive ourselves if we imagine that Cervantes's early modern readers dismissed the likes of Aristotle, Plato, or even Zeuxis alongside the romances of knight-

errantry. If the joke is made at the expense of antiquarian pedantry, one imagines that the scholars most familiar with such commentaries laughed loudest.[49]

As was often the case in subsequent satires, the antiquarian concerns are bundled with the epistemological ones, and the combination points us back to the early modern British context. For despite its wide acceptance, empiricism presented certain intellectual problems as well. As already noted, it challenged the foundations of traditional physic as many doctors found themselves wanting both to accommodate the new science of the Royal Society and to reject the empiric's result-driven medicine. Antiquarianism was susceptible to related objections. On the one hand, it boasted tangible evidence from the past, thereby grounding its research not on ideas but on the physicality of artifacts. Bones, fossils, pottery, coins, inscriptions, statues, and even manuscripts all offered tactile proof that was difficult to dispute. Nonetheless, these objects always demanded interpretation, and on this point the critics were quick to pounce.[50] The antiquary was routinely presented as one trapped by this physicality. Lost in the details of an artifact, he appears unable to integrate it into a larger narrative that might actually be judged meaningful (history proper); or alternatively, he does so only through logical somersaults that force whatever evidentiary weight the object might possess to conform with the strictures of a larger hypothesis.

The complaints made against medical empirics here surface in regard to the antiquary. As Porter notes, even in the eighteenth century quackery was not limited strictly to medicine; Tobias Smollett (himself a physician), for instance, noted the abundance of quacks in religion, law, politics, patriotism, and government. Similarly, one could be accused of quacking in antiquities.

In 1738 Francis Wise published his *Letter to Dr. Mead concerning Some Antiquities in Berkshire: Particularly shewing that the White Horse . . . is a Monument of the West-Saxons, made in memory of a great Victory obtained over the Danes A.D. 871*. Wise offers a defense of antiquarianism, arguing for its consistency with "polite times." He submits dutiful praise to Mead, "the greatest master . . . [and] greatest patron of ancient learning, the present age can boast of."[51] And then matching a surplus of speculation with pronounced self-assurance, he launches into the argument, convinced he has pinpointed the location of Ashdown, the site of the battle that resulted in King Alfred's ascendancy to the throne. Wise attempts to coordinate the textual record with various forms of material and visual evidence, including the natural landscape, the White Horse of Uffington itself (a giant Bronze-

Age figure cut in the chalky hillside), and the iconography of Anglo-Saxon battle standards.[52]

Writing under the pseudonym "Philalethes Rusticus," William Asplin responded to Wise's text with *The Impertinence and Imposture of Modern Antiquaries Displayed; or, A Refutation of the Rev. Wise's Letter to Dr. Mead*. The tract takes issue with nearly all of Wise's claims and ridicules Mead for having his name attached to it.[53] Asplin suggests that Wise's *Letter* may call into question the credibility of Mead's own "noble collection of curiosities" and tarnish his reputation in the Republic of Letters. For when foreigners

> behold the learned Doctor himself a Dupe to such an assuming Empirick, such an arrant Quack in Antiquities will they not naturally infer—*If such an one can hit his blind side, tis not the first time he has been imposed upon* or that at least . . . *he is now grown over-credulous, and gives an implicit faith to every sham Pretender to Discoveries.*[54]

The adjective *arrant* calls to mind Cervantes's knight of La Mancha, and "Rusticus" later quotes directly from the story.

Before giving the French or Italians an opportunity to question the integrity of Mead's collection, "Rusticus" proceeds to do so himself. He goes straight for the jugular, targeting the prized bronze head from the Arundel collection, long believed to be a depiction of Homer (plate 6). Pursuing an analogy between religious relics and antiquities, "Rusticus" judges there can be no "doubt but a certain society has as much regard for a superstitious Head of Homer, now in possession of their patron, as any convent abroad has for that of John the Baptist."[55]

George North came to Wise's aid with his anonymously published *Answer to a Scandalous Libel*, though he spends more energy defending Mead and excusing the doctor's involvement than validating Wise's argument. North asserts the authenticity of the bronze bust and touts its provenance. In countering the accusations of quackery, he contrasts Wise's performance with the infamous Mary Toft case, arguing that an antiquary's error can hardly be equated with the dangers of willful deception in medicine.[56]

Or perhaps it can. For both medical expertise and erudition more generally were tied up together in the 1719 debate between Mead and Woodward. The dismissal of Woodward's fossils was a way of impugning his physic. Likewise, portraying Mead as fixated on "gawdy prints or drawings" cast doubt on his judgment in treating a patient's illness. One kind of quackery implied the other, and the Don Quixote references proved particularly well suited for asserting both.

The 1742 Edition of Don Quixote

Soon after Coypel's *Don Quixote* illustrations became available in London, John Carteret began planning a critical edition of the text in the original Spanish. Instead of using the French images, however, he commissioned new works from John Vanderbank. By 1730 all sixty-eight images were finished, and the book finally appeared in 1738.[57] It includes an explanation of the illustrations by Dr. John Oldfield, who along with Lord Carteret played a major role in directing Vanderbank's work. The "Advertencias de Don Juan Oldfield Doctor en Medicina, sobre les Estampes desta Historia" describes in detail the project's illustrative goals and contrasts Vanderbank's designs with those of Coypel. Oldfield argues that rather than "mere embellishments," illustrations are "capable of answering a higher purpose, by representing and illustrating many things, which cannot be so perfectly expressed by words."[58] This assertion of the unique properties of images is the predominant theme of the essay, which H. A. Hammelmann considers the "first serious discussion" of book illustration in English.[59] Moreover, because of Oldfield's attention to the relationship between words and pictures, the "Advertisement" is important not only for the topic of illustration but for art theory more generally.

Oldfield's essay (in its original English) also appeared alongside Vanderbank's illustrations in Charles Jervas's 1742 translation.[60] With an additional preface by the antiquary William Warburton, who explicates the history of chivalry, this edition of *Don Quixote* unites art, medicine, and antiquarianism within a single publishing venture and allows us to consider more closely the importance of empiricism for all three fields.

Jervas studied under Godfrey Kneller in the mid-1690s. With funding from George Clark of All Souls, Oxford, he spent ten years in Italy, returning to London in 1709. Ellis Waterhouse considered him "a dull painter," and even in the eighteenth century George Vertue compared his portraits to mannered fan painting.[61] Regardless, Jervas was successful and certainly had his supporters. Alexander Pope (fig. 4) took painting lessons from him for more than a year and in 1716 wrote that he longed to see Jervas develop into a history painter (that same year, Jervas published a revised edition of Dryden's translation of *De arte graphica*).[62] In 1723, he succeeded Kneller as Principal Painter to King George I, continuing in this capacity under George II, and late in his career he enjoyed the patronage of Sir Robert Walpole.

Above all, in translating *Don Quixote*, Jervas aimed for accuracy. Countering earlier tendencies to make the text as familiar as possible to an English readership, Jervas rendered his Cervantes dry. In his preface, he writes

that many of the book's original readers accepted the narrative "as a true history," and that even in the eighteenth century it remained a common enough belief among the Spanish that a Spaniard in London, when asked about Don Quixote, felt compelled to explain "that there never was such a person." This seriousness (itself bordering on the ridiculous) was what was most lacking in previous English translations. Jacob Tonson, who purchased the copyright for the translation from Jervas's widow upon the painter's death, presumably thought of the text as an acceptable English equivalent of Carteret's critical edition, which he had published four years earlier.

A similar emphasis on verisimilitude characterizes Vanderbank's illustrations, as Dr. Oldfield explains in his commentary. Paulson has stressed the consistency that the illustrative program bears with the neoclassical aesthetics of Richard Boyle, third Earl of Burlington, heavily shaped by Anthony Ashley Cooper, third Earl of Shaftesbury, and neo-Palladianism.[63] Following Continental theory, Oldfield attempts to link the genre of illustration to a larger moral program associated with history painting, emphasizing, for instance, the role of the visual in moving the internal passions of the reader. He specifically rejects Coypel's pictures on the grounds that they are set too "immediately before the eye, [and] become too shocking for the belief," and argues instead that the artist should pay more attention to "the proper attitudes and gestures" of the characters, providing the particular details that are less easily conveyed through verbal descriptions.[64] In addition to this interest in decorum, Oldfield's description of the allegorical frontispiece (fig. 43) calls to mind Shaftesbury's program for the *Judgement of Hercules*. The doctor casts Cervantes as Hercules, who, in accepting the task of driving out "the monsters that had usurped [Parnassus] the seat of the Muses," restores the mount to its rightful, classical inhabitants. Don Quixote, shown in the distance, appears hardly more admirable than the beasts he confronts. It is Cervantes-as-Hercules, armed with harp, club, and the mask of "raillery and satire" (the picture's only reference to humor), who plays the part of the hero.[65]

But if the "Advertisement" espouses an idealizing aesthetic in some ways consistent with that of Shaftesbury or Burlington, it also charts different waters with its emphasis on images as a source of empirical data. In discussing the reception of the images, Oldfield refers not to the reader's mind or thoughts but again and again to his *eye*, which he describes as "the immediate judge." In particular, Oldfield maintains that the illustrations should deal not with the fantastic parts of the story, which are, he argues, effective verbally but weakened when pictured; instead, the illustrations should focus our attention on the gestures, expressions, and nuances of relationships within the story. In faulting Coypel's work, he specifically cites the scenes

FIGURE 43 Gerard Vander-
gucht, after John Vanderbank,
engraving. Frontispiece from
Cervantes, *Don Quixote,* trans.
Jervas (London, 1742). Cour-
tesy The Newberry Library,
Chicago.

with the windmills and the flocks of sheep as examples that gain nothing
from being illustrated. Depictions of these events fail to explain Don Quix-
ote. "Nor is the ludicrous nature of his exploits, or the design of the author
to expose the like absurdities in the writers of romance by them, an ex-
cuse for infringing, and in a manner destroying all the credibility and veri-
similitude of them." While Oldfield is adamant that texts can do things that
pictures cannot, he also grants pictures certain unique functions and at no
point denigrates them in relation to texts. On the contrary, illustrations al-
leviate "tedious and ineffectual" writing or the "imperfection of the reader's
imagination."[66]

Vanderbank's designs bear out this emphasis on pictorial verisimilitude.
Don Quixote is shown interacting with people, contemplating action that
has just occurred, or preparing for action. Instead of animating events,
the images work to describe visually the dynamics between characters

and settings, and rarely do they aspire to the momentous character of history painting. *Don Quixote, Sancho, Maritornes, and the Innkeeper's Daughter* (fig. 44), for instance, with its emphasis on dialogue and emotional interaction, is typical. Having been thrashed by muleteers, Don Quixote and Sancho have sought shelter in the attic of an inn. The innkeeper, her daughter, and the servant Maritornes (shown with the torch) express concern over the knight's wounds while Don Quixote responds with archaic speeches of gratitude that are completely lost on the women. Sancho meanwhile notes his own wounds, which in the text he attributes simply to *observing* his master's misfortune. Vanderbank incorporates these varied responses into a coherent image structured around the model of conversation. Similarly, with *The Adventure of Mambrino's Helmet* (fig. 45), Vanderbank depicts the barber as an incidental figure fleeing in the distance. His bewilderment expressed as shock at Don Quixote's madness is contrasted with that of Sancho, who, placed in the foreground, stares in still, quiet disbelief at the barber's basin

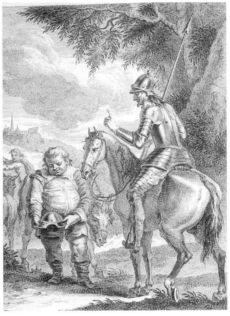

FIGURE 44 Gerard Vandergucht, after John Vanderbank, *Don Quixote, Sancho, Maritornes, and the Innkeeper's Daughter*, before 1730. Engraving; from Cervantes, *Don Quixote*, trans. Jervas (London, 1742). Courtesy The Newberry Library, Chicago.

FIGURE 45 Gerard Vandergucht, after John Vanderbank, *The Adventure of Mambrino's Helmet*, before 1730. Engraving; from Cervantes, *Don Quixote*, trans. Jervas (London, 1742). Courtesy The Newberry Library, Chicago.

while his master assures him it, in fact, is hardly as it appears. Throughout all of the illustrations, the concentration remains on comparable details of gesture, expression, or topography. Oldfield and Vanderbank never attempt to show us the world as Don Quixote envisions it; instead, they aim to demonstrate just how unenchanted the world he inhabits really is.

From a medical standpoint, Oldfield's emphasis on the eye is significant. Vision is presented not as an invisible activity of the mind but rather in tangible physiological terms. The "passions and affections" had yet to be partitioned to the realm of neurology, and were still largely understood to pulse throughout the body in the material form of nerves and blood. The semiotics Oldfield prescribes for viewing the illustrations parallel those that he would have used as a physician to diagnose patients. Exterior signs—facial expressions, gestures, and glances—point to interior realities, the conditions that cannot be represented directly, the same kinds of signs Don Quixote is perpetually misunderstanding.

Perhaps the strangest component of the Jervas edition is the antiquarian essay on the history of chivalry. Not content to provide an overview of romances, Warburton delves into the earliest "records of the northern nations" when "controversies and disputes" were settled by the sword. He traces the combat theme through all of European history, crediting the Italians with moderating the barbarity—though in doing so, they laid the foundations that eventually served to support the complex system of chivalry. The broad scope of the argument is peppered with dozens of specific rulers, writers, and even examples of "authentic" challenges and responses. Romulus and his rival Scato, the Roman commander Varus, the Danish historian Krantz, King Aldanus of Sweden, and the Italian historian Fausto are all marshaled into the argument, which by the end bears a striking resemblance to Don Quixote's own speeches.

The essay offers another glimpse of the subjective character of the legitimacy of antiquarian topics. The boundary between erudition and aimless wandering through the past rests on anything but objective foundations. Even as Warburton recognizes Cervantes's intention to banish through ridicule the trappings of chivalry, "that giant of false honour, and all the monsters of false wit,"[67] it never occurs to him that his own uses of history might be comparable, and he remains oblivious to the text's methodological implications for engaging the past.

When considered alongside Warburton's essay, the frontispiece assumes new significance. Not only does it contrast a fantastic and monstrous aesthetic with a classical one; it also frames the story of *Don Quixote* in Renaissance terms. The temporal issue is not the struggle between the past and

modernity as one aims to live in the present, but the pursuit of a previous unblemished historical moment. Recovery is the central task at hand, and recovery is the antiquary's specialty.

Writing in the 1930s, Jorge Luis Borges emphasized the extent to which *Don Quixote* depends on "subterranean" complexities.[68] Failing to acknowledge—much less accommodate—this hermeneutical labyrinth, the Jervas edition ultimately falters. On the one hand, it embraces an empirical stance via Vanderbank's illustrations and Dr. Oldfield's commentary. Yet at the same time, a residual classicism bloated with an unwieldy antiquarian apparatus and ideals of literalism leaves Cervantes and his characters lifeless. The reader wonders if Jervas and Warburton understood the book's humor at all. What makes the edition interesting, however, is the uneasy relationship between these conflicting aesthetic and scholarly impulses. Oldfield's emphasis on individual discernment, verisimilitude, and the epistemological potential of images fed the antiquarian instincts that facilitated Warburton's essay. The eclectic outcome merely conforms to the larger inconsistencies found in Georgian virtuosic culture.

Hogarth's Analysis of Beauty *and Sancho's Surprise*

One might regard the examples from this chapter as mere footnotes to the story of the English reception of *Don Quixote*. Nonetheless, my contention is considerably more ambitious. Within a society that embraced, emulated, and appropriated Cervantes's story, the text provided a vocabulary for addressing basic dilemmas growing out of the empirical reorientation of English learned culture. Just as a seemingly curious bit of medical folklore involving Sydenham's reading advice turns out to connect Restoration insecurities over the role of experience with Georgian debates over smallpox, and just as a pamphlet debate over the location of a medieval battle could end up calling into question the legitimacy of classical statuary (and by association the collecting legacy of the early Stuart era), the artistic significance of Don Quixote imagery in Georgian England extends beyond the immediate context of Vanderbank's prints and the publication of two books in 1738 and 1742.

William Hogarth also participated in the project. Only one of his images was included in the finished series, but about 1726 he produced seven compositions, and Paulson suggests that the eager printmaker, then approaching thirty, was attempting to expand his role from engraver to designer, to join *sculpsit* with *invenit.*[69] We have already seen how Hogarth sampled passages from Coypel's *Don Quixote* series in 1724 (figs. 41–42), and thus, as with his

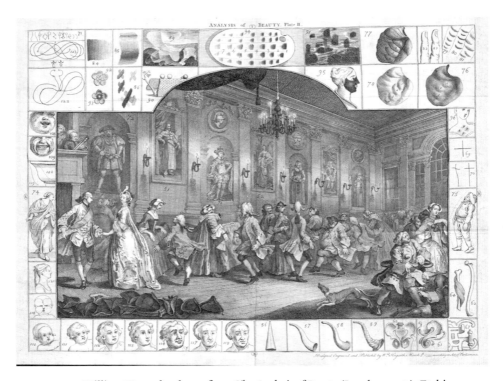

FIGURE 46 William Hogarth, plate 2 from *The Analysis of Beauty* (London, 1753). Etching and engraving. Used by permission from University of Chicago Library, Special Collections Research Center.

novelist peers, the aspirations of his early career were shaped by and re-sponded to the Don Quixote mania that swept England. Three decades later the same figure of Sancho would appear in the margins of the second plate of *The Analysis of Beauty* (fig. 46, #75).

In his chapter entitled "Attitude," Hogarth contrasts this depiction of Sancho with the marginal figure at the left edge of the plate, "the Samaritan woman [fig. 46, #74], taken from one of the best pictures Annibale Car-racci ever painted."[70] Sancho's simple curvature of surprise serves as a foil to underscore the more graceful serpentine lines of the woman's pose and drapery. But Hogarth complicates matters as he interjects issues of content into formal analysis. The central image in plate 2 depicts a dance dominated not by the elegant decorum of Carracci's art but by the everyday awkward-ness of common men and women. Hogarth proves that even these forms can be used to achieve artistically satisfying arrangements, but they also signal his true allegiances. While he looks to the classical tradition for support, he ultimately insists not on idealized forms but on the beauty of everyday mod-

ern life ("Who but a bigot, even to the antiques, will say that he has not seen faces and necks, hands and arms in living women, that even the Grecian Venus doth but coarsely imitate?").[71] Paulson judges that Sancho's surprise is here meant to undermine the civic humanist aesthetics of Shaftesbury, which would associate moral virtue with ideal beauty. The point of the story of the Samaritan woman is that Christ immediately recognized her moral failings and accepted her despite them. She is thus an unlikely candidate to advocate for any essential coupling of physical beauty and abstract notions of the Good. Such an a priori pairing is, for Hogarth, the true measure of quixotism.[72]

The source of Sancho's surprise in Coypel's original image was Don Quixote's inability to distinguish art and life. Working out a productive relationship between the two spheres may be the single theme that best encapsulates all of Hogarth's work. It certainly governs the logic of the two plates included in *The Analysis of Beauty*. Given that plate 1 (fig. 47) show-

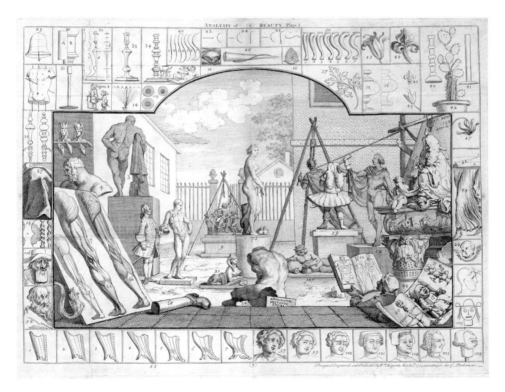

FIGURE 47 William Hogarth, plate 1 from *The Analysis of Beauty* (London, 1753). Etching and engraving. Used by permission from University of Chicago Library, Special Collections Research Center.

cases canonical works of classical sculpture, one might understand it over and against the scene of modern merriment of plate II, a contrast between the timeless sphere of art and the fashionable world of contemporary society at play. But the contrast also works within the logic of each image. For the dancers frolic in front of familiar portraits of Tudor and Stuart rulers, and the setting for plate I is no museum, real or imagined. It is, instead, an evocation of the statuary yard at Hyde Park Corner, which, under the direction of Hogarth's friend Henry Cheere, provided lead copies of these familiar works. The Farnese Hercules, the Belvedere Torso, the Venus de Medici, and the Apollo Belvedere appear simultaneously as Greco-Roman masterpieces and Georgian commodities. The intersection of past and present, art and life, is highlighted by the "dancing master" juxtaposed against the Antinous. Hogarth's point is that the stiff symmetrical posture of the former pales in comparison to the sweeping contrapposto of the latter, though a more irreverent reading might see the contemporary fop as making a pass at Emperor Hadrian's nude lover.[73]

Debates over whether England should found a state-sponsored academy for the training of artists provided the immediate occasion for the book's publication. Despite the lack of a centralized institution on the French model, there had by the mid-eighteenth century been several successful artists' associations in London. In the 1670s and '80s, Peter Lely apparently headed up a group that offered life drawing instruction. The Virtuosi of St. Luke brought together artists and connoisseurs for regular meetings starting in 1689 and continuing into the 1740s, while the Rose and Crown Club provided a similar social function particularly for artists from about 1704 until 1745. The Academy in Great Queen Street met throughout the 1710s by subscription, first under the direction of Godfrey Kneller and then James Thornhill (Hogarth's father-in-law from 1729). The St. Martin's Lane Academy operated for four years, starting in 1720, under the leadership of Vanderbank and Louis Chéron, and in 1735 (right after Thornhill's death) it was revived by Hogarth, providing, in Ilaria Bignamini's judgment, "the core of a more institutional system for the arts which developed in London from the mid-1730s onwards."[74] Whether one stresses continuity or change between it and the Royal Academy of Arts founded in 1768, St. Martin's was the crucial forerunner.

These associations granted substantial agency to the artists involved, fostered community among the participants, and in many cases facilitated life drawing. Both manifestations of the St. Martin's Academy offered access to male and female models nearly a century before the female nude would become a regular feature of academic practice on the Continent. The groups

existed for the benefit of their members, and the artists involved were not beholden to a hierarchical system of patronage. Whatever was lacking in terms of prestige was compensated for in terms of independence. Or at least Hogarth and his followers believed as much.

An empirical sensibility pervaded these academies, not only because they were burdened with little of the Neoplatonic theory that granted the arts a place in the service of an elaborate court culture; their loose organization also permitted virtuosic interactions more easily than their Continental counterparts. The surgeon and collector Alexander Geekie joined the Great Queen Street Academy in 1711, the year of its inception (he had already acquired in 1703 a portrait of Locke directly from the artist, by Kneller, that was later purchased by Robert Walpole).[75] As Kneller's successor at Great Queen Street, Thornhill—a great-nephew, incidentally, of Dr. Sydenham— was the first native-born English artist to be knighted; in addition, he was elected Fellow of the Royal Society (fig. 48). Also a Fellow was the anatomist William Cowper, who participated in the Virtuosi of St. Luke.[76] Cowper, as discussed in chapter 2, was responsible for publishing John Evelyn's anatomic tables in the *Philosophical Transactions* in 1702. His protégé, the surgeon William Cheselden, belonged to the first St. Martin's Lane Academy and may have offered anatomic instruction for the group.[77] In 1712 Cheselden had sent notice to the Royal Society of unusually large human bones found in a Roman urn at St. Albans and the following year was made a Fellow. Alongside Mead, he earns mention in Pope's "Imitations of Horace" ("I'll do what Mead and Cheselden advise / To keep these limbs and preserve these eyes").[78] Mead was the dedicatee of his immensely successful *Anatomy of the Human Body,* and both men attended at the death of Isaac Newton.[79] Dr. Charles Peters, an additional beneficiary of Mead's support (his 1720 treatise on syphilis is dedicated to Mead), was a member of the Virtuosi of St. Luke, and finally Martin Folkes was closely associated with the second St. Martin's Academy.[80] While not a man of medicine, Folkes served as president of both the Royal Society and the Society of Antiquaries, and played a prominent role in the Foundling Hospital, which offered an important exhibition venue for St. Martin's members.[81]

Long regarded as advancing an empiricist mode of aesthetics, *The Analysis of Beauty,* in fact, can be seen as the culmination of a tradition stretching back to William Salmon, indeed even to Richard Haydocke's translation of Lomazzo. Discarding Shaftesbury's moral expectations of beauty, Hogarth casts visual grace in terms of experience and the reader's own eyes. He emphasizes causality and narrative progression in time.[82] He writes to instruct and takes it for granted that his subject can be explained to a wide audi-

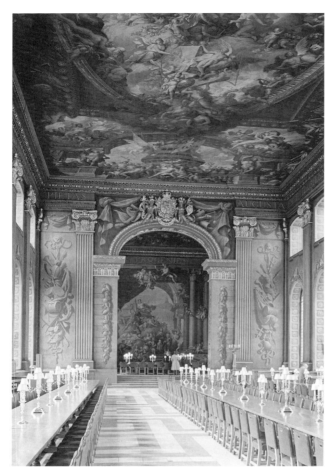

FIGURE 48 James Thornhill, ceiling of the entrance to the Painted Hall, 1707–27. Royal Naval College, Greenwich. Photograph John Bethell / The Bridgeman Art Library. Used by permission from The Bridgeman Art Library. Thornhill's 1689 apprenticeship to Thomas Highmore was funded by an inheritance of £30 he received from his great-uncle, Dr. Sydenham. Decades later, Thornhill's work at Greenwich was understood by many in the Georgian period to mark the emergence of British history painting. Significantly, the site for this public mode of painting, which glorified both the state and the Crown, was a hospital associated with Christopher Wren and his virtuosic circle.

ence.[83] He appeals to everyday objects—furniture, locks of hair, parsley, and corsets—and insists beauty is not limited to the masterpieces coveted by the connoisseurs. The short, tightly focused chapters break with conventions more common for idealist modes of theory, and a number of the topics recall Salmon's *Polygraphice*. Even more important for the work's empiricist character are the two plates. The text continually returns the reader to the prints, and they play an essential part in the argument thanks to Hogarth's interactive use of the marginal images, aptly described by Barbara Stafford as "boxed pictograms and eccentric rebuses, inlaid like a rough-cut mosaic or jigsaw puzzle."[84] The process of reading becomes an empirical project of visual discovery in its own right.

Haydocke's mannerist endorsement of pyramidal forms that employ ser-

pentlike lines provides the theoretical basis for the book; and even when the translation by the seventeenth-century physician is used as a negative example, as in the plate of Dürer's proportions taken from Haydocke (just below the Apollo Belvedere in fig. 47), one is reminded of the role medical men played in shaping this tradition. Hogarth's recasting of the importance of proportion and symmetry here is significant. He dismisses the latter as being too uniform and an obstacle to variety. He accepts the former as vital but discounts any inherent ideals that would tie proportions to universal harmonic conceptions, such as music. Rather, he insists that proportion (as well as symmetry, to the extent it is required) is guided by utility, its "fitness" for the task at hand. The revision coincides with the larger seismic shifts playing out in medical theory as traditional conceptions of the body held in check by a balance of humors began to yield to more pragmatic approaches to health and disease, a process that would last well into the nineteenth century (for Haydocke, symmetry still implied an ordered, healthy body). The eighteenth-century anatomic illustration in plate 1 (shown in the lower left corner of fig. 47) depends on the revised edition of Cowper's *Myotomia Reformata,* which appeared posthumously in 1724—and was edited by Mead.

The emphasis on utility, which opens the body of the book, calls to mind the Royal Society's History of Trades program, as does the final chapter, entitled "Action." Hogarth singles out English workmanship as a distinctly modern accomplishment and presents Christopher Wren as the nation's quintessential architect (Inigo Jones barely squeezes in through a footnote). Hogarth's love of curiosity and variety corresponds to the Royal Society's polymathic pursuits, as does his interest in shells and flowers. Methodologically, he rejects analogy in favor of synecdoche.[85] And perhaps more telling, he sent a copy to the Royal Society a week before the work was available for purchase.[86]

A number of medical connections also tie *The Analysis of Beauty* to this virtuosic sphere. In addition to the anatomic tables already cited, Hogarth includes several views of bones and muscles in the margins of plate 2, and he employs the language of dissection in the introduction. He stresses the importance of understanding not only the exteriors of the bodies depicted but also "the inside of those surfaces," and vividly encourages the reader to "let every object under our consideration, be imagined to have its inward contents scooped out so nicely, as to have nothing of it left but a thin shell." He credits Dr. John Kennedy, "a learned antiquarian and connoisseur," with introducing him to Lomazzo, and acknowledges himself "particularly indebted to one gentleman for his corrections and amendment of at least a

third part of the wording."[87] The unnamed friend is Dr. Benjamin Hoadly, a royal physician, FRS, and son of the well-known bishop.[88]

For all Hogarth accomplishes in *The Analysis of Beauty* in terms of articulating a coherent counterargument to Shaftesbury's republican notion of taste, there are, as critics have long noted, inconsistencies.[89] Hogarth offers classical conceptions of beauty—be they ancient works of sculpture or seventeenth-century history paintings—as proof of both natural beauty and all that is wrong with the art of his own period. He advocates simplicity and a program of demystification but endows his serpentine line of beauty with totemic properties, supported by the rhetoric of hieroglyphs (Warburton, the antiquary who provides the essay on chivalry for Jervas's *Don Quixote*, may have fueled Hogarth's imagination with his *Divine Legation of Moses*).[90] And finally, Hogarth makes room for convention in matters of taste while arguing for universal principles drawn from nature.

These tensions can be mapped onto the larger sources of friction explored throughout this chapter. Empiricism, even in the visual arts, still required the security that came with rational systems. Even Hogarth needed the learned numismatist, Dr. Kennedy. The same edition of Lomazzo that misguidedly emphasizes stiff proportional tables supplied the crucial quote about the serpentine line, and Cowper's *Myotomia Reformata* would not exist without the discourse of virtuosic connoisseurship that nurtured Mead's collecting and patronage interests. Despite all the differences between Hogarth and the idealists he repudiates, it is what he and they have in common that compels him to distinguish himself.

In a 1737 essay in which Hogarth tests some of the arguments that later appear in *The Analysis of Beauty,* he identifies as "quacks" those dubious connoisseurs set on selling Old Master Holy Families and Venuses to naïve Englishmen.[91] In the same way that Francis Wise's rival could impugn Mead's reputation by suggesting that Wise quacked in antiquities, Hogarth saw in the critics and dealers around him quacks in art. As with the examples already examined in this and the previous chapter, brandishing the quackery label was an alluring strategy for preserving professional status and defining boundaries in a crowded marketplace.

Amid this confusion, gaping from the right-hand edge of plate 2 (fig. 46), facing the text as one pulls out the folded print, Sancho surveys the maelstrom. He has seen it all before and still can only respond with dismay.

"Inspiring Reciprocal Emulation and Esteem"

Dr. Richard Mead and Early Georgian Virtuosity

Ever a master of juxtaposition, William Hogarth produced his most potent visual critique of the medical profession in 1736. *The Company of Undertakers* (fig. 49) frames the field in terms of heraldry, folding fifteen practitioners into this highly prescribed semiotic system.[1] The central figure in the Harlequin outfit is Mrs. Sarah Mapp, a woman widely hailed as an effective healer. A bonesetter whom no one would have ever confused with a proper physician, she was nonetheless consulted by all segments of society, including even Queen Caroline. To the left of Mapp is John "Chevalier" Taylor, an itinerant oculist who, after training as a surgeon (he studied under William Cheselden), embarked upon a series of adventures across the courts of Europe, later expounded in a three-volume autobiography.[2] Leaning in from the right-hand side is Joshua Ward, famous for his mass-marketed, antimony-based "Drops and Pills," which earned him the favor of George II and a variety of privileges, including passage through St. James Park in his ornate carriage and an office at Whitehall.[3] Gathered around a flask of urine, a dozen doctors—here called "Quack-Heads"—crowd the lower two-thirds of the escutcheon, while against the black border (signifying recent death), Hogarth adds two pairs of crossed bones and a Latin motto from the *Aeneid*: ET PLURIMA MORTIS IMAGO (Everywhere the image of death).

The figures below the nebulae (the wavelike boundary dividing the field) may have been based on particular physicians. Writing several decades later, John Nichols identified two men: Dr. Pierce Dod, an influential member of

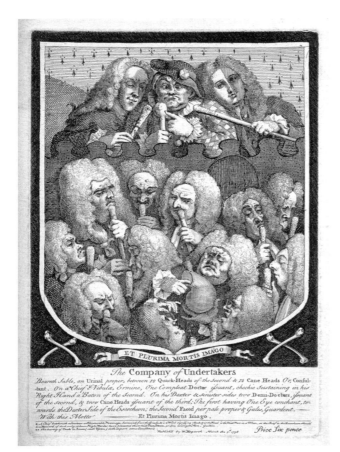

FIGURE 49 William Hogarth, *The Company of Undertakers*, 1736. Used by permission from Wellcome Library, London.

the Royal College of Physicians, a Fellow of the Royal Society, and an opponent of smallpox inoculation; and Dr. John Bamber, who after training as a surgeon earned his MD and worked as a man-midwife and a lithotomist. Both were attached to St. Bartholomew's Hospital.

The print foregrounds the issue of identity and professional image. What, Hogarth asks, is the face of medicine in Georgian London? To answer, one need only look for the physicians' coat of arms, easily recognized by the disarray of pompous self-conviction that renders indistinguishable irregular practitioners and orthodox physicians. However much or little the latter may have read of the ancient authorities, ultimately they, too, are dependent on their senses, and nothing exists to ensure their judgment will be any sounder than their heterodox counterparts. Ironically, Hogarth suggests, the more doctors attend to their own appearances—donning an air of thoughtful solemnity under a respectable periwig—the more they live

up to the traditions of the profession here mocked as heraldic posing. To reinforce the technical fuss over the coat of arms' details, Hogarth jabs at the antiquary's genealogical obsessions by referencing in the inscription two standard sources from the fifteenth and early seventeenth centuries, Nicholas Upton and John Guillim (presumably Hogarth's own knowledge of heraldry stemmed from his training as a silver engraver). Finally, as the motto implies, the doctors' inheritance from the Greco-Roman tradition is neither Hippocrates nor Galen but instead a reference to Death's claim over both the Trojans and the Greeks.

As noted in the previous chapter, Dr. Richard Mead was reviled on several occasions in the tumultuous world of eighteenth-century print culture. Along with the 1719 pamphlet war with Dr. John Woodward, Mead's reputation as a connoisseur was questioned in 1738 in connection with Francis Wise's conjecture over the White Horse of Uffington. In addition, several texts appeared in the early 1720s challenging Mead's prescriptions for countering the plague, and in 1748 the Cervantes references resurfaced with an attack on Mead's role in publishing a Latin translation of the oldest known treatise on smallpox, an Arabic text by Muhammed ibn Zakariya al-Razi (865–925), the Baghdad physician better known in the West as Rhazes.[4] *The Cornutor of Seventy-Five. Being a genuine Narrative of the Life, Adventures, and Amours, of Don Ricardo Honeywater, Containing among Other Particulars, his Intrigue with Donna Maria W——s . . . Written originally in Spanish, by the Author of "Don Quixot," and translated into English by a Graduate of the College of Mecca in Arabia* criticized not only the translation but cast Mead as an impotent lecher. Laurence Sterne picked up the salacious thread and, as Roy Porter suggests, modeled the sexually ridiculous Dr. Kunastrokius of *Tristram Shandy* after Mead.[5]

Hogarth's *Company of Undertakers* draws upon a similar satirical tradition, employing sexual ribaldry to impugn the figure of the learned doctor. With minimal imagination, the physicians' gold-headed canes can be read as phalluses, the ultimate objects of the doctors' attention and authority, even if, as Hogarth hints, one is perfectly justified in questioning the usefulness of these sticks, which seem to provide only self-satisfaction. Nothing in Hogarth's image inculpates Mead, but he did at the time possess the most famous gold-headed cane in all of medicine, inherited from his mentor Dr. John Radcliffe and eventually given to the Royal College of Physicians.[6]

This same cane helps mark Mead's identity in an anonymous 1745 print satirizing Robert Walpole's death (fig. 50). Bound for the underworld (Pluto's dominion) with Exchequer tallies, *"Riches," "Court promises,"* and *"£4000 Tax,"* the recently deceased prime minister sits astride a human-headed don-

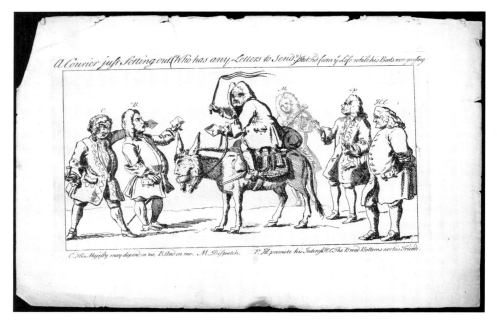

FIGURE 50 *Horace Walpole astride a Human-Headed Donkey,* ca. 1745. Used by permission from Wellcome Library, London.

key surrounded by five standing figures: (*B.*) William Pulteney, Earl of Bath; (*C.*) Lord Carteret, Earl of Granville; (*P.*) Thomas Pelham, Duke of Newcastle; (*H.C.*) Sir John Hynde Cotton; and (*M.*) Dr. Mead. The crude etching is equally hard on Walpole's political enemies and makes much of the circumstances of his demise: "*At length Old O[rfor]d must depart, Help'd on by medicinal Art.*" In fact, his death was the result not of Mead's care (though Mead had been his doctor since at least the 1720s) but that of Mead's colleague Dr. James Jurin, who prescribed Joanna Stephens's caustic nostrum to treat the severe pain of a bladder stone. The medicine may have succeeded in dissolving the obstruction but did Walpole in as well. In any event, Mead is shown with the cane and a recipe for "*The Bite of a Mad Dog,*" one of his signature treatments related to his broader interests in poisons.[7] That Stephens had received £5000 from Parliament for her formula further demonstrates how wide-ranging therapeutic regimes could be during the period, even—perhaps especially—for the gilded elite.

But this print is exceptional. Mead almost never appears as the butt of visual satire, and even in this instance, he's hardly the principal target. In fact, even the textual attacks on Mead's expertise or his character belie the

general esteem afforded the doctor both by his contemporaries and by sub-sequent biographers. For apart from the scurrilous pamphlets produced by a small number of detractors, the past two and a half centuries have produced only glowing accounts of the physician. Samuel Johnson famously judged that Mead "lived more in the broad sunshine of life than almost anyone," and the sentiment reverberates throughout all the major accounts of the physician's life, from that offered by Dr. Matthew Maty right after Mead's death in 1754 to those of Arnold Zuckerman and Richard Hardway Meade in the 1960s and 1970s.[8]

Unfortunately, the sunshine has made it difficult to assess Mead and his role in Georgian society, and the "Great Man" tradition of biography has eclipsed more critical modes of engagement, particularly given that Whig-gish narratives of triumph have proved most resilient in the history of medi-cine. Because Mead has been celebrated as one of the leading physicians of the eighteenth century—thanks not only to his royal and aristocratic pa-tients but also to his advocacy of smallpox inoculation, his theory of con-tagion, and his administrative work for seven of London's hospitals—his other cultural aspirations, including his patronage of artists and scholars, his ten-thousand-volume library, and his impressive collection of paintings and sculpture, have been seen as mere accoutrements of a successful medi-cal career, proof of his accomplished refinement but ultimately incidental, or at least tangential and separable from his genius as a physician. Indeed, integrating Mead's polymathic appetites, his collections, and his social and professional networks is an enormous undertaking that far exceeds the pa-rameters of a single chapter.[9] My intentions here are considerably more modest, though the implications of the argument should not be underesti-mated. I suggest that Mead fits squarely within the virtuosic tradition of the seventeenth century that nourished the arts and knowledge of the natural world alongside each other within the context of the Royal Society. After a synopsis of Mead's career that stresses these connections and the extent to which Mead successfully addressed the nagging dilemma posed by an empiricist orientation, the chapter concludes by considering Mead's sup-port for the Foundling Hospital. This charitable institution dedicated to the rearing of unwanted children provides a means of examining Mead's place within the Georgian art world, particularly in relation to Hogarth and the discourse of civic humanism. According to this account, London circa 1750 marks not the sui-generis inception of an institutional base for the arts in England but a culmination of a virtuosic tradition stretching back to the early Stuart court.

Mead and Newtonian Medicine

The son of Matthew Mead, a prominent Dissenting divine, Richard was born in August 1673 just outside London in Stepney.[10] He received a solid education that expectedly emphasized Latin and to a lesser degree Greek. The former, as noted in the *Gentleman's Magazine,* he learned "by habit rather than rule."[11] In the aftermath of the 1683 Rye House Plot, Matthew was suspected of being involved in the plan to assassinate Charles II, and in 1686 he fled to Holland, following the pattern of more famous enemies of the Crown including Lord Ashley, Earl of Shaftesbury, and John Locke. At the end of the decade, at the age of seventeen, Richard also moved to Holland, settling first at Utrecht to study under "the celebrated antiquarian" Johann George Graevius and then proceeding to Leiden in the spring of 1693 to pursue a medical education. There Mead briefly studied under the celebrated Scottish Newtonian Archibald Pitcairne. Dr. Pitcairne was a founding member of the Royal College of Physicians in Edinburgh in 1681 and an outspoken Jacobite throughout his life.[12] He accepted the teaching appointment at Leiden in the spring of 1692, stopping on his way to visit Isaac Newton at Cambridge. Pitcairne delivered his inaugural lecture that April but remained in Leiden only until the summer of 1693, just a few months after Mead matriculated.[13] Despite the brief temporal overlap, the two men developed an enduring friendship, and Mead later helped secure the release of Pitcairne's son, who had been imprisoned for his involvement in the Jacobite uprising of 1715.[14]

An early admirer of Newton, Pitcairne saw in the *Principia* a model for how one might construct a foundation for medicine based on mathematical certainty. Thanks to the work of Anita Guerrini, it is clear that Pitcairne, together with his friend and colleague David Gregory, became a focal point for a number of budding Newtonian physicians of the next generation, including George Cheyne, William Cockburn, John Freind, and Herman Boerhaave (Mead's housemate in Leiden).[15] After two years of medical studies, Mead thus left Holland fully committed to what seemed the path to real medical advancement. Following a brief stay back in England, he traveled south to Italy with his older brother Samuel, David Polhill, and Thomas Pellett (the future president of the College of Physicians), and on August 26, 1695, he received his MD from the University at Padua, continuing to Rome and Naples before returning to London the next year.

As Mead set about building his practice in Stepney, Cockburn and Cheyne had begun to explore how firmly Newtonian methods could be brought to bear on physic, at least in terms of theory and rhetoric. Cockburn's 1696

Account . . . of the Distempers that Are Incident to Seafaring People and his "Discourse on the Operation of a Blister When It Cures a Fever," published in the *Philosophical Transactions* in 1699, both were premised on a Newtonian conception of the body.[16] Similarly, Cheyne's *New Theory of Continual Fevers* of 1701 built on Pitcairne's work, especially criticizing the ambiguity inherent in chemical-based approaches; it undoubtedly helped secure his election to the Royal Society later that year. In 1702 his *Essay Concerning the Improvements in the Theory of Medicine* made explicit the connection between Newton and physic's future. As Guerrini summarizes, the *Essay* outlines four requirements for advancement:

- improved anatomic knowledge

- "Compleat History of Nature"

- "Compleat System of Mechanick Phylosophy"

- "Principia medicinae theoreticae mathematicae"

Cheyne elaborates the third item as "an Account of all the Visible Effects of Nature upon Geometrick Principles," noting such had already been produced by "that stupendiously Great Man, Mr. Newton" and asserting that a "Principia medicinae" would entail this same approach applied to "the more minute . . . Appearances of Nature."[17]

Mead made his publishing debut the same year with *A Mechanical Account of Poisons in Several Essays*. As explained in the preface, he wanted to see

> how far I could carry mechanical considerations in accounting for those surprising changes which poisons make in an animal body, concluding (as I think fairly) that if so abstruse phaenomena as these did come under the known laws of motion, it might very well be taken for granted, that the more obvious appearances in the same fabric are owing to such causes as are within the reach of geometrical reasoning.[18]

At stake was more than just the immediate subject of snakes and poisons—a topic addressed by notable seventeenth-century natural philosophers including Francesco Redi.[19] Instead, Mead was attempting to demonstrate the applicability of mathematics to the study of the human body more generally. Appropriately enough, he was elected a Fellow of the Royal Society in 1703,

the same year Newton took over as president and thirteen years before he was elected a Fellow of the Royal College of Physicians.[20]

For this generation of Newtonian physicians, mathematics would serve as the solution to the vexing problem of how to embrace the New Philosophy of empiricism without becoming an empiric. In the words of Mead, "mathematical learning will be the distinguishing mark of a physician from a quack."[21] Iatromathematics, with its emphasis on measurement and motion, provided a framework in which observation and experiment were legitimized, even as physicians could still claim to be acting on the basis of causes and medical theory.

None of which is to say that Newtonian conceptions of physic were viewed as a challenge to the authority of ancient medicine. Later in life, Mead worked especially hard to cultivate links that would tie himself to the past. Hanging above the fireplace in his library was a painting from the mid-1730s by Giovanni Panini, *Prayer to Aesculapius on the Isola Tiberina* (figs. 51–52).[22] Mead may have visited the islet while in Rome (John Evelyn did), as well as the Temple of the Sybil at Tivoli, which Panini's capriccio here employs as a model for the shrine to the god of healing. A catalogue of Mead's collection states that the picture "was painted on purpose for Dr. Mead's gallery, where it was placed over the chimney at the upper end."[23] The effect of the painting would have been heightened if, as Mary Webster suggests, we are to understand the statue to the right of the fireplace in the print of the library as Mead's own statue of the ancient god.[24]

The theme of a city racked by plague accorded well with Mead's reputation as an expert on the subject. After a 1719 outbreak at Marseilles spread panic across Europe, Mead, using the same mechanistic approach to health, extended his poison studies to formulate a theory of contagion in *A Short Discourse Concerning Pestilential Contagion*. That the plague atrophied on its own hardly inhibited sales of Mead's text, which went through eight editions in just two years.[25]

In *A Mechanical Account of Poisons*, Mead presented mathematics as the path to a "new animal oeconomy" that will "convince the world that the most useful of arts, if duly cultivated, is more than either meer conjecture or base empiricism." And yet his commitment to the past emerges from the warrant underlying his argument. For he likens the medical practitioner who lacks mathematical proficiency to one ignorant of classical languages: "he who wants this necessary qualification will be as ridiculous as one without Greek or Latin."[26] Mead may have thought rather differently than the ancient Roman masses about Aesculapius's influence, but he still prided himself as a student and colleague of Galen.

FIGURE 51 Giovanni Paolo Panini, *Prayer to Aesculapius on the Isola Tiberina*, 1734. Oil on canvas. Untraced.

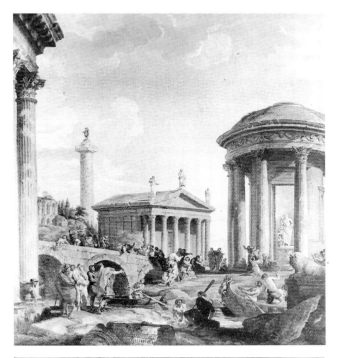

FIGURE 52 *The Library of Dr. Mead's House in Great Ormond Street*, 1755. Engraving.

With a striking expression of disappointment, Mead responded in a 1733 letter to Boerhaave over his friend's decision not to proceed with

> plans to publish the ancient writers on medicine. I regret this, and with me the sons of physicians will regret it likewise. What is to become of the as yet unpublished Greek *Codex* of Oribasius? What of the later books of Aetius which are not yet printed in Greek? What of the emendations to Nican-

der, that I sent you some years ago from our Bentley who is by far the first among the critics?[27]

Whatever being a modern, Newtonian physician entailed, one still desperately needed the Ancients.

Mead's second book exemplifies how Newtonian and ancient models could be seen to support each other. *De imperio solis ac lunae in corpora humana et morbis inde oriundis* of 1704 (translated in 1748 as *A Treatise Concerning the Influence of the Sun and Moon upon Human Bodies and the Diseases thereby Produced*) recasts traditional Galenic conceptions of the relationship between health and the celestial realm in terms of Newtonian notions of attraction and planetary motion.[28] Robert Boyle had distinguished between unfounded astrological prophecy ("judicial astrology") and areas that he believed to be legitimately affected by the heavens, including weather, health, and the atmosphere ("natural astrology"). A text such as William Salmon's 1679 *Horae Mathematicae, seu Urania. The Soul of Astrology: containing that art in all its parts* was exactly the wrong kind of stargazing—though, as stressed in chapter 3, the boundaries between quackery and orthodoxy are hardly as neat as they sometimes first appear.[29] We might, in fact, see Mead's *Treatise* as an attempt to shore up the divide between the two, an attempt to provide medical astrology with the same degree of certainty and respectability granted astronomical studies as practiced by the likes of Christopher Wren (who understood his own work to have medical implications). Pitcairne, in his inaugural lecture at Leiden, had similarly looked to astronomy as a basis for modern medicine, thrilled by what he saw as its mathematically derived certainty.[30] As Anna Marie Roos has stressed, however successful Mead was in refashioning ancient ideas in the new garb of Newtonianism, his "actual medical treatments and causal explanations of disease were entirely traditional."[31] Synthesizing the old and new in a manner that does justice to each was (and is) rarely easy; the point is that the new advances in astronomy were thought to bear on ancient medical theory, not negate it.

Mead's role in the conflict between Newton and John Flamsteed, the director of the Royal Observatory at Greenwich, further evidences the doctor's engagement with astronomy and his own privileged place among Newton's circle of supporters. Flamsteed drew the ire of Newton and Edmond Halley, both of whom accused him of hoarding the data he amassed as Royal Astronomer and of failing to provide accurate observations. In December 1710 a Royal Warrant was issued, authorizing Newton "together with such others as the Council of our said Royal Society shall think fitt to join with you to be constant Visitors of Our Said Royal Observatory." This group was given

power to demand from Flamsteed "a true & fair Copy of the Annual Observations he shall have made . . . [and to] Order and Direct Our said Astronomer . . . to make such Astronomical Observations as you in your Judgment shall think proper." Finally, the group was placed in charge of inspecting the observatory's instruments and overseeing the repair or replacement of any found to be defective.[32]

To Flamsteed's consternation, all of the charges were carried out. The committee formed to oversee the observatory included Newton, Francis Robartes, Dr. John Arbuthnot, Halley, Abraham Hill, Christopher Wren, his son Christopher Wren Jr., Dr. Hans Sloane, and Dr. Mead. A letter dated May 30, 1711, signed by Newton, Sloane, and Mead ordered Flamsteed "to observe the Eclipses of the Sun and Moon this Year . . . and to send Your Observations to us at Our Meeting at the House of the Royal Society," while another, from July 3, 1712, signed by the same three men along with Halley and Hill demanded Flamsteed's "compliance," noting that his observations for the previous year were overdue.[33] Finally, Mead was among those who visited the observatory, as evidenced by a report from May 24, 1714, which catalogued the instruments and described their condition.[34]

The conflict emphasizes the deficiencies of the period's institutional structure, where patronage still mattered immensely. At the same time, it defines Mead's place within Newton's circle and provides a broader context for the doctor's ideas on the relationship between health and the heavenly spheres. Regardless of how absurd or incidental to medicine they may seem now, they were worked out at a period when Mead, through his position in the Royal Society, held a remarkable degree of authority even over the Royal Astronomer.

Having proved his loyalty, Mead was appointed by Newton in 1717 to one of the society's vice-president positions. The astronomer's trust in the doctor is perhaps most clearly shown by the fact that Mead was one of Newton's own physicians and attended at his deathbed in March 1726. John Conduitt's influential biography particularly stresses the soundness of Newton's senses and the interaction between the two men. Aware of his mortality, Newton read the day's newspapers and "held a pretty long discourse with Dr. Mead." Only at the end did he become "insensible," and as if inevitable once the senses were gone, Newton died.[35]

Mead as Reader and Patron

Next to Newton, Dr. Radcliffe may have been the single most important patron for Mead; and for Mead's actual practice and client base, we need

to consider another, earlier, deathbed scene from 1714. Fearing the end was near, Queen Anne sent for Radcliffe, who audaciously refused to go but sent his protégé, Dr. Mead, instead. While Mead did little to help the queen, he accurately predicted her impending death, and his reputation benefited as a result under the new Hanoverian Crown.[36] When Radcliffe himself died later that year, Mead inherited a large portion of his practice, leasing his predecessor's house on Bloomsbury Square, just a couple of blocks southeast of the current site of the British Museum.[37]

In a tale reminiscent of Thomas Sydenham's recommendation of *Don Quixote* as a useful text for aspiring young doctors, Radcliffe, when asked about the small number of books in his study, is said to have motioned to some vials, a skeleton, and an herbal and stated matter-of-factly, "This is Radcliffe's library."[38] Although the conversation supposedly took place while Radcliffe was still in residence at Oxford, the anecdote was applied more broadly to demonstrate that his knowledge rested on a practical, material basis rather than on the textual tradition of medical theory. It echoes a story told of Descartes, who when asked about his library by a visitor, led the man to a shed where a dead calf was waiting to be dissected. As Richard Watson notes in his biography of the philosopher, the incident is usually cited as proof of Descartes' empiricist commitments; though given that it originates with one of Descartes' opponents, Samuel Sorbière, we might see in it a more belligerent insinuation, "wisdom in the calfskins on real scholars' shelves, stinking guts in Descartes's."[39] The similarities between the two stories reinforce their formulaic character, as well as the inherent methodological conflict they describe. How much trust should we, in fact, place in an aspiring physician who disdains reading?

In another anecdote used to evince Radcliffe's indifference toward books, the doctor purportedly visited Mead and found him immersed in Hippocrates. He asked the younger man if he read the ancient text in Greek, to which Mead answered, "Yes." When Radcliffe replied that he himself had never read Hippocrates at all, Mead shrewdly judged, "You, sir, have no occasion, you are Hippocrates himself."[40] Whatever the story lacks in veracity, it foregrounds Mead's commitments to the authority of the Ancients and the grace with which he navigated the terrain of the Moderns. He refused to be forced to choose between the two.

Outrageous anecdotal quips such as those attributed to Sydenham and Radcliffe, of course, obscure more complicated realities. The inventory drawn up at Radcliffe's death in 1714 includes over two hundred books—by no means a large collection but still reasonably comprehensive—and the terms of his will established one of the most ambitiously conceived libraries

of the eighteenth century, Oxford's Radcliffe Camera, which, begun in 1737 and completed finally in 1749 to the designs of James Gibbs, stands adjacent to the Bodleian Library, near Wren's Sheldonian Theatre.[41]

Radcliffe's own books (including his copy of Hippocrates) came to be housed not in Oxford but in another of Gibbs's buildings, the library constructed for Mead at 49 Great Ormond Street. Mead had purchased Radcliffe's library from the trustees of the estate in 1718 and soon thereafter, having secured his position among London's medical establishment, moved several blocks east, to the house in which he would spend the next thirty-three years and which would become an inseparable component of his reputation as a learned admirer and supporter of the arts.[42] Having benefited so much from the patronage of Newton and Radcliffe, Mead would here become a powerful patron in his own right with an annual income of over £5000 and access to the highest levels of society.[43] In addition to his role as physician to George II (from 1727), Mead had contact with the French court through Claude Gros de Boze, secretary of the Royal Academy of Inscriptions and Belles Lettres, as well as with Charles III, the King of Naples, who sent Mead the first two volumes of the antiquities of Herculaneum. Mead provided recommendations for Englishmen abroad and received foreigners visiting London. He

> kept every day a public table for men of learning and ingenuity, at which he presided himself, and addressed the naturalist, the mathematician, the antiquarian, the painter, and the classic, each in his own language, displaying the merit of their discoveries, or their compositions, and inspiring reciprocal emulation and esteem.[44]

With over thirty books dedicated to him and his name a regular feature on subscription lists, Mead was a crucial fixture within London's community of scholars.

Multiple motivations must have figured into his decision to add the library in the garden behind his house, but the fire that destroyed much of the Cottonian Library on October 23, 1731, appears to have been one immediate concern. In a letter to Edward Harley, the Second Earl of Oxford, penned three days later, Mead writes,

> I have been at Ashburnham House. Dr. [Richard] Bentley tells me that half the manuscripts of the Cotton Library have been burnt. A great loss this, and I cannot but reflect, with how much concern, I have heard your Lordship's great father complain that care was not taken (according as the

Crown was obliged by two Acts of Parliament which he had provided) to maintain and keep in due repair the Cotton House, that the library might have been perpetually kept there. Dr. Bentley says that this calamity is the Nemesis of Cotton's ghost to punish the neglect in taking due care of his noble gifts to the public.[45]

Work on Mead's library began perhaps as early as 1732 and finished in 1734, the same year Gibbs also completed the first block of the new St. Bart's Hospital, which, as Christine Stevenson has suggested, may itself have been indebted to Mead's ideas on contagion.[46] One can imagine the pride Mead took in the new library, which demonstrated his own appreciation for the proper care learned objects require.

An engraving of Mead's library (fig. 52), complete with his arms and motto (*Non sibi sed toti* / "Not for himself but others"), underscores the degree to which the space came to be identified with the doctor.[47] The pronounced one-point perspective emphasizes the capacious shelves that here order knowledge under the gaze of eight watchful busts, together with a handful of pictures visible on the left wall and directly in front of us Panini's painting, flanked by two statues, and a profile in relief.

But as an image of Mead's erudition, the print omits much and particularly suppresses the eclectic array of objects Mead owned. We might be better served by a depiction like George Vertue's engraving of the Harley collection (fig. 53), which shows a library cluttered with objects: books, paintings, vases, small bronzes, marble busts, open cabinet drawers, and all manner of intellectual disarray. As already noted, Mead corresponded with the earl, and at the sale of Harley's coins he spent £4 11s.[48] Mead's librarian, William Hocker, was hired by the Harley estate to catalogue the deceased earl's manuscripts, and the title page for the Harley collection of pictures and antiquities could have been used, for the most part, to describe the doctor's collection—complete with references to Panini and "valuable curiosities out of the Arundel Collection."[49] Perhaps it was at Mead's request that such stimulating disorder *not* be included in the depiction of his own library. Perhaps, given Mead's reputation as a man of taste, the older baroque conventions that still pertain in the image of the earl's collection were by 1754 seen as outdated in relation to the emerging norms of neoclassicism. Or perhaps the view genuinely reflects something of Mead's own sensibilities regarding order and neatness. Regardless, it conveys little of what he possessed, other than books.

FIGURE 53 George Vertue, engraving. Frontispiece from *A Catalogue of the Collection of the Right Honourable Edward Earl of Oxford, Deceased: Consisting of Several Capital Pictures . . . Antiquities . . . Prints and Drawings* (London, 1742). Engraving. Photograph courtesy of Quaritch Rare Books & Manuscripts, London.

Mead as Collector

In fact, the sale of the library comprised only two of the six auctions that dispersed Mead's possessions. The other four included his coins, paintings, prints and drawings, and sculpture (ancient and modern). The painting collection consisted of approximately 180 works by about 90 artists, including Canaletto, Claude, Van Dyck, Hals, Holbein, Kneller, Maratti, Poussin, Raphael, Rembrandt, Rubens, Teniers, Titian, and Watteau. Over two-thirds of the painters were working in the seventeenth century. Some two dozen were still living as the Hanoverian reign began, while a dozen belonged to the sixteenth century. Over 50 pictures could loosely be described as historical, with 30 of these portraying biblical stories or saints. Paintings of classical subjects included images of *Venus, Jupiter and Danae, Cocles Defending the Bridge against Porsenna,* the *Aldobrandini Marriage,* and *Eurytus Teaching*

Hercules to Shoot. There were 47 portraits, some two dozen landscape and sea pieces, a dozen depictions of architectural scenes and ruins, and a dozen still-life and animal pictures.

Many of the works span standard genre categories and seem foremost to have served as "medical pictures," much like Panini's *Prayer to Aesculapius.* Many of the portraits, for example, depict Mead's medical forerunners: Vesalius, Harvey, Paracelsus, Turquet de Mayerne, Charleton, Locke, and Pitcairne. In several instances, history paintings highlighted anatomy, as in the case of Jusepe Ribera's *The Flaying of St. Bartholomew,* described in *A Catalogue of Pictures . . . of the Late Richard Mead, M.D.* as "the first picture purchased by Dr. Mead, who admired it for the just anatomical expression of the muscles in the [saint's] figure." Giulio Carpioni's *Apollo Flaying Marsyas* served as an appropriate classical complement to this scene of Christian martyrdom. Sebastiano Ricci's *Christ Healing the Blind Man* and Sebastiano Conca's *Tobias Healing His Father's Eyes* offered miraculous narratives of recovery, while Giovanni Lanfranco's *A Pope Raising the Dead* explored the theme more emphatically.[50] Six anatomic pictures by William Cowper return us again to the specifics of the body, even as they point to a further example of Mead's patronage. The revised edition of Cowper's *Myotamia Reformata; or, A New Administration of All the Muscles of Humane Bodies* appeared posthumously as a result of Mead's involvement.[51] As noted in the last chapter, a plate from the book figures in plate 1 of Hogarth's *Analysis of Beauty.*

The collection shows a special interest in artistic process, and some of the most impressive items can be understood as studies or intermediate works for larger projects. Rubens's *History of Achilles* cycle, for instance, is composed of eight oil sketches that served as the basis for a set of tapestries.[52] Likewise, three images associated with Raphael are cartoons.

The connoisseur's appreciation for the immediacy of the preliminary manifests itself most clearly in Mead's drawings, even as the collection is impossible to reconstruct apart from a sampling of key works. In 1739 Mead acquired sixty-six drawings attributed to Poussin, fifty-six of which are still considered autograph. Now part of the Royal Collection, the drawings had been assembled by Cardinal Camillo Massimi, who took art lessons under Poussin in the late 1630s; at this point he seems to have acquired the bulk of the drawings.[53]

While in Italy, the artist Allan Ramsay managed to acquire for Mead a collection of drawings by Pietro Santi Bartoli that also had belonged to Cardinal Massimi. A student of Poussin, Bartoli was a commissioner of antiquities for the Vatican (the same office held in the eighteenth century by Johann Winckelmann) and a colleague of Giovanni Pietro Bellori, with whom he co-

operated on a number of projects.[54] Mead's volume of watercolor drawings, which Claire Pace has identified as that now in the collection of Glasgow University, includes 127 works produced for the cardinal depicting ancient Roman paintings and mosaics—most famously for the period the Tomb of the Nasonii (then associated with Ovid), but also the Domus Aurea, the Baths of Titus, and the Pyramid of Cestius.[55] The volume included as well images of frescoes discovered in July 1668 near the Flavian Amphitheater, three of which entered the Massimi collection. These, too, ended up at Great Ormond Street, presumably in the late 1730s, about the same time Mead came into possession of the drawings.[56] George Turnbull consulted both the drawings and the wall paintings for his 1740 *Treatise on Ancient Painting*, and in 1757 the Comte de Caylus referred to the drawings as having been in Mead's possession, though he was uncertain what had become of them after the doctor's death.[57] While the Bartoli drawings belong to a category of works different from those of Poussin, establishing firm divisions based on later notions of fine art and archaeology are misguided, and the aesthetic and antiquarian impulses can hardly be partitioned so neatly. In both cases, the drawings can be seen as a crucial stage of production, sources for works in progress valuable in and of themselves, even as they point to a more finished final product.

Two additional bound volumes deserve comment in this context. Auctioned on the final day of the prints and drawings sale for £158 11s. and now part of the Royal Collection, the volumes contain ninety-five paintings (watercolor applied over etched outlines) on vellum produced by Maria Sibylla Merian, including all sixty images for the *Metamorphosis Insectorum Surinamensium* (plate 7) Her magnum opus, the *Metamorphosis* was the triumphal conclusion to Merian's two-year stay in Dutch Suriname, which she visited specifically to study the flora and fauna of the New World.[58] Available with plain black and white plates, engravings hand-colored by her daughters, or images colored by Merian herself, the work appeared in Dutch and Latin editions in 1705. Stunning in their execution, these staggeringly beautiful illustrations demonstrate the possibility of confluence between precise depictions of the natural world and aesthetic accomplishment of the highest order.

Edward Harley's daughter and heir, the Duchess of Portland, supplies a useful firsthand account of visiting Mead's collection in 1742. She reported to Elizabeth Montagu that she

> was extremely well entertained the other day with seeing Dr. Mead's curiosities. They are much finer than Sir Hans Sloane's. In particular he has a mummy much finer preserved. It is the custom to gild their faces, so that

all the features are painted over the gold. . . . Of all the things, except the pictures, which are exquisitely fine, none pleases me more than a mask in bronze, which is exceeding fine workmanship, and has upon it the symbols of all the gods: the crown of vine for Bacchus, a circle of iron for Pluto, the ears of Pan, and the bear of waves for Neptune.[59]

The response of the duchess—a formidable collector herself—reminds us of the privileged status still afforded objects of curiosity, even in the mid-eighteenth century. By contrast, twentieth-century art historical expectations have commonly separated objects now regarded as art from this wider array of artifacts, with curiosity serving as a criteria for expulsion from the art museum. Mead's collection of natural specimens—coral, fossils, snakes, a crocodile, a salamander, a chameleon, fish, frogs, and spiders—for instance, should not be pushed aside so easily.[60] They were considered an invaluable basis for natural philosophy, and Mead's own experimental researches had focused on poisonous snake venom. The association, for example, adds an extra layer of significance to a work like Alessandro Algardi's *Infant Hercules Strangling the Serpent* (fig. 54), which appeared as a decorative tailpiece in the 1745 edition of *A Mechanical Account of Poisons* (fig. 55).[61] To judge from the medal produced in honor of the doctor (fig. 56), members of the next generation also connected works from Mead's museum with his medical pursuits (the sun and moon on the back allude to Mead's treatise on the influence of the celestial spheres on health).

A mummy, such as that described by the duchess, was an especially appropriate item for a physician's collection and further blurred the lines between nature and art. About 1734, Mead had acquired two such artifacts from the ancient Egyptian necropolis of Saqqara. He donated one to the College of Physicians and retained the other for himself (fig. 57). Both were published by Alexander Gordon in his 1737 *Essay Towards Explaining the Antient Hieroglyphical Figures, on the Egyptian Mummy, in the Museum of Doctor Mead.*[62] The text affirms the degree to which Mead engaged medicine through his virtuosic pursuits, for Gordon insistently ties the ornament of the mummy to sun and moon iconography—which returns us once more to Mead's *Treatise Concerning the Influence of the Sun and Moon upon Human Bodies.* While it is impossible to prove this was Mead's interpretation, Gordon at least expected it to resonate with the doctor. Such a reading is consistent with Mead's general outlook on ancient religion, which he tended to see as containing truths wrapped in supernatural embellishments that could often be explained naturalistically.

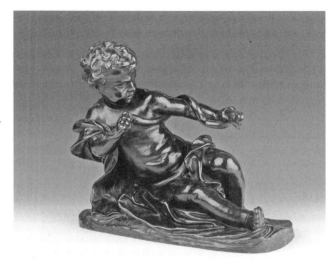

FIGURE 54 Alessandro Algardi, *Infant Hercules Strangling the Serpent,* ca. 1650. Bronze. Photograph courtesy John Culverhouse / Burghley House Collection, Stamford, Lincolnshire. Used by permission from John Culverhouse / Burghley House Collection.

FIGURE 55 Gerard Vandergucht, after Alessandro Algardi, *Infant Hercules Strangling the Serpent;* tailpiece from Richard Mead, *A Mechanical Account of Poisons,* 3rd ed. (London, 1745). Used by permission from Wellcome Library, London.

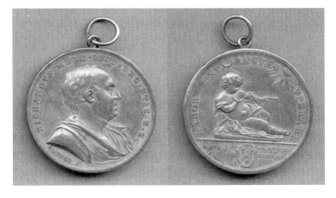

FIGURE 56 Lewis Pingo, *Medal of Dr. Richard Mead,* 1775. Silver. Photograph: Christopher Eimer.

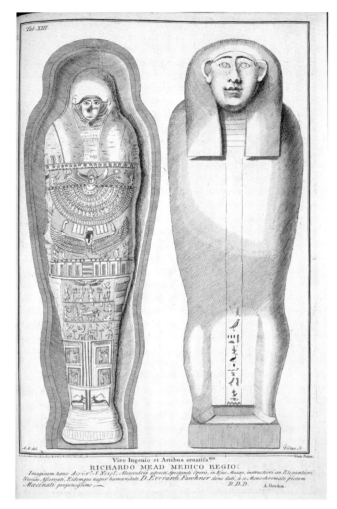

FIGURE 57 Mummy from Saqqara, Lower Egypt, owned by Dr. Richard Mead; from Alexander Gordon, *An Essay towards Explaining the Antient Hieroglyphical Figures, on the Egyptian Mummy, in the Museum of Doctor Mead* (London, 1737). Used by permission from the British Library, London.

Mead begins his *Harvey Oration*, delivered in October 1723, with a nod toward the Egyptians,

indeed a people the most ancient, and real masters of wisdom; among them was our art in so great esteem, that even their monarchs did not think it below them to practice it. We are informed, that Osiris and Queen Isis in particular were very great adepts in physic. Since their times rewards were assigned to physicians out of the public treasury, and the book which contained the rules for curing those affected with acute diseases, was held sacred.[63]

Mead's principal concern, however, lies with the status afforded physicians among the Greeks and Romans, and he creatively integrates textual and numismatic evidence to argue that doctors had been highly regarded in antiquity. If the spirit of the research placed Mead in line with a respected band of scholars from the previous two centuries who had pursued studies in medicine and coins—Continental doctors such as Paolo Giovio, Wolfgang Lazius, Jacob Spon, and Claude Genebrier—the project also aimed to produce tangible benefits in the present.[64] For Mead, the medical lessons gleaned from antiquity extended beyond theory and therapeutic regimes; social status in the eighteenth century might also hinge on the ancients.

The bronze mask that so pleased the Duchess of Portland is now in the British Museum. Cast probably between 200 BC and AD 100, it would originally have been one of two handle supports for a ritual vessel. As described by Ian Jenkins, such vessels resulted from the Alexandrian conquest of Egypt and the subsequent merging of Greek and Egyptian religious practices.[65] These eclectic origins find echo in the duchess's description of the piece, which she saw as in some way symbolizing "all the gods"; and whatever this understanding of the mask (presumably the same as Mead's) may have lacked, it suggests the extent to which curiosity is here founded on both quality ("exceeding fine workmanship") and iconography, standing in no way opposed to aesthetic concerns.

Allan Ramsay's first portrait of Mead (plate 8) was executed two years before the Duchess of Portland's visit and suggests one way Mead situated himself in relation to his collection. This standing three-quarter portrait presents the doctor as a self-possessed individual perfectly at ease among learned tomes and letters. Fashionably attired with sword at his side, he stands literally between the greats of antiquity, with Lord Arundel's bust of Homer (plate 6) at the left edge of the canvas and a statue of Aesculapius, perhaps that from his own library, in the niche on the right.[66] Contemporary with the picture are dozens of other portraits that draw upon the same sorts of accessories, and Pompeo Batoni made a handsome living in Rome painting young Grand Tourists with book or letter in hand and similar works of ancient sculpture to one side. Four years prior to the execution of Ramsay's portrait, in 1736, Mead had provided letters of introduction for the artist and his fellow traveler Dr. Alexander Cunyngham for their journey to Italy, and the two men returned in 1737 with new additions for Mead's collection: the Bartoli drawings already noted and a fragment of an ancient fresco.[67]

Yet whatever pictorial devices Ramsay may have acquired in Rome, Mead's portrait is not that of a young traveler posed against the backdrop of antiquity; nor does the picture mark his presence amid a distant, Mediter-

ranean landscape. Instead, Mead is shown to be entirely at home with these objects. As with Panini's capriccio, Homer and Aesculapius are natural inclusions for a learned physician and patron of ancient studies. In addition, however, to signaling an intellectual heritage, these works evidence Mead's refinement as a collector. He not only is shown to possess the ideals that eighteenth-century viewers would have understood Homer or Aesculapius to embody; he is shown as a man of taste among his collection, following in the tradition of Thomas Howard, second Earl of Arundel, and the Countess Aletheia, who a century earlier appeared in the *Madagascar Portrait* with the same bust of Homer.[68]

Just as the letters on the table allude to Mead's place in a learned social network, his relationship with Ramsay furthers the point. In addition to the connections already mentioned whereby Mead provided recommendation letters and Ramsay acted as an agent for the doctor, in 1739 the painter was admitted to Mead's Dining Club, a regular gathering of learned men in various fields. This relationship between sitter and painter, then, was itself based on mutual scholarly respect, and Mead's choice of Ramsay to execute the picture reinforces his own role as patron of the group.[69] As a physical sign of the relationship, the painting attests to Mead's support of the artist, who according to Vertue enjoyed "a great run of business for portraits" immediately following his return from Italy, with "people of the first quality being recommend by Dr. Mead."[70]

Along with these layers of meaning, the picture can be seen to recall Rubens's 1631 portrait of Dr. Théodore Turquet de Mayerne (plate 3), which Mead also owned.[71] Approximately the same size, both paintings include a statue of Aesculapius in a niche on the right-hand side of the canvas. Ramsay's portrait again connects the doctor to a previous medical exemplar while simultaneously underscoring the strengths of his collection. That Mayerne himself had been actively engaged with the fine arts and counted Rubens among his friends (as Mead did Ramsay) further strengthens the connection between the two physicians.

In various ways, Mead especially nurtured ties to Lord Arundel and his circle, and the bust of Homer included in Ramsay's portrait of the doctor is merely one of several examples. An equally impressive item from his collection is Rubens's portrait of the earl, now in the National Gallery (plate 2), which depicts Arundel wearing the medal of the Garter and a sumptuous fur-lined cloak.[72] Similarly, Mead owned one of Arundel's beloved works by Hans Holbein, a 1523 portrait of Erasmus sent to England by the Renaissance scholar himself (now at Longford Castle).

Though less immediate than these items of shared provenance, the con-

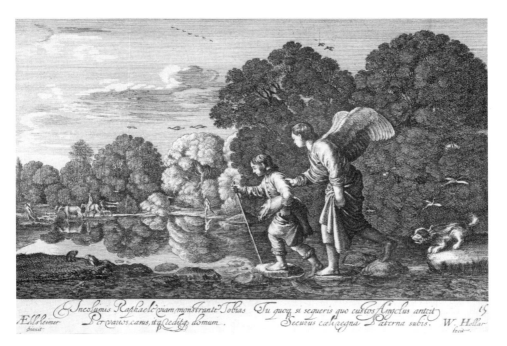

FIGURE 58 Wenceslaus Hollar, after Hendrick Goudt, after Adam Elsheimer, *Tobias and the Angel*. Etching. Used by permission from the Thomas Fisher Rare Book Library, University of Toronto.

nections between Arundel and Mead as forged by the latter's *Tobias and the Angel* (plate 9), likely the picture now in the National Gallery, are just as remarkable. Accepted today as a mid-seventeenth-century copy of an original painting by Adam Elsheimer now lost (the "large Tobias"), this work of oil on copper points back to Wenceslaus Hollar and his service for the earl.[73] Hollar's etching (fig. 58) of a somewhat different version of the picture (the "small Tobias" now in Frankfurt) is, in fact, a copy not of the original painting but of a print by Hendrick Goudt, which Arundel owned. The basic composition was widely known across Europe, partly because of Goudt's 1608 engraving. That Hollar went out of his way to replicate the inscription below the image (replacing only Goudt's signature with his own) indicates that this was indeed meant to be seen as a print copying a print. And yet the relationship of both images to the original painting never entirely disappears. Jacqueline Burgers suggests that Goudt's work may have helped spark Arundel's interest in the process of translating paintings into prints and perhaps encouraged him to employ Hollar in the first place.[74] Mead, himself an avid collector of Hollar's work, must have been aware of Hollar's copy

of Goudt's engraving (George Vertue acknowledges Mead as a key source for his 1745 *Description of the Works of the Ingenious Delineator and Engraver Wenceslaus Hollar*).[75] Mead's own painting of *Tobias and the Angel* thus pointed back to Arundel's circle through a series of associations that attested to the doctor's credentials as a connoisseur (like Arundel, Mead also had artists produce prints of many of the paintings in his collection).

The differences between the two versions of the painting by Elsheimer reinforce the virtuosic dimensions of Mead's collection. Both depict the young hero of the apocryphal book of Tobit as he's guided by the angel Raphael after having just wrestled from the water a fish that had attacked him. Though in some ways a reversal of the biblical Jonah story, the fish again serves as the catalyst for God's deliverance. For under the direction of Raphael, Tobias uses its gall, heart, and liver to cure his father's blindness and to free his future wife of an evil spirit. The book continues to be used as source material by scholars working on the history of ancient medicine (especially the treatment of cataracts), and these medical-antiquarian aspects would hardly have been lost on Mead.[76] But in contrast to the version engraved by Hollar, Mead's picture includes an older Tobias—he is, after all, headed to meet his bride-to-be—and it emphasizes the medical properties of the story. The young man's arm is placed in a sling; to the left of him we see blooming poppies and perhaps rhubarb (both were cultivated for their medicinal properties); and above the pair, there appears to be a eucalyptus tree, identified by its white disc-shaped blooms. Native to Australia, the plant had only just been discovered by Europeans, and it, too, was used for therapeutic purposes.

These were the sorts of details that would have appealed to Elsheimer's colleague, Johann Faber. A respected physician, pharmacology professor, and papal botanist, Faber belonged to the Accademia dei Lincei, one of the earliest and most important natural history associations in Europe, with members including Federico Cesi, Cassiano dal Pozzo, and Galileo Galilei. Taking its name from the sharp-sighted lynx, the academy attempted to engage nature empirically—attuned to the advantages and challenges of crafting a methodology dependent on the senses—and thus was an important precursor to the Royal Society.[77] Dr. Faber served as a witness at Elsheimer's wedding and perhaps introduced the painter to Rubens (Faber had treated the painter for pleurisy in 1606).[78]

Even if Mead were unaware of the depth of these connections, he would have appreciated the degree to which the artist gives visual expression to a biblical story of healing. Blurring rigid distinctions between miraculous cures, natural therapies, and divine providence, the story of Tobias fits nicely

with Mead's *Medica sacra,* a text that attempted to explain selected biblical diseases according to an eighteenth-century mechanized view of nature.[79] But beyond the ways in which the work might have resonated with Mead's own religious ideas, it allowed him to continue—consciously or not—the virtuosic legacy of the Lincei in Rome simply by his participation with these objects.

And equally crucial was the way in which these items were used. Rubens's portrait of Arundel, for instance, was engraved by Jacob Houbraken and included in Thomas Birch's *The Heads of Illustrious Persons of Great Britain* with a note indicating its place "In the Collection of Dr. Mead" (fig. 59).[80]

FIGURE 59 Jacob Houbraken, after Peter Paul Rubens, *Thomas Howard, Earl of Arundel.* Engraving; from Thomas Birch, *The Heads of Illustrious Persons of Great Britain, Engraved by Mr. Houbraken, and Mr. Vertue with Their Lives and Characters by Thomas Birch, A.M. F.R.S.,* vol. 2 (London, 1751). Used by permission from University of Chicago Library, Special Collections Research Center.

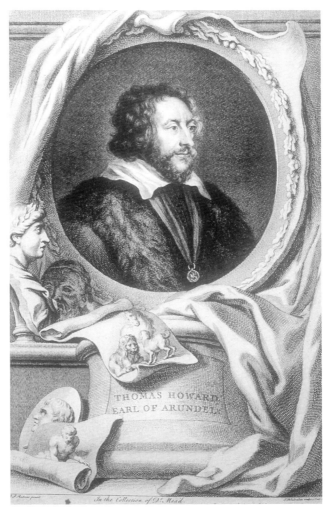

As we might expect by now, the familiar bronze head of Homer appears at the bottom edge of the decorative oval next to the earl's bust of the Empress Faustina (another work engraved by Hollar), works on paper, and a portrait relievo.[81] As a visual compendium of 109 key figures in British history covering not only members of royalty and the aristocracy but also poets, divines, physicians, and natural philosophers, the two-volume publication helped define and reinforce a canon of eminent British men and women. In addition, it served as a guide to the nation's leading collectors. Among those represented were the Earls of Burlington, Oxford, and Shaftesbury, the Dukes of Bedford and Devonshire, Robert Walpole, Dr. Sloane, Martin Folkes, and Jonathan Richardson. The source of seven portraits, Mead, however, provided the most images, and while this was in part due to his friendship with Birch, a fellow member and later secretary of the Royal Society, the degree to which the project asserted the strengths of his collection must nonetheless have been immediately apparent. One is hard pressed to find a portrait in the series of higher quality than Rubens's depiction of Arundel, and again even moderately informed readers would have recognized the head of Homer as an object whose provenance further connected the doctor to the earl.

As stressed in the first chapter, Harvey was a member of Arundel's circle, traveling with him on at least two occasions; and in 1636 he was sent to Rome with the earl's blessing to acquire paintings for Charles I. Mead's portrait of Harvey, which Houbraken also engraved for *The Heads of Illustrious Persons of Great Britain* (fig. 60), therefore reaffirmed Mead's connection to this coterie of seventeenth-century virtuosi, while implying a professional association with the celebrated physician as well. The naturalistically rendered snake on the caduceus in the foreground might have served as a subtle reminder of Mead's early venom studies, and one wonders if Evelyn's anatomic tables (discussed in chapter 2) inspired the depiction of the circulatory system. The print's juxtaposition of Harvey and Mead echoes a 1740 portrait of Mead, which depicts the Georgian physician alongside Minerva, who holds up a portrait of Harvey (fig. 61). If, as Desmond Shawe-Taylor suggests, Mead's cocked head signals his acceptance of the advice offered by these counselors, the image also functions as an endorsement from the deceased doctor and his allegorical escort. Birch's publication simply offers a more nuanced vision of this relationship for the consumption of a larger audience.[82]

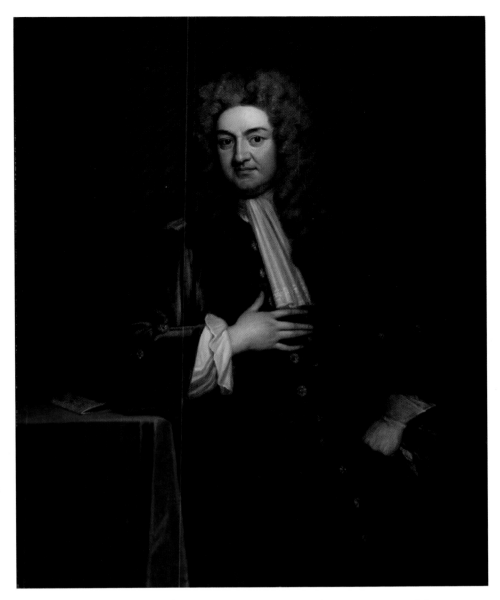

PLATE 1 Godfrey Kneller, *John Radcliffe, M.D. (1652–1714)*. Oil on canvas, 49 × 39" (124 × 99.4 cm). © Hunterian Museum and Art Gallery, University of Glasgow. Used by permission from Hunterian Museum and Art Gallery.

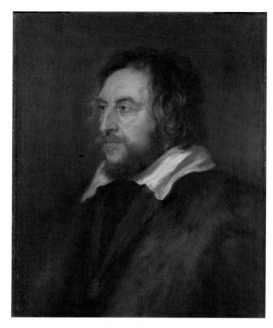

PLATE 2 Peter Paul
Rubens, *Thomas Howard,
Second Earl of Arundel*,
ca. 1629–36. Oil on canvas,
26½ × 21" (67 × 54 cm).
© National Gallery, London.
Used by permission from
The National Gallery.

PLATE 3 Attributed to Pe-
ter Paul Rubens, *Dr. Théodore
Turquet de Mayerne*, ca. 1630.
Oil on canvas, 54 × 43" (137.2
× 109.2 cm). North Carolina
Museum of Art, Raleigh,
purchased with funds from
the State of North Carolina.
Used by permission from
North Carolina Museum of
Art. Writing to the artist in
March of 1631, Turquet mod-
estly refused to believe "that
the ornaments of Aescula-
pius and a beacon inviting
ships to reach a safe harbor
were proper for my portrait."

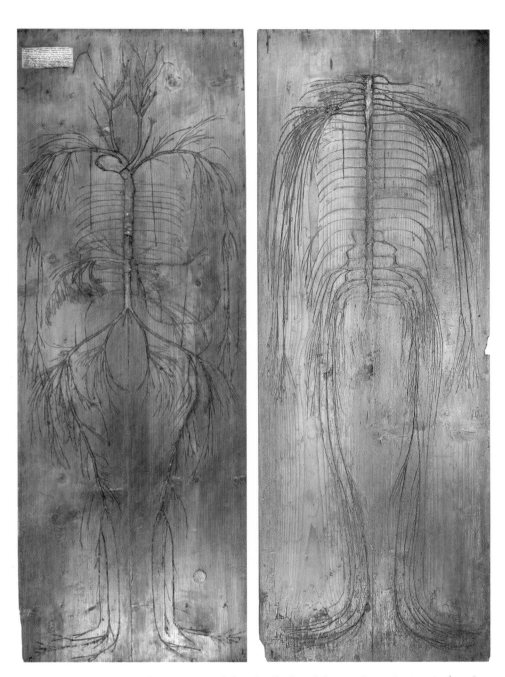

PLATE 4 Giovanni Leoni, (*A*), *Aorta and the Distribution of the Arteries*; and (*B*), *Spinal Cord and the Nerves of the Trunk and Extremities*, ca. 1646. Museum of the Royal College of Surgeons, London. John Evelyn acquired this set of four anatomic tables while studying anatomy in Padua. Shown here are actual human arteries and nerves mounted onto wooden panels.

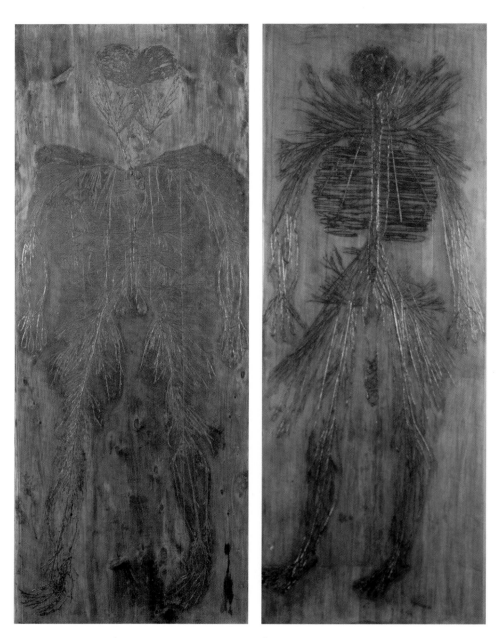

PLATE 5 (A), *Arteries*; (B), *Nervous Systems*, two of six anatomic tables acquired by Dr. John Finch in Padua, ca. 1650–60. © Royal College of Physicians, London. Used by permission of the Royal College of Physicians. Along with those belonging to Evelyn, also acquired in Padua, this is the only other set of anatomic tables known to exist. Finch was the brother-in-law of the niece of William Harvey.

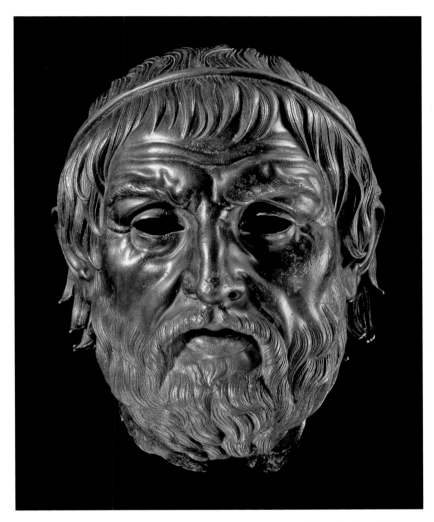

PLATE 6 Bronze head from a statue, perhaps a portrait of Sophocles, third century BCE. Bronze, 11½" (29.5 cm) high. © Copyright the Trustees of The British Museum. Used by permission from The British Museum, London. Long understood to be a portrait of Homer, the work was part of the Arundel collection before Dr. Richard Mead acquired it in 1720.

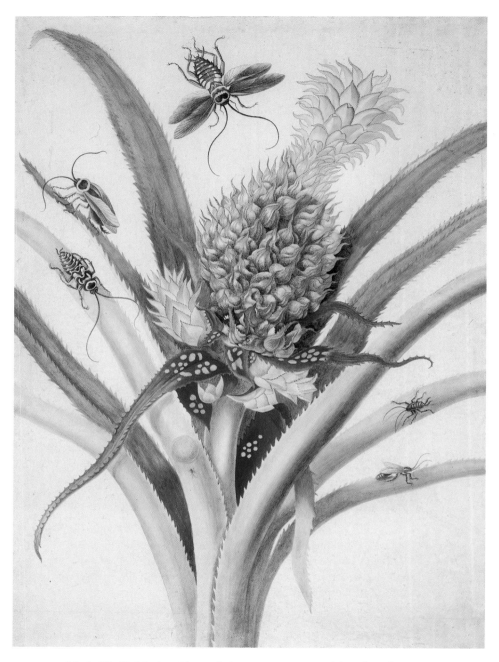

PLATE 7 Maria Sibylla Merian, *Pineapple* (Ananas comusus) *with Cockroaches*, ca. 1701–05. Watercolor on vellum. The Royal Collection © 2007, Her Majesty Queen Elizabeth II.

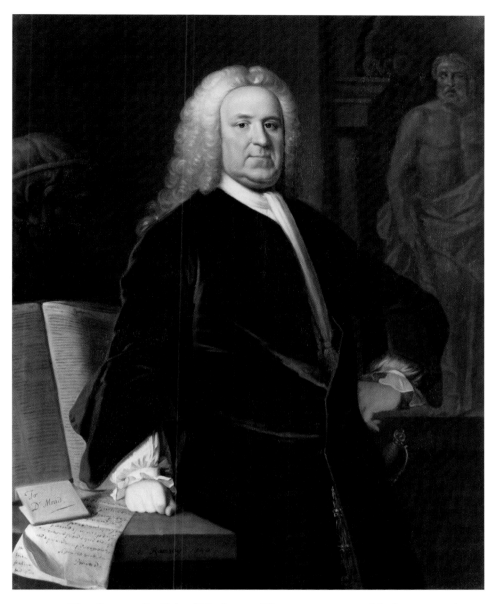

PLATE 8 Allan Ramsay, *Dr. Richard Mead*, 1740. Oil on canvas, 50 × 40" (126.4 × 101 cm).
Used by permission from National Portrait Gallery, London.

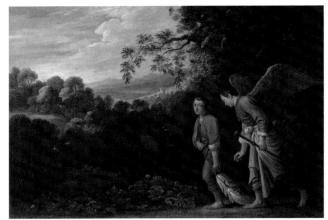

PLATE 9 After Adam
Elsheimer, *Tobias and
the Archangel Raphael
Returning with the Fish*,
mid-seventeenth century.
Oil on copper, 7½ × 11"
(19.3 × 27.6 cm).
© National Gallery, London.
Used by permission from
The National Gallery.

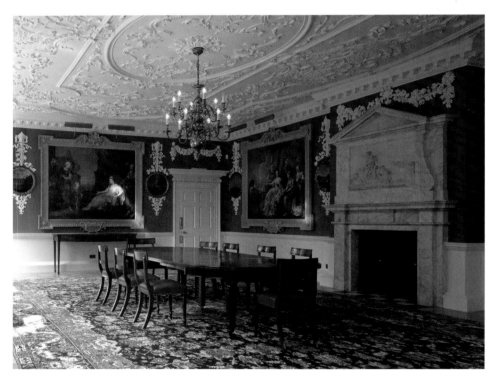

PLATE 10 Court Room of the Foundling Hospital, Foundling Museum, London. Photograph: Richard Bryant / arcaid.co.uk. Used by permission from Richard Bryant / Arcaid. The room's four history paintings date to 1746, while the eight roundels depicting London hospitals were in place by 1750.

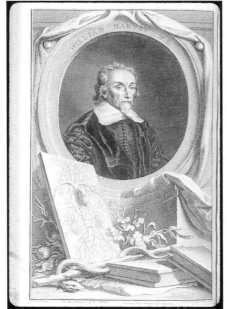

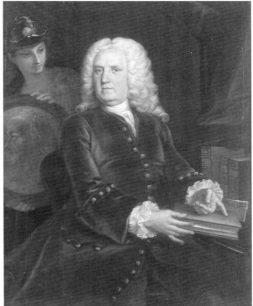

FIGURE 60 Jacob Houbraken, after William van Bemmel, *Dr. William Harvey.* Engraving; from Birch, *The Heads of Illustrious Persons of Great Britain,* vol. 1 (London, 1743). Used by permission from University of Chicago Library, Special Collections Research Center.

FIGURE 61 Unknown artist, *Dr. Richard Mead,* ca. 1740. Oil on canvas, 50 × 40" (126.4 × 101 cm). Royal College of Physicians, London. Used by permission from Royal College of Physicians.

Mead, Burlington, and Pope

In 1738 the Scottish art dealer Andrew Hay judged that the audience in London for objects of curiosity, antiquities, and the fine arts had seen better days: "the virtù is very low at present. Lord Burlington and Doctor Mead seem to be the principale supporters of it."[83] Apart from the issue of its accuracy, Hay's assessment suggests an affinity between these two collectors. Twenty years younger than Mead, Richard Boyle, third Earl of Burlington, forged his essential aesthetic commitments in conjunction with his travels in Italy in 1714-15 and 1719—approximately when Mead began collecting at a serious level. Burlington was particularly drawn to seicento painting and to the architecture of Andrea Palladio. Similarities in taste between Burlington and Mead are compelling, and points of contact between the two men help in plotting the doctor's place in the early Georgian world of the fine arts. At

the same time, Mead's engagement with the virtuosic tradition of the previous century raises questions about how closely he and Burlington can be aligned, or perhaps how apt the model of civic humanism as an overarching explanation is for addressing either man.

A friend and physician of Alexander Pope, Mead appears in the opening lines of the poet's "Epistle to Lord Burlington"—together with Sloane, Thomas Herbert, eighth Earl of Pembroke, Richard Topham, and Thomas Hearne—as a model of erudition, though ironically not a model to be emulated, or at least not in any immediate manner. If Mead and his fellow collectors represent the pinnacle of cultured acquisition, Pope asserts the futility of apish imitation and gross expenditure:

> Something there is more needful than expense,
> And something previous ev'n to taste—'tis sense:
> Good sense, which only is the gift of Heav'n,[84]

While the skeptics may have had trouble discerning exactly what distinguishes these virtuosi—not to mention Burlington himself—from the "imitating fools" whom Pope chastises, Mead could be numbered among the tasteful elect of Burlington's circle, at least by those inclined to accept Pope's argument.

In a more private context, Mead's name appears throughout Pope's correspondence from the early 1720s until his death in 1744. Pope writes, for instance, to Samuel Buckley commending the latter's plan to publish the first critical edition of Jacques-Auguste de Thou's history of the sixteenth century, a project supported by Mead, who not only helped defray publication costs but also purchased the source materials, assembled by the Jacobite Thomas Carte during his exile in France.[85] Pope also refers to dinner engagements with Mead, and, when Dr. Cunyngham presented the ancient fresco of *The Court of Augustus* at Great Ormond Street in May of 1737, Pope was among those at the table.[86] Most common are references to health concerns, and the correspondence includes dozens of examples Pope's reports on his own illnesses, descriptions of treatments prescribed by Mead (he was particularly fond of "Asses Milk," it seems), and inquiries into the health of others who similarly consulted the doctor.[87]

It was at Mead's request that Pope sat for his portrait at Jonathan Richardson's studio in January 1738. All three men were close acquaintances, and Richardson produced at least three images of the doctor at about this time: a painting, an etching, and a sketch in chalk.[88] Mead likewise owned several portraits of Pope by Richardson, and Maty's account of Mead's life, after

noting "he was the friend of Pope, of Halley, [and] of Newton," describes the way he placed portraits of them "near the Busts of their great Masters, the antient Greeks and Romans."[89]

Godfrey Kneller was responsible for the portraits of Halley and Newton, and next to Rubens was, with ten pictures, the best represented artist in the collection. The adaptation of Maty's life in the *Gentleman's Magazine* in regard to this modern trio of "great men" is worth noting. Bentley takes Halley's place, and the illustrious *"Greeks* and *Romans"* in Mead's collection are said to have been "the *Popes, Newtons,* and *Bentleys* of their time."[90] In an inversion of the usual ancient and modern categories, eminent Georgians are not cast as Ancients, but the illustrious men of antiquity are cast as Moderns. Cementing the connection in regard to Pope is the fact that in addition to being a celebrated poet, he also produced the first full English translations of Homer's *Iliad* and *Odyssey.* The first volume of the 1715 *Iliad* included a frontispiece engraving by Vertue of the Farnesina Homer, some five years before Mead acquired Lord Arundel's bronze bust.[91] Pope's accomplishment as a translator helped establish, by extension, the importance of the latter piece, and its subsequent reputation is thus indebted to these English editions, though it is difficult to imagine Mead conceding as much.

In the 1730s, Pope, Burlington, and Mead served on the committee responsible for the erection of a monument to Shakespeare in Poets' Corner at Westminster Abbey. They organized the raising of funds through public subscriptions to benefit performances of the Bard's plays at the Drury Lane Theatre and the Covent Garden Theatre. Vertue states that the shows "raisd about 300 pounds," which was "deposited in trust to the Earl of Burlington, Dr. Meade, and Mr. Alex. Pope."[92] Peter Scheemakers carved the marble statue (fig. 62), working after the designs of William Kent. As David Piper notes, the pose recalls that of the Farnese Hercules and, by extension, Paolo de Matthaeis's *Judgment of Hercules* painted for the Earl of Shaftesbury, even as Shakespeare is shown in vaguely seventeenth-century apparel, or "'Vandyke dress' . . . that peculiar never-never period costume in which so many eighteenth-century sitters from the 1720s on chose to have themselves portrayed."[93] A number of busts by Scheemakers were included in the 1755 sale of Mead's gems and sculptural works, and Mead's own monument in Westminster Abbey was executed by the artist.[94] In addition, Mead owned a portrait by Kent of Inigo Jones in which the image of the "English Palladio" is supported by the female personification of Architecture; and in a letter to Lady Burlington, Kent records dining with "Dr. Mead, Ld Oxford, Bryan [Fairfax], Sr Andrew [Fountaine], Pope, etc."[95]

Mead's place in this circle of tastemakers and his role in the monument

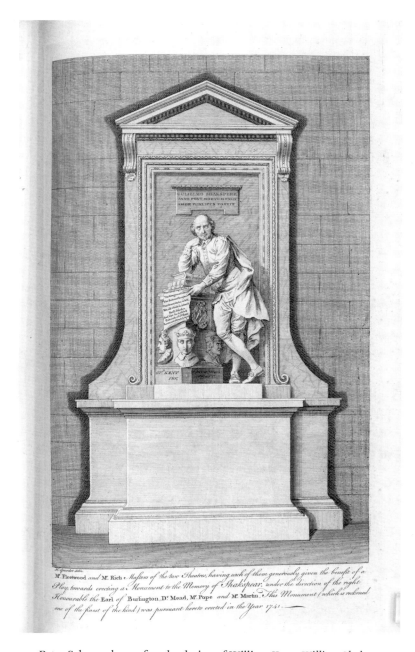

FIGURE 62 Peter Scheemakers, after the design of William Kent, *William Shakespeare*, 1741. Westminster Abbey, London. Marble. From John Dart, *Westmonasterium; or, The History of the Abbey Church of St Peter's Westminster*, vol. 2 (London, 1742). Used by permission from Harry Ransom Humanities Research Center, The University of Texas at Austin.

to Shakespeare, which was finally completed in 1741, helps explain Hay's pairing of Burlington with the doctor and suggests that we might understand the latter's artistic sensibilities as adhering to a Burlingtonian conception of aesthetics. Mead's involvement in the project and his patronage of Kent and Scheemakers complies, moreover, with the civic humanist model of art expounded so fruitfully in the past two decades by scholars such as John Barrell, Ann Bermingham, and David Solkin, all of whom have stressed the way in which artistic sophistication, formulated according to the principles of "public virtue," played a vital role in securing one's place in the Republic of Taste and consequently one's potential for wielding power. The idea for a monument to Shakespeare had been advanced as early as 1726 by John Rich, manager of the Covent Garden Theatre, but became viable only when Burlington, Mead, and Pope stepped in. As arbiters of taste, they provided the needed leadership and direction, organizing the public's efforts for the public's good, all according to appropriate aesthetic demands, befitting the Bard. As Morris Brownell notes, recognition of the public's role in the project—in the form of the inscription "Amor Publicus Posuit"—was added at Pope's insistence, over and against the objections of Mead, though the doctor was presumably pleased with the Herculean imagery, the sort of reference that common theatergoers who had contributed their half-guineas at the benefit plays might never notice.[96]

Mead's involvement in the 1730s and '40s with the origins of Guy's Hospital and the Foundling Hospital further demonstrates the relevance of the discourse of civic humanism for understanding Mead's life. Solkin has addressed Scheemakers's statue of Thomas Guy outside the former hospital in precisely these terms, and his scholarship on the Foundling has proved seminal for understanding charity in eighteenth-century England more generally.[97] Mead's own economic interests as a physician make him an interesting candidate for republican models of scholarship, which have grappled with the tensions between social and private interests, between the public good on the one hand and the flood of economic benefits to be gained from expanding markets on the other.

And yet, civic humanist accounts—for all they may disclose of Georgian ethics, motivations, and political ideologies—ultimately account for only a portion of Mead's intellectual and artistic pursuits (his absence from Solkin's work is striking). The doctor's ideals depended more on seventeenth-century antiquaries and learned physicians than disinterested abstraction. Moreover, civic humanist approaches fail to account for the actual venues and networks that, in many cases, proved most important for the arts in eighteenth-century England. Such approaches also tend to have little use

for the fact that even Burlington, a grandnephew of Robert Boyle's, was a member of both the Royal Society and the Society of Antiquaries, and that his intellectual pursuits owed as much to Newton as to Shaftesbury.[98] Charitable patronage resulting from anxieties over a thriving marketplace and the consumption of luxury goods goes only so far in explaining how hospitals became the first venues for the public display of contemporary art, the seeds of full-blown public exhibitions and a state-sanctioned academy.

Virtuosity at the Foundling and the Limits of Civic Humanism

The decade before William Hogarth became involved with the Foundling, he had provided, with the assistance of Charles Lambert, two large paintings for the Staircase Hall of the newly renovated St. Bartholomew's Hospital: *The Pool of Bethesda* and *The Good Samaritan* (the artist's experience at the hospital may have occasioned his inclusion of Drs. Dod and Bamber in *The Company of Undertakers*).[99] Hogarth was particularly eager for the project—agreeing even to do it without charge—since it initially seemed destined for Jacopo Amigoni, a favorite of the Burlington circle (Mead owned two paintings by the Roman expatriate, including a 1735 portrait of Queen Caroline, a royal gift for Mead's medical services). Amigoni had replaced Sir James Thornhill at Moor Park, the Restoration country house in Hertfordshire that Thornhill had redesigned for the estate's new owner, Benjamin Styles, in the fashionable Palladian manner. Toward the end of the project, as the architectural work and most of the paintings for the interior were finished, Styles grew dissatisfied, and the commission ended in a pair of lawsuits.[100] Amigoni thus represented for Hogarth all that was wrong with the patronage of art in England. In fact, Thornhill's commission at the Greenwich Naval Hospital (fig. 48) is the most striking precedent for Hogarth's work at St. Bart's. The medical context undoubtedly was bound up with political ideology, but we need not necessarily look to Continental notions of civic virtue as formulated by Shaftesbury. We could as easily approach it from the vantage point of virtue as understood by the circle of Christopher Wren and John Evelyn: the slippage of meaning found in the *virtuoso* label since the Restoration, in fact, turns out to matter a great deal. Hogarth's choice of subjects, a miracle and a parable drawn from the Gospels, were well suited for the hospital setting in the same way that many of Mead's pictures were appropriate for a learned physician. The way in which Hogarth approached the subjects, however, was considerably different. While indebted to Raphael's *Healing of the Lame Man in the Temple* and Charles Le Brun's theory of the passions,

Hogarth insists on locating these forms in relation to particular physical causes. Though large-scale history paintings, the two pictures depend on the same empiricist instincts as Hogarth's *Progresses,* set in contemporary London. Horace Walpole found them "ludicrous" and judged that "the genius that had entered so feelingly into the calamities and crimes of familiar life, deserted him in a walk that called for dignity and grace."[101] Other connoisseurs undoubtedly agreed, but Hogarth's reputation continued to rise. More important, the paintings at St. Bart's were not used to disqualify Hogarth from the Foundling project.

In contrast to the Staircase Hall project, the Foundling entailed the ornamentation of a space that required a number of easel pictures rather than one or two oversize wall paintings.[102] Hogarth, with colleagues from the St. Martin's Lane Academy, produced for the Court Room (plate 10) four pictures depicting God's providential care for children: Joseph Highmore's *Hagar and Ishmael,* Francis Hayman's *The Finding of the Infant Moses in the Bulrushes,* Hogarth's *Moses Brought before Pharoah's Daughter,* and James Wills's *The Little Children Brought before Christ.* The pictures point to three crucial moments in Judeo-Christian history: Abraham's attempts to father a vast nation, Moses's access to the wisdom of the Egyptians (later crucial for his leading the enslaved Israelites out of Egypt), and Christ's fulfillment of the Old Law, exemplified in the way he unexpectedly elevated the least of society. The distant past is contextualized within a pronounced Georgian present through the eight roundels by Edward Haytley, Samuel Wale, Richard Wilson, and Thomas Gainsborough, which depict the exteriors of London's leading charitable institutions: the Charterhouse and seven hospitals, including the Foundling.

This oscillation between past and present, between grand narratives and architectural portraits, can itself serve as a model for what Hogarth and his colleagues hoped to achieve: a new mode of history painting that could draw from the past—in terms of content and artistic accomplishments—and yet still belong in the present. The attention the Royal Society directed toward the natural world finds its aesthetic corollary in the paintings of Hogarth, who embraced the notion that art, at least at its best, could convey something of the truth of appearances.

Given the limited scale of the exhibition opportunities at the Foundling, especially in the first several decades, one might see it as a disappointing experiment for showcasing contemporary painters. But as Matthew Hargraves argues, the hospital's significance for the arts depended above all on the sense of community and institutional identity it provided. The annual artists' feasts hosted by the Virtuosi of St Luke and the Rose and Crown Club,

for instance, seem to have ended by the late 1740s, having been replaced by a "single, all-encompassing dinner at the Foundling."[103] A guest list from November 5, 1757, with the heading "Dilettante, Virtuosi Feast" reads like a Who's Who of midcentury artists and designers. Among the 154 names, one finds William Chambers, Francis Cotes, Hayman, Highmore, Hogarth, Nathaniel Hone, Thomas Hudson, Joshua Kirby, Ramsay, Sir Joshua Reynolds, Louis-François Roubiliac, John Michael Rysbrack, Benjamin Wilson, and Richard Wilson.[104]

In 1749, John Gwynn, an architect with ties to the St Martin's Lane Academy and a friend of Samuel Johnson's, published his *Essay on Design,* which advocated for an academy supported by public subscriptions. In it, Gwynn addresses perennial concerns over the gap in knowledge and skill between French and British artists, but attributes the deficiencies of the latter to the absence of an academy in England. Impressed with the success of hospitals funded not by the state but by the contributions of private citizens, he notes that "the Taste for subscribing to Hospitals and Infirmaries is now very much in vogue." On the basis of the observation, he asks his readers to consider the larger possibilities of such potential sources of patronage: "suppose you make an Hospital for Genius, since she is so little able to provide for herself."[105]

With this emphasis on the public good, Gwynn seems initially to fit squarely within the civic humanist tradition, but he doesn't stop there. Instead, he shifts the focus, suggesting that

> we may now alter the Expression from *Charity* to real *Interest* and *Pleasure.* The beneficent Patron of Learning and Arts will most likely be the subject of them: If he tastes them, he will have the double Pleasure of receiving his just Tribute, and observing how this Encouragement has succeeded: If Flattery only suits his Palate, he may probably have enough to satisfy his Vanity. For the Professors of the Arts I am treating of, though their Genius is exceedingly raised by great Actions, will not be more backward than the Colleges in preserving the Merit of those whom they know only by their Benefactions. Suppose then we change our Hospital to an *Academy,* in the sense of the Word received by the Learned?[106]

Gwynn goes on to reason that since the artists of ancient Athens enjoyed the kinds of esteem bestowed in his own day upon scholars from Oxford and Cambridge, contemporary painters and sculptors ought to have a comparable institutional affiliation.

As he advocates for an art academy, his own metaphors point to the

eclectically fluid and unfocused character of midcentury efforts to shore up support for such an institution. Still, the argument reinforces the degree to which the hospital provided a means for making such a case, however disjointed. And as Gwynn makes clear, that story is considerably more complicated than mere charity.

In fact, the plan fits within a larger scheme that can be traced back to the History of Trades project and the Royal Society's Restoration agendas. Gwynn argues that an art academy would teach "at least as much useful Knowledge in the Commerce of Life" as a university course of study in Latin or Greek.[107] As a model, he holds up the example of Count Luigi Marsigli, who donated to the Senate of Bologna his "Library, with his Collection of Rarities," which were to be distributed "in seven Apartments": the first for mathematics and the military arts, the second as an astronomical observatory, the third for "experiments in Natural History," the fourth for "Curiosities of Nature," the fifth for "ancient Works and Pieces relating to Erudition," the sixth a library, and finally, the seventh as an "Academy of Painting."[108] Marsigli himself was elected a Fellow of London's Royal Society in 1691, and in 1721 he spent six weeks in the British capital, where he was received personally into the esteemed body and introduced to the ideas, books, and collections of men such as Newton, Sloane, and Mead.[109] It is not therefore simply that the Foundling provided one of the first public exhibition venues for contemporary British artists. It did that but also more. It fostered a shared sense of identity among artists (however fleeting) and ensured that the rhetoric of early appeals for an art academy would take shape according to traditional virtuosic values of polymathic knowledge, exemplified by the Royal Society (here one might recall that the Foundling's architect, Theodore Jacobsen, was also an FRS). For all of the innovation that the Foundling represents, the institution also can be seen as one logical outcome of more than a century of engagement between medicine, virtuosity, and the fine arts. Within this context, it was perhaps inevitable that physicians would, at least initially, continue to occupy a privileged position. It was hardly by chance that Mead's support opened doors for the Foundling that even Thomas Coram's deep pockets could not.

As for Hogarth and Mead, their artistic sensibilities in many ways stood diametrically opposed. Ramsay's 1747 portrait of the doctor for the Foundling has, perhaps since it was first finished, been understood as a kind of challenge to Hogarth's 1740 portrait of Captain Coram, the institution's benefactor. The two portraits are comparable in size and format, but whereas Hogarth provides a psychological point of entry into the character of Coram, Ramsay emphasizes the doctor's dignified distance. Because of

Hogarth's open antipathy toward Burlington, one might be tempted to assume the same animosity existed between the artist and Mead. Remarkably, this does not seem to have been the case, or at least—and more important—there is no evidence from eighteenth-century public sources to suggest as much.

Placing Mead and Hogarth within the same contexts is hardly difficult, so long as one is content to forego any direct encounters. In addition to the time and energies they both gave to the cause of the Foundling, they knew many of the same people and often moved (however differently, given their social positions) in similar circles. Moreover, if in fact Dr. Dod was represented in Hogarth's *Company of Undertakers* (fig. 49), Mead would have been only too pleased, since Dod had been an outspoken opponent of Mead's regarding smallpox inoculation. Similarly, Mead must have been delighted to see Mapp and Ward satirized. As a royal physician, he could not have appreciated the open-mindedness with which the king and queen embraced alternative forms of medicine offered by these practitioners.

It is more difficult to know what Mead would have thought of Hogarth's inclusion of James Dalton's name on the wig box atop the Harlot's bed in plate 3 of *A Harlot's Progress*.[110] Dalton was a thief who in 1729 had tried to rob Mead while the doctor was in his coach. The failed attempt, which earned Dalton a three-year prison term, appeared in several newspapers, enhancing Mead's reputation as one of London's best-known physicians.

In a different vein, an 1888 article in the *Asclepiad* includes a reproduction of a sketch, purportedly by Hogarth, which depicts Mead "as a Militia Drill Sergeant" in less than flattering terms. Although the whereabouts of the drawing are now unknown (if the attribution is even reliable), there is nothing to suggest the sketch ever circulated.

I do not mean to suggest that Mead and Hogarth were friends or obvious allies, or even that Hogarth in any way benefited from Mead's superior position. I believe, however, that the difficulty in establishing direct contact between these two central figures of the London art world is itself significant. In contrast to traditional accounts that have placed the likes of Hogarth and Burlington in opposition to each other, we could more productively engage early Georgian art by instead addressing Hogarth and Mead as embodiments of two never-resolved positions at the center of the English virtuosic tradition since at least the Restoration.[111]

From the beginning of the History of Trades project, tensions arose between workers and gentlemen, between applied craft and abstract knowledge, between makers and scholars. Hogarth and Mead not only exemplified these positions; each, in his own manner, managed to reach out to the

other side. In *The Analysis of Beauty,* Hogarth genuinely struggles to reconcile his commitments to a modern English mode of painting with the authority still contained in classical models from the Continent. He draws on various scholars, antiquaries, and physicians. He even includes one of Mead's own publishing projects to make his case. Likewise, Mead was celebrated for his generous support of artists. Men such as Arthur Pond and Benjamin Wilson made copies of works in his collection, and Horace Walpole, for one, seemed especially annoyed at the warm reception Mead extended.[112] The doctor's support of Watteau during the painter's visit to England about 1719 places Mead in the company of his French counterparts, who embraced the notion that artists and aristocrats could, under certain circumstances anyway, interact freely. Jonathan Richardson and then Allan Ramsay emerged, for Mead, as models of what the learned painter might look like, and he offered enthusiastic encouragement to artists pursuing naturalist projects: Eleazar Albin (the watercolorist known for his depictions of insects and birds), George Edwards (the custodian of the Royal College of Physicians and author of *A Natural History of Birds*), and Mark Catesby (whose *Natural History of the Carolina, Florida, and the Bahama Islands* contains the earliest illustrations of much of North America's flora and fauna).[113]

But if both Hogarth and Mead can be accommodated within this virtuosic legacy I have tried to chart from the early seventeenth through the mid-eighteenth centuries, and if both managed to engage the other side, the end result looks less like cooperation or compromise than disjunction. Moreover, since each so effectively championed his primary commitments, the wider discourse has to a large extent faded into obscurity, especially as later narratives of British art, shaped by events from after the founding of the Royal Academy in 1768, have tended to extract works of art and their makers from their original and widely eclectic contexts. Whatever Mead thought of Hogarth, he could hardly have anticipated the degree to which the artist's reputation would expand over time while his own would fade.

Mead's solution to the nagging problem of how a learned physician could embrace the new empiricist orientations of the Royal Society without becoming an empiric turned out to be a balancing act that grew increasingly difficult to sustain over the courseof the century. But for Mead, at least, it was still possible to conceive of a unified field of knowledge where the New Science had yet to discredit the authority of Galen. If the Ancients and Moderns seem irreconcilable to us today, the disconnect underscores the distance between us and this moment when tensions between antiquity and modernity still played out as a rivalry between siblings, when a future without both was still unthinkable.

CONCLUSION

Among those present at the Foundling Hospital for the 1757 Dilettante and Virtuosi dinner was the architect James "Athenian" Stuart. He had returned just two years earlier from traveling throughout the eastern part of the Mediterranean, where, together with his colleague Nicholas Revett, he had made careful measurements and drawings of the monuments of ancient Athens. The resultant four-volume publication, *The Antiquities of Athens* (1762–1816), would provide the earliest authoritative views of many of the most important buildings from ancient Greece and eventually play an influential role in the Greek Revival.[1]

In 1757, well before anyone realized how long the wait for the books would be, Stuart was a sensation, an architect who had experienced first-hand the sources of classical architecture. This at least was how Stuart himself portrayed his travels in Athens, and his patrons were predisposed to agree (regardless of the protests of the likes of Giambattista Piranesi or Robert Adam). He was above all associated with the Society of Dilettanti, a social extension of the Grand Tour, which had since its inception in the 1730s cultivated a republic of taste based on ancient models and fraternal collegiality (Horace Walpole refused to see it as anything more than a drinking club).[2] But other affiliations were crucial for Stuart's career, too. In 1756 he was elected a member of the recently founded Society for the Encouragement of Arts, Manufactures, and Commerce—an institution that followed in the footsteps of the Royal Society in addressing a considerable array of interests from the fine arts to mechanics, from chemistry to colonial affairs, from agriculture to manufacturing.[3] His first recorded act was to propose Sir Joshua Reynolds for membership (William Hogarth and his circle had already been

inducted). In keeping with the group's wide mission, Stuart delivered an account of the production of silk as practiced on the island of Andros, and he produced the design of the inaugural prize medals distributed by the society (again the Royal Society with its Copley medal, the first of which was issued in 1737, served as the model). In 1758, Stuart himself was elected Fellow of the Royal Society, as well as the Society of Antiquaries, and—following in the footsteps of Christopher Wren—he was appointed surveyor to the Royal Hospital at Greenwich, a position he held until his death.

As Catherine Arbuthnott makes clear, Stuart fashioned himself as a traditional polymath. In 1769 he presented a paper to the Royal Society on Egyptian hieroglyphs; in 1773 he exhibited a depiction of a kangaroo brought back to England by Captain James Cook; and he generally nurtured ties to philosophers and the literati.[4] For all of the ways in which *The Antiquities* improved upon previous accounts of Athens, it also could be seen as the continuation of the work of Dr. Jacob Spon, the French physician and antiquary who with Sir George Wheler traveled to Greece in the seventeenth century, publishing *Voyage d'Italie, de Dalmatie, de Grèce et du Levant* in 1678. One imagines Stuart would have been perfectly at home in Dr. Richard Mead's library.

Such confidence in traditional models of erudition suggests their ongoing relevance even in the decades after Mead's death. On the other hand, that Stuart's patronage expectations ultimately faltered in comparison with the more entrepreneurial strategies of Josiah Wedgwood and Robert Adam indicates that this older virtuosic culture was indeed changing.[5]

What has gone unrecognized is the extent to which that virtuosic culture nonetheless provided the basis on which a late Georgian art world could be erected. The Royal Society supplied a platform for addressing art theory (albeit typically contextualized through the lens of utility) decades before there were any established art societies to do so. Mead's home served as an exhibition space, at least for the well connected, even before the Foundling was established. Toward the middle of the century, venues such as St. Bart's Hospital and the Court Room of the Foundling offered a glimpse of what a public contemporary art scene might look like in England. And, as I have stressed, these artistic engagements were, more often than not, intertwined with interests in the natural world broadly, particularly the human body and the discourse of medical knowledge and practice. Even the general drift toward neoclassical accuracy—characterized by meticulous attention to measurements, precedence of forms, and the reproduction of particular colors and compositions—might be connected to the previous generation's insistence on the abstract value of mathematics as a means of distinguish-

ing competency from quackery. Seventeenth-century debates over absolute and probable knowledge claims perhaps informed not only empiricism as a mode of philosophy but also neoclassicism as an aesthetic solution.

Connecting the material probed in the previous chapters to the late eighteenth and early nineteenth centuries would require consideration of a variety of topics: the ongoing role of physicians and artists in London's cultural and intellectual associations; the ways in which organizations like the Lunar Society continued to frame the fine arts in terms of utility and natural philosophy; the importance of Bath and other therapeutic centers for painting; the discourse of sensibility as a means of understanding physiology and aesthetics; the ways in which individual doctors continued to impact the arts (it is easy to forget that one of the most famous sitters in all of eighteenth-century portraiture, Jean-Paul Marat, was a physician who first made his reputation in London); the ongoing medical interests of artists (Philip James de Loutherbourg, for example, was keenly interested in alchemy, hermeticism, and faith healing); the development of private collections; and the formation of national museums (the first purchase of prints ever made for the British Museum came in 1806, when James Monro sold the institution an assortment of engravings he had inherited from his father, Dr. John Monro of Bethlehem Hospital).

There are numerous threads still to be traced within this period from 1600 until 1760 as well. For all the historical overlap between Mead and Dr. Hans Sloane, for instance, the latter could undoubtedly anchor a distinct, if complementary, story of his own.[6] Likewise, Martin Folkes, as vice president of the Foundling Hospital and president of both the Royal Society and the Society of Antiquaries, merits more attention than he has thus far received. Another FSA, the Yorkshire surgeon Francis Drake, points to the way in which many of the themes explored here within the context of London extended throughout England. With the support of Lord Burlington, Drake published *Eboracum; or, The History and Antiquities of the City of York*, which, among other things, attempted to fix the site of the ancient Roman station of Delgovitia at Londesborough, Burlington's Yorkshire seat. As further evidence emerged, Drake returned to the subject, collaborating with his friend Dr. John Burton; in 1747 their paper was read before the Royal Society and published in the *Philosophical Transactions*.[7]

Four years later Burton's *Essay Towards a Complete New System of Midwifery Theoretical and Practical* was published with eighteen engravings by George Stubbs.[8] As a prime example of a British artist shaped by virtuosic expectations, Stubbs himself studied anatomy with the surgeon Charles Atkinson and spent over a year drawing and dissecting a horse beginning in 1756.

Stubbs's *Anatomy of the Horse* appeared ten years later. In the 1760s the artist also began experimenting with wax and enamel painting—innovations that connect him back to Dr. Théodore Turquet de Mayerne.[9] In 1770 Stubbs was commissioned by Dr. William Hunter to paint the *Duke of Richmond's First Bull Moose,* an animal recently imported from North America.[10] The physician's fascination with the natural world and especially discoveries from the New World place him within the company of his predecessors, men like Sloane and Mead. And in fact, Hunter purchased a number of items from the sale of the latter's collections in 1754. As one appropriate end point for this present study, Hunter became the first professor of anatomy at the Royal Academy of Arts in 1768.[11]

Other individuals and networks could also be cited, but perhaps the most compelling examples of this virtuosic tradition in the second half of the century come from Joseph Wright. His paintings of figures transfixed by a statuette of an ancient gladiator, an orrery, or an air pump visualize the act of looking into the recesses of antiquity and the depths of nature. They draw upon late eighteenth-century pictorial devices, infusing ordinary interiors with enough visual drama to convey the intellectual significance of these encounters. The natural philosopher and the antiquary are presented as heroes, and erudition is elevated to epic proportions. The very act of looking—on the part of the figures within the paintings and ourselves as viewers—is celebrated as a compelling path to knowledge. In fact, because these images are so originally forceful in their depiction of the learned engagement between viewer and the objects of study, there is a tendency to accept them as entirely novel. But *what* these paintings depict is the result of the history of British art as it dates back at least to the Stuarts (Robert Boyle, of course, had grasped the implications of the vacuum in the 1660s). The mid-eighteenth-century achievement of the British Enlightenment was to transform the figure of the virtuoso into a genius, though it meant disavowing much of the virtuoso's actual identity. Wright's paintings ironically give visual expression to an empirical project that had itself been transformed by the 1760s. The virtuosi of the Stuart and early Georgian periods would increasingly be relegated to the shadows, and as art and cultural societies such as the Dilettanti and the Royal Academy came into their own, the Royal Society's interests in the visual arts and antiquarian matters would be shelved away in the archives. This book has attempted to recover an image of that older culture of erudition that brought the arts, medicine, and antiquarianism together in early modern England.

Introduction

1. William Pittis, *Some Memoirs of the Life of John Radcliffe, M.D.* (London, 1715), pp. 25-27. For Covent Garden's importance for English painters, see the exhibition catalogue by Kit Wedd, Lucy Peltz, and Cathy Ross, *Artists' London: Holbein to Hirst* (London: Merrel, 2001), p. 25.

2. Giovanni Paolo Lomazzo, *A Tracte Containing the Artes of Curious Paintinge, Carvinge, and Buildinge,* trans. Richard Haydocke (Oxford, 1598). The original Italian edition, *Trattato del arte della pittura, scultura, ed architettura,* was published in Milan in 1584.

3. Walter Houghton, "The English Virtuoso in the Seventeenth Century," *Journal of the History of Ideas* 3 (1942): 51-73, 190-219. Houghton identifies most of the pertinent characters and themes, but the last several decades of scholarship call into question nearly all of his conclusions. Nonetheless, the article has been immensely influential and continues to be cited with unqualified approval. Ann Bermingham, for instance, in *Learning to Draw: Studies in Cultural History of a Polite and Useful Art* (New Haven, CT: Yale University Press, 2000), pp. 45-46, 254n50, recommends it as an "excellent study." For the most cogent critique, see Brian Cowan, "Open Elite: Virtuosity and the Peculiarities of English Connoisseurship," *Modern Intellectual History* 1 (2004): 151-83; and Brian Cowan, *The Social Life of Coffee: The Emergence of the British Coffeehouse* (New Haven, CT: Yale University Press, 2005). I became familiar with Cowan's work only in the later stages of writing; working independently, we have reached many of the same conclusions, though I believe our targets and goals—while complementary—are ultimately different. For the exceptional, less enthusiastic responses to Houghton from previous generations, see Luigi Salerno, "Seventeenth-Century English Literature on Painting," *Journal of the Warburg and Courtauld Insti-*

tutes 14 (1951): 234–58; and Claire Pace, "Virtuoso to Connoisseur: Some Seventeenth-Century English Responses to the Visual Arts," *Seventeenth Century* 2 (1987): 167–88.

4. Drawing on early modern uses, the *Oxford English Dictionary* presents the virtuoso as a generalist or a specialist, a devotee of the arts or the sciences, a collector of antiquities or of natural specimens, an expert or a fool.

5. Henry Peacham, *Peacham's "Compleat Gentleman," 1634,* ed. G. S. Gordon (Oxford: Clarendon Press, 1906), pp. 104–5.

6. Baldassare Castiglione, *The Book of the Courtier,* trans. Thomas Hoby (1528; London: J. M. Dent & Sons, 1928), p. 268. For the book's reception, see Peter Burke, *The Fortunes of the Courtier: The European Reception of Castiglione's Cortegiano* (University Park: Pennsylvania State University Press, 1996). For associations between virtue and Renaissance objets d'art, see the exhibition catalogue edited by Luke Syson and Dora Thornton, *Objects of Virtue: Art in Renaissance Italy* (Los Angeles: Getty Museum, 2001). The malleability of the notion of virtue is neatly summarized in Leo Strauss's wry observation that virtue "which used to mean the manliness of man has come to mean the chastity of women." The frequency with which the quotation surfaces among conservatives attests to the stamina of the genre of virtue writing; see, for instance, Gertrude Himmelfarb, *The De-Moralisation of Society: From Victorian Virtues to Modern Values* (New York: Alfred Knopf, 1995), p. 15.

7. Castiglione, *Book of the Courtier,* p. 81. For the importance of drawing for the virtuosi, see F. J. Levy, "Henry Peacham and the Art of Drawing," *Journal of the Warburg and Courtauld Institutes* 37 (1974): 174–90; Bermingham, *Learning to Draw,* pp. 33–73; and Kim Sloan, *"A Noble Art": Amateur Artists and Drawing Masters, c. 1600–1800* (London: British Museum, 2000), pp. 11–39.

8. Castiglione, *Book of the Courtier,* pp. 77–82. Castiglione's discussion of assessing "the beautie of lively bodies" concludes with remarks on the pleasures derived specifically from "the beautie of a woman." This gendered dimension of the connoisseur's gaze persists throughout the history of the discourse. See Ann Bermingham's engaging discussion, "Elegant Females and Gentlemen Connoisseurs: The Commerce in Culture and Self-Image in Eighteenth-Century England," in *The Consumption of Culture 1600–1800: Image, Object, Text,* ed. Bermingham and John Brewer (New York: Routledge, 1995), pp. 489–513.

9. Burke, *Fortunes of the Courtier,* p. 97, states that Lord Arundel was described by his librarian, Franciscus Junius, "as the 'epitome' of Castiglione's *Courtier.*" In contrast, Cowan, *Social Life of Coffee,* p. 11, argues that virtuoso culture in England was from the beginning "formed at the margins" rather than at court, and he points to the political misfortunes of both Arundel and Francis Bacon as proof. It seems to me, however, that in terms of aspirations and intentions both men would have understood their activities as following, not breaking with, courtly traditions.

10. Quoted by Marjorie Nicolson in "Virtuoso," her entry in the *Dictionary of the History of Ideas,* ed. Philip Wiener (New York: Charles Scribner's Sons, 1968–74), 4:486–90. Despite the spelling, Evelyn refers here to a male collector. The female *virtuosa,* however, would also emerge as a type in the seventeenth century (exemplified

by Margaret Cavendish, Duchess of Newcastle), and Nicolson provides a useful starting point. For the full context of Evelyn's description, see *The Diary of John Evelyn*, ed. E. S. de Beer (London: Oxford University Press, 1955), 2:113–15.

11. Castiglione, *Book of the Courtier*, p. 292.

12. Thomas Shadwell, *The Virtuoso: A Comedy*, in *The Complete Works of Thomas Shadwell*, ed. Montague Summers (London: Benjamin Blom, 1968), 3:127. Summers notes that the play was also performed in 1704 and 1705.

13. Ibid., pp. 140–42. For Shadwell's sources, including Robert Hooke's *Micrographia* and articles from the *Philosophical Transactions*, see Claude Lloyd, "Shadwell and the Virtuosi," *PMLA* 44 (1929): 472–94.

14. For the perceived threat posed by the virtuosi of the Royal Society, see Barbara Benedict, *Curiosity: A Cultural History of Early Modern Inquiry* (Chicago: University of Chicago Press, 2001), esp. pp. 25–70.

15. Robert Boyle, *The Christian Virtuoso: Shewing, That by being addicted to Experimental Philosophy, a Man is rather Assisted, than Indisposed, to be a Good Christian* (London, 1691). The first part of the work appears in *The Works of Robert Boyle*, ed. Michael Hunter and Edward Davis (London: Pickering & Chatto, 1999–2000), 11:281–327. The appendix to the first part and the second part, both of which were published posthumously in 1744, appear in 12:367–530.

16. In addition to his satirical treatment of the virtuoso, Shadwell scrutinizes the figure of the libertine in his 1675 play, *The Libertine: A Tragedy*, in *Complete Works of Thomas Shadwell*, 3:7–93. Like the virtuoso, the libertine emphasized the role of the senses in engaging the material world. In the words of the character Don Antonio, "we live in the life of Sense, which no fantastick things, call'd Reason, shall controul" (p. 26). When transferred from the realm of morals to that of epistemology, the assertion could be seen to encapsulate the conflict between empiricism and rationalism that stood at the core of the Royal Society's intellectual program.

17. Anthony Ashley Cooper, *The Moralist, A Philosophical Rhapsody, Being a Recital of Certain Conversations on Natural and Moral Subjects*, in *Characteristics of Men, Manners, Opinions, Times*, ed. Lawrence Klein (New York: Cambridge University Press, 1999), pp. 234–35.

18. Cooper, *Miscellany III*, in *Characteristics*, ed. Klein, pp. 405–7.

19. Ibid., p. 407.

20. Lawrence Klein, *Shaftesbury and the Culture of Politeness: Moral Discourse and Cultural Politics in Early Eighteenth-Century England* (New York: Cambridge University Press, 1994), p. 37. Also see Felix Paknadel, "Shaftesbury's Illustrations of 'Characteristics,'" *Journal of the Warburg and Courtauld Institutes* 37 (1974): 290–312.

21. Cooper, *Miscellany III*, p. 405.

22. Cooper, *Soliloquy; or, Advice to an Author*, in *Characteristics*, p. 148. During the final months of his life, Shaftesbury became absorbed in planning the illustrations for the second edition of *Characteristics;* in a letter to Thomas Micklethwayte, dated June 20, 1712, he referred to the images as "my only amusement and allay of pain—I mean my virtuoso-doings." Quoted in Paknadel, p. 290.

23. Patrick Romanell, *John Locke and Medicine: A New Key to Locke* (Buffalo, NY: Prometheus Books, 1984), argues that Locke's medical experience played a crucial role in his philosophical development, particularly in matters of epistemology, and that Locke not only was influenced by Sydenham but that he in turn shaped the doctor's medical understanding (pp. 76ff.). See also William Osler, "John Locke as a Physician," *The Lancet* 2, no. 4025 (1900): 1115–23; James Dempster, "John Locke, Physician and Philosopher," *Annals of Medical History* 4 (1932): 12–60, 172–86; Kenneth Dewhurst, "Locke and Sydenham on the Teaching of Anatomy," *Medical History* 2 (1958): 1–12; and Kenneth Dewhurst, *John Locke (1632–1704): Physician and Philosopher* (London: Wellcome Historical Medical Library, 1963).

24. *The Correspondence of John Locke,* ed. E. S. de Beer (Oxford: Clarendon Press, 1976–89), 5:150–54. To be fair, Shaftesbury would later accuse Locke (after his death) of calibrating virtue solely on the basis of "Fashion or Custom," and as Daniel Carey explains in *Locke, Shaftesbury, and Hutcheson: Contesting Diversity in Enlightenment and Beyond* (New York: Cambridge University Press, 2006), pp. 98ff., the two men were diametrically opposed on the question of human nature, with Locke's embrace of diversity presenting an essential threat to the innate ideas and principles that anchored Shaftesbury's entire conception of humanity. I don't mean to suggest the philosophical differences weren't real—only that their starkness is blunted by actual human interaction and social context. See Anthony Ashley Cooper, *Several Letters Written by a Noble Lord to a Young Man at the University* (London, 1716), pp. 40–41.

25. Houghton, "English Virtuoso," pp. 68ff.

26. Samuel Johnson, *A Dictionary of the English Language* (London, 1755). Johnson's own conflicted attitudes toward the virtuosi appear in *The Rambler* 83 (January 1, 1751): "The virtuoso therefore cannot be said to be wholly useless; but perhaps he may be sometimes culpable for confining himself to business below his genius, and losing in petty speculations, those hours by which if he had spent them in nobler studies, he might have given new light to the intellectual world."

27. In his 1667 *History of the Royal Society*, Thomas Sprat asserts that in contrast to the old Scholastic philosophy, "the New shall impart to us the uses of all the Creatures, and shall enrich us with all the Benefits of Fruitfulness and Plenty"; quoted in Michael Hunter, *Science and Society in Restoration England* (Cambridge: Cambridge University Press, 1981), p. 87; chapter 4 addresses the topic of "Utility and Its Problems."

28. Houghton, "English Virtuoso," p. 70; C. P. Snow, *Two Cultures and the Scientific Revolution* (Cambridge: Cambridge University Press, 1960).

29. Houghton, "English Virtuoso," pp. 194, 201.

30. The standard source for the history of the College of Physicians during the Restoration is Harold Cook, *The Decline of the Old Medical Regime in Stuart London* (Ithaca, NY: Cornell University Press, 1986).

31. *A New General English Dictionary: Peculiarly Calculated for the Use and Improvement of Such as Are Unacquainted with the Learned Languages . . . Begun by the Rev. Thomas Dyche and Finished by William Pardon* (London, 1735). To be precise, the words *empiric, quack,* and *mountebank* are not, strictly speaking, synonymous. In contrast to

the first, an epistemological description, the other two relate to the method a practitioner uses to sell treatments. The quack cries his wares to the crowd, while the mountebank, elevated on whatever stage he can find, performs his routine, cajoling his audience from skepticism to hopeful belief. It is, however, easy to see how the words came to be used interchangeably.

32. Nicolas Le Fèvre, *Compleat Body of Chemistry*, esp. pp. 7–12, as quoted in Ken Arnold, *Cabinets for the Curious: Looking Back at Early English Museums* (Aldershot, UK: Ashgate, 2006), p. 145.

33. *A Letter from an Apothecary in London, to his Friend in the Country; Concerning the present practice of physick, in regard to Empiricks, Empirical methods of cure, and nostrums. With remarks on Dr. Mead's, Mr. Freke's, and Mr. Cheselden's Method of cure for the itch, by externals only; setting forth the dangerous consequences of such a method, if adhered to indiscriminately. Also some observations upon manna, showing it to be a composition, though commonly supposed a natural production; with remarks on Dr. Mead's certain cure for the bit of a mad dog* (London, 1752), p. 13.

34. Harold Cook, "The New Philosophy and Medicine in Seventeenth-Century England," in *Reappraisals of the Scientific Revolution*, ed. David Lindberg and Robert Westman (New York: Cambridge University Press, 1990), pp. 397–436. Throw in the surgeon, who historically was aligned with the barber and was as likely to spend his morning scraping teeth or removing vermin from a client's ear as amputating a leg, and we begin to realize how different early modern conceptions of the body and health were from our own; see Margaret Pelling, "Appearance and Reality: Barber-Surgeons, the Body, and Disease," in *The Making of the Metropolis*, ed. A. L. Beier and Roger Finlay (New York: Longman, 1986), pp. 82–112.

35. Richard Mead, *A Mechanical Account of Poisons in Several Essays* (London, 1702), unpaginated preface. The book went through some half-dozen editions during the first half of the century and was translated into Latin in 1737. That Mead understood the dilemma and generally navigated the choppy waters successfully does not mean he was immune from charges of empiricism, as evinced by the full title of the 1752 *Letter from a London Apothecary*, cited in note 33 above.

36. "Abstract of Dr. Mead's Mechanical Account of Poisons," *Philosophical Transactions of the Royal Society* 23 (1702–3): 1320–28.

37. Steven Shapin and Simon Schaffer, *Leviathan and the Air-Pump: Hobbes, Boyle, and the Experimental Life* (Princeton, NJ: Princeton University Press, 1985); Steven Shapin, "'A Scholar and a Gentleman': The Problematic Identity of the Scientific Practitioner in Early-Modern England," *History of Science* 29 (1991): 278–327; and Steven Shapin, *A Social History of Truth: Civility and Science in Seventeenth-Century England* (Chicago: University of Chicago Press, 1994). For France, see Jessica Riskin, *Science in the Age of Sensibility: The Sentimental Empiricists of the French Enlightenment* (Chicago: University of Chicago Press, 2002).

38. Arnaldo Momigliano, "Ancient History and the Antiquarian," *Journal of the Warburg and Courtauld Institutes* 13 (1950): 285–315. Also see Mark Salber Phillips, "Reconsiderations on History and Antiquarianism: Arnaldo Momigliano and the His-

toriography of Eighteenth-Century Britain," *Journal of the History of Ideas* 57 (1996): 297–316; and Ingrid Rowland, "Antiquarianism as Battle Cry," in *The Italian Renaissance in the Twentieth Century: Acts of an International Conference, Florence, Villa I Tatti, June 1999*, ed. Allen Grieco, Michael Rocke, and Feorella Superbi (Florence: Leo S. Olschki, 2002), pp. 401–11.

39. The company of scholars making meaningful contributions to the history of antiquarianism continues to grow. Anthony Grafton has been described by Marc Fumaroli as the "American leader of the school of Momigliano." As a point of entry his work, see Grafton's *Joseph Scaliger: A Study in the History of Classical Scholarship* (Oxford, 1983); *Defenders of the Text: The Traditions of Scholarship in an Age of Science, 1450–1800* (Cambridge, MA: Harvard University Press, 1991); and *Bring Out Your Dead: The Past as Revelation* (Cambridge, MA: Harvard University Press, 2004). Fumaroli's assessment appears in his review of Peter Miller's study of Nicolas-Claude Fabri de Peiresc, "The Antiquarian as Hero," *The New Republic* 224 (May 28, 2001): 33–38. Pointing to the work of Ingrid Rowland, Elizabeth Cropper, and Charles Dempsey, Fumaroli asks if "Peiresc's Republic of Letters [is] now being re-born in the United States?" I would add Paula Findlen, Thomas DaCosta Kaufmann, and Joseph Levine.

40. Peter Miller, *Peiresc's Europe: Learning and Virtue in the Seventeenth Century* (New Haven, CT: Yale University Press, 2000), p. 7.

41. Antiquaries were also keenly interested in textual sources but tended to engage even these forms of evidence in material terms, scrutinizing, for instance, the physical appearance of manuscripts and the inscriptions of ancient coins and marbles. The skills that ultimately led to the emergence of philology were first honed by Europe's leading antiquaries, though ironically these skills were later turned against the antiquarian community. Integral to this story is the Quarrel of the Ancients and the Moderns. Both antiquity and modernity mattered profoundly to both camps; the questions always came down to *how* one would negotiate these temporal periods and the extent to which one would subject the past to critical evaluation. Rather than relying on polarizing schemes to explain the period, Joseph Levine stresses the fluid character of the positions taken up by the Quarrel's participants: "the argument was never static and looked different at different times to different participants." See Levine, *Between the Ancients and the Moderns: Baroque Culture in Restoration England* (New Haven, CT: Yale University Press, 1999), p. x.

42. The subjective character of the past relates to Vasari's distinction between the "old" and the "ancient," as articulated in the preface to the *Lives of the Artists*. Prior to the modern era, history, too, could connote a wide variety of intellectual activities, extending well beyond narratives of human action at specific moments in the past. Often, the temporal component was negligible, as in the case of natural history, which itself encompassed a vast range of studies involving descriptive knowledge, akin to antiquarian practices. See Gianna Pomata and Nancy Siraisi, eds., *Historia: Empiricism and Erudition in Early Modern Europe* (Cambridge, MA: MIT Press, 2005). In the stimulating introduction, pp. 1–38, Pomata and Siraisi stress the degree to which "em-

pirical observation and philological reconstruction"—experience and text—worked hand in hand rather than against each other (p. 17). They also note the importance of *historia* for physicians and, vice versa, the contributions made by physicians to historical studies. For the problem of the particular vis-à-vis *historia*, see Donald Kelly's essay, "Between History and System," pp. 211–37.

43. See chapter 4 of the present text for the Mead-Woodward quarrel. The standard source for Woodward remains Joseph Levine, *Dr. Woodward's Shield: History, Science, and Satire in Augustan England* (Berkeley and Los Angeles: University of California Press, 1977). Also relevant is Levine's article, "The Antiquarian Enterprise, 1500–1800," in *Humanism and History: Origins of Modern English Historiography* (Ithaca, NY: Cornell University Press, 1987), pp. 73–106.

44. Pope's forceful embrace of the *Ancient* label—most famously in his *Battle of the Books* (London, 1724)—has tended to ossify the conflict into rigid binaries, and the figure of the Royal Society virtuoso has long been seen as the quintessential Modern. Accordingly, Woodward's attempts to impose what he viewed as a modern method on the study of ancient artifacts was seen as a corruption of the past. Importantly, however, other Fellows of the Royal Society were also generally unsympathetic to Woodward, and Mead, in particular, sided with Pope.

45. A persistent question in the historiography of the Royal Society is whether the eighteenth century marked a period of decline, and at the heart of this question lie the society's antiquarian endeavors. Regardless of how one addresses the question, it is impossible to ignore the fact that both individually and collectively, Royal Society Fellows pursued antiquarian studies. Martin Folkes, notably, served as president of both the Royal Society and the Society of Antiquaries toward the middle of the century. See Richard Sorrenson, "Towards a History of the Royal Society in the Eighteenth Century," *Notes and Records of the Royal Society of London* 50 (1996): 29–46.

46. André Rouquet, *The Present State of the Arts in England* (London, 1755). It first appeared in French but was translated into English the same year.

47. For the modernist position, as articulated by students of J. H. Plumb, see Roy Porter, *The Creation of the Modern World: The Untold Story of the British Enlightenment* (New York: Norton, 2000); and John Brewer, *The Pleasures of the Enlightenment: English Culture in the Eighteenth Century* (New York: Farrar, Straus & Giroux, 1997). For Porter's vast scholarly output, see Thomas Laqueur, "Roy Porter, 1946–2002: A Critical Appreciation," *Social History* 29 (February 2004): 84–91. For the ancien régime case, see Jonathan Clark, *English Society, 1688–1832: Ideology, Social Structure, and Political Practice during the Ancien Régime* (Cambridge: Cambridge University Press, 1985). As a third option, Steve Pincus compellingly presents the 1680s as the crucial decade for modernization. See "'To Protect English Liberties': The English Nationalist Revolution of 1688–1689," in *Protestantism and National Identity: Britain and Ireland, c. 1650– c. 1850*, ed. Tony Claydon and Ian McBride (New York: Cambridge University Press, 1998), pp. 75–104; and the essay coauthored with Alan Houston, "Modernity and Later-Seventeenth-Century England," in *A Nation Transformed: England after the Restoration*, ed. Alan Houston and Steve Pincus (New York: Cambridge University Press, 2001), pp. 1–19.

48. Including "the scientific laboratory, the academic journal, the learned society and the coffeehouse" (Cowan, *Social Life of Coffee*, p. 260). Cowan's book concludes around 1720, and he casts his work as engaging the long seventeenth century more than the eighteenth century. While he goes further than I in rejecting the modernist position, I am entirely sympathetic to his assertion that "the supposed early modern consumer revolution was less revolutionary than it was *evolutionary*" (p. 3), and that there is a particular danger in imposing later notions of liberal democracy onto the period (pp. 147–51). See also his review article, "Refiguring Revisionisms," *History of European Ideas* 29 (2003): 475–89.

49. Margaret Whinney and Oliver Millar, *English Art, 1625–1714* (Oxford: Clarendon Press, 1957); and Joseph Burke, *English Art, 1714–1800* (Oxford: Oxford University Press, 1976). Similar divisions are made within Ellis Waterhouse's survey, *Painting in Britain, 1530–1790* (New York: Penguin Books, 1953). Also see William Vaughan, *British Painting: The Golden Age from Hogarth to Turner* (London: Thames & Hudson, 1999). Kevin Sharpe and Steven Zwicker have worked to bridge the seventeenth and eighteenth centuries with their edited volume, *Refiguring Revolutions: Aesthetics and Politics from the English Revolution to the Romantic Revolution* (Berkeley and Los Angeles: University of California Press, 1998), though *aesthetics* here above all means "literature."

50. This work has depended heavily on Hans Baron and J. G. A. Pocock. See John Barrell, *The Political Theory of Painting from Reynolds to Hazlitt* (New Haven, CT: Yale University Press, 1986); John Barrell, "'The Dangerous Goddess': Masculinity, Prestige, and the Aesthetic in Early Eighteenth-Century Britain," in *The Birth of Pandora and the Division of Knowledge* (London: Macmillan, 1992), 63–87; Iain Pears, *The Discovery of Painting: The Growth of Interest in the Arts in England, 1680–1768* (New Haven, CT: Yale University Press, 1988); and David Solkin, *Painting for Money: The Visual Arts and the Public Sphere in Eighteenth-Century England* (New Haven, CT: Yale University Press, 1993). Much of this scholarship also took shape according to the divisions between traditional and the so-called new art history; see Solkin, "The Battle of the Books; or, the Gentlemen Provok'd—Different Views on the History of British Art," *Art Bulletin* 68 (1985): 507–15.

51. Carol Gibson-Wood, *Jonathan Richardson: Art Theorist of the English Enlightenment* (New Haven, CT: Yale University Press, 2000), p. 8.

52. Pamela Smith, *The Body of the Artisan: Art and Experience in the Scientific Revolution* (Chicago: University of Chicago Press, 2004). This important book is only the latest installment of interdisciplinary scholarship that explores the connections between art and medicine. It is difficult to overstate the importance of Barbara Stafford's inspired tome *Body Criticism: Imaging the Unseen in Enlightenment Art and Medicine* (Cambridge, MA: MIT Press, 1991). Also see Laurinda Dixon, *Perilous Chastity: Women and Illness in Pre-Enlightenment Art and Medicine* (Ithaca, NY: Cornell University Press, 1995); Julie Hansen, "Resurrecting Death: Anatomical Art in the Cabinet of Dr. Frederick Ruysch," *Art Bulletin* 78 (1996): 663–80; and Sheila Barker, "Poussin, Plague, and

Early Modern Medicine," *Art Bulletin* 86 (2004): 659–89. In terms of exhibitions, see Martin Kemp and Marina Wallace, *Spectacular Bodies: The Art and Science of the Human Body from Leonardo to Now* (Berkeley and Los Angeles: University of California Press, 2000); Ludmilla Jordanova, *Defining Features: Scientific and Medical Portraits* (London: Reaktion Books, 2000); and Gauvin Bailey et al., *Hope and Healing: Painting in Italy in a Time of Plague, 1500–1800* (Worcester, MA: Worcester Art Museum, 2005).

Chaper One

1. Marie Boas Hall stresses Oldenburg's role in instigating the *Transactions,* initially a private publication controlled entirely by Oldenburg, the Royal Society's secretary: "Oldenburg, the *Philosophical Transactions,* and Technology," in *The Uses of Science in the Age of Newton,* ed. John Burke (Berkeley and Los Angeles: University of California Press, 1983), pp. 21–47.

2. *Philosophical Transactions of the Royal Society* 3 (21 September 1668): 779–88; quotation is from p. 787. For the ways the *Transactions* helped establish the Royal Society's authority, see Robert Iliffe, "Author-Mongering: The Editor between Producer and Consumer," in *The Consumption of Culture 1600–1800: Image, Object, Text,* ed. Ann Bermingham and John Brewer (New York: Routledge, 1995), pp. 166–92; and Mario Biagioli, "Etiquette, Interdependence, and Sociability in Seventeenth-Century Science," *Critical Inquiry* 22 (1996): 193–238.

3. Olaus Borrichius, *De ortu et progressu chemiae dissertatio* (Copenhagen, 1668); Robert Anderson, *Stereometrical Propositions, variously applicable but particularly intended for gaging* (London, 1668); and Andrea Graba, *Elaphographia sive cervi descriptio physico-medico-chymica* (Jena, 1668).

4. Roland Fréart, Sieur de Chambray, *An Idea of the Perfection of Painting: Demonstrated from the Principles of Art, and by Examples conformable to the Observations, which Pliny and Quintilian have made upon the most celebrated pieces of the ancient painters, paralleled with some works of the most famous modern painters, Leonardo da Vinci, Raphael, Julio Romano, and N. Poussin,* translated by *John Evelyn* (London, 1668). The original French edition appeared in 1662.

5. John Locke, *An Essay Concerning Human Understanding,* ed. Peter Nidditch (Oxford: Clarendon Press, 1975), pp. 720–21. Begun in the late 1660s, the *Essay* was first published in 1689, the year after Locke was inducted into the Royal Society.

6. *Philosophical Transactions of the Royal Society* 3 (September 21, 1668), p. 784. Italics appear in the original.

7. Ibid., p. 785.

8. Though not specifically medical texts, two of the books included in the *Philosophical Transactions* review—Borrichi's chemical text and Graba's treatise on the stag—were presented as being of potential value to physicians. Borrichi was a Paracelsian physician, and Graba's book was described as explaining "the several uses of

the parts of a Stagg, which he [Graba] finds to be very many and of diverse kinds, viz. ornamental, mechanical, culinary, and medicinal" (ibid., p. 787).

9. For a full bibliography see Philip McEvansoneya, "Italian Paintings in the Buckingham Collection," in *The Evolution of English Collecting: Receptions of Italian Art in the Tudor and Stuart Periods,* ed. Edward Chaney (New Haven, CT: Yale University Press, 2003), pp. 315–36. For the gems, see p. 317.

10. Jeffrey Muller, *Rubens: The Artist as Collector* (Princeton, NJ: Princeton University Press, 1989), esp. pp. 48–63.

11. *The Life and Letters of Sir Henry Wotton,* ed. Logan Smith (Oxford: Clarendon Press, 1907), 2:256–58. The letter was included in *Reliquiae Wottonianae* (London, 1654), and excerpts of it appear, without attribution, in William Sanderson's *Graphice: The Use of the Pen and Pensil* (London, 1658); see Frederick Hard, "Ideas from Bacon and Wotton in William Sanderson's *Graphice,*" *Studies in Philology* 36 (1939): 227–34. Wotton's *Elements of Architecture* appeared in 1624.

12. Leonard Barkan, "Making Pictures Speak: Renaissance Art, Elizabethan Literature, Modern Scholarship," *Renaissance Quarterly* 48 (1995): 326–51. Also relevant is Leonard Barkan, *Unearthing the Past: Archaeology and Aesthetics in the Making of Renaissance Culture* (New Haven, CT: Yale University Press, 1999), chap. 2.

13. David Howarth usefully describes the collections of both men in "The Arundel Collection: Collecting and Patronage in England in the Reigns of Philip III and Philip IV," in *The Sale of the Century: Artistic Relations between Spain and Great Britain, 1604–1655,* exhibition catalogue, ed. Jonathan Brown and John Elliot (New Haven, CT: Yale University Press, 2002), pp. 69–86. Also relevant is Linda Peck, "Monopolizing Favour: Structures of Power in the Early Seventeenth-Century English Court," in *The World of the Favourite,* ed. J. H. Elliott and L. W. B. Brockliss (New Haven, CT: Yale University Press, 1999), pp. 54–70.

14. For details of the earl's life, see Mary Hervey, *The Life, Correspondence, and Collections of Thomas Howard, Earl of Arundel* (Cambridge: Cambridge University Press, 1921); and David Howarth, *Lord Arundel and His Circle* (New Haven, CT: Yale University Press, 1985). Graham Parry provides a chapter-length summary in *The Golden Age Restored: The Culture of the Stuart Court 1603–42* (New York: St Martin's Press, 1981), pp. 108–35. The August issue of *Apollo* 144 (1996) is devoted to the Arundel collection.

15. Joachim von Sandrart, *Teutsche Academie* (1675), vol. 2. The translation is that of Hervey, *Life, Correspondence, and Collections of Thomas Howard,* pp. 255–56, which also includes the 1655 inventory, appendix 5, pp. 473–500. For the Arundel garden, see John Dixon Hunt, "The British and the Grand Tour," *Studies in the History of Art* 25 (1989): 333–51.

16. Henry Peacham, *The Compleat Gentleman* (London, 1634), pp. 124–25. Howarth, *Lord Arundel,* pp. 120–21, quotes the passage and suggests it implies that "Arundel House was hardly to everyone's liking," that "there was something of the schoolroom about the whole palace." Hunt, "The British and the Grand Tour," p. 339, sees in the description evidence for viewing the gallery and garden as a memory theater.

17. From the dedication page of Evelyn's translation of Fréart's *An Idea of the Perfection of Painting* (London, 1668).

18. For the earl's relationship with Junius, see Philipp Fehl, "Franciscus Junius and the Defense of Art," in Franciscus Junius, *The Literature of Classical Art: "The Painting of the Ancients (De pictura veterum)" and a "Lexicon of Artists and Their Works,"* ed. Keith Aldrich, Philipp Fehl, and Raina Fehl (Berkeley and Los Angeles: University of California Press, 1991), pp. xxi–lxxxiii. For Jones, see Edward Chaney, "Inigo Jones in Naples," in *The Evolution of the Grand Tour: Anglo-Italian Cultural Relations since the Renaissance* (London: Frank Cass, 1998), pp. 168–202. For Van Dyck, see Christopher White, *Anthony van Dyck: Thomas Howard, the Earl of Arundel* (Malibu, CA: Getty Museum, 1995). For Rubens, see Christopher White, "Rubens's Portrait Drawing of Thomas Howard, Second Earl of Arundel," *Burlington Magazine* 137 (1995): 316–19.

19. David Howarth has recently asked whether agents such as Petty deserve more credit for shaping collections than they have traditionally received; see his essay, "A Question of Attribution: Art Agents and the Shaping of the Arundel Collection," in *Your Humble Servant: Agents in Early Modern Europe*, ed. Hans Cools, Marika Keblusek, and Badeloch Noldus (Hilversum, The Netherlands: Uitgeverij Verloren, 2006), pp. 17–28. Here, Howarth, notwithstanding the title of his 1985 book, also suggests that we might better understand the network around Arundel not as a "circle," but as a "cage," perhaps gilded but still confining.

20. Howarth, *Lord Arundel*, pp. 111–12. Originally erected at the Temple of Isis in Rome during the first century, the obelisk was appropriated by Maxentius for his fourth-century circus outside the city's walls. See Erik Iversen, *Obelisks in Exile*, vol. 1, *The Obelisks of Rome* (Copenhagen: G. E. C. Gad, 1968), pp. 76–92; and Jeffrey Collins, "Obelisks as Artifacts in Early-Modern Rome: Collecting the Ultimate Antiques," *Ricerche di Storia dell'arte* 72 (2000): 49–68.

21. Howarth, *Lord Arundel*, p. 2. The point that Arundel did not introduce collecting into England is made more emphatically by the collection of essays treating the Cecils, England's leading political family from 1558 to 1612; see Pauline Croft, ed., *Patronage, Culture, and Power: The Early Cecils* (New Haven, CT: Yale University Press, 2002), as well as Chaney, ed., *Evolution of English Collecting*. Also see Stephen Orgel, "Idols of the Gallery: Becoming a Connoisseur in Renaissance England," in *Early Modern Visual Culture: Representation, Race, and Empire in Renaissance England*, ed. Peter Erickson and Clarke Hulse (Philadelphia: University of Pennsylvania Press, 2000), pp. 251–83.

22. Francis Haskell, "Charles I's Collection of Pictures," in *The Late King's Goods: Collectors, Possessions and Patronage of Charles I in Light of the Commonwealth Sale Inventories*, ed. Arthur MacGregor (London: Oxford University Press, 1989), pp. 203–31; and Jonathan Brown, *Kings & Connoisseurs: Collecting in Seventeenth-Century Europe* (Princeton, NJ: Princeton University Press, 1995).

23. Howarth, *Lord Arundel*, p. 2.

24. Recent scholarship has stressed the role of the earl's wife, Aletheia Talbot (the granddaughter of Bess of Hardwick), in shaping the Arundel collection. See, for in-

stance, Jennifer Fletcher, "The Arundels in the Veneto," *Apollo* 144 (1996): 63–69; David Howarth, "The Patronage and Collecting of Aletheia, Countess of Arundel 1606–54," *Journal of the History of Collections* 10 (1998): 125–37; and Elizabeth Chew, "The Countess of Arundel and Tart Hall," in *Evolution of English Collecting*, ed. Chaney, pp. 285–314. As Fletcher notes, however, it was primarily in Italy that the countess's artistic interests were admired (though admittedly Junius dedicates his *Painting of the Ancients* to her). Because I am here interested in the Arundel collection for the impact it had on late-seventeenth and eighteenth-century England, I have not given Talbot the attention she otherwise deserves.

25. Francis Springell, *Connoisseur & Diplomat: The Earl of Arundel's Embassy to Germany in 1636* (London: Maggs Brothers, 1963), includes William Crowne's diary of the trip, reproductions of Wenceslaus Hollar's drawings, letters to William Petty, and Springell's commentary.

26. Frederick's acceptance of the Crown of Bohemia had sparked the Thirty Years' War to begin with. With no heir and his first wife recently deceased, Maximilian, the Duke of Bavaria, married the emperor's daughter (and his own niece) Maria Anna in 1635. Aged sixty-two by this time, the duke was actually five years older than his new father-in-law, to whom he was already related through his sister (also named Maria Anna), who had married the emperor in 1600. The birth of a son in October of 1636 made the acceptance of the English demands all the more unlikely. Ibid., pp. 28–35.

27. Arundel himself appreciated the difficulty of the mission, describing it in a letter to the Earl of Strafford as "a desperate business." The letter, dated April 7, 1636, is quoted by Springell, *Connoisseur & Diplomat*, p. 3. In Nuremberg Arundel was presented with two works by Dürer for Charles I: the 1498 *Self-Portrait* and *Portrait of the Artist's Father*. From the archbishop of Würzburg, the earl acquired for himself a *Madonna* also by Dürer, and Emperor Ferdinand presented him with eleven books of drawings, which Howarth suggests may have been the Gaddi drawings from Florence. The papal agent George Conn reported to Cardinal Barberini that soon after Arundel's return, "the King went privately to the house of the Earl of Arundel to see the pictures he has brought from Germany"; quoted by Howarth, *Lord Arundel*, p. 202.

28. William Harvey, *De motu cordis et sanguinis* (London, 1628). Its significance was hardly limited to the medical community. In 1635, for instance, Pierre Gassendi wrote to Peiresc defending the new theory, and the concept of the blood's circulation (though not Harvey's explanation of the heartbeat) proved important for Descartes' mechanistic philosophy. See Roger French, "Harvey in Holland: Circulation and the Calvinists," in *The Medical Revolution of the Seventeenth Century*, ed. Roger French and Andrew Wear (Cambridge: Cambridge University Press, 1989), pp. 46–86.

29. Harvey also accompanied the Duke of Lennox on his Continental travels in the early 1630s. See Geoffrey Keynes, *The Life of William Harvey* (Oxford: Clarendon Press, 1966), pp. 191–96. For the doctor's experience in Padua, see Jonathan Woolfson, *Padua and the Tudors: English Students in Italy, 1485–1603* (Toronto: University of Toronto Press, 1998), pp. 73ff.

30. At Arundel's invitation, Harvey stayed with the earl at Worksop Manor. A "fit of the stone" of Lord Portland the Lord High Treasurer led them to spend several days here before rejoining the royal entourage (Keynes, *Life of William Harvey*, pp. 197-98). Harvey and Thomas Hobbes both found natural justification for monarchical rule in the circulatory system, even as James Harrington saw in it evidence for the legitimacy of the balance of political power and the value of a bicameral legislature; see I. Bernard Cohen, "Harrington and Harvey: A Theory of the State Based on the New Physiology," *Journal of the History of Ideas* 55 (1994): 187-210.

31. Keynes, *Life of William Harvey*, pp. 232-38, 244-45, 256.

32. The quotation is included in Springell's account, *Connoisseur & Diplomat*, p. 12. In a letter dated June 16/26, Harvey mentions that he had also been hunting with the emperor (p. 113n96).

33. Ibid., p. 247. This and the following letters quoted by Springell come from BL Add. MS 15970. The *Meleager* is now in the Vatican Collection; see Francis Haskell and Nicholas Penny, *Taste and the Antique: The Lure of Classical Sculpture, 1500-1900* (New Haven, CT: Yale University Press, 1981), pp. 263-65.

34. Robert Harding, "John Evelyn, Hendrick van der Borcht the Younger, and Wenceslaus Hollar," *Apollo* 144 (August 1996): 39-44.

35. Springell, *Connoisseur & Diplomat*, p. 251.

36. The letter is dated September 8; ibid., p. 249. Arundel's witty conflation of Harvey with the doctor's own description of the blood's circulation is from a subsequent letter, dated October 18/28; ibid., p. 257.

37. Klara Garas, "The Ludovisi Collection of Pictures," *Burlington Magazine* 109 (1967): 287-89, 339-47; and Brown, *Kings & Connoisseurs*, pp. 131, 229.

38. Located near the Palazzo Barberini, the Villa Ludovisi remained an impressive Roman estate until its demolition in the 1880s. See Armando Schiavo, *Villa Ludovisi e Palazzo Margherita* (Rome: Banca Nazionale del Lavoro, 1981).

39. The interchange between physic and connoisseurship can also be seen to run the other way: Arundel's first trip to the Continent in 1612 was undertaken largely for health reasons, hence the appeal of Spa and Padua, both known for their salubrious waters. See Hervey, *Life, Correspondence, and Collections of Thomas Howard*, p. 64-67; and Howarth, *Lord Arundel*, p. 31.

40. John Webb, *The Most notable Antiquity of Great Britain vulgarly called Stone-Heng on Salisbury Plain. Restored by Inigo Jones* (London, 1655); and *A Vindication of Stone-Heng Restored* (London, 1665). In the latter volume Webb states that he would never have published the first book "had not our famous anatomist Doctor William Harvey, John Selden Esquire, and the best antiquaries then living overpersuaded me to it." See Keynes, *Life of William Harvey*, pp. 125-28.

41. Webb, *Stone-Heng Restored*, pp. 67ff. Stephen Orgel, "Inigo Jones on Stonehenge," *Prose* 3 (1971): 109-24; and Barbara Stafford, "'Illiterate Monuments': The Ruin as Dialect or Broken Classic," *The Age of Johnson* 1 (1987): 1-34. In addition, see Vaughan Hart, *Art and Magic in the Court of the Stuarts* (New York: Routledge, 1994), pp. 80-81, 132; within the context of Stonehenge, Hart also addresses Jones's

relationship with Dr. Robert Fludd, whom the architect seems to have met at Arundel House. Although Harvey was acquainted with Fludd and other Paracelsians, including Mayerne, there is little basis for Hart's description of Harvey as one of "the most distinguished Paracelsians in Britain."

42. Keynes, *Life of William Harvey*, pp. 126–27.

43. Barbara Stafford, "'Illiterate Monuments,'" pp. 9–10, provides a compelling account of the competing theories of Jones and Charleton, contrasting the architect's "Vitruvian Classicism" with the physician's more empirically oriented Epicureanism. Charleton and Stukeley also addressed the nearby site of Avebury. See William Stukely, *Stukeley's "Stonehenge": An Unpublished Manuscript 1721–1724*, ed. Aubrey Burl and Neil Mortimer (New Haven, CT: Yale University Press, 2005); Peter Ucko, Michel Hunter, Alan Clark, and Andrew David, *Avebury Reconsidered: From the 1660s to the 1990s* (London: Unwin Hyman, 1991); David Haycock, "'A Small Journey into the Country': William Stukeley and the Formal Landscapes of Stonehenge and Avebury," in *Producing the Past: Aspects of Antiquarian Culture and Practice 1700–1850*, ed. Martin Myrone and Lucy Peltz (Aldershot, UK: Ashgate, 1999), pp. 67–82; and Martin Myrone and Lucy Peltz, *William Stukeley: Science, Religion, and Archaeology in Eighteenth-Century England* (Woodbridge, Suffolk: Boydell Press, 2002).

44. Geoffrey Keynes, *The Portraiture of William Harvey* (London: Royal College of Surgeons, 1949), pp. 11–14, 32–33.

45. Mead owned the portrait and had it engraved by Jacob Houbraken in 1739. It is this engraving that identifies Bemmel as the painter.

46. Adriaan van de Spiegel, *Opera quae extant omnia* (Amsterdam, 1645), bk. 2, table 3. The identification comes from Wilson Steel, a librarian at Glasgow University, as noted in Keynes, *Portraiture of William Harvey*, p. 13. See also note 49 below. Harvey and Spiegel were at Padua together from 1600 to 1602. In 1991, Geoffrey Davenport, Librarian of the Royal College of Physicians, identified the book as Juan Valvedere's *Vivae imagines partium Corporis humani aeries formis expressae* (Antwerp, 1566), bk. 2, plate 2. See the entry on Bemmel's picture from the Hunterian Museum & Art Gallery Web site, www.hunterian.gla.ac.uk.

47. Keynes, *Portraiture of William Harvey*, p. 14.

48. Ibid., p. 14; and David Piper, "Take the Face of a Physician," in Gordon Wolstenholme and John Kerslake, *The Royal College of Physicians of London Portraits, Catalogue II* (Oxford: Excerpta Medica, 1977), pp. 25–49. Also, see Wolstenholme and Piper, *The Royal College of Physicians of London Portraits* (London: J. & A. Churchill, 1964), pp. 376–78; Piper tentatively attributes the portrait "to the very obscure Dutch artist Jean Demetrius." For Evelyn's description of Scarburgh's library, see *Diary of John Evelyn*, 5:206.

49. Piper, "Take the Face of a Physician," p. 34; Keynes, *Portraiture of William Harvey*, p. 14. Prior to the publication of the latter work, Keynes published a disastrous article, "The Portraits of William Harvey," in the *British Medical Journal* ([November 18, 1944]: 669–70), which led Wilson Steel to offer a correction in a subsequent issue of the same journal ([May 26, 1945]: 758). Keynes mistook S. Maria di Loreto

for the old College of Physicians building, and saw "the associated book, or MS., with the skulls, and Trajan's Column" as having "no particular relevance to Harvey." And though it is to Keynes's credit that he revised his views (with due acknowledgment to Wilson) and managed to shape this early essay into a more substantial work, even in *The Portraiture of William Harvey* he is above all interested simply in establishing a reliable likeness of the doctor and thus fails to appreciate the larger significance and value of the Glasgow portrait. His criticism of the ruins in the Scarburgh picture betray the persistence of his disregard for the Roman setting.

50. As the third largest repository for Hollar's work (after Windsor and Prague), the Thomas Fisher Rare Book Library at the University of Toronto has generously placed digital images of its collection online. The antiquarian significance of Hollar's work is demonstrated in part by the interest it garnered from George Vertue, whose *Description of the Works of the Ingenious Delineator and Engraver Wenceslaus Hollar* (London, 1745) established the basic classification scheme still used today; see Richard Pennington, *A Descriptive Catalogue of the Etched Work of Wenceslaus Hollar 1607–1677* (Cambridge: Cambridge University Press, 1982). The striking plate of Persepolis was included in Thomas Herbert, *Some Years' Travels into Divers Parts of Africa and Asia* (London, 1665), and is reproduced in Katherine Van Eerde, *Wenceslaus Hollar: Delineator of His Time* (Charlotteseville: University of Virginia Press, 1970), p. 78. See also Pierre de la Ruffinière du Prey, "Temple of Jerusalem Etchings for the Bible by Wenceslaus Hollar," in *Collected Opinions: Essays on Netherlandish Art in Honour of Alfred Bader,* ed. Volker Manuth and Axel Rüger (London: Paul Holberton, 2004), pp. 127–37.

51. Vertue refers to Hollar's drawing of Stonehenge; see Pennington, *Descriptive Catalogue,* p. xlvii. See also Marion Roberts, *Dugdale and Hollar: History Illustrated* (Newark: University of Delaware Press, 2002); and Rachel Doggett, Julie Biggs, and Carol Brobeck, *Impressions of Wenceslaus Hollar,* exhibition catalogue (Washington, DC: Folger Library, 1996).

52. See Myles Thoroton Hildyard's entry in the new *Oxford Dictionary of National Biography* (Oxford: Oxford University Press, 2004); Robert Thoroton, *The Antiquities of Nottinghamshire, Extracted Out of Records, Original Evidences, Ledger Books, other Manuscripts, and Authentick Authorities* (London, 1677), unpaginated preface.

53. Hollar notes his "aijant esté serviteur domestique du Duc de lorck," though this is the only evidence of the relationship. See Antony Griffiths and Gabriela Kesnerová, *Wenceslaus Hollar: Prints and Drawings from the Collections of the National Gallery, Prague and the British Museum, London,* exhibition catalogue (London: British Museum, 1983), p. 31.

54. As quoted in Pennington, *Descriptive Catalogue,* p. xxii.

55. Michael Vickers, "Hollar and the Arundel Marbles," *Städel-Jahrbuch* 7 (1979): 126–32.

56. The painting was part of a trio of pictures treating the realms of Venus, Juno, and Minerva; the second is now lost, though it's known through Hollar's print and copies; all three were part of the Arundel collection. See Rüdiger Klessmann et al.,

Adam Elsheimer 1578–1610, exhibition catalogue (London: Paul Holberton, 2006), pp. 160–63. My thanks to Jeremy Chen and Adam Wolpa for their thoughts on this sort of possibility space.

57. Hugh Trevor-Roper, *Europe's Physician: The Various Life of Theodore de Mayerne* (New Haven, CT: Yale University Press, 2006); Elizabeth Lane Furdell, *The Royal Doctors 1485–1714: Medical Personnel at the Tudor and Stuart Courts* (Rochester, NY: University of Rochester Press, 2001), pp. 103–20; Irene Scouloudi, "Sir Theodore Turquet de Mayerne: Royal Physician and Writer, 1573–1655," *Huguenot Society of London* 16 (1940): 301–37; and Randolph Vigne, "Mayerne and His Successors: Some Huguenot Physicians under the Stuarts," *Journal of the Royal College of Physicians of London* 20 (1986): 222–26.

58. For Mayerne's place within the larger Paracelsian context, see Allen Debus, *The English Paracelsians* (London: Oldbourne, 1965), pp. 150–56; and Hugh Trevor-Roper, "The Court Physician and Paracelsianism," in *Medicine at the Courts of Europe, 1500–1837,* ed. Vivian Nutton (New York: Routledge, 1990), pp. 79–94.

59. As noted by John Murdoch, "The Seventeenth-Century Enlightenment," in *The English Miniature* by John Murdoch, Jim Murrell, Patrick Noon, and Roy Strong (New Haven, CT: Yale University Press, 1981), pp. 85–162, esp. pp. 107–8.

60. BL MS Sloane 2052. Ernst Berger's 1901 German translation is available in English in Theodore Turquet de Mayerne, *Lost Secrets of Flemish Painting,* ed. Donald Fels, trans. Richard Bedell and Rebecca McClung (Floyd, VA: Alchemist, 2001), pp. 145–338. See also Hugh Trevor-Roper, "Mayerne and His Manuscript," in *Art and Patronage in the Caroline Courts,* ed. David Howarth (Cambridge: Cambridge University Press, 1993), pp. 264–93; Mansfield Kirby Talley, *Portrait Painting in England: Studies in the Technical Literature before 1700* (London: Paul Mellon Centre for Studies in British Art, 1981), pp. 72–149; and Ana Sánchez-Lassa de los Santos, "Technique and Materials in the Paintings of Orazio Gentileschi," in *Orazio Gentileschi at the Court of Charles I,* ed. Gabriele Finaldi, exhibition catalogue (London: National Gallery, 1999), pp. 79–97.

61. Mayerne, "Pictoria Sculptoria," p. 155.

62. Ibid., pp. 241–44.

63. Ibid., p. 186 and p. 311n87. The book in question appears to be Paracelsus, *Chirurgia minor,* ed. Gerhard Dorn (Basel, 1570).

64. Ibid., p. 169. Berger, in Mayerne, *Lost Secrets,* p. 303n45, cites John Gerard, *Catalogus arborum, fruticum ac plantarum tam indeginarum quam exoticarum in horto J. G. . . . nascentium* (London, 1596); and John Gerard, *The Herball: Or Generale Historie of Plantes* (London, 1597). One of England's most famous herbalists, Gerard oversaw the College of Physicians' physic garden as well as the gardens of William Cecil, Lord Burghley.

65. As noted by Ronald Lightbown, "Charles I and the Traditions of European Princely Collecting," in MacGregor, *The Late King's Goods,* pp. 53–72, esp. p. 68.

66. The principal treatise is entitled "Des Esmaulx," BL MS Sloane 1990. Trained

as a goldsmith in Geneva, Petitot likely studied a year or two in Paris with Jean Toutin, who is credited with reviving the art of enamel painting and may have been the first to paint portraits in the medium. Following this initial introduction, Petitot seems to have then perfected his own process in England with Mayerne's help. See Ronald Lightbown, "Jean Petitot and Jacques Bordier at the English Court," *Connoisseur* 168 (1968): 82–91; and Trevor-Roper, "Mayerne and His Manuscript," pp. 274ff.

67. Frances Huemer, *Corpus Rubenianum Ludwig Burchard, Part 19, Portraits I* (London: Harvey Miller, 1977), pp. 91–93, 178–80. Furdell, *Royal Doctors*, pp. 104–5, observes that "a posthumously published cookbook of his, *Archimagirus Anglo-Gallicus,* testified to his status as a gourmand."

68. Huemer includes the letter, dated March 25, 1631 (*Corpus Rubenianum Ludwig Burchard,* p. 180). The lighthouse iconography may depend on an image from Jacob Cat's 1627 emblem book. See John Martin, "Portraits of Doctors by Rembrandt and Rubens," *Proceedings of the American Philosophical Society* 130 (1986): 7–20.

69. See Edward Norgate, *Miniatura or the Art of Limning,* ed. Jeffrey Muller and Jim Murrell (New Haven, CT: Yale University Press, 1997); quotation is from p. 58; Martin Hardie's introduction to his edition, *Miniatura; or, The Art of Limning* (Oxford: Clarendon Press, 1919), pp. vi–xxix; R. D. Harley, *Artists' Pigments c. 1600–1835: A Study in English Documentary Sources* (London: Butterworths, 1982), pp. 9–12; and Talley, *Portrait Painting in England,* pp. 156–70. Two principal versions of Norgate's manuscript exist, the first written between 1621 and 1626, the second between 1648 and 1650. BL MS Harley 6000 includes a copy of the former; Bodleian MS Tanner 326 includes a copy of the latter. Hardie's edition is based on MS Tanner 326, while the more recent edition by Muller and Murrell collates this with another copy owned by the Royal Society (MS 136).

70. See the Muller-Murrell edition of Norgate's *Miniatura,* pp. 58, 70, 85, 90.

71. BL Add. MS 12461 was owned by Thoresby. BL Add. MS 23080 was owned by both Vertue and Walpole. Ibid., pp. 217–18.

72. In his *Athenae Oxoniensis,* Anthony Wood states that Haydocke "lived always a physician of good repute at Salisbury, and retiring for a time to London, died, and was buried there, a little before the grand rebellion." See Sarah Bakewell's entry in the *Oxford Dictionary of National Biography;* Frederick Hard, "Richard Haydocke and Alexander Browne: Two Half-Forgotten Writers on the Art of Painting," *PMLA* 55 (1940): 727–41; and Karl Josef Höltgen, "Richard Haydocke: Translator, Engraver, Physician," *The Library,* 5th ser., 22 (1978): 15–32.

73. Richard Haydocke, trans., *A Tracte Containing the Artes of Curious Paintinge, Carvinge, and Buildinge,* by Giovanni Paolo Lomazzo (Oxford, 1598). Lomazzo's treatise was published in Milan in 1584. The quotation comes from Dr. John Case's unpaginated foreword. Noting the enthusiasm Lomazzo's text generated in seventeenth-century Europe, Moshe Barasch in *Theories of Art from Plato to Winckelmann* (New York: New York University Press, 1985), p. 273, attributes the book's appeal to its comprehensive scope: "here was finally the longed-for, articulate, complete system of

painting." Also see Gerald Ackerman, "Lomazzo's Treatise on Painting," *Art Bulletin* 49 (1967): 317–26; and Martin Kemp, "'Equal Excellences': Lomazzo and the Explanation of Individual Style in the Visual Arts," *Renaissance Studies* 1 (1987): 1–26.

74. The "Censure" appears in bk. 3, pp. 125–33.

75. Bodley in a letter to the keeper of his library, dated June 4, 1601, writes, "If I could get Lomazius in Italian to be joined with Master Haidocke's English it would deserve a good place in the Library." Quoted in Hard, "Richard Haydocke and Alexander Browne," pp. 733–34.

76. Haydocke, *Tracte,* pp. 3–4. Later, in response to Lomazzo's judgment that God the Father is best "represented with perfect cleere colours," Haydocke adds in the margin, "And I that he should not be Painted at all." Both instances are noted by John Pope-Hennessy, "Nicholas Hilliard and Mannerist Art Theory," *Journal of the Warburg and Courtauld Institutes* 6 (1943): 89–100, esp. p. 90. More generally, see Clare Haynes, *Pictures and Popery: Art and Religion in England, 1660–1760* (Aldershot, UK: Ashgate, 2006). Also see Michael Wyatt, *The Italian Encounter with Tudor England: A Cultural Politics of Translations* (New York: Cambridge University Press, 2005), esp. pp. 157ff.

77. Haydocke, *Tracte,* unpaginated "Address to the Reader." Haydocke began translating with a copy from Thomas Allen, "that unfeigned lover and furtherer of all good arts," but it was so incomplete (like "the relics of a shipwreck"), that it was of limited use. A "perfect copy" was then "procured" from Italy by an unnamed, though "most kind gentleman," identified by Lucy Gent as Thomas Brette; see Höltgen, "Richard Haydocke," p. 20.

78. Haydocke, *Tracte,* unpaginated "Address to the Reader." Hilliard's treatise was not published until the twentieth century, when it appeared in *The Walpole Society* 1 (1911–12): 1–50. See the more recent edition by Arthur Kinney and Linda Bradley Salamon, *Nicholas Hilliard's "Art of Limning"* (Boston: Northeastern University Press, 1983), which includes a useful commentary by Salamon. For the dependence of Hilliard's text on the *Tracte,* see Pope-Hennessy, "Nicholas Hilliard and Mannerist Art Theory." As William Poole generously pointed out to me, the suggestion is made in Margery Corbett and Ronald Lightbown, *The Comely Frontispiece: The Emblematic Title-Page in England 1550–1660* (London: Routledge & Kegan Paul, 1979), that Haydocke was also closely associated with a fellow academic and amateur painter, Erasmus Williams (1552–1608).

79. Haydocke, *Tracte,* bk. 3, pp. 125–33.

80. Ibid,. p. 125.

81. Ibid., p. 126.

82. Ibid., p. 127.

83. Ibid., p. 133.

84. For a full discussion and bibliography, see Michael Baxandall, "English *Disegno,*" in *England and the Continental Renaissance: Essays in Honour of J. B. Trapp,* ed. Edward Chaney and Peter Mack (Woodbridge, Suffolk: Boydell Press, 1990), pp. 203–14.

85. Ibid., p. 208.

86. Haydocke, *Tracte*, p. 14. In regard to the *paragone* between painting and sculpture, Lomazzo does his best to remain neutral. Despite the disproportionate attention he gives to painting in the text, he insists several times that there is no essential difference between it and carving. I am not suggesting Haydocke would have viewed artists and physicians as equals—only that Haydocke would have identified with efforts to advance one's vocational status. Hilliard stresses the theme in the *Art of Limning:* "I wish it were so that none should meddle with limning but gentleman alone." He then proceeds to differentiate limning "as a thing apart from all other Painting or drawing." See the Kinney and Salamon edition, p. 16.

87. Höltgen, "Richard Haydocke," pp. 21ff. The classic discussion of Dürer's proportions is Erwin Panofsky, "The History of the Theory of Human Proportions as a Reflection of the History of Styles," in *Meaning in the Visual Arts* (Chicago: University of Chicago Press, 1955), pp. 55–107. Haydocke justifies the inclusion of his own images on economic grounds: "pictures cut in copper bear a higher rate of charge than in probabilities a professed scholar can undertake." As Antony Griffiths observes in *The Print in Stuart Britain 1603–1689* (London: British Museum, 1998), p. 31, the 1580s and '90s marked the (belated) shift in England from woodcuts to engravings, with a number of contemporary writers commenting on the increased expense of the new media. Karl Josef Höltgen, "An Unknown Manuscript Translation by John Thorpe of du Cerceau's *Perspective,*" in *England and the Continental Renaissance,* ed. Chaney and Mack, pp. 215–28, identifies editions of Serlio, Vitruvius, and du Cerceau as additional sources for Haydocke's plates. For Beham, see Pia Cuneo, "Beauty and the Beast: Art and Science in Early Modern European Equine Imagery," *Journal of Early Modern History* 4 (2000): 269–321.

88. Pope-Hennessy, "Nicholas Hilliard and Mannerist Art Theory," pp. 93–94.

89. Haydocke, *Tracte,* the first page of his unnumbered address to the reader.

90. Quoted in Gerald Beasley et al., *The Mark J. Millard Architectural Collection,* vol. 2, *British Books: Seventeenth through Nineteenth Centuries* (Washington, DC: National Gallery of Art, 1998), p. 366. Beasley finds the claim "disingenuous," and sees the book as a deliberate attempt on Wotton's part to enhance his reputation at exactly the point he was being considered for a provost position at Eton College. Regardless, that Wotton frames the book as a therapeutic diversion itself suggests the currency of such thinking. With the support of Buckingham, Wotton did, incidentally, receive the appointment, beating out a number of strong candidates, including Francis Bacon.

91. Quoted in Houghton, "English Virtuoso," p. 64.

92. Höltgen, "Richard Haydocke," pp. 27–28.

93. L. G. Wickham Legg, "On a Picture Commerative of the Gunpowder Plot Recently Discovered at New College, Oxford," *Archaeologia* 84 (1934): 27–39; Höltgen, "Richard Haydocke," p. 29, attributes the design to Haydocke.

94. My discussion of Highmore depends on Malcolm Oster's entry in the *Oxford Dictionary of National Biography.* Robert Frank, "Viewing the Body: Reframing Man and Disease in Commonwealth and Restoration England," in *The Restoration Mind,*

ed. W. Gerald Marshall (Newark: University of Delaware Press, 1997), pp. 65–110, describes the *Corporis humani disquisitio anatomica* as "the first genuinely original anatomic textbook by an Englishman" (p. 74). For all of his failings, Digby was also an important figure among the early Stuart virtuosi and admittedly deserves more attention than he receives here.

95. Along with these authors, Haydocke's translation is recommended in Sir George Buc's essay "The Third University in England" (1615); it seems to have informed William Burton's thoughts on paintings that appear in his 1622 *History of Leicestershire,* and it also was important for the 1668 anonymous treatise *The Excellency of the Pen and Pencil.* See Hard, "Richard Haydocke and Alexander Browne," p. 734. As Arundel's librarian, Junius could have also consulted the original Italian.

96. Noted by Hard, "Richard Haydocke and Alexander Browne," p. 735. See William Hogarth, *The Analysis of Beauty,* ed. Ronald Paulson (New Haven, CT: Yale University Press, 1997), pp. 2–3.

97. Hard, "Richard Haydocke and Alexander Browne," p. 735.

98. A smaller but still intriguing bridge between Haydocke and the virtuosi of the eighteenth century comes through a copy of Aelian's *Varia Historia* (Leiden, 1553), now in the Bodleian Library. Haydocke owned the octavo volume and added his signature; as William Poole kindly explained to me, the copy later turned up in the library of Dr. Hans Sloane.

99. Barbara Stafford has made this point in a variety of contexts. See especially *Body Criticism,* pp. 362–66.

100. John Aikin, *Biographical Memoirs of Medicine in Great from the Revival of Literature to the Time of Harvey* (London, 1780), pp. 21ff. For the larger context, see Vivian Nutton, "'A Diet for Barbarian': Introducing Renaissance Medicine to Tudor England," in *Natural Particulars: Nature and the Disciplines in Renaissance Europe,* ed. Anthony Grafton and Nancy Siraisi (Cambridge, MA: MIT Press, 1999), pp. 275–94.

101. Gianna Pomata and Nancy Siraisi, in particular, have begun to explore this vast topic within the Italian context. In addition to their insightful introduction and essays in the volume they coedited, *Historia,* see Siraisi, "Anatomizing the Past: Physicians and History in Renaissance Culture," *Renaissance Quarterly* 53 (2000): 1–30; and Siraisi, "History, Antiquarianism and Medicine: The Case of Girolamo Mercuriale," *Journal of the History of Ideas* 64 (2003): 231–50.

102. This is one of the claims made by Houghton, "English Virtuoso," esp. pp. 68ff.

103. Harold Cook, "Good Advice and Little Medicine: The Professional Authority of Early Modern English Physicians," *Journal of British Studies* 33 (1994): 1–31.

104. Francis Haskell, *History and Its Images: Art and the Interpretation of the Past* (New Haven, CT: Yale University Press, 1993), pp. 44–51; Patricia Rubin, *Giorgio Vasari: Art and History* (New Haven, CT: Yale University Press, 1995), pp. 95, 144–47, 162–64; and T. C. Price Zimmermann, *Paolo Giovio: The Historian and the Crisis of Sixteenth-Century Italy* (Princeton, NJ: Princeton University Press, 1995), esp. pp. 16ff. and 207ff.

105. For Aldrovandi as well as the rest of the Italian collectors mentioned in this section, see Paula Findlen's seminal study *Possessing Nature: Museums, Collecting, and Scientific Culture in Early Modern Italy* (Berkeley and Los Angeles: University of California Press, 1994). Aldrovandi's summary of his collection is quoted in Lorraine Daston and Katharine Park, *Wonders and the Order of Nature, 1150–1750* (New York: Zone Books, 1998), p. 154—an especially valuable text thanks to its broad historical scope. Also useful is Caroline Murphy, *Lavinia Fontana: A Painter and Her Patrons in Sixteenth-Century Bologna* (New Haven, CT: Yale University Press, 2003). For the connections between Aldrovandi and the Accademia dei Lincei, see David Freedberg, *The Eye of the Lynx: Galileo, His Friends, and the Beginnings of Modern Natural History* (Chicago: University of Chicago Press, 2002). I briefly discuss one of the Linceans, Dr. Johann Faber, in chapter 5 of the present text, p. 180.

106. Silvio Bedini, "The Evolution of Science Museums," *Technology and Culture* 6 (1965): 1–29; and Antonio Aimi, Vincenzo de Michele, and Alessandra Morandotti, "Towards a History of Collecting in Milan in the Late Renaissance and Baroque Periods," in *The Origins of Museums: The Cabinet of Curiosities in Sixteenth and Seventeenth-Century Europe,* ed. Oliver Impey and Arthur MacGregor (Oxford: Clarendon Press, 1985), pp. 24–38. The eighteenth-century library of Dr. Richard Mead included a copy of the catalogue of the Settala collection: Paolo Terzago, *Museo o galleria adunata dal sapere, e dallo studio del Sig. Canonico Manfredo Settala Nobile Milanese* (Tortona, 1666); see the *Bibliotheca Meadiana, sive Catalogus Librorum Richardi* (London, 1754), p. 36.

107. Paula Findlen, ed., *Athanasius Kircher: The Last Man Who Knew Everything* (New York: Routledge, 2004), esp. Martha Baldwin's contribution, "Reverie in the Time of Plague: Athanasius Kircher and the Plague Epidemic of 1656," pp. 63–77. Also useful are Harry Torrey, "Athanasius Kircher and the Progress of Medicine," *Osiris* 5 (1938): 246–75; John Fletcher, "Medical Men and Medicine in the Correspondence of Athanasius Kircher (1602–80)," *Janus* 56 (1969): 259–77; and Ingrid Rowland, *The Ecstatic Journey: Athanasius Kircher in Baroque Rome,* exhibition catalogue (Chicago: University of Chicago Library, 2000).

108. Carlo Ginzburg traces "the first attempt to establish connoisseurship" to Mancini in this widely read essay from 1979, which appeared in English as "Morelli, Freud, and Sherlock Holmes: Clues and Scientific Method," *History Workshop* 9 (1980): 5–36. Beginning with Mancini and ending with the late nineteenth-century triumvirate of medical men, Morelli, Freud, and Conan Doyle, it was reprinted in *Clues, Myths, and the Historical Method,* trans. John and Anne Tedeschi (Baltimore: Johns Hopkins University Press, 1989), pp. 96–125; see especially pp. 108–9.

109. Todd Olson, "Caravaggio's Coroner: Forensic Medicine in Giulio Mancini's Art Criticism," *Oxford Art Journal* 28 (2005): 83–98.

110. Ibid, pp. 89, 97–98. Olson struggles with the curious fact that Mancini, notwithstanding his harsh criticism, was willing to pay 200 scudi for the painting.

111. Daston and Park, *Wonders and the Order of Nature,* p. 311.

112. Findlen, *Possessing Nature,* pp. 7–8, 26, 33, 43, 146–50, 400. Findlen is generally valuable for the differences between the courtly culture of seventeenth-century

Italy and the "public" character of the Royal Society, though—following Houghton— she occasionally overstates the intellectual differences, portraying the society as being more modern than it actually was.

113. Quoted by Findlen, ibid., p. 96.

114. *Diary of John Evelyn*, 2:230, 283. Eighteen months later, Evelyn visited the Settala collection in Milan, where he was especially impressed by an assortment of crystals, pieces of amber containing insects, and objects woven from fibrous minerals; see p. 502.

Chapter Two

1. Charles II reestablished the practice soon after he became king. As a child, Samuel Johnson had been touched by Queen Anne. The Hanoverians discontinued the ritual, though it persisted in France even until the early nineteenth century. As Roy Porter notes in *The Greatest Benefit to Mankind: A Medical History of Humanity from Antiquity to the Present* (London: HarperCollins, 1997), p. 282, Louis XV touched some two thousand scrofula victims at his coronation in 1722, and in 1815 supporters of the Bourbon restoration hoped the practice would bolster royal support. See also Marc Bloch's 1924 study, *The Royal Touch: Sacred Monarchy and Scrofula in England and France*, trans. J. E. Anderson (London: Routledge & Kegan Paul, 1973); and David Sturdy, "The Royal Touch in England," in *European Monarchy: Its Evolution and Practice from Antiquity to Modern Times*, ed. Heinz Duchhardt, Richard Jackson, and David Sturdy (Stuttgart: Franz Steiner, 1992), pp. 171–84.

2. Evelyn left England in November 1643. In Paris in June of 1647, he married Mary Browne, the daughter of Richard Browne, the King's Resident to the French court, and then returned to England four months later, leaving Mary behind with her family. He traveled back to Paris in July of 1649 and there retained close ties to the exiled court until 1653, when he and Mary both moved back to England.

3. Quoted in Harding, "John Evelyn, Hendrick van der Borcht the Younger, and Wenceslaus Hollar," p. 43.

4. *Diary of John Evelyn*, 2:358. Evelyn continued to edit the diary decades after the initial entries, often employing published guides such as Richard Lassels, *The Voyage of Italy* (London, 1670); see Edward Chaney, "Evelyn, Inigo Jones, and the Collector Earl of Arundel," in *John Evelyn and His Milieu*, ed. Frances Harris and Michael Hunter (London: British Library, 2003), pp. 37–60.

5. For the larger tradition of Englishmen in Padua, see Woolfson, *Padua and the Tudors*. The city's most famous physician and anatomist was Andreas Vesalius (1514– 64), though the university's reputation hardly rested upon his shoulders alone. See Cynthia Klestinec, "A History of Anatomy Theaters in Sixteenth-Century Padua," *Journal of the History of Medicine and Allied Science* 59 (2004): 375–412; and Cynthia Klestinec, "Civility, Comportment, and the Anatomy Theater: Girolamo Fabrici and

His Medical Students in Renaissance Padua," *Renaissance Quarterly* 60 (2007): 434–63. As a starting point into the now sizable body of scholarship on early modern anatomy more generally, see Jonathan Sawday, *The Body Emblazoned: Dissection and the Human Body in Renaissance Culture* (New York: Routledge, 1995); Andrew Cunningham, *The Anatomical Renaissance: The Resurrection of the Anatomical Projects of the Ancients* (Aldershot, UK: Scolar Press, 1997); Andrea Carlino, *Books of the Body: Anatomical Ritual and Renaissance Learning,* trans. John Tedeschi and Anne Tedeschi (Chicago: University of Chicago Press, 1999); and Katherine Park, *Secrets of Women: Gender, Generation, and the Origins of Human Dissection* (New York: Zone Books, 2006).

6. *Diary of John Evelyn,* 2:464–66 (from which the quotations are taken), 475–76. True to form, Evelyn extracted moral lessons from these scenes, observing that to be a "Spectator of the miserie" endured by these patients would be a more effective deterrent from "the vice reigning in this licentious Country" than any "document or lecture." Similarly, Evelyn was offended by the doctors' "freely admitting young Gentlemen Travellers to see their operations upon some of the femal Sex, who even in the midst of their tortures, are not very modest, & when they begin to be well, plainely lew'd." The sparse entries in the diary during this nine-month period perhaps attest to the seriousness with which Evelyn engaged his studies, though silence obviously has its interpretive limits.

7. Evelyn donated the tables to the Royal Society in October 1667. In June 1781 they were turned over to the British Museum, and in 1809 they were given to the Royal College of Surgeons. I am indebted to Simon Chaplin, the curator of the Museum of the Royal College of Surgeons, for supplying photographs of the tables and sharing his notes from a talk he gave at the National Portrait Gallery in London in 2002. See Richard Aspin, "John Evelyn's Tables of Veins and Arteries: A Rediscovered Letter," *Medical History* 39 (1995): 493–99. This letter by Evelyn, now in the Wellcome Library in London, provides the fullest account of the origins of the tables. The first part of it appears as a preface to William Cowper's article, "An Account of Several Schemes of Arteries and Veins, dissected from adult Human Bodies," *Philosophical Transactions of the Royal Society* 23 (1702): 1177–1201.

8. Aspin, "John Evelyn's Tables of Veins and Arteries," p. 499. Simon Chaplin suggests the vessels may have been injected with wax to facilitate the dissection, while only the arteries seem to have been painted (red) after being glued down. Personal correspondence with Simon Chaplin, April 2003.

9. That the panels arrived in England is remarkable. Evelyn notes that though he sent them to Venice, they somehow ended up in Holland. Whether by "Accident or Ocassion," they remained there "a year or two," unbeknownst to Evelyn, who had by then settled in Paris. Richard Ford, a prominent merchant and later Lord Mayor, eventually discovered the tables, together with "several Bales of Books & other things" that Evelyn "had been Collecting in Italy," and forwarded them on to London, where Evelyn received them, probably in 1649 during an extended visit back to England; Aspin, "John Evelyn's Tables of Veins and Arteries," p. 499.

10. *Diary of John Evelyn*, 3:77–78.

11. This is Aspin's explanation in "John Evelyn's Tables of Veins and Arteries," p. 493.

12. *Diary of John Evelyn*, 2:52–53.

13. Presumably in part because of his translation of Gabriel Naudé, *Instructions Concerning Erecting of a Library* (London, 1661). In the Royal Society archives, there is also a book classification scheme by Evelyn in which medicine and the visual arts are especially well represented; see "John Evelyn's Plan for a Library," *Notes and Records of the Royal Society of London* 7 (1950): 193–94. Evelyn, together with Christopher Wren, was also consulted by Thomas Tenison regarding London's first public library, which opened in 1684 on the site of what is now the National Portrait Gallery; see *Diary of John Evelyn*, 4:367–68.

14. This characterization generally matches that of Charles O'Malley, "John Evelyn and Medicine," *Medical History* 12 (1968): 219–31, though O'Malley ultimately faults Evelyn for his wide array of interests. Also see Frank, "Viewing the Body," pp. 65, 110.

15. *Diary of John Evelyn*, 2:466ff. As Chaney notes in "Evelyn, Inigo Jones, and the Collector Earl of Arundel," p. 47, this passage has consistently caused confusion, since most commentators have tried to locate the sites not in Padua but in Mantua, mistaking the garden in the former for the city of the latter.

16. *Diary of John Evelyn*, 2:467–69.

17. In the *Diary*, 2:52–56, Evelyn describes the gallery of the Honselaarsdijk as "prettily painted with several huntings." He specifically mentions only Couwenberg, but his rationale for singling out the painter soon becomes clear: he himself had recently purchased one of Couwenberg's works. The passage throws into relief the difficulties presented by the *Diary*. That an artist of Couwenberg's caliber may be cited while Rubens is not thus depends on factors other than disinterested aesthetic valuations. For both the Honselaarsdijk and *The Crowning of Diana*, see the exhibition catalogue edited by Peter van der Ploeg and Carola Vermeeren, *Princely Patrons: The Collections of Frederick Henry of Orange and Amalia of Solms in The Hague* (The Hague: Mauritshuis, 1997), pp. 40–44, 200–203.

18. *Diary of John Evelyn*, 3:2–4.

19. Francis Haskell, *Patrons and Painters: Art and Society in Baroque Italy* (New Haven, CT: Yale University Press, 1980), pp. 17, 88, 131, 135.

20. Nehemiah Grew, *Musaeum Regalis Societatis; or, A Catalogue & Description of the Natural and Artificial Rarities Belonging to the Royal Society and Preserved at Gresham Colledge* (London, 1681), p. 4.

21. Evelyn's copy of Grew's catalogue is in the British Library. I am grateful to Matt Hunter for pointing the annotation out to me. Also see *Diary of John Evelyn*, 2:475, where Evelyn describes them as "the first of that kind [that] had ben ever seene in our Country, & for ought I know, in the World."

22. I am indebted to Fredrik Jonsson for raising this specific question, as well as providing valuable input for this section more generally.

23. *Diary of John Evelyn*, 3:338, 379; 4:291. In October 1662, for instance, he recorded a visit to the College of Physicians, noting a statue of "that renouned Physitian Dr. Harvey, inventor of the circulation of the blood." Twice on the occasion of the annual Harveian Oration, he cited the doctor's importance, and in 1685 he referred to Harvey's authority in regard to the illness of his daughter. Evelyn also was present at the Royal Society for a number of experiments on animals involving blood.

24. Gail Kern Paster, "Nervous Tension," in *The Body in Parts: Fantasies of Corporeality in Early Modern Europe*, ed. David Hillman and Carla Mazzio (New York: Routledge, 1997), pp. 106–25, stresses the crucial role "vital spirits" played in this tripartite division of nerves, arteries, and veins, and she warns against substituting "figurative where literal meanings ought to remain." She also notes the similarities Bacon saw between the action of "vital spirits" in the body's vascular vessels and the explosion of gunpowder in the barrel of a gun. The comparison is intriguing given that the wealth of the Evelyn family resulted from the production of gunpowder.

25. For this problem of picturing the unseen, see Stafford, *Body Criticism*.

26. Even if, as Simon Chaplin suggests, Evelyn's mounted anatomies perhaps benefited from wax injection, it would have been of a less refined variety, with the main goal being to dry the specimens.

27. Louis de Bils and Frederick Ruysch were also crucial for the shift from "dry" to "wet" specimens. See F. J. Cole, "The History of Anatomical Injections," in *Studies in the History and Method of Science*, ed. Charles Singer (Oxford: Clarendon Press, 1921), 2:285–343; and Harold Cook, "Time's Bodies: Crafting the Preparation and Preservation of Naturalia," in *Merchants & Marvels: Commerce, Science, and Art in Early Modern Europe*, ed. Pamela Smith and Paula Findlen (New York: Routledge, 2002), pp. 223–47.

28. L. M. Payne, "Tabulae Harveianae: A 17th-Century Teaching Aid," *British Medical Journal* (July 2, 1966): 38–39. The so-called Harvey tables were donated to the College of Physicians in 1823. See also Kemp and Wallace, *Spectacular Bodies*, pp. 40–42.

29. Sadly, the Royal Society proved to be a poor choice for the safe handling of the collection, selling off perhaps 90 percent of it in the nineteenth century as notions changed about what should constitute a scientific library. Estimates of the size of the original Arundel library range from 2,500 to 4,000 volumes. See Linda Peck, "Uncovering the Arundel Library at the Royal Society: Changing Meanings of Science and the Fate of the Norfolk Donation," *Notes and Records of the Royal Society of London* 52 (1998): 3–24.

30. The Royal Society met at Arundel House for nearly eight years—January 1667 to November 1674—during which time Gresham College was used to provide space for the Lord Mayor and merchants who had been displaced by the fire.

31. Fréart, *An Idea of the Perfection of Painting*. For relevant correspondence between Evelyn and Henry Howard, see the *Diary and Correspondence of John Evelyn*, ed. William Bray (New York: Scribner's, 1906), 3:352, 369.

32. *Diary of John Evelyn*, 3:501.

33. Thomas Sprat, in his *The History of the Royal Society of London* (London, 1667), judged the "General Collection" to be "one of the Principal Intentions" of the society (p. 386). See Michael Hunter, "The Cabinet Institutionalized: The Royal Society's 'Repository' and Its Background," in *The Origins of Museums,* ed. Impey and Mac-Gregor, pp. 159–67, esp. p. 164. For the society's "public" role, see William Eamon, "From the Secrets of Nature to Public Knowledge," in *Reappraisals of the Scientific Revolution,* ed. D. C. Lindberg and R. S. Westman (New York: Cambridge University Press, 1990), pp. 349–55; and Larry Stewart, *The Rise of Public Science: Rhetoric, Technology, and Natural Philosophy in Newtonian Britain, 1660–1750* (New York: Cambridge University Press, 1992).

34. Evelyn, quoted in Cowper, "An Account of Several Schemes of Arteries and Veins," pp. 1177–78.

35. *Diary of John Evelyn,* 2:223, 247. See Antony Griffiths, "The Arch of Titus by Carlo Maratti," *National Art Collections Fund Annual Review* (1992): 35–37. I do not mean to suggest Evelyn typically thought of knowledge as being unmediated (just the opposite is more likely), and one might argue he is able to place so much trust in these objects because he understands the circumstances of their production.

36. Robert Boyle, *Occasional Reflections upon Several Subjects* (London, 1665), in *Works of Robert Boyle,* 5:171. The reference to mummies as medicine comes in a discussion of cannibalism. For the relationship between medicines and museum artifacts, including mummies, see Arnold, *Cabinets for the Curious,* pp. 135–63. Arnold notes, p. 135, that for Nicolas Le Fèvre, the human mummy was "one of the noblest Remedies."

37. Samples from Sloane's *materia medica,* on loan from London's Natural History Museum, are featured in the British Museum's exhibition Enlightenment: Discovering the World in the Eighteenth Century, in the recently restored King's Library.

38. Grew, *Musaeum Regalis Societatis,* p. 4.

39. This sensibility is perhaps related to a broader skepticism identified by Deborah Harkness on the part of the early seventeenth-century English toward anatomy and dissection as obvious paths to improved medical practice. In *"Nosce teipsum:* Curiosity, the Humoural Body, and the Culture of Therapeutics in Late Sixteenth- and Early Seventeenth-Century England," in *Curiosity and Wonder from the Renaissance to the Enlightenment,* ed. R. J. W. Evans and Alexander Marr (Aldershot, UK: Ashgate, 2006), pp. 171–92, Harkness argues that for the English, the dictum "know thyself" was as likely to be understood as referring to an evaluation of the reactions of one's own living body to therapeutics as an invocation to study a dissected corpse. If she is right, we might see Evelyn's tables as marking a transition—even as they evince older attitudes that ultimately accommodate such displays as curiosities.

40. Henry Lyons, *The Royal Society 1660–1940: A History of Its Administration under Its Charters* (Cambridge: Cambridge University Press, 1944), appendix, pp. 341–42. T. P. R. Laslett questioned Lyons's bifurcation of the membership, arguing that such anachronistic divisions fail to account for major figures such as Evelyn and Boyle, both of whom participated in the construction of knowledge but, as gentlemen, held

no occupation; see Laslett, "The Foundation of the Royal Society and the Medical Profession in England," *British Medical Journal* (July 16, 1960): 165–69. As the Royal Society's function as an audience for knowledge production has become increasingly clear, Richard Sorrenson has made the pithy observation that to "criticize the bulk of the Fellows for not being productive . . . makes as much sense as finding fault with an opera audience for not singing." Sorrenson, "Towards a History of the Royal Society in the Eighteenth Century," 29–46; quotation is from p. 33. Also see Michael Hunter, *The Royal Society and Its Fellows 1660–1700: The Morphology of an Early Scientific Institution* (Chalfont St. Giles, Buckinghamshire: British Society for the History of Science, 1982); Charles Gillispie, "Physick and Philosophy: A Study of the Influence of the College of Physicians of London upon the Foundation of the Royal Society," *Journal of Modern History* 19 (1947): 210–25; A. Rupert Hall, "English Medicine in the Royal Society's Correspondence: 1660–1677," *Medical History* 15 (1971): 111–25; A. Rupert Hall, "Medicine and the Royal Society," in *Medicine in Seventeenth Century England*, ed. Allen Debus (Berkeley and Los Angeles: University of California Press, 1974), pp. 421–52; Roy Porter, "The Early Royal Society and the Spread of Medical Knowledge," in *Medical Revolution*, ed. French and Wear, pp. 272–93; and Philip Wilson, "An Enlightenment Science? Surgery and the Royal Society," in *Medicine in the Enlightenment*, ed. Roy Porter (Atlanta: Rodopi, 1995), pp. 360–86.

41. Of the 425 Fellows elected between 1660 and 1687, 50 also belonged to the College of Physicians; see Hall, "Medicine and the Royal Society," pp. 423–24.

42. Endowed by Harvey and completed in 1654, the Museum of the College of Physicians was principally a library, though it also included medical instruments and curiosities. That it burned in 1666 may have played a role in Evelyn's decision the following year to donate the tables to the Royal Society. For the collection, see Michael Hunter, "The Cabinet Institutionalized," p. 162. For the challenges facing the College, see Cook, *Decline of the Old Medical Regime*.

43. A. Rupert Hall, "Medicine and the Royal Society," p. 426; and Marie Boas Hall, *Henry Oldenburg: Shaping the Royal Society* (Oxford: Oxford University Press, 2002), esp. pp. 50–56.

44. I depend on the following: Kerry Downes, *The Architecture of Wren* (New York: Universe Books, 1982); William Gibson, "The Bio-Medical Pursuits of Christopher Wren," *Medical History* 14 (1970): 331–41; Michael Hunter, "The Making of Christopher Wren," in *Science and the Shape of Orthodoxy: Intellectual Change in Late Seventeenth-Century Britain* (Woodbridge, Suffolk: Boydell Press, 1995), pp. 45–65; Lisa Jardine, *On a Grander Scale: The Outstanding Life of Sir Christopher Wren* (London: HarperCollins, 2002); Lydia Soo, "Reconstructing Antiquity: Wren and His Circle and the Study of Natural History, Antiquarianism, and Architecture at the Royal Society" (Ph.D. diss., Princeton University, 1989); Lydia Soo, *Wren's "Tracts" on Architecture and Other Writings* (Cambridge: Cambridge University Press, 1998); and Adrian Tinniswood, *His Invention So Fertile: A Life of Sir Christopher Wren* (Oxford: Oxford University Press, 2001).

45. Wren's name appears throughout Evelyn's diary. In June 1679, Evelyn be-

came one of two godfathers to Wren's son William. Mentally handicapped, William lost his mother while still a baby, and of four children, only William and his older half-brother, Christopher Jr., lived to adulthood. The latter compiled *Parentalia; or, Memoirs of the Family of the Wrens . . . Chiefly of Sir Christopher Wren* (London, 1750), which includes a number of Wren's writings.

46. Robert Frank, *Harvey and the Oxford Physiologists* (Berkeley and Los Angeles: University of California Press, 1980), esp. pp. 43–89.

47. Quoted in Gibson, "The Bio-Medical Pursuits of Christopher Wren," p. 334.

48. Quoted in Michael Hunter, "The Making of Christopher Wren," p. 59; and Frank, *Harvey and the Oxford Physiologists,* p. 171.

49. An English translation of *The Anatomy of the Brain and Nerves* later appeared as part of a collection of Willis's work, *The Remaining Medical Works of That Famous and Renowned Physician Dr. Thomas Willis,* translated by Samuel Pordage (London, 1681).

50. Quoted by Gibson, "The Bio-Medical Pursuits of Christopher Wren," p. 338.

51. For an example of new approaches to Hooke that give him far more credit than he has typically received, see Matthew Hunter, "Robert Hooke Fecit: Making and Knowing in Restoration London" (Ph.D. diss., University of Chicago, 2007).

52. Stephen Pumfrey, "Ideas above His Station: A Social Study of Hooke's Curatorship of Experiments," *History of Science* 29 (1991): 1–44.

53. Christine Stevenson provides a fascinating account of Hooke's rebuilding of Bethlehem Hospital in *Medicine and Magnificence: British Hospital and Asylum Architecture, 1660–1815* (New Haven, CT: Yale University Press, 2000).

54. Richard Nichols notes, in *The Diaries of Robert Hooke, the Leonardo of London, 1635–1703* (Sussex: Book Guild, 1994), p. 142, that Hooke's diary includes over eight hundred entries pertaining to Wren.

55. John Summerson, *Sir Christopher Wren* (London: Collins, 1953), suggests this division, beginning the book with the assertion that "Sir Christopher Wren was a scientist who, at thirty, turned into an architect." Although Summerson goes on to qualify the claim, admitting its anachronisms, he nonetheless relies on the convenience of this facile compartmentalization to structure his account of Wren's career.

56. Levine, in *Between the Ancients and the Moderns,* pp. 178–81, notes the way in which this dialogue could easily deteriorate into a shouting match, as was the case at the Sheldonian's inauguration in July 1669 when the University Orator Robert South used the occasion to disparage the Royal Society and the New Philosophy. Lest one make too much of Wren's classical dependency, Downes, *Architecture of Wren,* pp. 32–39, stresses the extent to which Wren breaks from his prototype, arguing the Theater of Marcellus is largely "forgotten rather than remembered." Also see John Summerson, *The Sheldonian in Its Time* (Oxford: Clarendon Press, 1964); and Anthony Geraghty, "Wren's Preliminary Design for the Sheldonian Theatre," *Architectural History* 45 (2002): 275–88.

57. The letter from Abraham Hill to John Brookes, dated May 19, 1663, is quoted in Tinniswood, *His Invention So Fertile,* p. 103; and Charles Saumarez Smith, "Wren

and Sheldon," *Oxford Art Journal* 6 (1983): 45–50. Smith challenges readings of the theater that portray it strictly as a manifestation of "the natural experimental philosophy of the Royal Society" (p. 45) and instead stresses the theater's function (as actually built) as well as the role of Gilbert Sheldon, the sole patron behind the project's financing (and the namesake of Wren's first child, though he died before turning two). Appointed archbishop of Canterbury in 1663, Sheldon was eager to separate secular university rituals from sacred church rituals. Smith argues that Wren's design earned the approval of Sheldon's circle because of its "imagery of order, authority, and [traditional] scholarship" (p. 49). In taking into account these issues of patronage and reception, Smith rightfully reminds us of the wide range of responses a single building can evoke from different audiences; people can admire a building for different — even mutually exclusive — reasons. The contested character of the theater in no way reduces the degree to which Fellows of the Royal Society understood it as an expression of the group's intellectual aspirations.

58. Located on Monkwell Street, the building was demolished in 1784. A preliminary drawing by John Webb survives at Worcester College, Oxford. See John Harris, Stephen Orgel, and Roy Strong, *The King's Arcadia: Inigo Jones and the Stuart Court*, exhibition catalogue (London: Arts Council of Great Britain, 1973), p. 186.

59. Robert Plot, *Natural History of Oxfordshire* (Oxford, 1677), pp. 280–81. Arnold, *Cabinets for the Curious*, pp. 45–63, argues that Plot's text advanced a mode of "empirical investigation" akin to the collecting activities of early museums and the Royal Society.

60. David Sturdy and Neil Moorcraft, "Christopher Wren and Oxford's Garden of Antiquities," *Minerva* 10, no. 1 (1999): 25–28. For Evelyn's role, see his letter to Bathurst from September 9, 1667, in the *Diary and Correspondence of John Evelyn*, 3:354.

61. For the larger context of this French tradition of erudition, see Louis Antoine Olivier, "'Curieux,' Amateurs, and Connoisseurs: Laymen and the Fine Arts in the Ancien Regime" (Ph.D. diss., Johns Hopkins University, 1976), esp. pp. 24–35. Olivier usefully sifts through various terms applied to men of learning, observing that although the *virtuose* label appeared around the middle of the seventeenth century, it was long regarded as a neologism, and in fact, it was *curieux* that was used to convey the meaning that *virtuoso* suggested in English. *Amateur* and *connoisseur* came to be used regularly in the eighteenth century.

62. *The Correspondence of Henry Oldenburg*, ed. A. Rupert Hall and Marie Boas Hall (Madison: University of Wisconsin Press, 1965–86), 2:480–82; and 3:10–13. The assessment of Wren's methodological accomplishments depends on Michael Hunter, "The Making of Christopher Wren," esp. pp. 57–60. With intolerance toward Protestants mounting, Justel emigrated in 1681 to England, where he became FRS and royal librarian at St. James Palace; see Marie Boas Hall, *Henry Oldenburg*, p. 80.

63. *Correspondence of Henry Oldenburg*, 3:10–13.

64. To be precise, Browne possessed at this point only his MB; he received his MD

from Oxford in 1667, at which point he also was elected FRS. His letter appears in Margaret Whinney, "Sir Christopher Wren's Visit to Paris," *Gazette des Beaux-Arts* 51 (1958): 229–42; quotation is from p. 232.

65. No longer extant, the letter was included in Wren Jr., *Parentalia*, pp. 261–62, and appears in Whinney, "Sir Christopher Wren's Visit to Paris," pp. 235–38. For Evelyn as the recipient, see Jardine, *On a Grander Scale*, p. 242.

66. Walter Houghton, "The History of Trades: Its Relation to Seventeenth-Century Thought as Seen in Bacon, Petty, Evelyn, and Boyle," *Journal of the History of Ideas* 2 (1941): 33–60; Michael Hunter, *Science and Society in Restoration England*, pp. 87–112; Marie Boas Hall, "Oldenburg, the *Philosophical Transactions*, and Technology"; and Kathleen Ochs, "The Royal Society's History of Trades Programme: An Early Episode in Applied Science," *Notes and Records of the Royal Society* 39 (1985): 129–58.

67. Francis Bacon, *The Advancement of Learning* (New York: Modern Library, 2001), p. 74.

68. Francis Bacon, *The New Organon*, ed. Lisa Jardine and Michael Silverthorne (Cambridge: Cambridge University Press, 2000). Also see Lisa Jardine and Alan Stewart, *Hostage to Fortune: The Troubled Life of Francis Bacon* (London: Gollancz, 1998); and Antonio Perez-Ramos, *Francis Bacon's Idea of Science and the Maker's Knowledge Tradition* (Oxford: Oxford University Press, 1988). Interestingly, Bacon himself resists the "empirical" label, distinguishing "mechanic" natural philosophy from the "merely empirical and operative kind." See Sachiko Kusukawa, "Bacon's Classification of Knowledge," in *The Cambridge Companion to Bacon*, ed. Markku Peltonen (New York: Cambridge University Press, 1996), pp. 47–74; the above quotation is from p. 59.

69. Bacon, *New Organon*, p. 222.

70. Ibid., p. 228.

71. Robert Boyle, *The Usefulness of Natural Philosophy* (London, 1663), in *Works of Robert Boyle*, 3:295.

72. Christopher Merrett, *The Art of Glass, Wherein Are Shown the Wayes to Make and Colour Glass, Pastes, Enamels, Lakes, and other Curiosities* (London, 1668); Neri's treatise was published in 1612. See Marie Boas Hall, "Oldenburg, the *Philosophical Transactions*, and Technology," p. 27.

73. Ochs, "The Royal Society's History of Trades Programme," p. 144.

74. Linda Peck, *Consuming Splendor: Society and Culture in Seventeenth-Century England* (New York: Cambridge University Press, 2005), pp. 311ff., emphasizes the Royal Society's role in the proliferation of luxury goods, a category that further complicates the binary opposition of utility and "abstract knowledge" and adds an additional problem for the History of Trades project and its ultimate goals.

75. David Cram, Jeffrey Forgeng, and Dorothy Johnston, eds., *Francis Willughby's Book of Games: A Seventeenth-Century Treatise on Sports, Games, and Pastimes* (Aldershot, UK: Ashgate, 2003), esp. pp. 16–18, 35–40, 53–55, 314.

76. Houghton, "History of Trades," p. 56. For Houghton, the characterization is negative. A more productive framework for considering this range of interests comes from Richard Kroll, *The Material World: Literate Culture in the Restoration and Early*

Eighteenth Century (Baltimore: Johns Hopkins University Press, 1991), pp. 58ff., who argues that the Restoration's intellectual method, shaped largely by Pyrrhonian skepticism, was easily transferred across disciplines and proved adept at addressing a vast array of topics. See also Douglas Chambers, "John Evelyn and the Construction of the Scientific Self," in *The Restoration Mind,* ed. Marshall, pp. 132–46.

77. John Evelyn, *Essay on the First Book of T. Lucretius De Rerum Natura* (London, 1656). Pierre Gassendi, one of the most important advocates of a Christianized Epicureanism, became familiar to English readers in part through his biography of Nicolas-Claude Fabri de Peiresc, as translated by William Rand and published in 1657. Rand dedicated *The Mirrour of True Nobility and Gentility* to Evelyn, for as Kroll in *The Material World,* p. 141, explains, "just as Gassendi saw in Peiresc an anticipation of the ideal Epicurean gentleman and scholar, so Rand depicts Evelyn as an English version of the same *'Peireskian Vertues.'"* Also crucial was Dr. Walter Charleton's *Physiologia-Epicuro-Gassendo-Charltoniana* (London, 1654). See Robert Kargon, *Atomism in England from Hariot to Newton* (Oxford: Clarendon Press, 1966), pp. 77–92.

78. Evelyn MS 65, Christ Church, Oxford. See Michael Hunter, "John Evelyn in the 1650s," in *Science and the Shape of Orthodoxy,* pp. 67–98. Hunter suggests this is the volume Hartlib has in mind when he notes in his *Ephemerides* (1653) that Evelyn had "studied and collected a great Worke of all Trades" (p. 75). It also seems to have formed the basis of Evelyn's "Circle of Mechanical Trades," presented to the Royal Society in 1661.

79. Michael Hunter, "John Evelyn in the 1650s," p. 76.

80. Quoted in ibid., p. 80.

81. Ibid. Specifically, Evelyn cites "that Mathematico-Chymico-Mechanical School" of John Wilkins.

82. Ibid. As Michael Hunter notes, "capricious" does not appear in the version of the letter from Evelyn's Letterbook, though its inclusion is still preferable, based on the letter that was actually sent to Boyle.

83. For the larger historical context of these tensions, see Pamela Long, *Openness, Secrecy, Authorship: Technical Arts and the Culture of Knowledge from Antiquity to the Renaissance* (Baltimore: Johns Hopkins University Press, 2001).

84. Peltonen, *The Cambridge Companion to Bacon,* esp. Michel Malherbe, "Bacon's Method of Science," pp. 75–98.

85. John Evelyn, *Sculptura,* ed. C. F. Bell (Oxford: Clarendon Press, 1906); *Diary of John Evelyn,* 3:325; and Antony Griffiths, "John Evelyn and the Print," in *John Evelyn and His Milieu,* ed. Harris and Hunter, pp. 95–113.

86. Evelyn initially intended to publish a full account of the mezzotint process, which he attributes to Prince Rupert, though this, too, was omitted, presumably at Rupert's direction, though Evelyn promises he stands "always most ready (sub sigillo, and by his Highness's permission) to gratifie any curious, and worthy Person, with as full, and perfect a Demonstration of the entire Art, as my talent, and addresse will reach to; if what I am now preparing to be reserved in the Archives of the Royal Society concerning it, be not sufficiently instructive" (*Sculptura,* p. 148).

87. Ibid., p. 150.

88. As Bell notes in his introduction to Evelyn, *Sculptura*, p. vii, Evelyn's eulogy depends on the account of Samuel de Sorbière from *Lettres et Discours sur diverses matières curieuses* (Paris, 1660), p. 644. Evelyn specifically states, however, that "Monsieur Sorbiere is silent" on Favi's interests in the History of Trades; this notable addition is Evelyn's own. The life of Evelyn included in the second edition of *Sculptura*, ed. John Payne (London, 1755), similarly describes the work as a originating from Evelyn's interest in the History of Trades.

89. In contrast to Richard Haydocke, Evelyn understands *design* as having a graphic component, though later in the text he still feels compelled to pry apart design and drawing (*Sculptura*, pp. 105–6). See Baxandall, "English *Disegno*," p. 212.

90. Antony Griffiths, "The Etchings of John Evelyn," in *Art and Patronage in the Caroline Courts*, ed. David Howarth (Cambridge: Cambridge University Press, 1993), pp. 51–67.

91. Evelyn's print collection is sometimes described as numbering around seventy thousand on the basis of a reference in *Sculptura*, p. 135. In fact, Evelyn is there discussing the collection of Michel de Marolles, Abbé de Villeloin, not his own. Many of Evelyn's prints had already been sold when the collection was dispersed at auction in 1977 by Christie's; see Griffiths, "John Evelyn and the Print," pp. 95–97.

92. The session took place at night "by candle light, for the better finding out the shadows" (*Diary of John Evelyn*, 3:309). Also, see Richard Wendorf, *The Elements of Life: Biography and Portrait-Painting in Stuart and Georgian England* (Oxford: Clarendon Press, 1990), p. 126. As noted earlier, Cooper was one of the artists Mayerne consulted for his manuscript "Pictoria scultoria et quae subalternarum artium."

93. In his introduction to the 1906 edition, pp. xix–xx, Bell judges Evelyn's *Sculptura* to be of minimal "artistic historical value" and on the whole seems embarrassingly apologetic about the work, concluding that at least it is impossible "to deny that as an attempt to bring art criticism within the sphere of Natural Philosophy at a moment in the lifetime of Newton, Locke, and Hobbes, *Sculptura* takes a certain place in the history of English thought," even if "the actual contents of the volume itself might scarcely appear to warrant" the position (p. xx). With editorial introductions like this, one hardly needs critics.

94. Evelyn, *Sculptura*, pp. 13–16.

95. Kroll, *The Material World*, pp. 59ff., 165–79, argues that a pronounced awareness of context and the mediation process was central to the Restoration generally and particularly shaped Evelyn's thinking.

96. Roland Fréart, Sieur de Chambray, *A Parallel of the Antient Architecture with the Modern*, trans. John Evelyn (London, 1664). The first French edition appeared in 1650.

97. Evelyn's diary entry from October 19, 1661, suggests he had reservations about Denham's abilities. Disagreeing with the surveyor over the siting of the royal palace at Greenwich, Evelyn describes Denham as "a better poet than Architect," and

in fact, Denham's role being primarily administrative, there is no evidence to show he ever designed a building at all. *Diary of John Evelyn*, 3:301.

98. As Eileen Harris notes, the reception of the *Parallel* pales in comparison to that of the highly successful *Sylva*. Still, the former appeared in four editions (1664, 1707, 1723, and 1733) and initially helped expose English readers to Palladio, Scamozzi, Vitruvius, and Alberti at a time when there still were no English translations of the complete works of any of these authors. See Eileen Harris and Nicholas Savage, *British Architectural Books and Writers 1556–1785* (Cambridge: Cambridge University Press, 1990), pp. 196–201.

99. See the dedication to Denham. Evelyn's translation includes the same forty illustrations that appeared in the French edition. Eileen Harris suggests that Hugh May, while in Holland with the exiled court of Charles II, perhaps arranged for Charles Errard's original plates to be copied there, given that "few if any English engravers of the period were capable of reproducing the much admired plates of the *Parallèle*." See Harris and Savage, *British Architectural Books and Writers 1556–1785*, p. 196. Charles II was among those impressed with the plates, as Evelyn proudly recorded in his entry for October 28, 1664: "his Majestie gave me thanks (before divers Lords & noble men) for my Book of *Architecture* & *Sylva* againe: That they were the best printed & designed (meaning the *Tallè doucès* of the *Paralelles*) that he had seene" (*Diary of John Evelyn*, 3:387).

100. Todd Olson, *Poussin and France: Painting, Humanism, and the Politics of Style* (New Haven, CT: Yale University Press, 2002).

101. Ibid., chaps. 1 and 2, esp. pp. 1, 15, 25; quotations are from pp. 1 and 25.

102. Ibid., pp. 90–96.

103. *Diary of John Evelyn*, 3:26.

104. Ibid., 3:274.

105. Ibid., 3:9–10, 22.

106. Thomas Crow, "The Critique of Enlightenment in Eighteenth-Century Art," *Art Criticism* 3 (1987): 17–31 (quotation is from p. 19); and Louis Olivier, "The Case for the Fine Arts in Seventeenth-Century France," *Australian Journal of French Studies* 16 (1979): 377–88; quotation is from p. 380. In a letter from Rome dated March 1, 1665, Poussin himself praised Fréart for his *Idée*, calling him "the first among Frenchmen to have opened the eyes of those who only see through the eyes of others." A translation of the letter appears in Charles Harrison, Paul Wood, and Jason Gaiger, eds., *Art in Theory 1648–1815: An Anthology of Changing Ideas* (Oxford: Blackwell, 2000), pp. 70–71.

107. Donald Posner, "Concerning the 'Mechanical' Parts of Painting and the Artistic Culture of Seventeenth-Century France," *Art Bulletin* 75 (1993): 583–98; quotation is from p. 588. Posner sees 1630 as the "approximate starting point" of "this new interest" (ibid.).

108. One could chart the crucial differences between the Royal Society and the Académie royale de peinture et de sculpture according to how these theoretical po-

sitions were negotiated vis-à-vis practice. For these issues in regard to the French Academy, see Paul Duro, *The Academy and the Limits of Painting in Seventeenth-Century France* (Cambridge: Cambridge University Press, 1997); and Thomas Puttfarken, *The Discovery of Pictorial Composition: Theories of Visual Order in Painting 1400–1800* (New Haven, CT: Yale University Press, 2000).

109. Quotations in this and the next two paragraphs are taken from Evelyn's unpaginated note, "To the Reader," in Fréart, *An Idea of the Perfection of Painting.*

110. Evelyn's inclusion of Rubens, which runs counter to Fréart's preferences, attests to the esteem with which the painter was regarded by the early Stuarts. It is an additional instance of Evelyn's ability to draw upon French sources without conforming to the aesthetic boundaries and loyalties implicit in those sources' original context.

111. The English version, *The Painting of the Ancients,* appeared in 1638; a Dutch translation appeared in 1641. See Fehl, "Francis Junius and the Defense of Art," pp. xliii–xliv.

112. André Félibien adopts the same strategy; see Olivier, "The Case for the Fine Arts in Seventeenth-Century France," p. 383; and Posner, "Concerning the 'Mechanical' Parts of Painting," p. 583. An account of Félibien's *Entriens sur les Vies et sur les Ouvrages Des plus excellens Peintres, Anciens et Modernes* was included in the *Philosophical Transactions of the Royal Society* 1 (January 21, 1666): 383–84.

113. Pumfrey, "Ideas above His Station," pp. 1, 4, 16–17, stresses that Hooke was neither the only nor even the first curator of experiments during this period, but that he "was uneasily grafted" onto a system designed to accommodate "amateur, unspecialized *virtuoso curators.*" Because of his skill, he enjoyed far more power than his status would suggest; "yet, despite his intellectual importance, Hooke remained an anomaly within the Society—'last among equals.'" See also J. A. Bennett, "Robert Hooke as Mechanic and Natural Philosopher," *Notes and Records of the Royal Society* 35 (1980): 33–48; and Steven Shapin, "Who Was Robert Hooke?," in *Robert Hooke: New Studies,* ed. Michael Hunter and Simon Schaffer (Woodbridge, Suffolk: Boydell Press, 1989), pp. 253–85.

114. Evelyn, from his unpaginated note, "To the Reader," in Fréart, *An Idea of the Perfection of Painting.*

115. The statement by Christopher Wren Jr. is quoted by Michael Hunter, "The Making of Christopher Wren," pp. 45–46.

116. Quoted by Tinniswood, *His Invention So Fertile,* p. 185. Wren also makes use of a medical analogy in a letter to his soon-to-be wife, Faith, in order to explain why it took so long to have her watch repaired (p. 184).

117. Stafford, *Body Criticism,* pp. 58–65, makes a similar point in regard to the archaeological practices of Giambattista Piranesi, whom she argues employed "'surgical' strategies" to dissect ancient Roman structures. Also see her *Good Looking: Essays on the Virtue of Images* (Cambridge, MA: MIT Press, 1996), pp. 28–31. For the theoretical implications of analogical thinking in general, see her *Visual Analogy: Consciousness as the Art of Connecting* (Cambridge, MA: MIT Press, 1999).

118. Quoted by Barbara Shapiro, "Natural Philosophy and Political Periodization: Interregnum, Restoration and Revolution," in *A Nation Transformed: England after the Restoration,* ed. Alan Houston and Steven Pincus (Cambridge: Cambridge University Press, 2001), pp. 299–327; Charleton's quotation is from p. 303.

119. Celeste Brusati, *Artifice and Illusion: The Art and Writing of Samuel Van Hoogstraten* (Chicago: University of Chicago Press, 1995), pp. 91–92.

120. Samuel Pepys and Evelyn were regular guests at Povey's table. In 1665, Pepys succeeded him as treasurer of the Tangiers Committee, which managed the recently acquired colony. See Claire Tomalin, *Samuel Pepys: The Unequalled Self* (New York: Alfred A. Knopf, 2002), pp. 142–44.

121. Quoted in Thomas Birch, *The History of the Royal Society of London* (London, 1756–57), 2:84, 228–30. The first report was made on April 18, 1666, the second on December 19, 1667. Members of the proposed committee included Povey, Evelyn, Hooke, Sir Philip Carteret, Sir Theodore de Vaux, Thomas Henshaw, Dr. William Croone, and John Hoskins. In addition to Brusati's *Artifice and Illusion,* see Peck, *Consuming Splendor,* pp. 334–38.

122. Brusati, *Artifice and Illusion,* p. 93.

123. As Steven Shapin argues, "conventions and codes of gentlemanly conversation were mobilized as practically effective solutions to problems of scientific evidence, testimony, and assent," with Robert Boyle providing the ideal pattern of the gentlemanly experimental philosopher. See Shapin, *A Social History of Truth,* pp. 121–27; the above quotation is from p. 121.

124. Birch, *History of the Royal Society,* 2:84. Affirming the ties between art, medicine, and anatomy within the virtuosic context, Povey "presented a skeleton to the society" right after making his initial report in April of 1666.

125. Ibid., 2:229.

Chapter Three

1. Birch, *History of the Royal Society of London,* 2:203ff.

2. William Aglionby, *Painting Illustrated in Three Diallogues, Containing Some Choice Observations upon the Art Together with the Lives of the Most Eminent Painters, From Cimabue, to the Time of Raphael and Michelangelo* (London, 1685). The imprimatur mark is dated December 8, 1685. A second edition appeared in 1686, while a third appeared in 1719 under the title *Choice Observations upon the Art of Painting.*

3. Tancred Borenius, "An Early English Writer on Art," *Burlington Magazine* 39 (1921): 188–95; Gibson-Wood, *Jonathan Richardson,* esp. pp. 9–13, 144, 169, 180–81, 198–204.

4. "John Ellis to Lord Ambrose Williamson," February 8, 1698, Public Records Office, State Papers, 32.9, fols. 178–79; *Calendar of State Papers, Domestic Series, of the Reign of William III* (January–December 1698), ed. Edward Bateson (London: Stationery Office, 1933), p. 78.

5. Ellis reports that the appeal of Sayes Court for Peter lay in its privacy and its location, being "nearer the shipping, which he most delights in." That Peter's secretary allotted a sum of £162 for damages suggests the czar's visit was hardly in the property's best interest. *Notes and Queries*, 2nd ser., 1 (1856): 365–67.

6. George Clark, "Dr. William Aglionby, F.R.S.," *Notes and Queries*, 12th ser., 9 (1921): 141–43, provides the rare biographical sketch. Aglionby appears in neither the *Dictionary of National Biography* (1885–1900) nor the new *Oxford Dictionary of National Biography* (2004). The earliest description comes from John Macky, *Memoirs of the Secret Services of John Macky, Esq., during the Reigns of King William, Queen Anne, and King George I* (London, 1733), pp. 153–54, where he is described as "envoy to the Swiss Cantons." Macky judges that Aglionby "hath abundance of Wit, and understands most of the modern Languages well; knows how to tell a Story to the best Advantage; but has an affected manner of Conversation; is thin, splenetic, and tawny Complexioned, turned of Sixty Years old." This estimation of his age would date his birth to the mid-1640s. In *The Present State of the United Provinces of the Low Countries* (London, 1669), p. 363, however, Aglionby refers to the '40s as a period he himself could recall; Clark, p. 141, therefore, suggests that a birthdate in the late '30s is perhaps more likely. He must have been born no later than 1644, since his father died in 1643.

7. Hobbes joined the Devonshire household in 1608 as tutor to his contemporary the second Earl (1590–1628). In 1610, Hobbes accompanied him on his tour of the Continent and later served as the his secretary. Two decades later Hobbes returned to the Continent with the third Earl (1617–1684), consulting such intellectual giants as Pierre Gassendi and Galileo. The philosopher died at Hardwick Hall in 1679. See A. P. Martinich, *Hobbes: A Biography* (Cambridge: Cambridge University Press, 1999); and John Pearson, *Stags and Serpents: The Story of the House of Cavendish and the Duke of Devonshire* (London: Macmillan, 1983), pp. 35–36, 43–44.

8. *Thomas Hobbes: The Correspondence*, ed. Noel Malcolm (Oxford: Clarendon Press, 1994), pp. 7–10. A transcript of the letter, dated November 8/18, 1629, survives at the Bodleian, MS D 1104. Malcolm (pp. 777–78) provides a biographical summary for George, including references from Aubrey's *Brief Lives*.

9. Aubrey, as quoted in *Thomas Hobbes: The Correspondence*, p. 778. Macky, *Memoirs*, p. 153, states that William's father was a clergyman, reinforcing the case that William was George's son.

10. Chatsworth, uncatalogued Hardwick MS, Disbursements at Hardwick 1655–67, entry for December 1655, in *Thomas Hobbes: The Correspondence*, p. 778.

11. As Michael Hunter notes in *The Royal Society and Its Fellows*, pp. 104, 164–67, neither was especially active (nor should they be confused with their cousins, Sir Charles Cavendish and William Cavendish, first Duke of Newcastle, who were also important for Hobbes). Still, the third Earl was a regular subscriber and was genuinely interested in natural philosophy. Hunter suggests his minimal involvement can partially be explained by the fact that he spent much of his time in the country. For the larger Cavendish connections with Hobbes and the Royal Society, see Shapin and Schaffer, *Leviathan and the Air-Pump*; and Lisa Sarasohn, "Thomas Hobbes and the

Duke of Newcastle: A Study in the Mutability of Patronage before the Establishment of the Royal Society," *Isis* 90 (1999): 715–37.

12. "James Butler, first Duke of Ormonde to the Vice Chancellor of Oxford," 1678, Kilkenny Castle, Oxford Letters; *Calendar of the Manuscripts of the Marquess of Ormonde*, n.s., vol. 4 (London: Stationery Office, 1906), p. 618.

13. Both books as well as *The Present State of the Low Countries* were published by John Starkey. An advertisement of Starkey's inventory included in the back of *The Present State of the Low Countries* includes *The Art of Chymistry*, describing it as "rendred into English by W. A. Fellow of the Royal Society." See the British Library's copy. A note on the title page of *Il Nipotismo di Roma* states the work was "written originally in Italian in the year 1667 and Englished by W. A." Thibaut's *Cours de Chymie* also first appeared in 1667.

14. Aglionby's subtitle *The Delights of Holland* signals the relationship. See C. D. van Strien, *British Travellers in Holland During the Stuart Period: Edward Browne and John Locke as Tourists in the United Provinces* (Leiden: E. J. Brill, 1993), pp. 43–44.

15. The exemption came in 1668. The suggestion is made by Michael Hunter, *The Royal Society and Its Fellows*, pp. 87, 144, though admittedly he catalogues a number of other factors that also resulted in exemptions.

16. *Calendar of the Manuscripts of the Marquess of Ormonde*, p. 618.

17. Regarding the confirmation of Aglionby's degree, Clark, "Dr. William Aglionby, F.R.S.," p. 141, states that according to "R. L. Poole, the Keeper of the Archives of the University of Oxford . . . the Register of Convocation contains no record of the matter."

18. Bacon also recommends guidebooks to the traveler as "a good key to his inquiry." See "Of Travel," in the *Essays* (Amherst, NY: Prometheus Books, 1995), pp. 48–50.

19. Birch, *History of the Royal Society of London*, 4:224, 250–53, 324. Aglionby appears over fifty times in Birch's account; for the full list, see Gail Scala, "An Index of Proper Names in Thomas Birch, *The History of the Royal Society*," *Notes and Records of the Royal Society of London* 28 (1974): 263–329.

20. William Munk, *The Roll of the Royal College of Physicians, 1518–1825* (London: Royal College of Physicians, 1878), 1:475. He is entered as "Eglenby," and as Munk notes, though he appears as a Licentiate on the College list "immediately above Dr. William Sydenham," which would suggest a date of late summer or autumn 1687, Munk was unable to find any "record of his admission as such"; and thus, like so many other facts of Aglionby's life, the details remain a mystery. It is the college list that places Aglionby at Broad Street.

21. The attribution of the translation comes from Borenius, "An Early English Writer on Art," p. 189, on the basis of "an advertisement which appears on the Errata page of *Painting Illustrated*." Hedelin's *Pratique du Théâtre* first appeared in 1657. The appearance of the two texts by Aglionby in the same year might be seen to extend Leonard Barkan's contention that for the Elizabethans, "the theater *is* England's lively pictorial culture, the answer, the compensation, the *supplément* in the face of all

the paintings, sculpture, and art theory that was famously alive in the European civilizations" (Barkan, "Making Pictures Speak," p. 338). For the connections between painting and theater, see William Aglionby, trans., *The Whole Art of the Stage: Containing not only the rules of the drammatick art, but many curious observations about it, which may be of great use to the authors, actors, and spectators of plays* (London, 1684), p. 81.

22. *Calendar of State Papers, Foreign Series, Holland and Flanders* (London: Stationery Office), p. 221; and Clark, "Dr. William Aglionby, F.R.S.," pp. 141–42. The Spanish dispatches appear in the *Calendar of State Papers, Foreign Series, Spain* (London: Stationery Office), p. 75. As "agent to the King of Spain," Aglionby received "40s. by the day" from 1691 to 1693; warrant, dated December 26, 1691, Public Records Office, Home Office, Warrant Book 6, p. 235; *Calendar of State Papers, Domestic Series, of the Reign of William and Mary* (November 1691–End of 1692), ed. William John Hardy (London: Stationery Office, 1900), p. 42.

23. "Certificate of the Return of William Aglionby," November 28, 1694, Public Records Office, State Papers Domestic, Warrant Book 40, p. 10; *Calendar of State Papers, Domestic Series, of the Reign of William and Mary,* (1694–1695), ed. William John Hardy (London: Stationery Office, 1906), p. 346.

24. In 1697, Aglionby served as an intermediary in delivering a letter to King William; see "Sir William Trumbull to the Earl of Portland," February 16, 1697, Public Records Office, State Papers Domestic, Entry Book 99, p. 350; *Calendar of State Papers, Domestic Series, of the Reign of William III* (January–December 1697), ed. William John Hardy (London: Stationery Office, 1927), p. 37. In 1698 Aglionby was in Calais negotiating another postal treaty, this time with the French, and in 1701 he was once more in Spain with letters from the English king. See the *Calendar of State Papers, Domestic Series, of the Reign of William III* (January–December 1698), pp. 83, 112, 203, 239, 312. Narcissus Luttrell, in *A Brief Historical Relation of State Affairs, from September 1678 to April 1714* (Oxford: Oxford University Press, 1857), 5:21, notes that Aglionby arrived in Madrid on February 25, 1701.

25. Payment Authorization, July 26, 1702, Public Records Office, State Papers Domestic, Entry Book 352, pp. 35–36; *Calendar of State Papers, Domestic Series, of the Reign of Queen Anne* (1702–1703), ed. Robert Mahaffy (London: Stationery Office, 1916), p. 497. Aglionby left for Switzerland on September 14, 1702, and arrived in Zurich on the eighteenth of November. See Luttrell, *Brief Historical Relation of State Affairs,* 5:214; and *Calendar of State Papers, Domestic Series, of the Reign of Queen Anne* (1703–1704), ed. Robert Mahaffy (London: Stationery Office, 1924), p. 445.

26. Aglionby describes his accusers as "foreigners" who "can know nothing of me." The letter, dated November 1704, is in the British Library, Add. MS 29589, fols. 433–37. Aglionby's letter book from this period is at the Staffordshire Record Office, MS D661/18/3. Jonathan Swift also accuses Aglionby of being a papist in his annotations of John Macky's *Memoirs.* See *The Prose Works of Jonathan Swift,* ed. Temple Scott (London: George Bell and Sons, 1902), 10:272. In his letter to Nottingham, Aglionby never denies being a Roman Catholic. Instead, refuting the charge that he missed

services because of loyalties, he writes, "as for going to church I have constantly frequented the French church except when my health which is but tender here would not let me in the severe colds of winter."

27. Abel Boyer, *The History of the Life and Reign of Queen Anne* (London, 1722); Aglionby's death (November 28, by the Julian calendar) is noted in the "Annual List of the Most Eminent Persons Who Died in Queen Anne's Reign," immediately following the appendix, p. 40.

28. British Library, Sloane MS 4036, fols. 143–44. The letter is difficult to read because of Aglionby's consistently illegible handwriting and fading ink.

29. Aglionby presumably refers to Herrera's *Agricultura general que trata de la labranza del campo,* which was published in Madrid in 1677. The original, Latin edition of Burnet's book, *Telluris theoria sacra,* appeared in 1681, with the English translation appearing in 1684. See Roy Porter, *The Making of Geology: Earth Science in Britain 1660–1815* (Cambridge: Cambridge University Press, 1977); and Rhoda Rappaport, *When Geologists Were Historians 1665–1750* (Ithaca, NY: Cornell University Press, 1997). One of the most influential geologic texts of the seventeenth century, Burnet's book was admired by a number of Royal Society Fellows, including Evelyn and Isaac Newton. Its reception in more conservative quarters was less enthusiastic.

30. British Library, Sloane MS 4036, fol. 128; and Sloane MS 4030, fol. 411.

31. British Library, Sloane MS 4057, fols. 247 and 249. The year is given for neither, but the former is dated Friday, October 11; so it must, therefore, date to either 1689 or 1700. Aglionby's lodgings were then at Lombard Street. The letter states Aglionby's desire for Sloane's help in some sort of "trouble." Aglionby hopes that "we may go together to your bookseller and see what we can make of him."

32. Michael Hunter, *The Royal Society and Its Fellows,* pp. 39–41. Hunter notes that in 1685 the society membership was at an all-time low, with a mere forty-one members; yet this stemmed from the expulsion of dozens of inactive Fellows who had falsely swelled the group's ranks in the '70s.

33. Ibid., p. 40; and Lyons, *The Royal Society 1660–1940,* pp. 77–79, 93. Despite its royal charter, the society received no regular funding from the Crown but had to rely on members' subscriptions.

34. *Philosophical Transactions of the Royal Society* 3 (1668): 779–88; *Philosophical Transactions* 1 (1666): 383–84; and *Philosophical Transactions* 4 (1669): 953–56.

35. Aglionby, *Painting Illustrated,* pp. 1–5.

36. Ibid., unpaginated preface.

37. Salerno, "Seventeenth-Century English Literature on Painting," 234–58; quotations are from pp. 250–51. For Dufresnoy's *De arte graphica,* see *The Works of John Dryden,* vol. 20, *Prose 1691–1698: "De arte graphica" and Shorter Works,* ed. A. E. Wallace Maurer (Berkeley and Los Angeles: University of California Press, 1989); subsequent references to *De arte graphica* in the notes are to this edition—cf. *De arte graphica,* ed. with commentary by Christopher Allen, Yasmin Haskell, and Frances Muecke (Geneva: Droz, 2005).

38. Lawrence Lipking, *The Ordering of the Arts in Eighteenth-Century England* (Princeton: Princeton University Press, 1970), p. 112. In the preface, Aglionby acknowledges the *"Lives* are all taken out of *Vasari."*

39. A number of the definitions are interesting, but none perhaps more than that for *nudity:* "Signifies properly any Naked Figure of Man or Woman; but most commonly of Woman; as when we say, 'Tis a Nudity, we mean the Figure of a Naked Woman."

40. The advertisement appears at the front of the volume. Evelyn (following Fréart) provides explanations for a number of terms: *stampi,* or *prints; tramontano; elevato; schizzo, attittudo,* and *pellegrino.* Three of the six words reappear in Aglionby's list, though *attitudo* is rendered as *aptitude.*

41. Henry Wotton, in the preface of *The Elements of Architecture,* had similarly complained about the "poverty" of language for conveying "terms of Art and Erudition." And lest we see this as a uniquely English problem, Lorrain Daston, "Description by Omission: Nature Enlightened and Obscured," in *Regimes of Description: In the Archives of the Eighteenth Century,* ed. John Bender and Michael Marrinan (Stanford, CA: Stanford University Press, 2005), pp. 11–24, points out that as natural philosophers in France, ca. 1660s, were confronted by the lack of adequate means of describing the particulars of newly discovered plants, they looked to the vocabularies of artisans: the botanists of the Paris Académie royale des sciences judged that "we have in French many quite suitable words in this matter [of color], but which are not in any books, and which only painters, dyers, and weavers appear to have introduced into their common usage" (p. 11).

42. Aglionby, *Painting Illustrated,* pp. 5–6.

43. As noted by Baxandall, "English *Disegno*," pp. 212–13, Aglionby understands less of the Italian nuances of design than even Richard Haydocke or Evelyn.

44. Aglionby, *Painting Illustrated,* p. 10.

45. Ibid., pp. 10–13. Selecting the appropriate visual forms from nature is central to Dufresnoy's *De arte graphica:* "The principal and most important part of Painting, is to find out and thoroughly to understand what Nature has made most beautiful, and most proper to this Art; and that a choice of it may be made according to the gust and manner of the Ancients" (pp. 85, 116–17). For the broader history of the Zeuxis anecdote in the Renaissance, see Leonard Barkan, "The Heritage of Zeuxis: Painting, Rhetoric, and History," in *Antiquity and Its Interpreters,* ed. Alina Payne, Ann Kuttner, and Rebekah Smick (Cambridge: Cambridge University Press, 2000), pp. 99–109.

46. Aglionby, *Painting Illustrated,* pp. 15–16. Aglionby's antecedent is again ambiguous, and it is difficult to judge whether he is declaring Michelangelo to be the modern master of foreshortening, anatomy, or both. De Piles's commentary, "Works of the Principal and Best Painters of the Two Last Ages," however, clearly asserts anatomic mastery. De Piles states that Michelangelo "design'd more learnedly, and better understood all the Knittings of the Bones, with the Office and Situation of the Muscles, than any of the modern Painters," but says nothing specifically about the

Florentine's skills in foreshortening and, in fact, faults the "Liberties [he took] against the Rule of Perspective" (Dufresnoy, *De arte graphica*, p. 198).

47. Aglionby, *Painting Illustrated*, pp. 16–17. Dufresnoy, *De arte graphica*, p. 95, describes coloring as "the Soul of Painting . . . a deceiving Beauty."

48. The treatment of chiaroscuro (Aglionby, *Painting Illustrated*, pp. 24, 30–31), is especially strange. The Friend asks a question that groups fresco, distemper, oil, and chiaroscuro together, as if they were all types of media. Addressing chiaroscuro last, the Traveller states that it "comes nearer Design than Colouring," but proceeds to link it with paintings on wall or cloth. This is one of the few cases in the entire text where the unlearned Friend determines the agenda of the dialogue rather than simply asking leading questions. One wonders if Aglionby realized after the fact that he had failed to address chiaroscuro and found attaching it here the easiest solution. Alternatively, the awkward structure perhaps evinces Aglionby's own confusion.

49. Ibid., pp. 31–32.

50. Ibid., pp. 35–36, 56. Aglionby notes in passing, "there is great reason to suspect that the Ægyptians had the Art long before" the Greeks, though he discusses only the latter (pp. 35–36). Dufresnoy, *De arte graphica*, p. 88, similarly states that "painting first appear'd in Egypt," but came to resemble "the truth" only in Greece. As early as the fifteenth century, Alberti had made the point in his treatise (see Leon Battista Alberti, *On Painting*, trans. John Spencer [New Haven, CT: Yale University Press, 1966], p. 64–65). Claims for Egypt's primacy ultimately depend on Pliny.

51. Aglionby, *Painting Illustrated*, pp. 38, 44. In the preface (unpaginated), Aglionby challenges those who would place painters "among the Mechanicks," and notes that Pliny, in "the Tenth Chapter of the Thirty-fifth Book," ranked painting among the liberal arts.

52. Ibid., pp. 48–50.

53. Including Fabius, Pacuvius, Turpilius, and Titedius Labeo (ibid., pp. 61–62). The accounts of these ancient painters derive from Pliny, though Aglionby could have also relied on early modern sources. The point is that this material does not come from Dufresnoy or De Piles, neither of whom constructs a historical narrative of ancient art but includes ancient anecdotes only when such tales fit his rhetorical purposes.

54. Ibid., pp. 13, 62–63.

55. Ibid., p. 71.

56. Ibid., pp. 74–82; quotations are from pp. 74, 76, and 81.

57. Ibid., pp. 81, 85. Notwithstanding Caravaggio's faults, he is described as "an admirable Colourer" (ibid., pp. 84–85). The passage comes from Giovan Pietro Bellori, *The Lives of the Modern Painters, Sculptors, and Architects: A New Translation and Critical Edition*, by Alice Sedgwick Wohl, Hellmut Wohl, and Tomaso Montanari (Cambridge: Cambridge University Press, 2004), p. 1.

58. Aglionby, *Painting Illustrated*, pp. 90–95.

59. Ibid., p. 101. Design and color continue to figure into the dialogue but gener-

ally as they relate to the broader concept of invention. The tripartite scheme comes from Dufresnoy.

60. Ibid., pp. 121–22.

61. Ibid., p. 125.

62. Dufresnoy, *De arte graphica*, p. 126. De Piles later voices reservations about Fréart's *Idée*, directing the reader to Fréart's preface "rather . . . than to his Book" (p. 131).

63. Ibid., p. 87.

64. Lipking, *Ordering of the Arts*, pp. 38–65, is useful for *De arte graphica* and its English reception.

65. Dufresnoy, *De arte graphica*, pp. 198–206, includes his "Judgment . . . on the Works of the Principal and Best Painters of the Last Two Ages," but the Ancients receive only a paragraph, and the material is presented as an addendum to the poem, in contrast to Aglionby's vast historical survey at the center of the dialogues.

66. Aglionby, *Painting Illustrated*, p. 100.

67. Revised or new translations appeared in 1716, 1720, 1754, 1783, and 1789.

68. Dufresnoy, *De arte graphica*, pp. 101, 178.

69. Aglionby, *Painting Illustrated*, pp. 113–14.

70. Dufresnoy, *De arte graphica*, p. 178.

71. Aglionby, *Painting Illustrated*, p. 50.

72. Dufresnoy, *De arte graphica*, pp. 105, 188.

73. Aglionby, *Painting Illustrated*, preface.

74. Ibid, p. 35.

75. Lomazzo, *A Tracte,* translator Haydocke's address to the reader. Also see chapter 1 in the present text. The point is later echoed by Jonathan Richardson in *A Discourse on the Dignity, Certainty, Pleasure and Advantage of the Science of a Connoisseur* (London, 1719): "in all the other parts of the business of a *Connoisseur,* how many Hours of Leisure would Here be profitably employ'd, instead of what is Criminal, Scandalous, and Mischievous!" (p. 45)

76. Dufresnoy, *De arte graphica*, p. 105.

77. There was a school associated with Peter Lely that offered life drawing in the 1670s and possibly into the '80s. Yet little is known of it, and one can hardly compare it to the academies of the Continent. See Ilaria Bignamini, "George Vertue, Art Historian, and Art Institutions in London, 1689–1768," *Walpole Society* 54 (1988): 1–148, esp. pp. 22, 61; and Ilaria Bignamini, "The 'Academy of Art' in Britain before the Foundation of the Royal Academy in 1768," in *Academies of Art between Renaissance and Romanticism,* ed. Anton Boschloo (The Hague: SDU Uitgeverij, 1989), pp. 434–50. In the latter, Bignamini dates "the embryo of an actual 'institutional system' for the arts" in England to 1692 (p. 439).

78. Aglionby, *Painting Illustrated*, pp. 125–26.

79. Dufresnoy, *De arte graphica*, pp. 198, 203–4.

80. Ibid., p. 135. Aglionby, *Painting Illustrated*, p. 83.

81. Aglionby, *Painting Illustrated,* unpaginated preface.

82. "Brief Biographies of Italian Artists compiled by William Aglionby," Staffordshire Record Office, MS D661/18/4. No one, to my knowledge, has yet commented on this manuscript.

83. For Poussin as the culmination of Bellori's text, see Claire Pace and Janis Bell, "The Allegorical Engravings in Bellori's *Lives*," in *Art History in the Age of Bellori: Scholarship and Cultural Politics in Seventeenth-Century Rome*, ed. Janis Bell and Thomas Willette (New York: Cambridge University Press, 2002), pp. 191–223. Also useful is Katie Scott and Genevieve Warwick, eds., *Commemorating Poussin: Reception and Interpretation of the Artists* (New York: Cambridge University Press, 1999).

84. The subtitle of the *Philosophical Transactions of the Royal Society* is telling: "Giving some Accompt of the present Undertakings, Studies, and Labours of the Ingenious in many considerable Parts of the World." Regarding travel and the early Royal Society's attitudes toward foreigners, see Robert Iliffe, "Foreign Bodies: Travel, Empire and the Early Royal Society of London, Part I: Englishmen on Tour," *Canadian Journal of History* 33 (1998): 357–85; and Robert Iliffe, "Foreign Bodies: Travel, Empire and the Early Royal Society of London, Part II: The Land of Experimental Knowledge," *Canadian Journal of History* 34 (1999): 23–50. For travel and science more generally, see Barbara Maria Stafford, *Voyage into Substance: Art, Science, Nature, and the Illustrated Travel Account (1760–1840)* (Cambridge, MA: MIT Press, 1984).

85. Discussing the state of English trades several decades later, Daniel Defoe in *A Plan of the English Commerce Being a Compleat Prospect of the Trade of this Nation* (London, 1728), p. 300, characterized the English as poor inventors but outstanding imitators: "Hence, most of our great Advances in Arts, in Trade, in Government, and in almost all the great Things, we are now Masters of, and in which we so much exceed all our Neighbouring Nations, are really founded upon the Inventions of others." By the 1730s, national identity had become an important part of the discourse on English artistic production; I am suggesting this was not yet the case in the 1680s, when the History of Trades project could still accommodate the fine arts without these anxieties over emulation.

86. It would be useful to know more about Aglionby's own collection of pictures. In 1682 he acquired a painting from the auction of Sir Peter Lely's collection, timing which coincides with his attempts to establish himself in London as a medical virtuoso. The picture was a copy after Lely of a portrait of Geoffrey Chaucer for £1 6s. See Diana Dethloff, "The Executor's Account Book and the Dispersal of Sir Peter Lely's Collection," *Journal of the History of Collections* 8 (1996): 15–51, esp. pp. 37, 43. Lord Cavendish, incidentally, acquired nine pictures from the sale. I am grateful to Matt Hunter for the reference to Dethloff's article.

87. William Kirby, "A Quack of the Seventeenth Century," *The Pharmaceutical Journal and Pharmacist* 84 (1910): 255–62; Max Geshwind, "William Salmon, Quack-Doctor and Writer of Seventeenth-Century London," *Bulletin of the History of Dentistry* 43 (July 1995): 73–76; and C. J. S. Thompson, *The Quacks of Old London* (New York: Brentanos, 1928), pp. 125–32.

88. Quoted in Kirby, "A Quack of the Seventeenth Century," p. 257.

89. Roy Porter, *Quacks: Fakers & Charlatans in English Medicine* (Charleston, SC: Tempus Publishing, 2000), p. 28. This seminal study first appeared in 1989 as *Health for Sale: Quackery in England 1650–1850.*

90. Ibid., pp. 20ff.

91. Elizabeth Lane Furdell, *Publishing and Medicine in Early Modern England* (Rochester, NY: University of Rochester Press, 2002), pp. 151–52, 186–87. In arguing for the historical importance of quacks, F. N. L. Poynter defends Nicholas Culpeper on similar grounds: "If our concern is the history of medicine as it was professed and practiced, then Culpeper is a figure of outstanding importance, for he had a far greater influence on medical practice in England between 1650 and 1750 than either Harvey or Sydenham" (Poynter, "Nicholas Culpeper and His Books," *Journal of the History of Medicine* 17 [1962]: 152–67, esp. p. 153).

92. Porter, *Quacks,* p. 30.

93. *Horae Mathematicae, seu Urania. The Soul of Astrology: containing that art in all its parts* (London, 1679); and William Salmon, *Salmon's Almanack for 1684* (London, 1684). For the larger context, see Michael MacDonald, "The Career of Astrological Medicine in England," in *Religio Medici: Medicine and Religion in Seventeenth-Century England,* ed. Ole Peter Grell and Andrew Cunningham (Aldershot, UK: Scolar Press, 1996), pp. 62–90.

94. *Botanologia; or, The English Herbal, or the History of Plants* (London, 1710, 1711); and *The Family Dictionary; or, Household Companion Containing Directions for Cookery, Making all sorts of pastryware, Making of conserves, the making of all kinds of potable liquors, the making of all sorts of rare perfumes, the virtues and uses of the most usual herbs and plants, the preparations for medicines* (London, 1696, 1705, 1710). For *Aristotle's Master-Piece,* see Roy Porter and Lesley Hall, *The Facts of Life: The Creation of Sexual Knowledge in Britain, 1650–1950* (New Haven, CT: Yale University Press, 1995), pp. 33–64.

95. William Salmon, *A Discourse against Transubstantiation* (London, 1690); *A Discourse upon Water-Baptism* (London, 1700); and *A Dissertation Concerning the Lord's Supper* (London, 1708–9). For an example of how baptism could itself be implicated in the medical discourse of the period, see Mark Jenner, "Body and Self, Bathing and Baptism: Sir John Floyer and the Politics of Cold Bathing," in *Refiguring Revolutions,* ed. Sharpe and Zwicker, pp. 197–216.

96. Subsequent editions appeared in 1673, 1675, 1678, 1679, 1681, 1685, and 1701. To be precise, that of 1679 was an enlarged fourth edition, and that of 1685 was an enlarged fifth edition. See Henry and Margaret Ogden, "A Bibliography of Seventeenth-Century Writings on the Pictorial Arts in English," *Art Bulletin* 29 (1947): 196–201, esp. p. 199.

97. Talley, *Portrait Painting in England,* p. 189.

98. Ibid., pp. 189–90.

99. William Salmon, *Polygraphice, the Art of Drawing, Engraving, Etching, Limning, Painting, Washing, Varnishing, Colouring, and Dyeing* (London, 1672), unpaginated preface.

100. The imprimatur mark for the first edition is dated September 11, 1671.

101. Gibson-Wood, *Jonathan Richardson*, pp. 12–13.

102. Carol Gibson-Wood argues that from the first recorded public art auction in England in 1674 to the 1690s, demand for inexpensive pictures rose dramatically, and that to judge from probate inventories, even large quantities of pictures (as many as twenty-four thousand in 1691) could be accounted for. See her article, "Picture Consumption in London at the End of the Seventeenth-Century," *Art Bulletin* 84 (2002): 491–500.

103. Salmon, *Polygraphice*, bk. 3, chap. 13; p. 157 of the 1675 edition.

104. The passage appears in all of the editions. In the 1681 edition it is placed in bk. 4, pp. 322ff.

105. Cosmetics grew increasingly popular during the Restoration, though here, too, critics would have pointed to Nell Gwynn, the actress cum royal mistress, as proof of their threat to society. See Maggie Angeloglou, *A History of Make-Up* (New York: Macmillan, 1970), pp. 62–69. For Francis Bacon, the "cosmetic" constituted a legitimate topic of knowledge associated with the human body, though he had in mind issues of hygiene rather than "adulterate" uses of dyes and pigments; see Kusukawa, "Bacon's Classification of Knowledge," pp. 47–74, esp. p. 61. Regarding the Neoplatonist disdain for cosmetics and its impact on art theory, see Jacqueline Lichtenstein, *The Eloquence of Color: Rhetoric and Painting in the French Classical Age*, trans. Emily McVarish (Berkeley and Los Angeles: University of California Press, 1993), esp. pp. 37ff. and 169ff. Victoria Rimell, *Ovid's Lovers: Desire, Difference, and the Poetic Imagination* (New York: Cambridge University Press, 2006), pp. 41–69, usefully explicates Ovid's poem "Medicamini" ("Cosmetics for the Face"). For the problems in England resulting from connections between portrait painting and cosmetics, see Patricia Phillippy, *Painting Women: Cosmetics, Canvasses, and Early Modern Culture* (Baltimore: Johns Hopkins University Press, 2006), pp. 133ff.

106. For an eighteenth-century text, see Antoine Le Camus, *Abdeker; or, The Art of Preserving Beauty* (London, 1754), which combines practical cosmetic advice with an orientalizing love tale. It purports to be a translation of an Arabian text transported to Paris in 1740 by the Turkish ambassador's physician. Once more it is crucial to establish a medical provenance for a text on cosmetics.

107. The ancient author had in mind the physician's ability to judge the future based on his medical knowledge, not recourse to the supernatural—though, to be fair, Salmon believed his chiromancy to be a perfectly rational pursuit. The Hippocratic text is quoted in Joel Fineman, "The History of the Anecdote," in *The New Historicism*, ed. H. Aram Veeser (New York: Routledge, 1989), pp. 49–76; the quotation is from p. 56.

108. Sebastian Smith, *The Religious Impostor; or, The Life of Alexander, A Sham-Prophet, Doctor, and Fortune-Teller . . . Dedicated to Doctor S-lm-n, and the rest of the new Religious Fraternity of Free-Thinkers, near Leather-Sellers Hall* (Amsterdam, ca. 1700), unpaginated dedication.

109. Ibid., p. 4. Suggesting a date of 1692, the *Oxford English Dictionary* credits the text with providing the earliest printed used of *freethinker.*

110. Ibid., p. 21.

111. Daniel Turner, *The Modern Quack; or, The Physical Imposter Detected* (London, 1718), p. 79.

112. As Philip Wilson notes in his *Surgery, Skin, and Syphilis: Daniel Turner's London (1667–1741)* (Atlanta: Rodopi, 1999), pp. 193–96, Turner appropriated the Royal Society's motto "Nullius in Verba" for his own portrait, implying an association that never materialized. Turner's MD was an honorary degree from Yale, the first medical degree awarded in America and partially the result of Turner's donation of seventy-five books to the school.

113. George Rousseau, "Science Books and Their Readers in the Eighteenth Century," in *Books and Their Readers in Eighteenth-Century England,* ed. Isabel Rivers (Leicester: Leicester University Press, 1982), pp. 197–256. The Oxford antiquary Thomas Hearne owned several medical works by Salmon, and the Yorkshire antiquary Ralph Thoresby owned a copy of *Polygraphice.* For the catalogues of their libraries, see Stuart Piggott, ed,. *Antiquaries: Thoresby, Hearne, Vertue, Stukeley, and Grose,* vol. 10 of the series Sales Catalogues of Libraries of Eminent Persons (London: Sotheby, 1974).

114. *A Catalogue of Horace Walpole's Library,* ed. Allen Hazen (New Haven, CT: Yale University Press, 1969), 1:397. Writing to William Mason on January 17, 1780, Walpole referred to *Polygraphice* in the context of describing a medieval manuscript discovered by Rudolf Erich Raspe, which similarly includes "receipts for preparing the colours." See *Horace Walpole's Correspondence,* ed. W. S. Lewis (New Haven, CT: Yale University Press, 1937–83), 29:5–6.

115. William Salmon, *Bibliotheca Salmoneana: Pars Prima. Or, A Catalogue of the Remaining Part of the Library of the Learned Wiliam Salmon, M.D.* (London, 1713); and *Bibliotheca Salmoneana: Pars Secunda. Or, A Catalogue of the Remaining Part of the Library of the Learned Wiliam Salmon, M.D.* (London, 1714).

116. Such deceptions were expected, at least by cynical observers. For a sharp critique of physicians and auctions, see *The Tricks of the Town; or, Ways and Means for Getting Money. Wherein the Various Lures, Wiles, and Artifices, practiced by the Designing and Crafty upon the Weak and Unwary, are fully exposed* (London, 1732).

117. Engraved by Michael Vandergucht, the image is, in fact, a copy of Robert White's 1687 portrait of Salmon.

118. Geoffrey Wills notes that one of the earliest published recipes for "porcelain," though we would probably describe the final product "quite differently today," comes from the 1701 edition of *Polygraphice.* Wills, "An Early English China Formula," *Apollo* 67 (January 1958): 25; and Wills, "Salmon's *Polygraphice,*" *Apollo* 67 (February 1958): 58.

119. Negotiating this same popular marketplace, Mary Salmon — perhaps William's wife or a woman hoping to be viewed as such — ran what may have been London's first waxworks show at 17 Fleet Street, near the Temple. See Thompson, *Quacks of Old*

London, pp. 131–32; and E. J. Pyke, *A Biographical Dictionary of Wax Modellers* (Oxford: Clarendon Press, 1973), pp. 126–27.

120. Francis Clifton, *Tabular Observations Recommended as the Plainest and Surest Way of Practicing and Improving Physick. In a Letter to a Friend* (London, 1731); and Francis Clifton, *The State of Physick, Ancient and Modern Briefly Considered with a Plan for the Improvement of It* (London, 1732). In regard to Harvey, in the former text Clifton writes that he "laid the foundation so deep, and so wisely, in his discovery of the *Circulation,* that it was not doubted but the Art of Physick would soon be brought by it to the utmost perfection; so demonstrative were his proofs, and so sanguine the physicians. But whether the art is too difficult and extensive for the human mind entirely to comprehend; or whether the knowledge of the circulation is not of so much importance as was first apprehended; so it has fallen out, that we are but little the better for this discovery, and in some degree worse" (pp. 1–2). In regard to the quarrel between the Ancients and Moderns, in the latter volume Clifton writes that "notwithstanding all these discoveries, there was a time once when Physick was in a better state than it is at the present" (p. 2). Finally, in regard to Salmon's interest in chiromancy, it is worth noting that Clifton's ideal physician not only judges the present but also "foretells what is to come" (*Tabular Observations,* p. 12). For the early modern context of the tabulation grid, see Claudia Swan, "From Blowfish to Flower Still Life Painting: Classification and Its Images, circa 1600," in *Merchants & Marvels: Commerce, Science, and Art in Early Modern Europe,* ed. Pamela Smith and Paula Findlen (New York: Routledge, 2002), pp. 109–36.

121. For the uneasy relationship between the experimental method and orthodox medicine in the Restoration, see Cook, "The New Philosophy and Medicine in Seventeenth-Century England," 397–436.

122. Clifton, *Tabular Observations,* pp. 6–7.

123. John Oberndorff, *The Anatomyes of the True Physition, and Counterfeit Mountebanke, wherein both of them are graphically described and set out in their Right, and Orient Colours,* translated from the German by F. H., Fellow of the College of Physicians in London (London, 1602), p. 2. A similar argument appears in Everard Maynwaringe, *Medicus Absolutus Adespotos: The Compleat Physitian, Qualified and Dignified* (London, 1668).

124. George Castle, *The Chymical Galenist: A Treatise, Wherein the Practice of the Ancients is reconciled to the New Discoveries in the Theory of Physick. Shewing that many of the Rules, Methods, and Medicines are useful for the Curing of Diseases in this Age, and in the Northern Parts of the World. In which are some Reflections upon a book intitled "Medela Medicinae"* (London, 1667), p. 18.

125. Nearly a century later, T. B. in *A Call to the Connoisseurs; or, Decisions of Sense, with Respect to the Present State of Painting and Sculpture, and their several Professors in these Kingdoms* (London, 1761), p. 20, used the same logic to vouch for the authority of artists: "I would fain ask one of these easy good natured People, whether they would take the Prescription of a favourite Tradesman . . . against the opinion of a Physician." Just as tailors or potters would not be invited to override the expertise of

the learned doctor, the public should not challenge that of the painter or sculptor in regard to artistic matters.

126. Bernard Mandeville, *A Treatise of the Hypochondriack and Hysterick Diseases in Three Dialogues,* 2nd ed. (London, 1730), p. 56. The first edition appeared in 1711. Mandeville's empirical bias appears in regard to the History of Trades project, too; he attributes most improvements to laborers and practitioners rather than the "Learned Professors" who dedicate themselves to "the speculative part of Physick" and "not to great Proficients in Chymistry or other Parts of Philosophy" (pp. 33, 59). See James Sambrook, *The Eighteenth Century: The Intellectual and Cultural Context of English Literature 1700–1789* (New York: Longman, 1993), p. 17.

127. Mandeville, *Treatise of the Hypochondriack,* pp. 34–35.

128. Ibid., pp. 60–61.

129. As noted in the *OED;* Mandeville, *The Fable of the Bees,* 2nd ed. (London, 1723). The first appears to come from Richardson, *A Discourse on the Dignity, Certainty, Pleasure and Advantage of the Science of a Connoisseur.*

130. Thomas Willis, *The Anatomy of the Brain and Nerves,* in *The Remaining Medical Works of That Famous and Renowned Physician Dr. Thomas Willis,* trans. Samuel Pordage (London, 1681), p. 53.

131. Ibid., p. 54.

132. John Barker, *An Essay on the Agreement betwixt Ancient and Modern Physicians; or, A Comparison between the Practice of Hippocrates, Galen, Sydenham, and Boerhaave in Acute Diseases* (London, 1748), p. 283. Relevant here is Neal Gilbert's *Renaissance Concepts of Method* (New York: Columbia University Press, 1960), which contends that medicine played a valuable role in the history of method. Gilbert traces the earliest concern for method to Plato's *Phaedrus,* wherein Socrates likens the manner of medicine with that of rhetoric, since both "involve the analyzing of nature" (p. 3).

133. Barker, *Essay on the Agreement betwixt Ancient and Modern Physicians,* p. 284.

Chapter Four

1. Quoted in Richard Blackmore, *Treatise upon the Small-Pox* (London, 1723), p. xi. For Cervantes's text, I refer to the translation by Burton Raffel, *The History of That Ingenious Gentleman Don Quijote de La Mancha* (New York: Norton, 1995).

2. Samuel Johnson's life of Sydenham appeared in Sydenham's *Works,* ed. John Swan (London, 1742); and in the *Gentleman's Magazine* 12 (1742): 633–35. He writes, "it is certain that Sydenham did not think it impossible to write usefully on medicine, because he has himself written upon it; and it is not probable that he carried his vanity so far, as to imagine that no man had ever acquired the same qualifications beside himself. He could not but know that he rather restored, than invented most of his principles, and therefore, could not but acknowledge the value of those writers whose doctrines he adopted and enforced" (pp. 633–34).

3. *The Oxford English Dictionary,* 2nd ed. (1989), cites 1682 for *humour* being first

used in reference to "that quality of action, speech, or writing which excites amusement; oddity, jocularity, facetiousness, comicality, fun." The medical usage dates to the late fourteenth century. With Sancho's feast, Cervantes, *Don Quixote,* Raffel translation, pp. 590–96, explores the humorous potential for humoral medicine.

4. Johnson's account was influential, and Dr. John Coakley Lettsom, in the *Gentleman's Magazine* 90 (1801): 1071, lists the reading recommendation as one of only four biographical facts generally known of Sydenham. For twentieth-century references, see Joseph Payne, *Thomas Sydenham* (New York: Longman's, Green, & Co., 1900), p. 191; and Kenneth Dewhurst, *Dr. Thomas Sydenham (1624–1689): His Life and Original Writings* (London: Wellcome Historical Medical Library, 1966), p. 49. For the anecdote's inclusion in surveys, see Douglas Guthrie, *A History of Medicine* (New York: Thomas Nelson, 1945), p. 202; and Porter, *Greatest Benefit to Mankind,* p. 229.

5. Cervantes, *Don Quixote,* Raffel translation, p. 10; emphasis added. For the text's reception in England, see Edwin Knowles, "Cervantes and English Literature," in *Cervantes across the Centuries,* ed. Angel Flores and M. J. Benardete (New York: Gordian, 1947), pp. 277–303; Stuart Tave, *The Amiable Humorist: A Study in Comic Theory and Criticism of the Eighteenth and Early Nineteenth Centuries* (Chicago: University of Chicago Press, 1960); and Ronald Paulson, *Don Quixote in England: The Aesthetics of Laughter* (Baltimore: Johns Hopkins University Press, 1998).

6. Paulson, *Don Quixote in England,* pp. vii–viii, states that his book "could also have been called *Don Quixote and British Empiricism.*" Addressing Whig ideology as shaped by Thomas Hobbes and John Locke, he posits empiricism as a characteristic of his ideal eighteenth-century reader and uses it to explain in part why *Don Quixote* was read so differently in England than in Spain or France, both of which were ruled by "centralized, absolutist Roman Catholic governments" (pp. xi–xiii).

7. Despite the familiarity of the Sydenham anecdote, medical historians have paid little attention to *Don Quixote* and its English reception. Jerome Head, "Medical Allusions in *Don Quixote,*" *Annals of Medical History* 6 (1934): 169–79, offers little more than a catalogue of ailments included in Cervantes's text. More promising is Ludwig Edelstein, "Sydenham and Cervantes," *Supplement to the Bulletin of the History of Medicine* 3 (1944): 55–61; reprinted in *Ancient Medicine: Selected Papers of Ludwig Edelstein,* ed. Owsei Temkin and C. Lilian Temkin (Baltimore: Johns Hopkins University Press, 1967), pp. 455–61, though Edelstein addresses only the Sydenham anecdote and treats even it as a straightforward word of advice.

8. K. Bryn Thomas, *James Douglas of the Pouch and His Pupil William Hunter* (London: Pitman Medical Publishing, 1964), pp. 70–71. Douglas later became an avid Horace collector and in 1739 published a catalogue of his collection, which secured his admission into Pope's *Dunciad.* Even Horace, however, is absent from the 1698 list.

9. Pope's letter to George Lyttelton is quoted by Tave, *Amiable Humorist,* pp. 154–55.

10. Samuel Baker, *Bibliotheca Meadiana, Sive Catalogus Librorum Richardi Mead, M.D.* (London, 1754), pp. 153, 163. Cervantes was similarly well represented on the shelves of Britain's leading antiquaries. Martin Folkes owned at least four editions.

See *A Catalogue of the Entire and Valuable Library of Martin Folkes, Esq. President of the Royal Society . . . which will be sold by Auction by Samuel Baker at his House in York Street, Covent Garden* (London, 1756).

11. For summaries of the English translations, see Carmine Rocco Linsalata, *Smollett's Hoax: Don Quixote in English* (Stanford, CA: Stanford University Press, 1956), pp. 3–12; and Sandra Gerhard, *Don Quixote and the Shelton Translation: A Stylistic Analysis* (Potomac, MD: Studia Humanitatis, 1982), pp. 1–24.

12. Quoted by Tave, *Amiable Humorist*, p. 161. Johnson's statement appeared in the *Rambler* 2 (March 24, 1750).

13. Paulson, *Don Quixote in England*, p. ix.

14. Ibid., pp. 30–31.

15. Johannes Hartau, "Don Quixote in Broadsheets of the Seventeenth and Early Eighteenth Centuries," *Journal of the Warburg and Courtauld Institutes* 48 (1985): 234–38; quotation is from p. 236.

16. Prints of Coypel's work began to appear as early as 1723. A set of nine engravings after Coypel was available in London in 1725, as were Vandergucht's set of twenty-four engravings. Twenty-two of the images were included in a 1725 edition of Shelton's translation, and they appeared regularly (though often in poor form) throughout the next several decades. See H. S. Ashbee, *An Iconography of Don Quixote 1605–1895* (London: Bibliographical Society, 1895).

17. Katie Scott, "D'Un Siecle à L'Autre: History, Mythology, and Decoration in Early Eighteenth-Century Paris," in *The Loves of the Gods: Mythological Painting from Watteau to David*, ed. Colin Bailey, exhibition catalogue (Fort Worth, TX: Kimbell Art Museum, 1992), pp. 32–59; quotations are from pp. 36–37. See also Edith Standen, "The Memorable Judgment of Sancho Panza: A Gobelins Tapestry in the Metropolitan Museum," *Metropolitan Museum Journal* 10 (1975): 97–106.

18. Knowles, "Cervantes and English Literature," p. 284, cautions against overstating the seventeenth-century English reception of *Don Quixote* and notes that during this period, the work was more popular in France. He in part attributes the growth of British interests to the return of Loyalists after the Restoration.

19. Mark Hallett, *The Spectacle of Difference: Graphic Satire in the Age of Hogarth* (New Haven, CT: Yale University Press, 1999), pp. 71–91.

20. The ad appeared on December 2, 1724, in the *Daily Post*; ibid., pp. 78–79.

21. Christopher Merrett, *The Character of a Compleat Physician, or Naturalist* (London, 1680). While this work is familiar to medical historians, the reference to *Don Quixote* has, to my knowledge, gone unnoted.

22. Ibid., pp. 6–7.

23. In the first issue of the *True Patriot* (November 5, 1745), Henry Fielding judged that "fashion is the great Governor of this World. It presides not only in Matters of Dress and Amusement, but in Law, Physic, Politics, Religion, and all other Things of the gravest Kind." He went on to note how not only things but people come in and out of fashion. As examples, he cites Shakespeare, Handel, Lord Coke, and Dr. Syden-

ham. See Henry Fielding, *"The True Patriot" and Related Writings,* ed. W. B. Coley (Middletown, CT: Wesleyan University Press, 1987), pp. 103–5.

24. Blackmore, *Treatise upon the Small-Pox,* pp. vi, xi–xiv, xix, xxix. Revising Shadwell's critique of empiricism in *The Virtuoso,* Blackmore asserts that physicians who rely on systems rather than observation "may as well imagine they can learn to swim in the parlours without going into the water" (p. vi).

25. Merrett, *Character of a Compleat Physician,* p. 8.

26. Ibid., p. 6. Given Merrett's rejection of material excesses — carriages, velvet coats, fine wigs, and the like — one could also frame the issue in terms of contemporary debates over luxury commodities. In linking the Royal Society to the trade in luxury goods, Peck, in *Consuming Splendor,* p. 322, points out that Royal Society members filed patents not only "for engines and cauldrons but [also for] luxury goods such as coaches and clocks."

27. Blackmore, *Treatise upon the Small-Pox,* xii. This reading of Sydenham's advice may explain Samuel Johnson's efforts to reinterpret it.

28. Stafford's discussion of "visual quackery" is useful. See her *Body Criticism,* pp. 362ff.

29. Roy Porter, *Bodies Politic: Disease, Death, and Doctors in Britain, 1650–1900* (London: Reaktion Books, 2001), esp. pp. 135–39; quotations are from pp. 132 and 135.

30. Levine, *Dr. Woodward's Shield,* esp. pp. 13–17. Over a dozen primary texts relate to the quarrel, and it is rare to see more than a few discussed in any detail. In several cases, the chronology is difficult to establish, but most of the pamphlets were published in 1719, with a new one appearing each month. Authorship is also fairly speculative given the anonymity of the tracts, though point of view is usually all too clear. See Valerie Anne Ferguson, "A Bibliography of the Works of Richard Mead, M.D., F.R.S. (1673–1754)," M.A. thesis, University of London, 1959.

31. "Dr. Byfield" [John Freind], *A Letter to the Learned Dr. Woodward* (London, 1719). A note at the end of the text reads, "Rainbow Coffee-House, Dec. 14. 1718." The false Byfield attribution seems to have been intended to suggest Dr. Timothy Byfield as the author.

32. [John Harris], *A Letter to the Fatal Triumvirate: In Answer to That Pretended to Be Written by Dr. Byfield: and Shewing Reasons Why Dr. Woodward Should Take No Notice of It* (London, 1719), pp. 7–8. The authorial attribution comes from Woodward himself. As Levine notes in *Dr. Woodward's Shield,* p. 13, Harris had earlier defended Woodward's *Natural History of the Earth.*

33. "Andrew Tripe" [William Wagstaffe], *A Letter from the Facetious Dr. Andrew Tripe at Bath to his Loving Brother the Profound Greshamite, Shewing, that the Scribendi Cacoethes is a Distemper arising from a Redundancy of Biliose Salts, and not to be Eradicated but by a Diurnal Course of Oyls and Vomits* (London, 1719); quotations are from pp. 23–24. Mead was identified by Woodward and his supporters as the author, but Wagstaffe wrote several other texts under the pseudonym Andrew Tripe; in this *Letter*

he references "a certain author" responsible for *A Commentary on the History of Tom Thumb,* which he certainly wrote.

34. *The Two Sosias; or, The True Dr. Byfield at the Rainbow Coffee-House, to the Pretender in Jermyn Street. In Answer to a Letter, wrote by him, assisted by his two associates* (London, 1719).

35. John Dryden, *Amphitryon; or, The Two Sosias. A Comedy as it is Acted at the Theatre Royal* (London, 1691). Dryden alludes to *Don Quixote* in his dedicatory preface in a self-deprecating comparison of his own foolishness with that of Sancho Panza.

36. *The Two Sosias; or, The True Dr. Byfield,* p. 9.

37. *Harlequin-Hydaspes; or, The Greshamite, A Mock Opera, As it is Performed at the Theatre in Lincoln's Inn Fields* (London, 1719) also ridicules Woodward. For the issue of quackery and theater, see M. A. Katritzky, "Was *Commedia dell'arte* Performed by Mountebanks? *Album amicorum* Illustrations and Thomas Platter's Description of 1598," *Theatre Research International* 23 (1998): 104–25; and Jonathan Marks, "The Charlatans of the Pont-Neuf," *Theatre Research International* 23 (1998): 133–41. For the commedia dell'arte tradition in the Mead-Woodward quarrel as it relates to Mead's support of Watteau, see my article, "Dr. Richard Mead and Watteau's 'Comédiens italiens,'" *Burlington Magazine* 145 (2003): 265–72.

38. "Momophilus Carthusiensis," *A Serious Conference between Scaramouch and Harlequin, Concerning the Three and One* (London, 1719), p. 8.

39. Woodward's degree was from Cambridge, and upon his death, he bequeathed most of his collection to the university, where it now forms part of the Sedgwick Museum.

40. "Momophilus Carthusiensis," *A Serious Conference,* pp. 9–10.

41. *An Account of a Strange and Wonderful Dream Dedicated to Dr.* M——d (London, 1719), pp. 10–16; quotations are from pp. 11, 15, and 16.

42. *The Life and Adventures of Don Bilioso de L'Estomac. Translated from the Original Spanish into French; done from the French into English with a Letter to the College of Physicians* (London, 1719). Displaying far more wit than the majority of the texts, it has speculatively been ascribed to both Mead and Arbuthnot. Lisa Cody, *Birthing the Nation: Sex, Science, and the Conception of Eighteenth-Century Britons* (Oxford: Oxford University Press, 2005), pp. 113–19, considers how it and other texts from the quarrel attack Woodward by calling into question his sexual interests and masculinity. What was for the satirists a "myopic and useless sexual obsession" was a common theme of this genre of raillery (p. 113).

43. *The Life and Adventures of Don Bilioso de L'Estomac,* pp. 8, 9.

44 Porter, *Bodies Politic,* p. 139.

45. John Earle, *Micro-Cosmography; or, A Piece of the World Discover'd in Essays and Characters* (London, 1628). By 1633, the book had already been through six editions, and it was reprinted as late as 1732. In the introduction to their collection of essays on the topic of antiquarianism, Myrone and Peltz provide a nice summary of antiquarian satire and consider some of the historiographical implications of this discourse, *Producing the Past,* pp. 1–14. In connection with his argument about distinguishing

gentlemen and pedants, Shapin notes that the "literary form of the collection of characters" itself has roots in antiquity, specifically Theophrastus's *Characters.* See his article "A Scholar and a Gentleman."

46. Claire Preston, "The Jocund Cabinet and the Melancholy Museum in Seventeenth-Century English Literature," in *Curiosity and Wonder from the Renaissance to the Enlightenment,* ed. Evans and Marr, pp. 87–106, examines Browne's text in light of the "curiosity spoof" genre. *Urne-Buriall* "exhibits its relentlessly learned and ungainsayable accumulation of facts only to bring the labouriously constructed edifice of examples to dissolution in the final chapter, where Browne concludes that just as urns and tombs cannot guarantee lasting memory, no amount of learning can secure what we have lost" (p. 93).

47. Cervantes, *Don Quixote,* pp. 24–25 (vol. 1, chap. 4).

48. Bruce Wardropper, "*Don Quixote:* Story or History," *Modern Philology* 63 (1965): 1–11; quotation is from p. 1.

49. See Frederick De Armas, *Cervantes, Raphael, and the Classics* (Cambridge: Cambridge University Press, 1998).

50. For difficulties of interpretation of antiquarian artifacts, see Haskell, *History and Its Images,* esp. pp. 81–200.

51. Francis Wise, *A Letter to Dr. Mead concerning Some Antiquities in Berkshire: Particularly Shewing That the White Horse, Which Gives Its Name to the Vale, Is a Monument of the West-Saxons, Made in Memory of a Great Victory Obtained over the Danes* A.D. 871 (Oxford, 1738), pp. 3, 5.

52. For Wise, see Strickland Gibson, "Francis Wise, B.D.: Oxford Antiquary, Librarian, and Archivist," *Oxoniensia,* 1 (1936): 173–95; and my own summary in *Eighteenth-Century British Historians,* vol. 36 of the *Dictionary of Literary Biography,* ed. Ellen J. Jenkins (New York: Thomson Gale, 2007), pp. 375–79. For the prominent role Alfred imagery played within the circle of Frederick, Prince of Wales (including Thomas Arne's "Rule Britannia" anthem), see Simon Keynes, "The Cult of King Alfred the Great," *Anglo-Saxon England* 28 (1999): 225–356, esp. pp. 274ff.

53. Ironically, Wise seems to have sought Mead's patronage in order to shore up his candidacy for the librarianship of the new Radcliffe Library in Oxford. He must, therefore, have cringed to see not only his scholarship challenged but Mead's reputation attacked as well. Regardless, in May 1748 he did become the first Radcliffe Librarian. The damage a dedication could do to a patron's reputation is suggested by a text from the *True Patriot* that satirizes the figure of the virtuoso. Writing in 1747, the author addressed how one should evaluate a book's worth: "there is another way of judging of the Excellency of the Book, viz. by observing whom it is dedicated to: And it can hardly be imagined what an Effect a Dedication to his Grace of——, my Lord C——, or Dr. M——, &c. has sometimes had, in filling the Bookseller's Pocket." I think W. B. Cowley is surely right in identifying the last figure as Mead. See Fielding, "*The True Patriot" and Related Writings,* p. 254.

54. "Philalethes Rusticus" [William Asplin], *The Impertinence and Imposture of Modern Antiquaries Displayed; or, A Refutation of the Rev. Wise's Letter to Dr. Mead, concern-*

ing the White Horse, and other Antiquities in Berkshire, in a Familiar Letter to a Friend (London, 1740), pp. v–vi.

55. Ibid., p. xv. The attack on Mead's prized bust calls to mind the scene of the "enchanted bust" in Cervantes, *Don Quixote,* Raffel translation, pp. 674–83 (vol. 2, chap. 62), where a similar bronze work makes the knight-errant the laughingstock of the other characters.

56. George North, *An Answer to a Scandalous Libel, Entitled "The Impertinence and Imposture of Modern Antiquaries Displayed; or, A Refutation of the Reverend Mr. Wise's Letter to Dr. Mead, concerning the White Horse, and Other Antiquities in Berkshire"* (London, 1741), pp. 7–11. Dr. James Douglas, who as noted above took Sydenham's reading advice to heart, was among the doctors who eventually exposed the Mary Toft hoax, though not before Toft, who claimed to have given birth to rabbits, made a general mockery of the medical establishment (Douglas himself hardly escaped untarnished). Not surprisingly, Hogarth found the subject irresistible. See Denis Todd, *Imagining Monsters: Miscreations of the Self in Eighteenth-Century England* (Chicago: University of Chicago Press, 1995); Fiona Haslam, *From Hogarth to Rowlandson: Medicine in Art in Eighteenth-Century Britain* (Liverpool: Liverpool University Press, 1996), pp. 27–51; and Cody, *Birthing the Nation,* pp. 120–51.

57. Miguel de Cervantes Saavedra, *Vida y hechos del ingenioso hidalgo don Quixote de La Mancha* (London, 1738). As noted by H. A. Hammelmann, "John Vanderbank's Don Quixote," *Master Drawings* 7 (1969): 3–15, however unusual this kind of enterprise may have been in eighteenth-century Britain, it was consistent with three other editions of foreign-language works also published by Jacob Tonson: *Racine* (1723), Tasso's *Gerusalemme Liberata* (1724), and Plutarch's *Lives.* Hogarth produced seven designs for *Don Quixote,* though only one, *The First Adventure,* was included; see Paulson, *Don Quixote in England,* pp. 45–58.

58. Miguel de Cervantes Saavedra, *The Life and Exploits of the Ingenious Gentleman Don Quixote De La Mancha,* trans. Charles Jervas (London, 1742), p. xxvi.

59. Hammelmann, "John Vanderbank's Don Quixote," p. 6.

60. Cervantes, *Life and Exploits,* trans. Jervas. For the Tonson edition, Oldfield's text was translated into Spanish by Gregorio Mayans y Siscar, the king of Spain's librarian, who also provided a biography of Cervantes (ibid., p. 12).

61. Waterhouse, *Painting in Britain 1530–1790,* pp. 149–50. George Vertue, *The Notebooks of George Vertue relating to Artists and Collections in England, The Walpole Society* 22 (1933–34), p. 15.

62. During one of Jervas's visits to Ireland, Pope was staying at the painter's house at Cleveland Court, St. James. From here Pope wrote the letter, dated November 29, 1716. See Mansfield Kirby Talley, "Extracts from Charles Jervas's 'Sale Catalogues' (1739): An Account of Eighteenth-Century Painting Materials and Equipment," *Burlington Magazine* 120 (1978): 6–11; p. 7.

63. Paulson, *Don Quixote in England,* pp. 48–49.

64. John Oldfield, "Advertisement concerning the Prints," in Jervas's edition of *Don Quixote,* p. xxvi.

65. Ibid., pp. xxxi–xxxii. Also, see H. A. Hammelmann, "Two Eighteenth-Century Frontispieces," *Journal of the Warburg and Courtauld Institutes* 31 (1968): 448–49.

66. Oldfield, "Advertisement," pp. xxiv, xxv, xxviii.

67. Ibid., p. xxiii.

68. "Pierre Menard, Author of the *Quixote*," in *Collected Fictions: Jorge Luis Borges*, trans. Andrew Hurley (New York: Viking Press, 1998), pp. 88–95; quotation is from p. 90. Here the protagonist attempts to rewrite *Don Quixote*, to compose not *"another* Quixote . . . [but] *the* Quixote," though "he had no intention of copying it" (p. 91). Menard refuses to admit the difficulty, or at least the *essential* difficulty, of the task and instead gives voice to the thoughts of writers and academics everywhere: "If I could just be immortal, I could do it" (pp. 91–92).

69. Paulson, *Don Quixote in England*, pp. 45–58. For recent work on Hogarth including full bibliographies, see David Bindman, Frédéric Ogée, and Peter Wagner, eds., *Hogarth: Representing Nature's Machines* (Manchester: Manchester University Press, 2001), pp. 49–70; Bernadette Fort and Angela Rosenthal, eds., *The Other Hogarth: Aesthetics of Differences* (Princeton, NJ: Princeton University Press, 2001); and the exhibition catalogue ed. Mark Hallett and Christine Riding, *Hogarth: The Artist and the City* (London: Tate, 2006).

70. William Hogarth, *The Analysis of Beauty*, ed. Ronald Paulson (New Haven, CT: Yale University Press, 1997), p. 103.

71. "And what sufficient reason can be given why the same may not be said of the rest of the body?" (Ibid., p. 59.)

72. Ibid., pp. xxxii, 154–55. More immediately, Sancho can be seen to gasp at the young woman at the far right edge of the dance, who receives an amorous missive as her unsuspecting husband looks on.

73. Ibid., pp. 3, 4, 29, 104, 147. The previous incarnation of the master of the dance as a poor judge of anatomy appears in Hogarth's satire of the Toft Hoax, which mocks Nathanael St. André, Anatomist to the Royal Household, as "The Dancing Master or Praeternatural Anatomist."

74. Bignamini, "George Vertue," pp. 1–148; quotation is from p. 95. In addition to this crucial study, see Bignamini, "The 'Academy of Art' in Britain before the Foundation of the Royal Academy in 1768."

75. Bignamini, "George Vertue," pp. 74, 79. A useful biographical sketch of Geekie appears in Larissa Dukelskaya and Andrew Moore, eds., *A Capital Collection: Houghton Hall and the Hermitage* (New Haven, CT: Yale University Press, 2002), pp. 298, 433.

76. Bignamini, "George Vertue," pp. 34, 40, 53, 56.

77. Ibid., pp. 91, 93. For Cheselden as public anatomist, see Anita Guerrini, "Anatomists and Entrepreneurs in Early Eighteenth-Century London," *Journal of the History of Medicine and Allied Sciences* 59 (2004): 219–39.

78. Alexander Pope, "Imitations of Horace," line 51; in *The First Epistle of the First Book of Horace Imitations* (London, 1738).

79. Known for performing lithotomies in less than a minute, Cheselden was widely respected as surgeon and provided medical care to Queen Caroline. As evinced

by the frontispiece for his *Osteographia,* he employed a camera obscura to aid with the illustrations.

80. Bignamini, "George Vertue," pp. 36, 43.

81. Mark Girouard, "Hogarth and His Friends: English Art and Rococo—II," *Country Life* 139 (1966): 188–90. Parts 1, pp. 58–61, and 3, pp. 224–27, of the series are also relevant.

82. Rosamaria Loretelli, "The Aesthetics of Empiricism and the Origin of the Novel," *The Eighteenth Century* 41 (2000): 83–109, esp. pp. 102–4.

83. "The more prevailing the notion may be, that painters and connoisseurs are the only competent judges of things of this sort; the more it becomes necessary to clear up and confirm, as much as possible . . . that no one may be deterred, by the want of such previous knowledge, from entering into this enquiry" (Hogarth, *Analysis of Beauty,* p. 18). In regard to this issue of audience, John Bender suggests that Hogarth's "facticity"—by which he means a Heideggerian self-conscious and "self-reflexive visual staging of ordinary objects and bodily forms"—works "to establish consensus about moral issues in the way experimental science sought consensus about empirical fact" (Bender, "Matters of Fact: Virtual Witnessing and the Public in Hogarth's Narratives," in *Hogarth,* ed. Bindman, Ogée, and Wagner, pp. 49–70).

84. Stafford, in *Body Criticism,* p. 325, stresses the limits to what Hogarth can picture in the two prints, notably in regard to color. Image 95 in fig. 46 shows the woman's face darkest where in fact, according to Hogarth, it "would be whitest" (*Analysis of Beauty,* p. 89). As Stafford makes clear, however, this concern with the "unseen" emerges as an Enlightenment problem, resulting from empiricist expectations.

85. Hogarth, *Analysis of Beauty,* pp. xxxviii, 25–27, 46–47. For Hogarth's distrust of analogy, see Peter De Bolla, "Criticism's Place," *Theory and Interpretation: The Eighteenth Century* 25 (1984): 199–214. To be fair, Hogarth breaks from mechanical conceptions of the body that dominated the Royal Society's activities. See Michael Baridon, "Hogarth's 'Living Machines of Nature' and the Theorisation of Aesthetics," in *Hogarth,* ed. Bindman, Ogée, and Wagner, pp. 85–101.

86. Letter from William Hogarth to Thomas Birch, November 25, 1753; BL Add. MS 4310, fol. 122. Hogarth judges that the book "will receive great Honour" by the Royal Society's "Acceptance of it." The letter would have been known to eighteenth-century readers through John Nichols, *Biographical Anecdotes of William Hogarth; with a Catalogue of His Works Chronologically Arranged and Occasional Remarks,* 2nd ed. (London: John Nichols, 1782), 430–31. Hogarth expected the book to matter to the learned group and perhaps hoped it would be reviewed in the *Philosophical Transactions.* I see no reason to accept the suggestion that the copy was merely intended for the society's library, an assertion made in the twentieth century by a librarian of the Royal Society; see Ronald Paulson, *Hogarth: His Life, Art, and Times,* 2 vols. (New Haven, CT: Yale University Press, 1971), 1:185, 454n11.

87. Hogarth, *Analysis of Beauty,* pp. 21, 7, 14.

88. Along these lines, also see Shearer West, "Polemic and the Passions: Dr. James

Parsons's Human Physiology Explained and Hogarth's Aspirations for British History Painting," *British Journal of Eighteenth-Century Studies* 13 (1990): 73–89.

89. As Paulson notes, in *Don Quixote in England*, pp. xxxxiv, xlvi, Allan Ramsay responded to *The Analysis* in his *Essay on Taste*, which appeared in *The Investigator* (London, 1755). Emphasizing the crucial role of movement and the "doubling of vision" in *The Analysis*, Tom Huhn, *Imitation and Society: The Persistence of Mimesis in the Aesthetics of Burke, Hogarth, and Kant* (University Park: Pennsylvania State University Press, 2004), pp. 64–101, is useful for both problems and solutions.

90. Paulson notes, in *Don Quixote in England*, p. xxxv, that Warburton subscribed to *The Analysis* for two copies and seems to have believed his work had served Hogarth. In the *Divine Legation of Moses* (London, 1738–41), Warburton traced the Pythagorean mysteries to Egypt and emphasized the ability of hieroglyphs both to reveal and to cloak knowledge.

91. Hogarth signed the essay, a defense of his father-in-law Thornhill, as "Britophil." As Paulson notes, it appeared in *St. James Evening Post* (7–9 June 1737) and the following month in *London Magazine*. See Hogarth, *Analysis of Beauty*, p. xviii.

Chapter Five

1. Ronald Paulson, *Hogarth's Graphic Works*, 2 vols. (New Haven, CT: Yale University Press, 1970), cat. #144; and Haslam, *From Hogarth to Rowlandson*, pp. 52–66.

2. For Taylor, see Porter, *Quacks*, pp. 67ff.

3. Marjorie Nicolson, "Ward's 'Pill and Drop' and Men of Letters," *Journal of the History of Ideas* 29 (1968): 177–96.

4. For al-Razi and *al-Jadari wa'l-hasba* [*Smallpox and Measles*], see Porter, *Greatest Benefit to Mankind*, pp. 95ff.; and L. I. Conrad, "Arab-Islamic Medicine," in *Companion Encyclopedia of the History of Medicine*, ed. W. F. Bynum and Roy Porter (London: Routledge, 1993), pp. 676–727.

5. Porter, *Bodies Politic*, p. 138. In a letter dated July 25, 1750, Horace Walpole attributed Mead's eventual financial troubles—despite an income of over £5000—to excessive sexual activity: "he was very voluptuous; and secret history says that as his seraglio were obliged to take extraordinary pains, they too had extraordinary pay." See *Horace Walpole's Correspondence*, ed. Lewis, 20:165. Walpole was, however, hardly a friend to Mead, and thus it's difficult to evaluate such gossip.

6. William Macmichael, *The Gold-Headed Cane* (London: J. Murray, 1827). New editions regularly appeared until 1968. The work has, unfortunately, often been accepted as a primary source despite its late date—and the fact that the central character is a cane.

7. *Catalogue of Political and Personal Satires Preserved in the Department of Prints and Drawings in the British Museum*, 11 vols. (London: British Museum, 1978), vol. 3, pt. 1 (1734–50), cat. #2629. The entry mistakenly refers to Jurin as a quack; that he

was a respected, orthodox physician and still prescribed Mrs. Stephens's nostrum underscores the complexity of Georgian medicine. Hallett, in *Spectacle of Difference*, pp. 162ff., addresses the print as political caricature and satirical appropriation; the human-headed pack animal is a reworking of Bickam's own 1736 print, *An Ass Loaded with Preferments*, which targeted clerical corruption under Walpole and itself depended on Marcellus Laroon's *Cries of London*. Without naming Mead, Hallett suggests that the doctor "is depicted with a deliberately finer line" in order to suggest depth and to indicate, metaphorically, "his social inferiority" (p. 164). Both claims may be true, but the treatment of Mead also aligns him with Walpole in a way that the others are not. Enemy or not, Mead was still his doctor, and for all that distinguished Mead from his aristocratic patients, he still occupied a privileged role within their circles.

8. *Boswell's Life of Johnson*, ed. George Birkbeck Hill and L. F. Powell (Oxford: Clarendon Press, 1934–64), 3:355; Matthew Maty, *Authentic Memoirs of the Life of Richard Mead, M.D.* (London, 1755); Arnold Zuckerman, "Dr. Richard Mead (1674–1754): A Biographical Study," (Ph.D. diss. University of Illinois, 1965); and Richard Hardway Meade, *In the Sunshine of Life: A Biography of Dr. Richard Mead, 1673–1754* (Philadelphia: Dorrance & Co., 1974). Maty's text first appeared in French in the *Journal Britanique* (July–August 1754), testament to the respect Mead garnered across the Channel. An abridged version, likely the work of Samuel Johnson, appeared as "Some Account of the Life and Writings of the Late Dr. Richard Mead," *Gentleman's Magazine* 24 (November 1754): 510–15; see John Abbott, "Dr. Johnson and the Life of Dr. Richard Mead," *Bulletin of the John Rylands Library Manchester* 54 (1971): 12–27.

9. For the collection, Mary Webster's two-part article, "Taste of an Augustan Collector: The Collection of Dr. Richard Mead," *Country Life* 147 (January 29, 1970): 249–51; 148 (September 24, 1970): 765–67, remains a useful starting point, now updated by Ian Jenkins, "Dr. Richard Mead (1673–1754) and His Circle," in *Enlightening the British: Knowledge, Discovery, and the Museum in the Eighteenth Century*, ed. R. G. W. Anderson, et al. (London: British Museum Press, 2003), pp. 127–35. Mead appears briefly in Jonathan Scott, *The Pleasures of Antiquity: British Collectors of Greece and Rome* (New Haven, CT: Yale University Press, 2003), pp. 35–38, though in fact Scott's generally useful book here underscores the problems art historians have had in addressing Mead. The doctor is grouped with John Woodward, Hans Sloane, and Thomas Herbert, the eighth Earl of Pembroke, in a chapter entitled "Collecting under the Later Stuarts." While Mead's earliest ideas on art took shape during this period, most of the objects in his own collection were acquired well after 1714, and the division between this chapter and the next two, "Grand Tour Collecting" and "The Heyday of Collecting," have the effect of bracketing out Mead's circle from the major figures of the first half of the century.

10. It was Matthew who in 1679 dropped the final *e* from the family's surname; see Meade, *In the Sunshine of Life*, p. 145n28.

11. "Some Account of the Life and Writings of the Late Dr. Richard Mead," p. 510.

12. See Theodore Brown, "Medicine in the Shadow of the *Principia*," *Journal of the History of Ideas* 48 (1987): 629–48; Anita Guerrini, "The Tory Newtonians: Gregory,

Pitcairne, and Their Circle," *Journal of British Studies* 25 (1986): 288–311; Anita Guerrini, "Archibald Pitcairne and Newtonian Medicine," *Medical History* 31 (1987): 70–83; and Anita Guerrini, "Isaac Newton, George Cheyne, and the 'Principia Medicinae,'" in *The Medical Revolution of the Seventeenth-Century*, ed. Roger French and Andrew Wear (Cambridge: Cambridge University Press, 1989), pp. 222–45.

13. Zuckerman, "Dr. Richard Mead," p. 12, gives the date of Mead's matriculation as April 18, 1693, citing the *Album Studiosorum Academiae Lugduno Batavae MDLXXV–MDCCCLXXV; Accedunt Nomina curatorum et professorum per eadem secula* (The Hague, 1875).

14. Ibid., p. 23.

15. As Guerrini explains in "The Tory Newtonians," the group's pervasive interest in Newtonian natural philosophy did not entail an allegiance to a larger "Newtonian ideology" based on religion or politics. In contrast to Newton, the majority of Pitcairne's circle embraced High Church Toryism and often Jacobitism; and yet "their nonconformity did not make them any less 'Newtonian'" (p. 311). Mead's political and religious commitments are more complicated. He abandoned his Dissenting background and explicitly espoused only a latitudinarian, Whiggish form of orthodoxy. Still, his circle of friends and acquaintances included a large number of staunch Tories. He helped secure not only the release of Pitcairne's son but also Dr. Freind, who had likewise been imprisoned for political reasons. As a starting point, see Ludmilla Jordanova, "Richard Mead's Communities of Belief in Eighteenth-Century London," in *Christianity and Community in the West: Essays for John Bossy*, ed. Simon Ditchfield (Aldershot, UK: Ashgate, 2001), pp. 241–59.

16. As noted by T. Brown, "Medicine in the Shadow of the *Principia*," p. 633, Cockburn became a licentiate of the College of Physicians in 1694, but after finding the college unreceptive to Newtonian approaches increasingly turned his attention to the Royal Society. It would be another two decades before the college would embrace the new physic.

17. Guerrini, "Isaac Newton, George Cheyne, and the 'Principia Medicinae,'" p. 228.

18. Mead, *Mechanical Account of Poisons*, unpaginated preface. Several paragraphs later he cites the work of Cheyne and Pitcairne as models for this "mechanical way of reasoning."

19. Jay Tribby, "Cooking (with) Clio and Cleo," *Journal of the History of Ideas* 52 (1991): 417–39, makes clear the extent to which seventeenth-century experiments with vipers, such as those of Redi, were bound up with historical concerns dating back to antiquity. Approaching this material according to later notions of "science" simply does not work, though Tribby suggests the Royal Society marks a departure from earlier Italian traditions. Mead's text is one of the points where we can chart this shift. By the second half of the eighteenth century, Mead had joined Redi as a "touchstone" authority on the subject, though one to surpass. See Felix Fontana, *Treatise on the Venom of the Viper*, trans. Joseph Skinner (London, 1795), p. vi; the first French edition appeared in 1765.

20. While Mead held various college offices and was even offered the presidency in 1744 (which he declined), these came after his reputation has been made. It was the Royal Society that provided the right, initial opportunities. For the insight *A Mechanical Account of Poisons* provides into Mead's understanding of mental illness, see Akihito Suzuki, "Dualism and the Transformation of Psychiatric Language in the Seventeenth and Eighteenth Centuries," *History of Science* 33 (1995): 414–47; and Suzuki, "Psychiatry without Mind in the Eighteenth Century: The Case of British Iatro-Mathematicians," *Archives Internationales d'Histoire des Sciences* 48 (June 1998): 119–46.

21. Mead, *Mechanical Account of Poisons,* unpaginated preface.

22. Ferdinando Arisi, *Gian Paolo Panini e i fasti della Roma del '700* (Rome: Ugo Bozzi, 1986), p. 342, describes the painting as being in a private collection in Naples.

23. *A Catalogue of Pictures, Consisting of Portraits, Landscapes, Sea-Pieces, Architecture, Flowers, Fruits, Animals, Histories of the Late Richard Mead, M.D. Sold by Auction on March 1754* (London, 1755). Whereas copies of Langford's auction catalogue are relatively common, the only copy of *A Catalogue of Pictures* I am aware of belongs to the British Library. William Whitley, *Artists and Their Friends in England* (London: Medici Society, 1928), 1:28, quotes from it but gives no citation, and few subsequent scholars seem to have consulted it.

24. Webster, "Taste of an Augustan Collector," p. 767.

25. Richard Mead, *A Short Discourse concerning Pestilential Contagion and the Methods to Be Used to Prevent It* (London, 1720); the eighth edition was published in 1723, with a final ninth edition appearing in 1744. As a journalist, Daniel Defoe provided regular updates on the spread of the plague at Marseilles; see *Daniel Defoe: His Life and Recently Discovered Writings Extended from 1716 to 1729,* ed. William Lee (London, 1869), pp. 277, 284, 427–30. Also see Arnold Zuckerman, "Plague and Contagion in Eighteenth-Century England: The Role of Richard Mead," *Bulletin of the History of Medicine* 78 (2004): 273–308.

26. Mead, *Mechanical Account of Poisons,* unpaginated preface.

27. Quoted in *Boerhaave's Correspondence,* ed. G. A. Lindeboom (Leiden: E. J. Brill, 1962–79), 1:205–7.

28. Anna Marie Roos, "Luminaries in Medicine: Richard Mead, James Gibbs, and Solar and Lunar Effects on the Human Body in Early Modern England," *Bulletin of the History of Medicine* 74 (2000): 433–57.

29. Mead was, as noted by Roos, derided by William Douglas, in *The Cornutor of Seventy-Five* (London, 1748), p. 20, for his service as "principal secretary to all the Planets, and Prime Minister of the Sun and Moon, of whose powers and Faculties he wrote a learned and elaborate *Treatise,* proving that not a Plant could grow without Leave of the Sun."

30. T. Brown, "Medicine in the Shadow of the *Principia*," p. 631.

31. Roos, "Luminaries in Medicine," p. 436.

32. *The Correspondence of Isaac Newton,* H. ed. W. Turnbull et al. (Cambridge: Cambridge University Press, 1959–77), 5:79–81. This last charge was especially insulting, since Flamsteed had equipped the observatory largely at his own expense. For

bibliography and the quarrel's historiographical stakes, see William Ashworth, "Labour Harder Than Thrashing: John Flamsteed, Property, and Intellectual Labour in Nineteenth-Century England," in *Flamsteed's Stars: New Perspectives on the Life and Works of the First Astronomer Royal (1646–1719)*, ed. Frances Willmoth (Woodbridge, Suffolk: Boydell Press, 1997), pp. 199–216.

33. *Correspondence of Sir Isaac Newton*, ed. W. Turnbull et al.,5:131, 313.

34. British Library, Add. MS 46172, fol. 102, "Letter from the Royal Society to the Ordnance Board." Mead's signature is one of the seven on the report along with that of Hans Sloane.

35. A. Rupert Hall, ed., *Isaac Newton: Eighteenth-Century Perspectives* (Oxford: Oxford University Press, 1999), p. 33.

36. A. Sakula, "Dr. John Radcliffe, Court Physician, and the Death of Queen Anne," *Journal of the Royal College of Physicians of London* 19 (1985): 255–60.

37. The house is located on the southwestern corner of the square (often then referred to as Southampton Square) in what is now Bloomsbury Way. Dr. Hans Sloane lived across the square at 3 Bloomsbury Place.

38. Campbell Hone, *The Life of Dr. John Radcliffe 1652–1714: Benefactor of the University of Oxford* (London: Faber and Faber, 1950), p. 28.

39. Richard Watson, *Cogito, Ergo Sum: The Life of René Descartes* (Boston: David R. Godine, 2002), p. 257.

40. Hone, *Life of Dr. John Radcliffe*, pp. 28, 81.

41. Ibid., pp. 80–81, 118–20. Radcliffe left £40,000 for the new library, the initial circular plan of which was conceived by Nicholas Hawksmoor.

42. The house, described by Maty as "a Temple of Nature and a Repository of Time" (*Authentic Memoirs of the Life of Richard Mead*, p. 51) was located at the northern corner of Great Ormond Street and Powis Place. In the mid-nineteenth century it became a children's hospital and features in Charles Dickens, *Our Mutual Friend*, which appeared in serial form in the 1860s. In the early 1870s, it was torn down to make room for the current hospital. See Austin Dobson, "Dr. Mead's Library," in *Eighteenth-Century Vignettes*, 3rd ser. (London: Chatto & Windus, 1896), pp. 29–50.

43. For Mead's salary see Anne Digby, *Making a Medical Living: Doctors and Patients in the English Market for Medicine, 1720–1911* (Cambridge: Cambridge University Press, 1994), p. 189. John Hawkins estimated his income to have been as much as £7000. See "Anecdotes from John Hawkins's Life of Dr Johnson: Of Doctor Mead," which appeared in both *European Magazine* (March 1787): 143, and *Walker's Hibernian Magazine; or, Compendium of Entertaining Knowledge* (April 1787): 176.

44. "Some Account of the Life and Writings of the Late Dr. Richard Mead," pp. 514–15.

45. *Historical Manuscripts Commission: Report on the Manuscripts of the Grace the Duke of Portland, Preserved at Welbeck Abbey*, vol. 6 (London: Stationery Office, 1901), p. 41.

46. Stevenson, *Medicine and Magnificence*, p. 131; Bryan Little, *The Life and Works of James Gibbs 1682–1754* (London: B. T. Batsford, 1955), pp. 119–21; and Terry Fried-

man, *James Gibbs* (New Haven, CT: Yale University Press, 1984), pp. 210, 305. Mead's acquaintance with Gibbs dates at least to 1728, when in August of that year he, along with Dr. Freind, served on the Bart's Building Committee; see Little, *Life and Works of James Gibbs,* p. 120. As a token of appreciation for the library, Mead presented Gibbs with a silver cup engraved, "IACOBO GIBBS Eximio Architecto ob operam in aedificanda bibliotecha sua feliciter positam hoc poculum dono dedit Richardus Mead med-reg MDCCXXXIV" (ibid.).

47. The motto also appears beneath Arthur Pond's 1739 engraving of Mead. In a letter to his son dated August 6, 1741, the Earl of Chesterfield quotes Lucan's description of Cato's character from *Pharsalia:* "Non sibi, sed toti genitum se credere mundo." See *Letters to His Son,* ed. Oliver Leigh (New York: Tudor Publishing, 1937), p. 402. For the original passage in English, see Lucan's *Civil War,* trans. P. F. Widdows (Bloomington: Indiana University Press, 1988), p. 37 (book 2, pp. 380ff.). The quotation appears in the midst of Stoic ideals, including Cato's restraint from sexual pleasures ("his iron love resisted even legitimate love . . . as for sexual love, it had but a single purpose—procreation of children; he stood to the city as father"). Given the insinuations of lechery that surrounded Mead toward the end of his life, the motto may have been intended to counter such accusations, while the paternalistic imagery fits nicely with Mead's support of the Foundling Hospital.

48. *A Catalogue of Greek, Roman, and English Coins, Medallions, and Medals of the Right Honourable Edward Earl of Oxford . . . 18 March 1741-2* (London, 1742). The British Library's copy includes annotations of buyers. Mead purchased lot 243.

49. *A Catalogue of the Collection of the Right Honourable Edward Earl of Oxford, Deceased: Consisting of Several Capital Pictures by the most Eminent Italian, French, and Flemish Masters, great Variety of Greek and Roman Antiquities . . . together with several very scarce Books of Prints and Drawings; particularly of the most famous Altars, Vestments, Chalices, &c. by J. Paulo Panini and others . . . with divers other valuable Curiosities out of the Arundel Collection* (London, 1742). There is no evidence that Mead played any role in the production of the print of his own library, which seems to have appeared after his death. For Hocker, see BL Add. MS 4310, fol. 118, "Letter from William Hocker to Thomas Birch," dated January 11, 1741/42; and Add. MS 4475, fol. 122, "Letter from William Hocker to Thomas Birch," dated January 16, 1741/42.

50. Purchased in 1994 by the National Gallery of Scotland, Ricci's picture underscores the challenges of reconstructing Mead's collection. Of the approximately 180 paintings known by title and (usually) artist, only a modest portion have yet to be identified. And yet, as with the Ricci, the works that are known are typically of excellent quality, often still possessed of their original attributions. Watteau's *Italian Comedians* in the National Gallery in Washington, DC; Claude's *The Ford* in the Metropolitan Museum of Art, New York; and Poussin's *Baptism of Christ* (likely) in the Philadelphia Museum of Art all attest to Mead's standards as a connoisseur.

51. William Cowper, *Myotamia Reformata; or, A New Administration of All the Muscles of Humane Bodies . . . to which are subjoined, a Graphical Description of the bones and other anatomical observations,* ed. Richard Mead, Joseph Tanner, James Jurin, and

Henry Pemberton, rev. ed. (London, 1724). Cowper himself published the first edition in 1698, using plates from Govaert Bidloo's *Anatomia humani corporis* (Amsterdam, 1685). See Fenwick Beekman, "Bidloo and Cowper, Anatomists," *Annals of Medical History* 7 (March 1935): 113–29.

52. See Friso Lammertse et al., *Peter Paul Rubens: The Life of Achilles,* exhibition catalogue (Rotterdam: NAi Publishers, 2003); and Julius Held, *The Oil Sketches of Peter Paul Rubens* (Princeton, NJ: Princeton University Press, 1980), 1:169–84.

53. Martin Clayton, *Poussin: Works on Paper, Drawings from the Collection of Her Majesty Queen Elizabeth II,* exhibition catalogue (London: Merrell Holberton, 1995). The provenance depends on the work of Timothy Standring, who notes that Mead paid 300 scudi for the collection; see "Poussin et le cardinal Massimo d'après les archives Massimo," in *Nicolas Poussin (1594–1665): Actes du colloque organizé au Musée du Louvre par le Service culturel, du 19 au 21 octobre 1994,* ed. Alain Mérot (Paris: La documentation française, 1996), 1:363–92. Also see Anthony Blunt, "The Massimi Collection of Drawings in the Royal Library at Windsor Castle," *Master Drawings* 14 (1976): 3–31. For Massimi's kinship to the Marchese Vincenzo Giustiniani, see Elizabeth Cropper and Charles Dempsey, *Nicolas Poussin: Friendship and the Love of Painting* (Princeton, NJ: Princeton University Press, 1996). Haskell, *Patrons and Painters,* pp. 115ff., describes Giustiniani and Massimi respectively as "the first and the last great Roman patrons of the seventeenth century."

54. Ronald Ridley, "To Protect the Monuments: The Papal Antiquarian (1534–1870)," *Xenia Antiqua* 1 (1992): 117–54.

55. A volume of drawings by Bartoli at Windsor Castle was long connected to Mead—see Adolf Michaelis, *Ancient Marbles in Great Britain,* trans. C. A. M. Fennell (Cambridge: Cambridge University Press, 1882), p. 50—though Anthony Blunt challenged the idea in "Don Vincenzo Vittoria," *Burlington Magazine* 109 (1967): 31–32. Claire Pace, "Pietro Santi Bartoli: Drawings in Glasgow University Library after Roman Paintings and Mosaics," *Papers of the British School at Rome* 47 (1979): 117–55, esp. pp. 124ff., provides a thorough review of the historiography and a detailed argument for accepting the Glasgow volume as that which Mead possessed. For the Nasonii Tomb, which Bellori connected to Ovid soon after its 1674 discovery, see J. B. Trapp, "Ovid's Tomb," *Journal of the Warburg and Courtauld Institutes* 36 (1973): 35–76.

56. For Ramsay's role in acquiring the drawings, see Iain Gordon Brown, "Allan Ramsay's Rise and Reputation," *Walpole Society* 50 (1984): 209–47, pp. 234, 239–40. The relevant correspondence includes no mention, however, of the fresco panels, though George Turnbull attests they were in Mead's possession by 1740. For the wall paintings, see Marco Buonocore et al., *Camillo Massimo Collezionista di Antichità: Fonti e materiali* (Rome: "L'Erma" di Bretschneider, 1996), esp. pp. 48–54, 223–32; and Hetty Joyce, "Grasping at Shadows: Ancient Paintings in Renaissance and Baroque Rome," *Art Bulletin* 74 (1992): 219–46, esp. pp. 240–43. Mead's bust of Theophrastus also came from the Massimi collection.

57. Pace, "Pietro Santi Bartoli," p. 126; George Turnbull, *A Treatise on Ancient Painting* (London, 1740); and the Comte de Caylus, *Avertissement* for the *Recueil de*

peintures antiques, ed. Pierre-Jean Mariette (Paris, 1757). The provenance remains unclear for this volume, which was not included in any of the auctions of Mead's collections.

58. Jane Roberts, ed., *George III & Queen Charlotte: Patronage, Collecting, and Court Taste* (London: Royal Collection Publications, 2004), pp. 195–96, notes that the two volumes were among the earliest works acquired by the future king. Also, see Natalie Zemon Davis, *Women on the Margins: Three Seventeenth-Century Lives* (Cambridge, MA: Harvard University Press, 1995), pp. 140–202; and Sharon Valiant, "Maria Sibylla Merian: Recovering an Eighteenth-Century Legend," *Eighteenth-Century Studies* 26 (1993): 467–79.

59. Quoted in Emily Climenson, ed., *Elizabeth Montagu: The Queen of the Blue Stockings, Her Correspondence from 1720 to 1761* (New York: Dutton & Co., 1906), 1:128. See also the chapter on the duchess and her circle in Charlotte Gere and Marina Vaizey, *Great Women Collectors* (London: Philip Wilson, 1999), pp. 77–87. See also Arthur MacGregor, ed., *Sir Hans Sloane: Collector, Scientist, Antiquary,* exhibition catalogue (London: British Museum, 1994), p. 177.

60. For these as well as various instruments including globes, telescopes, microscopes, a camera obscura, concave and convex mirrors, and thermometers, see the auction catalogue *Museum Meadianum, sive Catalogus Nummorum, Veteris Aevi Monumentorum, ad Gemmarum, cum aliis quibusdam Artis recentioris et Naturae Operibus Quae Vir Clarissimus Richardus Mead, M.D.* (London, 1755), pp. 257–62.

61. Maty (*Authentic Memoirs of the Life of Richard Mead,* p. 8) underscores the conection. For the bronze, now in The Burghley House Collection, see Charles Avery's entry, in *Effigies & Ecstasies: Roman Baroque Sculpture and Design in the Age of Bernini,* exhibition catalogue, ed. Aidan Weston-Lewis (Edinburgh: National Gallery of Scotland, 1998), pp. 94–95; and Jennifer Montagu, *Alessandro Algardi* (New Haven, CT: Yale University Press, 1985).

62. Gordon's essay on Mead's mummy appeared alongside his *Essay Towards Explaining the Hieroglyphical Figures, on the Coffin of the Antient Mummy Belonging to Captain William Lethieullier* (London, 1737). See Karl Dannenfeldt, "Egypt and Egyptian Antiquities in the Renaissance," *Studies in the Renaissance* 6 (1959): 7–27; and Tim Knox, "The Vyne Ramesses: 'Egyptian Monstrosities' in British Country House Collections," *Apollo* 157 (April 2003): 32–38. Descriptions of Mead's Egyptian pieces, including his mummy, appear in the auction catalogue *Museum Meadianum, sive Catalogus Nummorum,* pp. 213–17.

63. Richard Mead, "An Anniversary Oration in Honour of Harvey, &c. Delivered before the Royal College of Physicians at London, upon the 18th of October 1723," in *The Medical Works of Dr. Richard Mead* (Edinburgh, 1763), 3:243–57; quotation is from pp. 244–45.

64. Not to mention Mead's own countryman John Evelyn, whose *Numismata* of 1697 remained influential for decades. For the larger numismatic context, including the role of physicians, see Haskell, *History and Its Images,* pp. 19, 44, 64–66.

65. Ian Jenkins, "The Masks of Dionysos/Pan-Osiris-Apis," *Jahrbuch des Deutschen Archäologischen Instituts* 109 (1994): 273–99.

66. Alastair Smart, *Allan Ramsay: A Complete Catalogue of His Paintings* (New Haven, CT: Yale University Press, 1999), p. 157.

67. Upon the death of his brother in 1746, Cunyngham (who earned his MD at Leiden under Boerhaave) became Sir Alexander Dick, but even as a baron he continued to pursue his interests in physic and natural philosophy and served as president of the College of Physicians of Edinburgh from 1756 to 1763. The fresco, described by Mead as the Court of Augustus, was engraved by Bernard Baron and appears in Charles Rollin, *The History of the Arts and Sciences of the Antients* (London, 1768), vol. 1, plate x. Cunyngham presented the fresco to Mead in May 1737. See Athol Forbes, ed., *Curiosities of a Scots Charta Chest 1600–1800 with the Travels and Memoranda of Sir Alexander Dick, Baronet of Prestonfield, Midlothian Written by Himself* (Edinburgh: William Brown, 1897), p. 124. Also relevant is Iain Gordon Brown, "Allan Ramsay: Artist, Author, Antiquary," in *Allan Ramsay and the Search for Horace's Villa*, ed. Bernard Frischer and Iain Gordon Brown (Aldershot, UK: Ashgate, 2001), pp. 7–26.

68. For the *Madagascar Portrait,* now at Arundel Castle, see David Howarth and Nicholas Penny, *Thomas Howard, Earl of Arundel,* exhibition catalogue (Oxford: Ashmolean Museum, 1985), p. 62.

69. The best account of the Dining Club comes from Alastair Smart, *Allan Ramsay: Painter, Essayist, and Man of the Enlightenment* (New Haven, CT: Yale University Press, 1992). The main primary source is the British Library manuscript, Birch MS 4478c, "The Diary of Thomas Birch."

70. Quoted by Smart, *Allan Ramsay: A Complete Catalogue,* p. 157. Ramsay's father, the poet Allan Ramsay, attributed much of his son's success to Mead's support, as evinced by a letter to the doctor dated March 4, 1740: "The Name and Accomplishments of Doctor Mead have been long known in the most distant parts of our Thule, and my Son does, and may justly, boast of the approbation of so excellent a Judge, who has with so much generosity endeavored to put his dawning Genious in the best Light." See *The Works of Allan Ramsay,* ed. Burns Martin et al. (Edinburgh: William Blackwood, 1945–74), 4:218–19.

71. For this and other networks of meanings at play in Mead's collection of portraits, see Ludmilla Jordanova, "Portraits, People and Things: Richard Mead and Medical Identity," *History of Science* 41 (2003): 293–313.

72. Huemer, *Corpus Rubenianum Ludwig Burchard,* pp. 104–7. In keeping with the general scholarly consensus, Huemer dates the portrait to Rubens's 1629–30 stay in London. Howarth, however, in *Lord Arundel,* pp. 154–56, argues the picture was painted in 1636 during the earl's diplomatic mission to the Continent, in deliberate response to Dürer's portrait of Willibald Pirckheimer, whose library Arundel had just acquired. If correct, this explanation extends the collector-homage function of the portrait back to the sixteenth century.

73. Rüdiger Klessmann, ed., *Adam Elsheimer 1578–1610,* exhibition catalogue (Ed-

inburgh: National Gallery of Scotland, 2006), pp. 152-55, 166-69, 186-88. Michael Levey, *The National Gallery Catalogue, The German School* (London: National Gallery of London, 1959), pp. 40-41, describes the National Gallery picture as "possibly" that owned by Mead. Given that the dimensions of the work correspond with those listed in *Catalogue of Pictures, Consisting of Portraits, Landscapes, Sea-Pieces*—7½ inches by 11 inches—I am inclined to accept the identification. As Levey also notes, fewer copies were made of "the large Tobias" than its counterpart. While a medical student in Leiden in the 1690s, Mead may have even seen the original version of the latter, since it was acquired by an art dealer in the city in 1673 for the large sum of 600 guilders (this is the last point at which Elsheimer's original has been traced); see Klessmann, *Adam Elsheimer*, p. 166. Prior to 1646, Arundel owned at least three works by Elsheimer, as evidenced by etchings made by Hollar (see chapter 1 of the present text), and the earl may have owned four others for a total of seven pictures—more than any other seventeenth-century collector according to Emile Gordenker, "Hidden Treasures: Collecting Elsheimer's Paintings in Britain," in Klessmann, *Adam Elsheimer*, pp. 193-202.

74. Jacqueline Burgers, *Wenceslaus Hollar: Seventeenth-Century Prints from the Museum Boymans-Van Beuningen* (Alexandria, VA: Art Services International, 1994), p. 106. Hollar's copy of the print implies a contest not only between himself and Goudt, but also between the techniques of etching and engraving.

75. Vertue, *Description of the Works of the Ingenious Delineator and Engraver Wenceslaus Hollar*, p. 136.

76. H. T. Swan, "An Ancient Record of 'Couching' for Cataract," *Journal of the Royal Society of Medicine* 88 (1995): 208-11.

77. The academy's story is brilliantly recounted in Freedberg, *Eye of the Lynx*. For Faber's role generally, see pp. 74, 112, 183-86, 258-61, 372. For his complicated relationship with the evidentiary potential of pictures, see esp. pp. 356-65.

78. Ibid., p. 426n36. Faber owned some paintings by Elsheimer as well as two engravings by Goudt after the artist, *Saint John the Baptist* and the "small Tobias," both printed on silk. The prints were later acquired by Cassiano dal Pozzo. See Christian Tico Seifert, "Adam Elsheimer's Artistic Circle in Rome," in Klessmann, *Adam Elsheimer*, pp. 209-23, esp. pp. 210, 217. On p. 169, Klessmann suggests that Elsheimer may have included "the botanical details" of the "large Tobias" "at the request of an interested patron, or even his friend Dr. Faber."

79. Richard Mead, *Medica sacra: Sive, de morbis insignioribus, qui in bibliis memorantur, commentaries* (London, 1749). Thomas Stack's English translation appeared in 1755, the year after Mead's death. While never questioning the possibility of miracles, Mead worked to demystify stories of biblical recovery wherever he felt it would not disrupt the integrity of the text; he was particularly skeptical of anything that, according to a Protestant outlook, smacked of Roman Catholic superstition. See Jordanova, "Richard Mead's Communities of Belief."

80. Thomas Birch, *The Heads of Illustrious Persons of Great Britain, Engraved by*

Mr. Houbraken, and Mr. Vertue with Their Lives and Characters by Thomas Birch, A.M. F.R.S., 2 vols. (London, 1743, 1751).

81. The embellishments around the portraits in Birch's volume were engraved by Hubert Gravelot and constitute an important chapter in the history of the rococo style in Britain; see Mark Girouard, "Coffee at Slaughter's: English Art and the Rococo—I," *Country Life* 139 (1966): 58–61.

82. Desmond Shawe-Taylor, *Genial Company: The Theme of Genius in Eighteenth-Century British Portraiture,* exhibition catalogue (London: Christie's, 1987), p. 23. Also, see Wolstenholme and Piper, *Royal College of Physicians of London Portraits,* pp. 282–83. Piper sees the style of the painting as being "very close to that of William Hoare" but makes no attribution judgment.

83. The letter is dated May 2, 1738, and addressed to Sir John Clerk of Penicuik; Scottish Record Office (Edinburgh) GD 18/4665/I. Quoted in I. Brown, "Allan Ramsay's Rise and Reputation," p. 231. A similar pairing comes from Scipione Maffei, who visited London in 1736. In the 1745 Verona edition of Voltaire's *Merope,* he writes, "I found the same pleasure in England, when Mylord the Earl of Burlington and Dr. Mead . . . took me to the villa of Mr. Pope, who is the Voltaire of England as you [Voltaire] are the Pope of France." Quoted and translated from the Italian in George Dorris, "Scipione Maffei amid the Dunces," *Review of English Studies* 16 (1965): 288–90.

84. Alexander Pope, "Of Taste, An Epistle to Lord Burlington," lines 41–43; in *Twickenham Edition of the Poems of Alexander Pope,* vol. 3.2, *Epistles to Several Persons* (New Haven, CT: Yale University Press, 1951), pp. 124–51. The poem singles out Mead for his library; see lines 10, 41–43.

85. *The Correspondence of Alexander Pope,* ed. George Sherburn (Oxford: Clarendon Press, 1956), 2:471, 529. Buckley's seven-volume folio edition of de Thou's *Historiarum sui temporis ab 1543 usque annum 1607* appeared in 1733. Specifically, Pope is responding to Buckley's *Letter to Dr. Mead Concerning an Edition of Thouanus' History* (London, 1728), which provided a description of the project for would-be subscribers. See Samuel Kinser, *The Works of Jacques-Auguste de Thou* (The Hague, Netherlands: Martinus Nijhoff, 1966); and Haskell, *History and Its Images,* pp. 68ff.

86. See Forbes, *Curiosities of a Scots Charta Chest,* p. 124. For other references to Pope's presence at Mead's table, see *Correspondence of Alexander Pope,* ed. Sherburn, 2:529; and 3:331–32.

87. *Correspondence of Alexander Pope,* 3:278, 453; 4:200–207, 338–39, 374–75, 461, 467, 487, 499, 511–12, 522.

88. In a letter to Richardson dated January 4, 1738, Pope writes, "I keep my promise in acquainting you a day before, that I will come to you tomorrow morning by eleven, to sit till one of you please, for the Drs picture." See ibid., 4:p. 91. For the relationship between the painter and the poet, see Gibson-Wood, *Jonathan Richardson,* esp. pp. 80–86. The painting is in the collection of the National Portrait Gallery and is currently on display at Beningbrough Hall in Yorkshire. The sketch, dated October 5, 1738, is in the British Museum.

89. Maty, *Authentic Memoirs of the Life of Richard Mead,* p. 51. Also see William Wimsatt, *The Portraits of Alexander Pope* (New Haven, CT: Yale University Press, 1965), pp. 205-9.

90. "Some Account of the Life and Writings of the Late Dr. Richard Mead," p. 515.

91. Wimsatt, *Portraits of Alexander Pope,* pp. 26, 196.

92. George Vertue, "Vertue's Notebooks, volume III," *Walpole Society* 22 (1933-4), p. 101. Also see Morris Brownell, *Alexander Pope & the Arts of Georgian England* (Oxford: Clarendon Press, 1978), pp. 354-55; Michael Dobson, *The Making of the National Poet: Shakespeare, Adaptation, and Authorship, 1660-1769* (Oxford: Clarendon, 1992), pp. 134-46; Matthew Craske, "Westminster Abbey 1720-70: A Public Pantheon Built upon Private Interest," in *Pantheons: Transformations of a Monumental Idea,* ed. Matthew Craske and Richard Wrigley (Aldershot, UK: Ashgate, 2004), pp. 57-80; and Philip Connell, "Death and the Author: Westminster Abbey and the Meanings of the Literary Monument," *Eighteenth-Century Studies* 38 (2005): 557-85.

93. David Piper, *"O Sweet Mr. Shakespeare I'll Have His Picture": The Changing Image of Shakespeare's Person, 1600-1800,* exhibition catalogue (London: National Portrait Gallery, 1964), pp. 20-22.

94. *A Catalogue of the Genuine and Entire Collection of Valuable Gems, Bronzes, Marble, and Other Busts and Antiquities of the late Doctor Mead. Which will be sold by Auction, By Mr. Langford . . . On Tuesday the 11th of yhis Instant March 1755, and the four following Days* (London, 1755). Also see Margaret Whinney, *Sculpture in Britain 1530 to 1830* (Harmondsworth, UK: Penguin Books, 1964), pp. 96-97, 119, 261; and Ingrid Roscoe, "Peter Scheemakers," *The Walpole Society* 61 (1999): 163-204. The Scheemakers busts in Mead's collection portrayed Shakespeare, Milton, Pope, and Alexander the Great.

95. Quoted in Jacques Carré, *Lord Burlington (1694 -1753): Le connaisseur, le mécène, l'architecte* (Clermont-Ferrand, France: Adosa, 1993), p. 272.

96. Brownell, *Alexander Pope & the Arts of Georgian England,* p. 354.

97. David Solkin, "Samaritan or Scrooge? The Contested Image of Thomas Guy in Eighteenth-Century England," *Art Bulletin* 78 (1996): 467-84; and Solkin, *Painting for Money.*

98. Philip Ayres, *Classical Culture and the Idea of Rome in Eighteenth-Century England* (New York: Cambridge University Press, 1997), p. 108; and his "Burlington's Library at Chiswick," *Studies in Bibliography* 45 (1992): 113-27, stress the extent to which Burlington's library "was a working collection." In this sense, Burlington and Mead were in full agreement. In addition to mathematical and drawing instruments, the earl owned works by Newton, books on astronomy, and a telescope.

99. Jenny Uglow, *Hogarth: A Life and a World* (London: Faber & Faber, 1997), pp. 267-68, 277-94.

100. See T. P. Hudson, "Moor Park, Leoni, and Sir James Thornhill," *Burlington Magazine* 113 (1971): 657-61; and John Shipley, "Ralph, Ellys, Hogarth, and Fielding: The Cabal against Jacopo Amigoni," *Eighteenth-Century Studies* 1 (1968): 313-31.

101. Quoted in Uglow, *Hogarth*, p. 284. Robin Simon likewise stresses the empiricist dimensions of Hogarth's work at St. Bart's; see *Hogarth, France, and British Art: The Rise of the Arts in 18th-Century Britain* (London: Paul Holberton, 2007), p. 196.

102. Rhian Harris and Robin Simon, eds., *Enlightened Self-Interest: The Foundling Hospital and Hogarth*, exhibition catalogue (London: Thomas Coram Foundation for Children, 1997); Ruth McClure, *Coram's Children: The London Foundling Hospital in the Eighteenth Century* (New Haven, CT: Yale University Press, 1981); and Gillian Wagner, *Thomas Coram, Gent.: 1668–1751* (Woodbridge, Suffolk: Boydell Press, 2004).

103. Matthew Hargraves, *"Candidates for Fame": The Society of Artists of Great Britain, 1760–1791* (New Haven, CT: Yale University Press, 2005), p. 11.

104. John Brownlow, *Memoranda; or, Chronicles of the Foundling Hospital, Including Memoirs of Captain Coram, &c.* (London, 1847), pp. 17–20.

105. John Gwynn, *An Essay on Design: Including Proposals for Erecting a Public Academy to Be Supported by Voluntary Subscription* (London, 1749), p. 78. I am grateful to Hargraves, *"Candidates for Fame,"* p. 11, for noting the quotation.

106. Gwynn, *An Essay on Design*, p. 89. Hargraves doesn't pursue this argument; nor does he mention the rhetorical role Marsigli plays for Gwynn. A full discussion of Gwynn's and civic humanism would include his *London & Westminster Improved, to Which Is Prefixed a Discourse on Public Magnificence* (London, 1766).

107. Ibid, p. 90.

108. Ibid, pp. 86–88.

109. John Stoye, *Marsigli's Europe, 1680–1730: The Life and Times of Luigi Ferdinando Marsigli, Solider and Virtuoso* (New Haven, CT: Yale University Press, 1994), pp. 291–95.

110. Ronald Paulson, *Hogarth: His Life, Art, and Times* (New Haven, CT: Yale University Press, 1971), 1:240–44.

111. Simon notes, in *Hogarth, France, and British Art*, pp. 70, 138, that Mead owned four finely bound volumes of Hogarth's complete works and that Hogarth in turn owned a copy of *Imitations of Drawings by Old Masters* by Arthur Pond and George Knapton, which reproduced images from Mead's collection. While I fully support Simon's attempts to understand Hogarth within a broader European context, I'm afraid he may overstate the relationship between Hogarth and Mead along the way—at least in terms of the present evidence. In suggesting here that Mead and Hogarth had more in common than has traditionally been acknowledged, I do not mean to speculate about how they related to each other personally.

112. Walpole stated that Mead spent as much as £70 a week on hospitality. The sum is regularly cited in biographical accounts of Mead, though in fact, the context of the assertion perhaps calls into question its factual validity. It appears in the same letter noted earlier (July 25, 1750) in which Walpole scoffs at Mead's alleged sexual proclivities, just when Mead seemed to be on the verge of bankruptcy. Writing to Horace Mann, Walpole gleefully reports that "Dr Meade is undone, his fine collection is going to be sold; he owes above five and twenty thousand pounds. . . . All the world thought him immensely rich; but besides the expense of his collection, he kept a

table, for which alone he is said to have allowed seventy pounds a week." Whether or not Walpole was right about the amount of the expenditure, the claim seems reliable as an indication of Mead's hospitality (however negatively Walpole may have understood it). See *Horace Walpole's Correspondence,* 20:165; also, pp. 185, 189. For Pond's connections with Mead, see Louise Lippincott, *Selling Art in Georgian London: The Rise of Arthur Pond* (New Haven, CT: Yale University Press, 1983), esp. pp. 60, 89, 121, 129. The son of an apothecary, Pond was himself a Fellow of both the Royal Society and the Society of Antiquaries.

113. Mead provided substantial support for the third volume of Albin's *Natural History of Birds* (London, 1738). Catesby honored Mead's patronage by naming the Shooting Star after him, *Dodecatheon meadia* (Linnaeus relied largely on Catesby here); for the varieties, see Norman Fassett, "Dodecatheon in Eastern North America," *American Midland Naturalist* 31 (1944): 455–86. Both Edwards and Catesby were members of the Royal Society. See A. Stuart Mason, *George Edwards: The Bedell and His Birds* (London: Royal College of Physicians of London, 1992); and Amy Meyers and Margaret Pritchard, eds., *Empire's Nature: Mark Catesby's New World Vision* (Chapel Hill: University of North Carolina, 1999), esp. David Brigham, "Mark Catesby and the Patronage of Natural History in the First Half of the Eighteenth Century," pp. 91–146.

Conclusion

1. Susan Weber Soros, ed., *James "Athenian" Stuart, 1713–1788: The Rediscovery of Antiquity,* exhibition catalogue (New Haven, CT: Yale University Press, 2006). Among the many excellent essays, see especially Kerry Bristol, "The Social World of James 'Athenian' Stuart," pp. 145–92.

2. Lionel Cust, *History of the Society of Dilettanti* (New York: Macmillan, 1898), p. 36. Also see Bruce Redford, "*Seria Ludo:* George Knapton's Portraits of the Society of Dilettanti," *The British Art Journal* 3 (2001): 56–68; and Bruce Redford, *Dilettanti: The Antic and the Antique in Eighteenth-Century England,* exhibition catalogue (Los Angeles: J. Paul Getty Research Institute, 2008). Especially promising is Jason Kelly's work: "Riots, Revelries, and Rumor: Libertinism and Masculine Associations in Enlightenment London," *Journal of British Studies* 45 (2006): 759–95; and *The Society of Dilettanti, 1732–1816: Archaeology and Identity in the British Enlightenment* (New Haven, CT: Yale University Press, forthcoming).

3. Soros, *James "Athenian" Stuart,* pp. 580–81. The society later came to be known as the Royal Society of Arts (RSA). See D. G. C. Allan and John Abbott, eds., *"The Virtuoso Tribe of Arts and Sciences": Studies in Eighteenth-Century Work & Membership of the London Society of Arts* (Athens: University of Georgia Press, 1992). For the relationship between the RSA and the other art societies that emerged from the community around the Foundling, see Hargraves, *"Candidates for Fame".*

4. Catherine Arbuthnott, "The Life of James 'Athenian' Stuart, 1713–1788," in So-

ros, *James "Athenian" Stuart*, pp. 59–101, esp. pp. 76ff. Also, see Bristol's essay, "The Social World of James 'Athenian' Stuart," pp. 155ff.

5. Viccy Coltman, *Fabricating the Antique: Neoclassicism in Britain, 1760–1800* (Chicago: University of Chicago Press, 2006), offers a fascinating account of late eighteenth-century engagements with the past. Coltman approaches neoclassicism not as a style but as a way of thinking about the world—a system of thought that was translated into material culture and then collected. Although she expands the usual cast of characters, Adam, Wedgwood, and Revett remain central to the story. For all of the book's successes, however, it never completely manages to explain why this neoclassicism emerged when it did—as opposed to twenty or fifty years earlier—or how we might position it in relation to the previous century of British engagement with ancient Greece or Rome.

6. An invaluable starting place is MacGregor, *Sir Hans Sloane.*

7. John Burton, "A Dissertation on the Situation of the Ancient Roman Station of Delgovitia in Yorkshire," *Philosophical Transactions* 44 (1746): 541–56. Ayres, *Classical Culture and the Idea of Rome in Eighteenth-Century England*, pp. 108–14, provides an excellent summary. Ayres notes that Drake achieved for Burlington "precisely what Stukeley had for Pembroke—given him a tangible hereditary connection with Roman history in the very soil he sat on" (p. 110). On the other hand, Ayres is interested in the material because of Burlington, not Drake, and he makes nothing of the medical identities of these men.

8. Nicholas Hall, ed., *Fearful Symmetry: George Stubbs, Painter of the English Enlightenment* (New York: Hall & Knight, 2000), pp. 154ff. Trained in Leiden under Dr. Herman Boerhaave, Burton is widely understood as the model for Dr. Slop of Laurence Sterne's *Tristram Shandy*. See, for instance, Arthur Cash, "The Birth of Tristram Shandy: Sterne and Dr. Burton," in *Studies in the Eighteenth Century*, ed. R. F. Brissenden (Canberra: Australian National University Press, 1968), pp. 133–54. A more nuanced argument is made by Donna Landry and Gerald MacLean, "Of Forceps, Patents, and Paternity: *Tristram Shandy*," *Eighteenth-Century Studies* 23 (1990): 522–43.

9. Malcolm Warner and Robin Blake, eds., *Stubbs & the Horse*, exhibition catalogue (New Haven, CT: Yale University Press, 2004), p. 162. Especially useful is the essay from Lance Mayer and Gay Myers, "Painting in an Age of Innovation: Stubbs's Experiments in Enamel and Wax," pp. 123–39.

10. See Peter Black, ed., *"My Highest Pleasure": William Hunter's Art Collection* (London: Paul Holberton, 2007).

11. Anne Darlington, "The Teaching of Anatomy and the Royal Academy of Arts, 1768–1782," *Journal of Art & Design Education* 5 (1986): 263–71.

SELECTED BIBLIOGRAPHY

Given the necessarily wide scope of the bibliography, not all sources consulted are included. Items connected with particular points—matters of fact or information regarding a specific work of art, for instance—are typically omitted, though they do appear in the notes.

Manuscripts

London, British Library

Add. MS 4223, fols. 17–33. Biographical Anecdotes M–S, Birch Collection.

Add. MS 4310, fol. 118. Letter from William Hocker to Thomas Birch, January 11, 1741/42.

Add. MS 4310, fol. 122. Letter from William Hogarth to Thomas Birch, November 25, 1753.

Add. MS 4475, fol. 122. Letter from William Hocker to Thomas Birch, January 16, 1741/42.

Add. MS 29589, fols. 433–37. Letter from William Aglionby to Daniel Finch, second Earl of Nottingham, November 1704.

Add. MS 46172, fol. 102. Letter from the Royal Society to the Ordnance Board, May 24, 1714.

Sloane MS 4030, fol. 411. Letter from William Aglionby to Hans Sloane, January 1705.

Sloane MS 4034, fols. 1–2. Memorandum on the safety of goods brought from Italy, September 13, 1743.

Sloane MS 4036, fol. 128. Letter from William Aglionby to Hans Sloane, June 1692.

Sloane MS 4036, fols. 143–44. Letter from William Aglionby to Hans Sloane, April 1693.

Sloane MS 4057, fol. 247. Letter from William Aglionby to Hans Sloane, October 11, 1689/1700.
Sloane MS 4057, fol. 249. Letter from William Aglionby to Hans Sloane, n.d.

London, Society of Antiquaries
MS 206, fols. 63-64. Inoculation of Six Criminals with Small Pox.

London, Wellcome Library for the History and Understanding of Medicine
Wellcome MS 7315/1. Letter from Dr. Mead to Samuel Johnson, June 30, 1720.
Wellcome MS 7315/3. Letter from Dr. Mead to Brian Fairfax in Panton Square, October 17, 1729.

Stafford, Staffordshire Record Office
MS D661/18/3. William Aglionby's letter book, ca. 1702-5.
MS D661/18/4. English translation of Bellori's *Le vite de' pittori, scultori, ed architetti moderni* in William Aglionby's hand.

Printed Primary Sources

Aglionby, William, trans. *The Art of Chymistry: As it is Now Practiced,* by Pierre Thibaut. London, 1668. [The original French text appeared in 1667.]
———, trans. *Il Nipotismo di Roma; or, The History of the Popes' Nephews,* bu Gregorio Leti. London, 1673. [The original Italian edition appeared in 1667.]
———. *Painting Illustrated in Three Diallogues, Containing Some Choice Observations upon the Art Together with the Lives of the Most Eminent Painters, From Cimabue, to the Time of Raphael and Michelangelo. With an Explanation of the Difficult Terms.* London, 1685.
———. *The Present State of the United Provinces of the Low Countries as to the Government, Laws, Forces, Riches, Manners, Customes, Revenue, and Territory of the Dutch: In Three Books . . . The Delights of Holland Collected by W. A., Fellow of the Royal Society.* London, 1669.
———, trans. *The Whole Art of the Stage: Containing not only the rules of the drammatick art, but many curious observations about it, which may be of great use to the authors, actors, and spectators of plays: Together with much critical learning about the stage and plays of the antients,* by François-Hédelin Aubignac. London, 1684. [The original French edition appeared in 1657.]
Aikin, John. *Biographical Memoirs of Medicine in Great from the Revival of Literature to the Time of Harvey.* London, 1780.
Alberti, Leon Battista. *On Painting.* Translated by John Spencer. New Haven, CT: Yale University Press, 1966. [First published in Latin in 1435, in Italian in 1436.]
An Account of a Strange and Wonderful Dream Dedicated to Dr. M——d. London, 1719.
Asplin, William [Philalethes Rusticus, pseud.] *The Impertinence and Imposture of*

Modern Antiquaries Displayed; or, A Refutation of the Rev. Wise's Letter to Dr. Mead, concerning the White Horse, and other Antiquities in Berkshire, in a Familiar Letter to a Friend. London, 1740.

B., T. *A Call to the Connoisseurs; or, Decisions of Sense, with Respect to the Present State of Painting and Sculpture, and their several Professors in these Kingdoms.* London, 1761.

Bacon, Francis. *The Advancement of Learning.* New York: Modern Library, 2001. [First published in 1605.]

———. *Essays.* Amherst, NY: Prometheus Books, 1995. [First published in 1597.]

———. *The New Organon.* Edited by Lisa Jardine and Michael Silverthorne. Cambridge: Cambridge University Press, 2000. [First published in 1620.]

Barker, John. *An Essay on the Agreement betwixt Ancient and Modern Physicians; or, A Comparison between the Practice of Hippocrates, Galen, Sydenham, and Boerhaave in Acute Diseases.* London, 1748.

Birch, Thomas. *The Heads of Illustrious Persons of Great Britain, Engraved by Mr. Houbraken, and Mr. Vertue with Their Lives and Characters by Thomas Birch, a.m. F.R.S.* 2 vols. London, 1743, 1751.

———. *The History of the Royal Society of London for Improving of Natural Knowledge.* 4 vols. London, 1756-57. [For an index, see Scala (1974).]

Blackmore, Richard. *Treatise upon the Small-Pox.* London, 1723.

Boerhaave, Herman. *Boerhaave's Correspondence.* Edited by G. A. Lindeboom. 3 vols. Leiden: E. J. Brill, 1962-79.

Boswell, James. *Boswell's Life of Johnson.* Edited by George Birkbeck Hill and L. F. Powell. 6 vols. Oxford: Clarendon Press, 1934-64.

Boyer, Abel. *The History of the Life and Reign of Queen Anne.* London, 1722.

Boyle, Robert. *The Works of Robert Boyle.* Edited by Michael Hunter and Edward Davis. 14 vols. London, Pickering & Chatto, 1999-2000.

Buckley, Samuel. *Letter to Dr. Mead Concerning an Edition of Thouanus' History.* London, 1728.

Burton, John. "A Dissertation on the Situation of the Ancient Roman Station of Delgovitia in Yorkshire." *Philosophical Transactions of the Royal Society* 44 (1746): 541-56.

Carthusiensis, Momophilius [pseud]. *A Serious Conference between Scaramouch and Harlequin, Concerning the Three and One. With a Dedication to the Two Eminent Meetings within the Bills of Mortality.* London, 1719.

Castiglione, Baldassare. *The Book of the Courtier.* Translated by Thomas Hoby. London: J. M. Dent & Sons, 1928. [Hoby's translation of the 1528 text first appeared in 1561.]

Castle, George. *The Chymical Galenist: A Treatise, Wherein the Practice of the Ancients is reconciled to the New Discoveries in the Theory of Physick. Shewing that many of the Rules, Methods, and Medicines are useful for the Curing of Diseases in this Age, and in the Northern Parts of the World. In which are some Reflections upon a book intitled "Medela Medicinae."* London, 1667.

Cervantes Saavedra, Miguel de. *The History of That Ingenious Gentleman Don Quijote de La Mancha*. Translated by Burton Raffel. New York: Norton, 1995.

——. *The Life and Exploits of the Ingenious Gentleman Don Quixote De La Mancha*. Translated by Charles Jervas. London, 1742.

Clifton, Francis. *The State of Physick, Ancient and Modern Briefly Considered with a Plan for the Improvement of It*. London, 1732.

——. *Tabular Observations Recommended as the Plainest and Surest Way of Practicing and Improving Physick. In a Letter to a Friend*. London, 1731.

Cooper, Anthony Ashley [third Earl of Shaftesbury]. *Characteristics of Men, Manners, Opinions, Times*. Edited by Lawrence Klein. New York: Cambridge University Press, 1999. [First published in 1711.]

——. *Several Letters Written by a Noble Lord to a Young Man at the University*. London, 1716.

Cowper, William. "An Account of Several Schemes of Arteries and Veins, dissected from adult Human Bodies, and given to the Repository of the Royal Society by John Evelyn, Esq. To which are subjoined a Description of the Extremities of the Vessels, and the Manner the Blood is seen by the Microscope to pass from the Arteries to the Veins." *Philosophical Transactions of the Royal Society* 23 (1702): 1177–1201.

——. *Myotamia Reformata; or, A New Administration of All the Muscles of Humane Bodies . . . to which are subjoined, a Graphical Description of the bones and other anatomical observations*. Edited by Richard Mead, Joseph Tanner, James Jurin, and Henry Pemberton. Rev. ed. London, 1724.

Defoe, Daniel. *A Plan of the English Commerce Being a Compleat Prospect of the Trade of this Nation*. London, 1728.

Douglas, William. *The Cornutor of Seventy-Five*. London, 1748.

Dryden, John. *Amphitryon; or, The Two Sosias. A Comedy as it is Acted at the Theatre Royal*. London, 1691.

Dufresnoy, Charles-Alphonse. *De arte graphica*. In *The Works of John Dryden*, vol. 20, *Prose 1691–1698: "De Arte Graphica" and Shorter Works*. Edited by A. E. Wallace Maurer. Berkeley and Los Angeles: University of California Press, 1989. [Dryden's translation first appeared in 1695.]

——. *De arte graphica*. Edited with commentary by Christopher Allen, Yasmin Haskell, and Frances Muecke. Geneva: Droz, 2005.

Earle, John. *Micro-Cosmography; or, A Piece of the World Discover'd in Essays and Characters*. London, 1628.

Evelyn, John. *Diary and Correspondence of John Evelyn*. Edited by William Bray. 4 vols. New York: Scribner's, 1906.

——. *The Diary of John Evelyn*. Edited by E. S. de Beer. 6 vols. London: Oxford University Press, 1955.

——. *John Evelyn's "Elysium Britannicum" and European Gardening*. Edited by Therese O'Malley and Joachim Wolschke-Bulmahn. Washington, DC: Dumbarton Oaks, 1998.

———. *Sculptura.* Edited by C. F. Bell. Oxford: Clarendon Press, 1906. [First published in 1662.]Fielding, Henry. *"The True Patriot" and Related Writings.* Edited by W. B. Coley. Middletown, CT: Wesleyan University Press, 1987. [The first issue appeared in 1745.]

Folkes, Martin. *A Catalogue of the Entire and Valuable Library of Martin Folkes, Esq. President of the Royal Society . . . which will be sold by Auction by Samuel Baker at his House in York Street, Covent Garden.* London, 1756.

Fontana, Felix. *Treatise on the Venom of the Viper.* Translated by Joseph Skinner. London, 1795. [The first French edition appeared in 1765.]

Fréart, Roland, Sieur de Chambray. *An Idea of the Perfection of Painting: Demonstrated from the Principles of Art, and by Examples conformable to the Observations, which Pliny and Quintilian have made upon the most celebrated pieces of the ancient painters, paralleled with some works of the most famous modern painters, Leonardo da Vinci, Raphael, Julio Romano, and N. Poussin.* Translated by John Evelyn. London, 1668. [The original French edition appeared in 1662.]

———. *A Parallel of the Antient Architecture with the Modern, In a Collection of Ten Principal Authors who have Written upon the Five Orders . . . With Leon Baptista Alberti's "Treatise of Statues."* Translated by John Evelyn. London, 1664. [The original French edition appeared in 1650.]

Freind, John [Dr. Byfield, pseud.]. *A Letter to the Learned Dr. Woodward.* London, 1719.

Gordon, Alexander. *Essay Towards Explaining the Antient Hieroglyphical Figures, on the Egyptian Mummy, in the Museum of Doctor Mead.* London, 1737.

———. *Essay Towards Explaining the Hieroglyphical Figures, on the Coffin of the Ancient Mummy Belonging to Captain William Lethieullier.* London, 1737.

Grew, Nehemiah. *Musæum Regalis Societatis; or, A Catalogue & Description of the Natural and Artificial Rarities Belonging to the Royal Society and Preserved at Gresham Colledge. Made by Nehemiah Grew M.D., Fellow of the Royal Society, and of the Colledge of Physicians. Whereunto is Subjoyned the Comparative Anatomy of Stomach and Guts by the same Author.* London, 1681.

Harlequin-Hydaspes; or, The Greshamite, A Mock Opera, As it is Performed at the Theatre in Lincoln's Inn Fields. London, 1719.

Harley, Edward. *A Catalogue of the Collection of the Right Honourable Edward Earl of Oxford, Deceased . . . which will be sold by Auction by Mr. Cock at his House in the Great Piazza, Covent-Garden on Monday the 8th of March, 1741–2, and the five following days.* London, 1742.

———. *A Catalogue of Greek, Roman, and English Coins, Medallions, and Medals of the Right Honourable Edward Earl of Oxford . . . 18 March 1741–2.* London, 1742.

[Harris, John]. *A Letter to the Fatal Triumvirate: In Answer to That Pretended to Be Written by Dr. Byfield; And Shewing Reasons Why Dr. Woodward Should Take No Notice of It.* London, 1719.

———. *Lexicon Technicum; or, An Universal English Dictionary of Arts and Sciences: Explaining not only the Terms of Art, but the Arts Themselves.* 2 vols. London, 1704.

Harvey, William. *The Anatomical Exercises: "De motu cordis" and "De circulatione sanguinis."* Edited by Geoffrey Keynes. New York: Dover Publications, 1995. [The original Latin edition appeared in 1628 and the first English translation in 1653.]

Hawkins, John. "Anecdotes from John Hawkins's Life of Dr. Johnson: Of Doctor Mead." *European Magazine* (March 1787): 143. [The piece also appeared in *Walker's Hibernian Magazine; or, Compendium of Entertaining Knowledge* (April 1787): 176.]

Haydocke, Richard, trans. *A Tracte Containing the Artes of Curious Paintinge, Carvinge, and Buildinge,* by Giovanni Paolo Lomazzo. Oxford, 1598. [The original Italian edition appeared in 1584.]

Hobbes, Thomas. *Thomas Hobbes: The Correspondence.* Edited by Noel Malcolm. Oxford: Clarendon Press, 1994.

Hogarth, William. *The Analysis of Beauty.* Edited by Ronald Paulson. New Haven, CT: Yale University Press, 1997. [First published in 1753.]

Hooke, Robert. *The Diaries of Robert Hooke, the Leonardo of London, 1635–1703.* Edited by Richard Nichols. Sussex: Book Guild, 1994.

Johnson, Samuel. "Life of Dr. Sydenham." *Gentleman's Magazine* 12 (1742): 633–35.

Junius, Franciscus. *The Literature of Classical Art: "The Painting of the Ancients (De pictura veterum)" and a "Lexicon of Artists and Their Works."* Edited by Keith Aldrich, Philipp Fehl, and Raina Fehl. 2 vols. Berkeley and Los Angeles: University of California Press, 1991. [First published in 1638 and 1694.]

Le Camus, Antoine. *Abdeker; or, The Art of Preserving Beauty.* London, 1754.

Lettsom, John Coakley. "Cursory Observations on Dr. Sydenham's Life." *Gentleman's Magazine* 90 (1801): 1071.

The Life and Adventures of Don Bilioso de L'Estomac. Translated from the Original Spanish into French; done from the French into English with a Letter to the College of Physicians. London, 1719.

A List of the Members of the Society of Antiquaries of London, From Their Revival in 1717, to June 19, 1796. Arranged in Chronological and Alphabetical Order. London, 1798.

Lloyd, Claude. "Shadwell and the Virtuosi." *PMLA* 44 (1929): 472–94.

Locke, John. *The Correspondence of John Locke.* Edited by E. S. de Beer. 8 vols. Oxford: Clarendon Press, 1976–89.

———. *An Essay concerning Human Understanding.* Edited by Peter Nidditch. Oxford: Clarendon Press, 1975. [First published in 1689.]

Macky, John. *Memoirs of the Secret Services of John Macky, Esq., during the Reigns of King William, Queen Anne, and King George I.* London, 1733.

Mandeville, Bernard. *A Treatise of the Hypochondriack and Hysterick Diseases in Three Dialogues.* 2nd ed. London, 1730. [First edition published in 1711.]

Maty, Matthew. *Authentic Memoirs of the Life of Richard Mead, M.D.* London, 1755. [Expanded form of "Eloge du Docteur Richard Mead," *Journal Britannique* (July–August 1754).]

Mayerne, Théodore Turquet de. *Lost Secrets of Flemish Painting.* Edited by Donald Fels. Translated by Richard Bedell and Rebecca McClung. Floyd, VA: Alchemist,

2001. [Based on Ernst Berger's 1901 German translation of BL MS Sloane 2052.]

Maynwaringe, Everard. *Medicus Absolutus Adespotos: The Compleat Physitian, Qualified and Dignified.* London, 1668.

Mead, Richard. *Bibliotheca Meadiana, sive Catalogus Librorum Richardi Mead . . . Apud Samuel Baker, In Vico dicto York Street, Covent Garden, Londini, Die Lunae, 18 Novembris, M.DCC.LIV. Iterumque Die Lunae, 7 Aprilis, M.DCC.LV.* London, 1754.

——. *A Catalogue of the Genuine and Capital Collection of Pictures, by the most celebrated Masters, of that late Great and Learned Physician, Doctor Richard Mead, Deceased.* London, 1754.

——. *A Catalogue of the Genuine and Entire Collection of Valuable Gems, Bronzes, Marble, and Other Busts and Antiquities of the late Doctor Mead. Which will be sold by Auction, By Mr. Langford . . . On Tuesday the 11th of this Instant March 1755, and the four following Days.* London, 1755.

——. *A Catalogue of the Genuine, Entire, and Curious Collection of Prints and Drawings (bound and unbound) of the Late Doctor Mead . . . which (by order of the executors) will be sold by auction by Mr. Langford at his house in the Great Piazza, Covent-Garden, on Monday the 13th of January 1755, and the thirteen following evenings.* London, 1755.

——. *A Catalogue of Pictures, Consisting of Portraits, Landscapes, Sea-Pieces, Architecture, Flowers, Fruits, Animals, Histories of the Late Richard Mead, M.D. Sold by Auction on March 1754.* London, 1755.

——. *A Discourse on the Small Pox and Measles.* London, 1748. [First Latin edition appeared in 1747.]

——. *A Mechanical Account of Poisons in Several Essays.* London, 1702.

——. *The Medical Works of Dr. Richard Mead.* 3 vols. Edinburgh, 1763.

——. *Museum Meadianum, sive Catalogus Nummorum, Veteris Aevi Monumentorum, ad Gemmarum, cum aliis quibusdam Artis recentioris et Naturae Operibus Quae Vir Clarissimus Richardus Mead, M.D.* London, 1755.

——. *A Short Discourse Concerning Pestilential Contagion and the Methods to Be Used to Prevent It.* London, 1720.

——. *A Treatise Concerning the Influence of the Sun and Moon upon Human Bodies and the Diseases thereby Produced.* London, 1748. [First Latin edition appeared in 1704.]

Merrett, Christopher. *The Art of Glass, Wherein Are Shown the Wayes to Make and Colour Glass, Pastes, Enamels, Lakes, and other Curiosities.* London, 1668. [An expanded translation of Antonio Neri's *L'Arte Vetraria* from 1612.]

——. *The Character of a Compleat Physician, or Naturalist.* London, 1680.

Munk, William. *The Roll of the Royal College of Physicians, 1518–1825.* 3 vols. London: Royal College of Physicians, 1878.

Newton, Isaac. *The Correspondence of Isaac Newton.* Edited by H. W. Turnbull et al. 7 vols. Cambridge: Cambridge University Press, 1959–77.

Norgate, Edward. *Miniatura; or, The Art of Limning.* Edited by Martin Hardie. Oxford: Clarendon Press, 1919.

———. *Miniatura or the Art of Limning.* Edited by Jeffrey Muller and Jim Murrell. New Haven, CT: Yale University Press, 1997.

North, George. *An Answer to a Scandalous Libel, Entitled "The Impertinence and Imposture of Modern Antiquaries Displayed; or, A Refutation of the Reverend Mr. Wise's Letter to Dr. Mead, concerning the White Horse, and other Antiquities in Berkshire."* London, 1741.

Oberndorff, John. *The Anatomyes of the True Physition, and Counterfeit Mounte-banke, wherein both of them are graphically described and set out in their Right, and Orient Colours, translated from the German by F. H., Fellow of the College of Physicians in London.* London, 1602.

Oldenburg, Henry. *The Correspondence of Henry Oldenburg.* Edited by A. Rupert Hall and Marie Boas Hall. 13 vols. Madison: University of Wisconsin Press, 1965–86.

Peacham, Henry. *Peacham's "Compleat Gentleman," 1634.* Edited by G. S. Gordon. Oxford: Clarendon Press, 1906.

Piggott, Stuart, ed. *Antiquaries: Thoresby, Hearne, Vertue, Stukeley, and Grose.* Sales Catalogues of Libraries of Eminent Persons, vol. 10. London: Sotheby, 1974.

Pittis, William. *Some Memoirs of the Life of John Radcliffe, M.D.* London, 1715.

Plot, Robert. *Natural History of Oxfordshire.* Oxford, 1677.

Pope, Alexander. *The Correspondence of Alexander Pope.* Edited by George Sherburn. 5 vols. Oxford: Clarendon Press, 1956.

———. "Of Taste, an Epistle to Lord Burlington." *Twickenham Edition of the Poems of Alexander Pope,* vol. 3.2, *Epistles to Several Persons,* pp. 124–51. New Haven, CT: Yale University Press, 1951.

Ramsay, Allan. *The Works of Allan Ramsay.* Edited by Burns Martin et al. 6 vols. Edinburgh: William Blackwood, 1945–74.

Richardson, Jonathan. *A Discourse on the Dignity, Certainty, Pleasure and Advantage of the Science of a Connoisseur.* London, 1719.

Rollin, Charles. *The History of the Arts and Sciences of the Antients.* 3 vols. London, 1768.

Rouquet, André. *The Present State of the Arts in England.* London, 1755.

Salmon, William. *Bibliotheca Salmoneana: Pars Prima. Or, A Catalogue of the Remaining Part of the Library of the Learned Wiliam Salmon, M.D.* London, 1713.

———. *Bibliotheca Salmoneana: Pars Secunda. Or, A Catalogue of the Remaining Part of the Library of the Learned Wiliam Salmon, M.D.* London, 1714.

———. *A Discourse against Transubstantiation.* London, 1690.

———. *A Discourse upon Water-Baptism.* London, 1700.

———. *A Dissertation Concerning the Lord's Supper.* London, 1708–9.

———. *Polygraphice, the Art of Drawing, Engraving, Etching, Limning, Painting, Washing, Varnishing, Colouring, and Dyeing.* London, 1672. [Subsequent editions appeared in 1673, 1675, 1678, 1679, 1681, 1685, 1701.]

——. *Salmon's Almanack for 1684.* London, 1684.

——. *Synopsis Medicinae; or, A compendium of Astrological, Galenical, and Chymical Physick, in three books.* London, 1671. [Subsequent editions appeared in 1681, 1685, 1689, 1695.]

Sanderson, William. *Graphice: The Use of the Pen and Pensil.* London, 1658.

Scala, Gail. "An Index of Proper Names in Thomas Birch, *The History of the Royal Society.*" *Notes and Records of the Royal Society of London* 28 (1974): 263–329.

Shadwell, Thomas. *The Complete Works of Thomas Shadwell.* Edited by Montague Summers. 5 vols. London: Benjamin Blom, 1968.

Smith, Sebastian. *The Religious Impostor; or, The Life of Alexander, A Sham-Prophet, Doctor, and Fortune-Teller . . . Dedicated to Doctor S-lm-n, and the rest of the new Religious Fraternity of Free-Thinkers, near Leather-Sellers Hall.* Amsterdam, ca. 1700.

Sprat, Thomas. *The History of the Royal Society of London for the Improving of Natural Knowledge.* London, 1667.

Stukeley, William. *Stukeley's "Stonehenge": An Unpublished Manuscript 1721–1724.* Edited by Aubrey Burl and Neil Mortimer. New Haven, CT: Yale University Press, 2005.

Swift, Jonathan. *The Prose Works of Jonathan Swift.* Edited by Temple Scott. 12 vols. London: George Bell and Sons, 1897–1908.

Thou, Jacques-Auguste de. *Historiarum sui temporis ab 1543 usque annum 1607.* Edited by Samuel Buckley. 7 vols. London, 1733.

The Tricks of the Town; or, Ways and Means for Getting Money. Wherein the Various Lures, Wiles, and Artifices, practiced by the Designing and Crafty upon the Weak and Unwary, are fully exposed. London, 1732.

Turnbull, George. *A Treatise on Ancient Painting.* London, 1740.

Turner, Daniel. *The Modern Quack; or, The Physical Imposter Detected. In Three Parts . . . With a Supplement, displaying the present Set of Pretenders to Clap-curing.* London, 1718.

The Two Sosias; Or, The True Dr. Byfield at the Rainbow Coffee-House, to the Pretender in Jermyn Street. In Answer to a Letter, wrote by him, assisted by his two associates. With a preface relating to the late famous exploits of the facetious Dr. Andrew Tripe. London, 1719.

Vertue, George. *A Description of the Works of the Ingenious Delineator and Engraver Wenceslaus Hollar, Disposted into Classes of Different Sorts; with Some Account of His Life.* London, 1745.

——. *The Notebooks of George Vertue relating to Artists and Collections in England. The Walpole Society* 22 (1933–34).

Wagstaffe, William [Andrew Tripe, pseud.]. *A Letter from the Facetious Dr. Andrew Tripe at Bath to his Loving Brother the Profound Greshamite, Shewing, that the Scribendi Cacoethes is a Distemper arising from a Redundancy of Biliose Salts, and*

not to be Eradicated but by a Diurnal Course of Oyls and Vomits. With an Appendix concerning the Application of Socrates his Clyster and the Use of Clean Linen in the Controversy. London, 1719.

Walpole, Horace. *A Catalogue of Horace Walpole's Library.* Edited by Allen Hazen. 3 vols. New Haven, CT: Yale University Press, 1969.

———. *Horace Walpole's Correspondence.* Edited by W. S. Lewis. 48 vols. New Haven, CT: Yale University Press, 1937–83.

Webb, John. *The Most notable Antiquity of Great Britain vulgarly called Stone-Heng on Salisbury Plain. Restored by Inigo Jones.* London, 1655.

———. *A Vindication of Stone-Heng Restored.* London, 1665.

Willis, Thomas. *The Remaining Medical Works of That Famous and Renowned Physician Dr. Thomas Willis.* Translated by Samuel Pordage. London, 1681.

Wise, Francis. *A Letter to Dr. Mead Concerning Some Antiquities in Berkshire: Particularly Shewing that the White Horse, which gives its name to the Vale, is a Monument of the West-Saxons, made in memory of a great Victory obtained over the Danes* A.D. *871.* Oxford, 1738.

Woodward, John. *The State of Physick and of Diseases. With An Inquiry into the causes of the late increase . . . of the small pox, with some considerations upon the new practice of purging in that disease.* London, 1718.

Wotton, Henry. *The Life and Letters of Sir Henry Wotton.* Edited by Logan Smith. 2 vols. Oxford: Clarendon Press, 1907.

Wren, Christopher Jr. *Parentalia; or, Memoirs of the Family of the Wrens . . . Chiefly of Sir Christopher Wren.* London, 1750.

Secondary Sources

Abbott, John. "Dr. Johnson and the Life of Dr. Richard Mead." *Bulletin of the John Rylands Library Manchester* 54 (1971): 12–27.

Ackerman, Gerald. "Lomazzo's Treatise on Painting." *Art Bulletin* 49 (1967): 317–26.

Allan, D. G. C., and John Abbott, eds. *"The Virtuoso Tribe of Arts and Sciences": Studies in Eighteenth-Century Work & Membership of the London Society of Arts.* Athens: University of Georgia Press, 1992.

Arnold, Ken. *Cabinets for the Curious: Looking Back at Early English Museums.* Aldershot, UK: Ashgate, 2006.

Aspin, Richard. "John Evelyn's Tables of Veins and Arteries: A Rediscovered Letter." *Medical History* 39 (1995): 493–99.

Ayres, Philip. "Burlington's Library at Chiswick." *Studies in Bibliography* 45 (1992): 113–27.

———. *Classical Culture and the Idea of Rome in Eighteenth-Century England.* New York: Cambridge University Press, 1997.

Bailey, Gauvin, et al. *Hope and Healing: Painting in Italy in a Time of Plague, 1500–1800.* Worcester, MA: Worcester Art Museum, 2005.

Baldwin, Martha. "Reverie in the Time of Plague: Athanasius Kircher and the Plague Epidemic of 1656." In Findlen (2004), 63-77.

Baridon, Michael. "Hogarth's 'Living Machines of Nature' and the Theorisation of Aesthetics." In Bindman, Ogée, and Wagner (2001), 85-101.

Barkan, Leonard. "The Heritage of Zeuxis: Painting, Rhetoric, and History." In *Antiquity and Its Interpreters,* edited by Alina Payne, Ann Kuttner, and Rebekah Smick, 99-109. Cambridge: Cambridge University Press, 2000.

———. "Making Pictures Speak: Renaissance Art, Elizabethan Literature, Modern Scholarship." *Renaissance Quarterly* 48 (1995): 326-51.

———. *Unearthing the Past: Archaeology and Aesthetics in the Making of Renaissance Culture.* New Haven, CT: Yale University Press, 1999.

Barker, Sheila. "Poussin, Plague, and Early Modern Medicine." *Art Bulletin* 86 (2004): 659-89.

Barrell, John. "'The Dangerous Goddess': Masculinity, Prestige, and the Aesthetic in Early Eighteenth-Century Britain." In *The Birth of Pandora and the Division of Knowledge,* 63-87. London: Macmillan, 1992.

———. *The Political Theory of Painting from Reynolds to Hazlitt.* New Haven, CT: Yale University Press, 1986.

Baxandall, Michael. "English *Disegno.*" In Chaney and Mack (1990), 203-14.

Beasley, Gerald, et al. *The Mark J. Millard Architectural Collection,* vol. 2, *British Books: Seventeenth through Nineteenth Centuries.* Washington, DC: National Gallery of Art, 1998.

Bedini, Silvio. "The Evolution of Science Museums." *Technology and Culture* 6 (1965): 1-29.

Beekman, Fenwick. "Bidloo and Cowper, Anatomists." *Annals of Medical History* 7 (1935): 113-29.

Bell, Janis, and Thomas Willette, eds. *Art History in the Age of Bellori: Scholarship and Cultural Politics in Seventeenth-Century Rome.* Cambridge: Cambridge University Press, 2002.

Bellori, Giovan Pietro. *Giovan Pietro Bellori: The Lives of the Modern Painters, Sculptors, and Architects; A New Translation and Critical Edition.* By Alice Sedgwick Wohl, Hellmut Wohl, and Tomaso Montanari. Cambridge: Cambridge University Press, 2004.

Bender, John. "Matters of Fact: Virtual Witnessing and the Public in Hogarth's Narratives." In Bindman, Ogée, and Wagner (2001), 49-70.

Benedict, Barbara. *Curiosity: A Cultural History of Early Modern Inquiry.* Chicago: University of Chicago Press, 2001.

Bennett, J. A. "Robert Hooke as Mechanic and Natural Philosopher." *Notes and Records of the Royal Society* 35 (1980): 33-48.

Bermingham, Ann. "Elegant Females and Gentlemen Connoisseurs: The Commerce

in Culture and Self-Image in Eighteenth-Century England." In Bermingham and Brewer (1995), 489–513.

———. *Learning to Draw: Studies in the Cultural History of a Polite and Useful Art.* New Haven, CT: Yale University Press, 2000.

Bermingham, Ann, and John Brewer, eds. *The Consumption of Culture 1600–1800: Image, Object, Text.* New York: Routledge, 1995.

Biagioli, Mario. "Etiquette, Interdependence, and Sociability in Seventeenth-Century Science." *Critical Inquiry* 22 (1996): 193–238.

Bignamini, Ilaria. "The 'Academy of Art' in Britain before the Foundation of the Royal Academy in 1768." In *Academies of Art between Renaissance and Romanticism,* edited by Anton Boschloo, 434–50. The Hague: SDU Uitgeverij, 1989.

———. "George Vertue, Art Historian, and Art Institutions in London, 1689–1768." *Walpole Society* 54 (1988): 1–148.

Bindman, David, Frédéric Ogée, and Peter Wagner, eds. *Hogarth: Representing Nature's Machines.* Manchester: Manchester University Press, 2001.

Blunt, Anthony. "Don Vincenzo Vittoria." *Burlington Magazine* 109 (1967): 31–32.

———. "The Massimi Collection of Drawings in the Royal Library at Windsor Castle." *Master Drawings* 14 (1976): 3–31.

Borenius, Tancred. "An Early English Writer on Art." *Burlington Magazine* 39 (1921): 188–95.

Brewer, John. *The Pleasures of the Enlightenment: English Culture in the Eighteenth Century.* New York: Farrar, Straus & Giroux, 1997.

Brigham, David. "Mark Catesby and the Patronage of Natural History in the First Half of the Eighteenth Century." In Meyers and Pritchard (1999), 91–146.

Brown, Iain Gordon. "Allan Ramsay: Artist, Author, Antiquary." In *Allan Ramsay and the Search for Horace's Villa,* edited by Bernard Frischer and Ian Gordon Brown, 7–26. Aldershot, UK: Ashgate, 2001.

———. "Allan Ramsay's Rise and Reputation." *Walpole Society* 50 (1984): 209–47.

Brown, Jonathan, and John Elliot, eds. *The Sale of the Century: Artistic Relations between Spain and Great Britain, 1604–1655.* Exhibition catalogue. New Haven, CT: Yale University Press, 2002.

Brown, Theodore. "Medicine in the Shadow of the *Principia.*" *Journal of the History of Ideas* 48 (1987): 629–48.

Brownell, Morris. *Alexander Pope & the Arts of Georgian England.* Oxford: Clarendon Press, 1978.

Brownlow, John. *Memoranda; or, Chronicles of the Foundling Hospital, including Memoirs of Captain Coram, &c.* London, 1847.

Brusati, Celeste. *Artifice and Illusion: The Art and Writing of Samuel Van Hoogstraten.* Chicago: University of Chicago Press, 1995.

Burgers, Jacqueline. *Wenceslaus Hollar: Seventeenth-Century Prints from the Museum Boymans-Van Beuningen.* Alexandria, VA: Art Services International, 1994.

Burke, Joseph. *English Art, 1714–1800.* Oxford: Oxford University Press, 1976.

Burke, Peter. *The Fortunes of the Courtier: The European Reception of Castiglione's Corte-giano.* University Park: Pennsylvania State University Press, 1996.

Carey, Daniel. *Locke, Shaftesbury, and Hutcheson: Contesting Diversity in Enlightenment and Beyond.* New York: Cambridge University Press, 2006.

Carlino, Andrea. *Books of the Body: Anatomical Ritual and Renaissance Learning.* Translated by John Tedeschi and Anne Tedeschi. Chicago: University of Chicago Press, 1999.

Carré, Jacque. *Lord Burlington (1694–1753): Le connaisseur, le mécène, l'architecte.* Clermont-Ferrand, France: Adosa, 1993.

Cash, Arthur. "The Birth of Tristram Shandy: Sterne and Dr. Burton." In *Studies in the Eighteenth Century,* edited by R. F. Brissenden, 133–54. Canberra: Australian National University Press, 1968.

Chambers, Douglas. "John Evelyn and the Construction of the Scientific Self." In Marshall (1997), 132–46.

Chaney, Edward. "Evelyn, Inigo Jones, and the Collector Earl of Arundel." In Harris and Hunter (2003), 37–60.

——, ed. *The Evolution of English Collecting: Receptions of Italian Art in the Tudor and Stuart Periods.* New Haven, CT: Yale University Press, 2003.

——. *The Evolution of the Grand Tour: Anglo-Italian Cultural Relations since the Renaissance.* London: Frank Cass, 1998.

Chaney, Edward, and Peter Mack, eds. *England and the Continental Renaissance: Essays in Honour of J. B. Trapp.* Woodbridge, Suffolk: Boydell Press, 1990.

Chew, Elizabeth. "The Countess of Arundel and Tart Hall." In Chaney (2003), 285–314.

Clark, George. "Dr. William Aglionby, F.R.S." *Notes and Queries,* 12th ser., 9 (1921): 141–43.

Clark, Jonathan. *English Society, 1688–1832: Ideology, Social Structure, and Political Practice during the Ancien Régime.* Cambridge: Cambridge University Press, 1985.

Clayton, Martin. *Poussin: Works on Paper, Drawings from the Collection of Her Majesty Queen Elizabeth II.* London: Merrell Holberton, 1995.

Climenson, Emily, ed. *Elizabeth Montagu: The Queen of the Blue Stockings, Her Correspondence from 1720 to 1761.* 2 vols. New York: Dutton & Co., 1906.

Cody, Lisa. *Birthing the Nation: Sex, Science, and the Conception of Eighteenth-Century Britons.* Oxford: Oxford University Press, 2005.

Cohen, I. Bernard. "Harrington and Harvey: A Theory of the State Based on the New Physiology." *Journal of the History of Ideas* 55 (1994): 187–210.

Cole, F. J. "The History of Anatomical Injections." In *Studies in the History and Method of Science,* edited by Charles Singer, 2:285:343. Oxford: Clarendon Press, 1921.

Collins, Jeffrey. "Obelisks as Artifacts in Early-Modern Rome: Collecting the Ultimate Antiques." *Ricerche di Storia dell'arte* 72 (2000): 49–68.

Coltman, Viccy. *Fabricating the Antique: Neoclassicism in Britain, 1760–1800.* Chicago: University of Chicago Press, 2006.

Connell, Philip. "Death and the Author: Westminster Abbey and the Meanings of the Literary Monument." *Eighteenth-Century Studies* 38 (2005): 557–85.

Cook, Harold. *The Decline of the Old Medical Regime in Stuart London.* Ithaca, NY: Cornell University Press, 1986.

——. "Good Advice and Little Medicine: The Professional Authority of Early Modern English Physicians." *Journal of British Studies* 33 (1994): 1–31.

——. "The New Philosophy and Medicine in Seventeenth-Century England." In *Reappraisals of the Scientific Revolution,* edited by David Lindberg and Robert Westman, 397–436. Cambridge: Cambridge University Press, 1990.

——. "Time's Bodies: Crafting the Preparation and Preservation of Naturalia." In Smith and Findlen (2002), 223–47.

Cottom, Daniel. *Cannibals & Philosophers: Bodies of Enlightenment.* Baltimore: Johns Hopkins University Press, 2001.

Cowan, Brian. "Open Elite: Virtuosity and the Peculiarities of English Connoisseurship." *Modern Intellectual History* 1 (2004): 151–83.

——. "Refiguring Revisionisms." *History of European Ideas* 29 (2003): 475–89.

——. *The Social Life of Coffee: The Emergence of the British Coffeehouse.* New Haven, CT: Yale University Press, 2005.

Craske, Matthew. "Westminster Abbey 1720–70: A Public Pantheon Built upon Private Interest." In *Pantheons: Transformations of a Monumental Idea,* edited by Matthew Craske and Richard Wrigley, 57–80. Aldershot, UK: Ashgate, 2004.

Cropper, Elizabeth, and Charles Dempsey. *Nicolas Poussin: Friendship and the Love of Painting.* Princeton, NJ: Princeton University Press, 1996.

Crow, Thomas. "The Critique of Enlightenment in Eighteenth-Century Art." *Art Criticism* 3 (1987): 17–31.

Cuneo, Pia. "Beauty and the Beast: Art and Science in Early Modern European Equine Imagery." *Journal of Early Modern History* 4 (2000): 269–321.

Cunningham, Andrew. *The Anatomical Renaissance: The Resurrection of the Anatomical Projects of the Ancients.* Aldershot, UK: Scolar Press, 1997.

Cust, Lionel. *History of the Society of Dilettanti.* New York: Macmillan, 1898.

Dannenfeldt, Karl. "Egypt and Egyptian Antiquities in the Renaissance." *Studies in the Renaissance* 6 (1959): 7–27.

Darlington, Anne. "The Teaching of Anatomy and the Royal Academy of Arts, 1768–1782." *Journal of Art & Design Education* 5 (1986): 263–71.

Daston, Lorraine. "Description by Omission: Nature Enlightened and Obscured." In *Regimes of Description: In the Archives of the Eighteenth Century,* edited by John Bender and Michael Marrinan, 11–24. Palo Alto, CA: Stanford University Press, 2005.

Daston, Lorraine, and Katharine Park. *Wonders and the Order of Nature, 1150–1750.* New York: Zone Books, 1998.

De Bolla, Peter. "Criticism's Place." *Theory and Interpretation: The Eighteenth Century* 25 (1984): 199–214.

Debus, Allen. *The English Paracelsians*. London: Oldbourne, 1965.

Dempster, James. "John Locke, Physician and Philosopher." *Annals of Medical History* 4 (1932): 12–60, 172–86.

Dethloff, Diana. "The Executor's Account Book and the Dispersal of Sir Peter Lely's Collection." *Journal of the History of Collections* 8 (1996): 15–51.

Dewhurst, Kenneth. *Dr. Thomas Sydenham (1624–1689): His Life and Original Writings*. London: Wellcome Historical Medical Library, 1966.

———. *John Locke (1632–1704): Physician and Philosopher*. London: Wellcome Historical Medical Library, 1963.

———. "Locke and Sydenham on the Teaching of Anatomy." *Medical History* 2 (1958): 1–12.

Digby, Anne. *Making a Medical Living: Doctors and Patients in the English Market for Medicine, 1720–1911*. Cambridge: Cambridge University Press, 1994.

Dixon, Laurinda. *Perilous Chastity: Women and Illness in Pre-Enlightenment Art and Medicine*. Ithaca, NY: Cornell University Press, 1995.

Dobson, Austin. "Dr. Mead's Library." *Eighteenth-Century Vignettes*, 3rd ser., 29–50. London: Chatto & Windus, 1896.

Dobson, Michael. *The Making of the National Poet: Shakespeare, Adaptation, and Authorship, 1660–1769*. Oxford: Clarendon, 1992.

Dorris, George. "Scipione Maffei amid the Dunces." *Review of English Studies* 16 (1965): 288–90.

Downes, Kerry. *The Architecture of Wren*. New York: Universe Books, 1982.

Duro, Paul. *The Academy and the Limits of Painting in Seventeenth-Century France*. Cambridge: Cambridge University Press, 1997.

Eamon, William. "From the Secrets of Nature to Public Knowledge." In *Reappraisals of the Scientific Revolution*, edited by D. C. Lindberg and R. S. Westman, 349–55. Cambridge: Cambridge University Press, 1990.

Edelstein, Ludwig. "Sydenham and Cervantes." *Supplement to the Bulletin of the History of Medicine* 3 (1944): 55–61. Reprinted in *Ancient Medicine: Selected Papers of Ludwig Edelstein*, edited by Owsei Temkin and C. Lilian Temkin, 455–61. Baltimore: Johns Hopkins University Press, 1967.

Evans, R. J. W., and Alexander Marr, eds. *Curiosity and Wonder from the Renaissance to the Enlightenment*. Aldershot, UK: Ashgate, 2006.

Fehl, Philipp. "Franciscus Junius and the Defense of Art." Introduction to Junius ([1638, 1694] 1991), 1:xxi–lxxxiii.

Ferguson, Valerie Anne. "A Bibliography of the Works of Richard Mead, M.D., F.R.S. (1673–1754)." M.A. thesis, University of London, 1959.

Findlen, Paula, ed. *Athanasius Kircher: The Last Man Who Knew Everything*. New York: Routledge, 2004.

———. *Possessing Nature: Museums, Collecting, and Scientific Culture in Early Modern Italy*. Berkeley and Los Angeles: University of California Press, 1994.

Fineman, Joel. "The History of the Anecdote." In *The New Historicism,* edited by H. Aram Veeser, 49–76. New York: Routledge, 1989.

Fletcher, Jennifer. "The Arundels in the Veneto." *Apollo* 144 (1996): 63–69.

Fletcher, John. "Medical Men and Medicine in the Correspondence of Athanasius Kircher (1602–80)." *Janus* 56 (1969): 259–77.

Forbes, Athol, ed. *Curiosities of a Scots Charta Chest 1600–1800 with the Travels and Memoranda of Sir Alexander Dick, Baronet of Prestonfield, Midlothian Written by Himself.* Edinburgh: William Brown, 1897.

Fort, Bernadette, and Angela Rosenthal, eds. *The Other Hogarth: Aesthetics of Differences.* Princeton, NJ: Princeton University Press, 2001.

Frank, Robert. *Harvey and the Oxford Physiologists.* Berkeley and Los Angeles: University of California Press, 1980.

———. "Viewing the Body: Reframing Man and Disease in Commonwealth and Restoration England." In Marshall (1997), 65–110.

Freedberg, David. *The Eye of the Lynx: Galileo, His Friends, and the Beginnings of Modern Natural History.* Chicago: University of Chicago Press, 2002.

French, Roger. "Harvey in Holland: Circulation and the Calvinists." In French and Wear (1989), 46–86.

French, Roger, and Andrew Wear, eds. *The Medical Revolution of the Seventeenth Century.* Cambridge: Cambridge University Press, 1989.

Friedman, Terry. *James Gibbs.* New Haven, CT: Yale University Press, 1984.

Fumaroli, Marc. "The Antiquarian as Hero." *New Republic* 224 (May 28, 2001): 33–38.

Furdell, Elizabeth Lane. *The Royal Doctors 1485–1714: Medical Personnel at the Tudor and Stuart Courts.* Rochester, NY: University of Rochester Press, 2001.

Geraghty, Anthony. "Wren's Preliminary Design for the Sheldonian Theatre." *Architectural History* 45 (2002): 275–88.

Gere, Charlotte, and Marina Vaizey. *Great Women Collectors.* London: Philip Wilson, 1999.

Geshwind, Max. "William Salmon, Quack-Doctor and Writer of Seventeenth-Century London." *Bulletin of the History of Dentistry* 43 (July 1995): 73–76.

Gibson, Strickland. "Francis Wise, B.D.: Oxford Antiquary, Librarian, and Archivist." *Oxoniensia* 1 (1936): 173–95.

Gibson, William. "The Bio-Medical Pursuits of Christopher Wren." *Medical History* 14 (1970): 331–41.

Gibson-Wood, Carol. *Jonathan Richardson: Art Theorist of the English Enlightenment.* New Haven, CT: Yale University Press, 2000.

———. "Picture Consumption in London at the End of the Seventeenth-Century." *Art Bulletin* 84 (2002): 491–500.

Gilbert, Neal. *Renaissance Concepts of Method.* New York: Columbia University Press, 1960.

Gillispie, Charles. "Physick and Philosophy: A Study of the Influence of the College

of Physicians of London upon the Foundation of the Royal Society." *Journal of Modern History* 19 (1947): 210-25.

Ginzburg, Carlo. "Morelli, Freud, and Sherlock Holmes: Clues and Scientific Method." *History Workshop* 9 (1980): 5-36.

Girouard, Mark. "Coffee at Slaughter's: English Art and the Rococo—I." *Country Life* 139 (1966): 58-61.

———. "Hogarth and His Friends: English Art and Rococo—II." *Country Life* 139 (1966): 188-90.

———. "The Two Worlds of St Martin's Lane: English Art and the Rococo—III." *Country Life* 139 (1966): 224-27.

Grafton, Anthony. *Defenders of the Text: The Traditions of Scholarship in an Age of Science, 1450-1800.* Cambridge, MA: Harvard University Press, 1991.

Griffiths, Antony. "The Arch of Titus by Carlo Maratti." *National Art Collections Fund Annual Review* (1992): 35-37.

———. "The Etchings of John Evelyn." In Howarth (1993), 51-67.

———. "John Evelyn and the Print." In Harris and Hunter (2003), 95-113.

———. *The Print in Stuart Britain 1603-1689.* Exhibition catalogue. London: British Museum, 1998.

Guerrini, Anita. "Anatomists and Entrepreneurs in Early Eighteenth-Century London." *Journal of the History of Medicine and Allied Sciences* 59 (2004): 219-39.

———. "Archibald Pitcairne and Newtonian Medicine." *Medical History* 31 (1987): 70-83.

———. "Isaac Newton, George Cheyne, and the 'Principia Medicinae.'" In French and Wear (1989), 222-45.

———. "The Tory Newtonians: Gregory, Pitcairne, and Their Circle." *Journal of British Studies* 25 (1986): 288-311.

Guthrie, Douglas. *A History of Medicine.* New York: Thomas Nelson, 1945.

Hall, A. Rupert. "English Medicine in the Royal Society's Correspondence: 1660-1677." *Medical History* 15 (1971): 111-25.

———. "Medicine and the Royal Society." In *Medicine in Seventeenth Century England,* edited by Allen Debus, 421-52. Berkeley and Los Angeles: University of California Press, 1974.

Hall, Marie Boas. *Henry Oldenburg: Shaping the Royal Society.* Oxford: Oxford University Press, 2002.

———. "Oldenburg, the *Philosophical Transactions,* and Technology." In *The Uses of Science in the Age of Newton,* edited by John Burke, 21-47. Berkeley and Los Angeles: University of California Press, 1983. 21-47.

Hallett, Mark. *The Spectacle of Difference: Graphic Satire in the Age of Hogarth.* New Haven, CT: Yale University Press, 1999.

Hallett, Mark, and Christine Riding. *Hogarth: The Artist and the City.* Exhibition catalogue. London: Tate, 2006.

Hammelmann, H. A. "John Vanderbank's Don Quixote." *Master Drawings* 7 (1969): 3-15.

——. "Two Eighteenth-Century Frontispieces." *Journal of the Warburg and Courtauld Institutes* 31 (1968): 448-49.

Hansen, Julie. "Resurrecting Death: Anatomical Art in the Cabinet of Dr. Frederick Ruysch." *Art Bulletin* 78 (1996): 663-80.

Hanson, Craig. "Dr. Richard Mead and Watteau's 'Comédiens italiens.'" *Burlington Magazine* 145 (2003): 265-72.

——. "Francis Wise." *Eighteenth-Century British Historians.* Vol. 336 of *Dictionary of Literary Biography,* edited by Ellen J. Jenkins, 375-79. New York: Thomson Gale, 2007.

Hard, Frederick. "Ideas from Bacon and Wotton in William Sanderson's *Graphice.*" *Studies in Philology* 36 (1939): 227-34.

——. "Richard Haydocke and Alexander Browne: Two Half-Forgotten Writers on the Art of Painting." *PMLA* 55 (1940): 727-41.

Harding, Robert. "John Evelyn, Hendrick van der Borcht the Younger, and Wenceslaus Hollar." *Apollo* 144 (August 1996): 39-44.

Hargraves, Matthew. *"Candidates for Fame": The Society of Artists of Great Britain, 1760-1791.* New Haven, CT: Yale University Press, 2005.

Harkness, Deborah. *"Nosce teipsum:* Curiosity, the Humoural Body, and the Culture of Therapeutics in Late Sixteenth- and Early Seventeenth-Century England." In Evans and Marr (2006), 171-92.

Harley, R. D. *Artists' Pigments c. 1600-1835: A Study in English Documentary Sources.* London: Butterworths, 1982.

Harris, Eileen, and Nicholas Savage. *British Architectural Books and Writers 1556-1785.* Cambridge: Cambridge University Press, 1990.

Harris, Frances, and Michael Hunter, eds. *John Evelyn and His Milieu.* London: British Library, 2003.

Harris, John, Stephen Orgel, and Roy Strong. *The King's Arcadia: Inigo Jones and the Stuart Court.* Exhibition catalogue. London: Arts Council of Great Britain, 1973.

Harris, Rhian, and Robin Simon, eds. *Enlightened Self-Interest: The Foundling Hospital and Hogarth.* Exhibition catalogue. London: Thomas Coram Foundation for Children, 1997.

Hart, Vaughan. *Art and Magic in the Court of the Stuarts.* New York: Routledge, 1994.

Hartau, Johannes. "Don Quixote in Broadsheets of the Seventeenth and Early Eighteenth Centuries." *Journal of the Warburg and Courtauld Institutes* 48 (1985): 234-38.

Haskell, Francis. "Charles I's Collection of Pictures." In MacGregor (1989), 203-31.

——. *History and Its Images: Art and the Interpretation of the Past.* New Haven, CT: Yale University Press, 1993.

——. *Patrons and Painters: Art and Society in Baroque Italy.* New Haven, CT: Yale University Press, 1980.

Haskell, Francis, and Nicholas Penny. *Taste and the Antique: The Lure of Classical Sculpture, 1500–1900.* New Haven, CT: Yale University Press, 1981.

Haslam, Fiona. *From Hogarth to Rowlandson: Medicine in Art in Eighteenth-Century Britain.* Liverpool: Liverpool University Press, 1996.

Haycock, David. "'A Small Journey into the Country': William Stukeley and the Formal Landscapes of Stonehenge and Avebury." In Myrone and Peltz (1999), 67–82.

———. *William Stukeley: Science, Religion, and Archaeology in Eighteenth-Century England.* Woodbridge, Suffolk: Boydell Press, 2002.

Haynes, Clare. *Pictures and Popery: Art and Religion in England, 1660–1760.* Aldershot, UK: Ashgate, 2006.

Head, Jerome. "Medical Allusions in *Don Quixote.*" *Annals of Medical History* 6 (1934): 169–79.

Hervey, Mary. *The Life, Correspondence, and Collections of Thomas Howard, Earl of Arundel.* Cambridge: Cambridge University Press, 1921.

Hilliard, Nicholas. *Nicholas Hilliard's "Art of Limning."* Edited by Arthur Kinney and Linda Bradley Salamon. Boston: Northeastern University Press, 1983.

Himmelfarb, Gertrude. *The De-Moralisation of Society: From Victorian Virtues to Modern Values.* New York: Alfred Knopf, 1995.

Höltgen, Karl Josef. "Richard Haydocke: Translator, Engraver, Physician." *The Library,* 5th ser., 22 (1978): 15–32.

———. "An Unknown Manuscript Translation by John Thorpe of du Cerceau's *Perspective.*" In Chaney and Mack (1990), 215–28.

Hone, Campbell. *The Life of Dr. John Radcliffe 1652–1714: Benefactor of the University of Oxford.* London: Faber and Faber, 1950.

Houghton, Walter. "The English Virtuoso in the Seventeenth Century." *Journal of the History of Ideas* 3 (1942): 51–73, 190–219.

———. "The History of Trades: Its Relation to Seventeenth-Century Thought as Seen in Bacon, Petty, Evelyn, and Boyle." *Journal of the History of Ideas* 2 (1941): 33–60.

Howarth, David. "The Arundel Collection: Collecting and Patronage in England in the Reigns of Philip III and Philip IV." In Brown and Elliot (2002), 69–86.

———. *Lord Arundel and His Circle.* New Haven, CT: Yale University Press, 1985.

———. "The Patronage and Collecting of Aletheia, Countess of Arundel, 1606–54." *Journal of the History of Collections* 10 (1998): 125–37.

———. "A Question of Attribution: Art Agents and the Shaping of the Arundel Collection." In *Your Humble Servant: Agents in Early Modern Europe,* edited by Hans Cools, Marika Keblusek, and Badeloch Noldus, 17–28. Hilversum, The Netherlands: Uitgeverij Verloren, 2006.

———, ed. *Art and Patronage in the Caroline Courts.* Cambridge: Cambridge University Press, 1993.

Howarth, David, and Nicholas Penny. *Thomas Howard, Earl of Arundel.* Exhibition catalogue. Oxford: Ashmolean Museum, 1985.

Huhn, Tom. *Imitation and Society: The Persistence of Mimesis in the Aesthetics of Burke, Hogarth, and Kant.* University Park: Pennsylvania State University Press, 2004.

Hunter, Matthew. "Robert Hooke Fecit: Making and Knowing in Restoration London." Ph.D. diss., University of Chicago, 2007.

Hunter, Michael. "The Cabinet Institutionalized: The Royal Society's 'Repository' and Its Background." In Impey and MacGregor (1985), 159–67.

———. "The Making of Christopher Wren." In *Science and the Shape of Orthodoxy: Intellectual Change in Late Seventeenth-Century Britain*, 45–65. Woodbridge, Suffolk: Boydell Press, 1995.

———. *Robert Boyle by Himself and His Friends.* London: William Pickering, 1994.

———. *The Royal Society and Its Fellows 1660–1700: The Morphology of an Early Scientific Institution.* Chalfont St. Giles, Buckinghamshire: British Society for the History of Science, 1982.

———. *Science and the Shape of Orthodoxy: Intellectual Change in Late Seventeenth-Century Britain.* Woodbridge: Boydell Press, 1995.

———. *Science and Society in Restoration England.* Cambridge: Cambridge University Press, 1981.

Iliffe, Robert. "Author-Mongering: The Editor between Producer and Consumer." In Bermingham and Brewer (1995), 166–92.

———. "Foreign Bodies: Travel, Empire and the Early Royal Society of London, Part I: Englishmen on Tour." *Canadian Journal of History* 33 (1998): 357–85.

———. "Foreign Bodies: Travel, Empire and the Early Royal Society of London, Part II: The Land of Experimental Knowledge." *Canadian Journal of History* 34 (1999): 23–50.

Impey, Oliver, and Arthur MacGregor, eds. *The Origins of Museums: The Cabinet of Curiosities in Sixteenth- and Seventeenth-Century Europe.* Oxford: Clarendon Press, 1985.

Iversen, Erik. *Obelisks in Exile*, vol. 1, *The Obelisks of Rome*. Copenhagen: G. E. C. Gad Publishers, 1968.

Jardine, Lisa. *On a Grander Scale: The Outstanding Life of Sir Christopher Wren.* London: HarperCollins, 2002.

Jenkins, Ian. "Dr. Richard Mead (1673–1754) and His Circle." In *Enlightening the British: Knowledge, Discovery, and the Museum in the Eighteenth Century*, edited by R. G. W. Anderson et al., 127–35. London: British Museum Press, 2003.

———. "The Masks of Dionysos/Pan-Osiris-Apis." *Jahrbuch des Deutschen Archäologischen Instituts* 109 (1994): 273–99.

Jordanova, Ludmilla. *Defining Features: Scientific and Medical Portraits.* Exhibition catalogue. London: Reaktion Books, 2000.

———. "Portraits, People and Things: Richard Mead and Medical Identity." *History of Science* 41 (2003): 293–313.

———. "Richard Mead's Communities of Belief in Eighteenth-Century London." In *Christianity and Community in the West: Essays for John Bossy*, edited by Simon Ditchfield, 241–59. Aldershot, UK: Ashgate, 2001.

Joyce, Hetty. "Grasping at Shadows: Ancient Paintings in Renaissance and Baroque Rome." *Art Bulletin* 74 (1992): 219–46.

Kargon, Robert. *Atomism in England from Hariot to Newton*. Oxford: Clarendon Press, 1966.

Katritzky, M. A. "Was *Commedia dell'arte* Performed by Mountebanks? *Album amicorum* Illustrations and Thomas Platter's Description of 1598." *Theatre Research International* 23 (1998): 104–25.

Kelly, Donald. "Between History and System." In Pomata and Siraisi (2005), 211–37.

Kelly, Jason. "Riots, Revelries, and Rumor: Libertinism and Masculine Associations in Enlightenment London." *Journal of British Studies* 45 (2006): 759–95.

Kemp, Martin. "'Equal Excellences': Lomazzo and the Explanation of Individual Style in the Visual Arts." *Renaissance Studies* 1 (1987): 1–26.

Kemp, Martin, and Marina Wallace. *Spectacular Bodies: The Art and Science of the Human Body from Leonardo to Now*. Exhibition catalogue. Berkeley and Los Angeles: University of California Press, 2000.

Kerslake, John. *Early Georgian Portraits: National Portrait Gallery*. 2 vols. London: HMSO, 1977.

Keynes, Geoffrey. *The Life of William Harvey*. Oxford: Clarendon Press, 1966.

———. "The Portraits of William Harvey." *British Medical Journal* (November 18, 1944): 669–70.

———. *The Portraiture of William Harvey*. London: Royal College of Surgeons, 1949.

Keynes, Simon. "The Cult of King Alfred the Great." *Anglo-Saxon England* 28 (1999): 225–356.

Kirby, William. "A Quack of the Seventeenth Century." *The Pharmaceutical Journal and Pharmacist* 84 (1910): 255–62.

Klein, Lawrence. *Shaftesbury and the Culture of Politeness: Moral Discourse and Cultural Politics in Early Eighteenth-Century England*. New York: Cambridge University Press, 1994.

Klestinec, Cynthia. "Civility, Comportment, and the Anatomy Theater: Girolamo Fabrici and His Medical Students in Renaissance Padua." *Renaissance Quarterly* 60 (2007): 434–63.

———. "A History of Anatomy Theaters in Sixteenth-Century Padua." *Journal of the History of Medicine and Allied Science* 59 (2004): 375–412.

Knowles, Edwin. "Cervantes and English Literature." In *Cervantes across the Centuries*, edited by Angel Flores and M. J. Benardete, 277–303. New York: Gordian Press, 1947.

Knox, Tim. "The Vyne Ramesses: 'Egyptian Monstrosities' in British Country House Collections." *Apollo* 157 (April 2003): 32–38.

Kroll, Richard. *The Material World: Literate Culture in the Restoration and Early Eighteenth Century*. Baltimore: Johns Hopkins University Press, 1991.

Kusukawa, Sachiko. "Bacon's Classification of Knowledge." In Peltonen (1996), 47–74.

Laqueur, Thomas. "Roy Porter, 1946-2002: A Critical Appreciation." *Social History* 29 (2004): 84-91.

Laslett, T. P. R. "The Foundation of the Royal Society and the Medical Profession in England." *British Medical Journal* (July 16, 1960): 165-69.

Legg, L. G. Wickham. "On a Picture Commerative of the Gunpowder Plot Recently Discovered at New College, Oxford." *Archaeologia* 84 (1934): 27-39.

Levine, Joseph. *Between the Ancients and the Moderns: Baroque Culture in Restoration England.* New Haven, CT: Yale University Press, 1999.

———. *Dr. Woodward's Shield: History, Science, and Satire in Augustan England.* Berkeley and Los Angeles: University of California, 1977.

———. *Humanism and History: Origins of Modern English Historiography.* Ithaca, NY: Cornell University Press, 1987.

Levy, F. J. "Henry Peacham and the Art of Drawing." *Journal of the Warburg and Courtauld Institutes* 37 (1974): 174-90.

Lichtenstein, Jacqueline. *The Eloquence of Color: Rhetoric and Painting in the French Classical Age.* Translated by Emily McVarish. Berkeley and Los Angeles: University of California Press, 1993.

Lightbown, Ronald. "Charles I and the Traditions of European Princely Collecting." In MacGregor (1989), 53-72.

———. "Jean Petitot and Jacques Bordier at the English Court." *Connoisseur* 168 (1968): 82-91.

Lipking, Lawrence. *The Ordering of the Arts in Eighteenth-Century England.* Princeton, NJ: Princeton University Press, 1970.

Lippincott, Louise. *Selling Art in Georgian London: The Rise of Arthur Pond.* New Haven, CT: Yale University Press, 1983.

Little, Bryan. *The Life and Works of James Gibbs 1682-1754.* London: B. T. Batsford, 1955.

Long, Pamela. *Openness, Secrecy, Authorship: Technical Arts and the Culture of Knowledge from Antiquity to the Renaissance.* Baltimore: Johns Hopkins University Press, 2001.

Loretelli, Rosamaria. "The Aesthetics of Empiricism and the Origin of the Novel." *The Eighteenth Century* 41 (2000): 83-109.

Luttrell, Narcissus. *A Brief Historical Relation of State Affairs, from September 1678 to April 1714.* 6 vols. Oxford: Oxford University Press, 1857.

Lyons, Henry. *The Royal Society 1660-1940: A History of Its Administration under Its Charters.* Cambridge: Cambridge University Press, 1944.

MacDonald, Michael. "The Career of Astrological Medicine in England." In *Religio Medici: Medicine and Religion in Seventeenth-Century England,* edited by Ole Peter Grell and Andrew Cunningham, 62-90. Aldershot, UK: Scolar Press, 1996.

MacGregor, Arthur, ed. *The Late King's Goods: Collectors, Possessions and Patronage of Charles I in Light of the Commonwealth Sale Inventories.* London: Oxford University Press, 1989.

———, ed. *Sir Hans Sloane: Collector, Scientist, Antiquary.* Exhibition catalogue. London: British Museum, 1994.

Macmichael, William. *The Gold-Headed Cane.* London: J. Murray, 1827.

Marshall, W. Gerald, ed. *The Restoration Mind.* Newark: University of Delaware Press, 1997.

Mason, A. Stuart. *George Edwards: The Bedell and His Birds.* London: Royal College of Physicians of London, 1992.

McClure, Ruth. *Coram's Children: The London Foundling Hospital in the Eighteenth Century.* New Haven, CT: Yale University Press, 1981.

McEvansoneya, Philip. "Italian Paintings in the Buckingham Collection." In Chaney (2003), 315–36.

Meade, Richard Hardway. *In the Sunshine of Life: A Biography of Dr. Richard Mead, 1673–1754.* Philadelphia: Dorrance & Co., 1974.

Meyers, Amy, and Margaret Pritchard, eds. *Empire's Nature: Mark Catesby's New World Vision.* Chapel Hill: University of North Carolina, 1999.

Michaelis, Adolf. *Ancient Marbles in Great Britain.* Translated by C. A. M. Fennell. Cambridge: Cambridge University Press, 1882.

Miller, Peter. *Peiresc's Europe: Learning and Virtue in the Seventeenth Century.* New Haven, CT: Yale University Press, 2000.

Momigliano, Arnaldo. "Ancient History and the Antiquarian." *Journal of the Warburg and Courtauld Institutes* 13 (1950): 285–315.

Murdoch, John. "The Seventeenth-Century Enlightenment." In *The English Miniature,* by John Murdoch, Jim Murrell, Patrick Noon, and Roy Strong, 85–162. New Haven, CT: Yale University Press, 1981.

Myrone, Martin, and Lucy Peltz, eds. *Producing the Past: Aspects of Antiquarian Culture and Practice 1700–1850.* Aldershot, UK: Ashgate, 1999.

Nicolson, Marjorie. "Virtuoso." In *Dictionary of the History of Ideas,* 5 vols., edited by Philip Wiener, 4:486–90. New York: Charles Scribner's Sons, 1968–1974.

———. "Ward's 'Pill and Drop' and Men of Letters." *Journal of the History of Ideas* 29 (1968): 177–96.

Nutton, Vivian. "'A Diet for Barbarians': Introducing Renaissance Medicine to Tudor England." In *Natural Particulars: Nature and the Disciplines in Renaissance Europe,* edited by Anthony Grafton and Nancy Siraisi, 275–94. Cambridge, MA: MIT Press, 1999.

Ochs, Kathleen. "The Royal Society's History of Trades Programme: An Early Episode in Applied Science." *Notes and Records of the Royal Society* 39 (1985): 129–58.

Ogden, Henry, and Margaret Ogden. "A Bibliography of Seventeenth-Century Writings on the Pictorial Arts in English." *Art Bulletin* 29 (1947): 196–201.

Olivier, Louis Antoine. "The Case for the Fine Arts in Seventeenth-Century France." *Australian Journal of French Studies* 16 (1979): 377–88.

———. "'Curieux,' Amateurs, and Connoisseurs: Laymen and the Fine Arts in the Ancien Regime." Ph.D. diss., Johns Hopkins University, 1976.

Olson, Todd. "Caravaggio's Coroner: Forensic Medicine in Giulio Mancini's Art Criticism." *Oxford Art Journal* 28 (2005): 83-98.

——. *Poussin and France: Painting, Humanism, and the Politics of Style.* New Haven, CT: Yale University Press, 2002.

O'Malley, Charles. "John Evelyn and Medicine." *Medical History* 12 (1968): 219-31.

Orgel, Stephen. "Idols of the Gallery: Becoming a Connoisseur in Renaissance England." In *Early Modern Visual Culture: Representation, Race, and Empire in Renaissance England,* edited by Peter Erickson and Clarke Hulse, 251-83. Philadelphia: University of Pennsylvania Press, 2000.

——. "Inigo Jones on Stonehenge." *Prose* 3 (1971): 109-24.

Osler, William. "John Locke as a Physician." *The Lancet* 2 (1900): 1115-23.

Pace, Claire. "Pietro Santi Bartoli: Drawings in Glasgow University Library after Roman Paintings and Mosaics." *Papers of the British School at Rome* 47 (1979): 117-55.

——. "Virtuoso to Connoisseur: Some Seventeenth-Century English Responses to the Visual Arts." *Seventeenth Century* 2 (1987): 167-88.

Pace, Claire, and Janis Bell. "The Allegorical Engravings in Bellori's *Lives.*" In Bell and Willette (2002), pp. 191-223.

Panofsky, Erwin. "The History of the Theory of Human Proportions as a Reflection of the History of Styles." In *Meaning in the Visual Arts,* 55-107. Chicago: University of Chicago Press, 1955.

Park, Katherine. *Secrets of Women: Gender, Generation, and the Origins of Human Dissection.* New York: Zone Books, 2006.

Parry, Graham. *The Golden Age Restored: The Culture of the Stuart Court 1603-42.* New York: St Martin's Press, 1981.

Paster, Gail Kern. "Nervous Tension." In *The Body in Parts: Fantasies of Corporeality in Early Modern Europe,* edited by David Hillman and Carla Mazzio, 106-25. New York: Routledge, 1997.

Paulson, Ronald. *Don Quixote in England: The Aesthetics of Laughter.* Baltimore: Johns Hopkins University Press, 1998.

——. *Hogarth: His Life, Art, and Times.* 2 vols. New Haven, CT: Yale University Press, 1971.

——. *Hogarth's Graphic Works.* 2 vols. New Haven, CT: Yale University Press, 1970.

Payne, Joseph. *Thomas Sydenham.* New York: Longman's, Green, & Co, 1900.

Payne, L. M. "Tabulae Harveianae: A 17th-Century Teaching Aid." *British Medical Journal* (July 2, 1966): 38-39.

Pears, Iain. *The Discovery of Painting: The Growth of Interest in the Arts in England, 1680-1768.* New Haven, CT: Yale University Press, 1988.

Pearson, John. *Stags and Serpents: The Story of the House of Cavendish and the Duke of Devonshire.* London: Macmillan, 1983.

Peck, Linda Levy. *Consuming Splendor: Society and Culture in Seventeenth-Century England.* New York: Cambridge University Press, 2005.

——. "Monopolizing Favour: Structures of Power in the Early Seventeenth-

Century English Court." In *The World of the Favourite*, edited by J. H. Elliott and L. W. B. Brockliss, 54–70. New Haven, CT: Yale University Press, 1999.

———. "Uncovering the Arundel Library at the Royal Society: Changing Meanings of Science and the Fate of the Norfolk Donation." *Notes and Records of the Royal Society of London* 52 (1998): 3–24.

Pelling, Margaret. "Appearance and Reality: Barber-Surgeons, the Body, and Disease." In *The Making of the Metropolis*, edited by A. L. Beier and Roger Finlay, 82–112. New York: Longman, 1986.

Peltonen, Markku, ed. *The Cambridge Companion to Bacon*. New York: Cambridge University Press, 1996.

Perez-Ramos, Antonio. *Francis Bacon's Idea of Science and the Maker's Knowledge Tradition*. Oxford: Oxford University Press, 1988.

Phillippy, Patricia. *Painting Women: Cosmetics, Canvasses, and Early Modern Culture*. Baltimore: Johns Hopkins University Press, 2006.

Phillips, Mark Salber. "Reconsiderations on History and Antiquarianism: Arnaldo Momigliano and the Historiography of Eighteenth-Century Britain." *Journal of the History of Ideas* 57 (1996): 297–316.

Piper, David. *"O Sweet Mr. Shakespeare I'll Have His Picture": The Changing Image of Shakespeare's Person, 1600–1800*. Exhibition catalogue. London: National Portrait Gallery, 1964.

———. "Take the Face of a Physician." In Wolstenholme and Kerslake (1977), 25–49.

Pomata, Gianna, and Nancy Siraisi, eds. *Historia: Empiricism and Erudition in Early Modern Europe*. Cambridge, MA: MIT Press, 2005.

Pope-Hennessy, John. "Nicholas Hilliard and Mannerist Art Theory." *Journal of the Warburg and Courtauld Institutes* 6 (1943): 89–100.

Porter, Roy. *Bodies Politic: Disease, Death, and Doctors in Britain, 1650–1900*. London: Reaktion Books, 2001.

———. "The Early Royal Society and the Spread of Medical Knowledge." In French and Wear (1989), 272–93.

———. *The Greatest Benefit to Mankind: A Medical History of Humanity from Antiquity to the Present*. London: HarperCollins, 1997.

———. Introduction to *Science, Culture, and Popular Belief in Renaissance Europe*, edited by Stephen Pumfrey, Paolo Rossi, and Maurice Slawinski, 1–15. Manchester: Manchester University Press, 1991.

———. *The Making of Geology: Earth Science in Britain 1660–1815*. Cambridge: Cambridge University Press, 1977.

———. *Quacks: Fakers & Charlatans in English Medicine*. Charleston, SC: Tempus Publishing, 2000.

Porter, Roy, and Lesley Hall. *The Facts of Life: The Creation of Sexual Knowledge in Britain, 1650–1950*. New Haven, CT: Yale University Press, 1995.

Posner, Donald. "Concerning the 'Mechanical' Parts of Painting and the Artistic Culture of Seventeenth-Century France." *Art Bulletin* 75 (1993): 583–98.

Poynter, F. N. L. "Nicholas Culpeper and His Books." *Journal of the History of Medicine* 17 (1962): 152–67.

Preston, Claire. "The Jocund Cabinet and the Melancholy Museum in Seventeenth-Century English Literature." In Evans and Marr (2006), 87–106.

Pumfrey, Stephen. "Ideas above His Station: A Social Study of Hooke's Curatorship of Experiments." *History of Science* 29 (1991): 1–44.

Pyke, E. J. *A Biographical Dictionary of Wax Modellers.* Oxford: Clarendon Press, 1973.

Redford, Bruce. *Dilettanti: The Antic and the Antique in Eighteenth-Century England.* Exhibition catalogue. Los Angeles: J. Paul Getty Research Institute, 2008.

Riskin, Jessica. *Science in the Age of Sensibility: The Sentimental Empiricists of the French Enlightenment.* Chicago: University of Chicago Press, 2002.

Roberts, Jane, ed. *George III & Queen Charlotte: Patronage, Collecting, and Court Taste.* London: Royal Collection Publications, 2004.

Romanell, Patrick. *John Locke and Medicine: A New Key to Locke.* Buffalo, NY: Prometheus Books, 1984.

Roos, Anna Marie. "Luminaries in Medicine: Richard Mead, James Gibbs, and Solar and Lunar Effects on the Human Body in Early Modern England." *Bulletin of the History of Medicine* 74 (2000): 433–57.

Rousseau, George. "Science Books and Their Readers in the Eighteenth Century." In *Books and Their Readers in Eighteenth-Century England,* edited by Isabel Rivers, 197–256. Leicester: Leicester University Press, 1982.

Rowland, Ingrid. "Antiquarianism as Battle Cry." In *The Italian Renaissance in the Twentieth Century: Acts of an International Conference, Florence, Villa I Tatti, June 1999,* edited by Allen Grieco, Michael Rocke, and Feorella Superbi, 401–11. Florence: Leo S. Olschki, 2002.

———. *The Culture of the High Renaissance: Ancients and Moderns in Sixteenth-Century Rome.* Cambridge: Cambridge University Press, 1998.

———. *The Ecstatic Journey: Athanasius Kircher in Baroque Rome.* Exhibition catalogue. Chicago: University of Chicago Library, 2000.

Sakula, A. "Dr. John Radcliffe, Court Physician, and the Death of Queen Anne." *Journal of the Royal College of Physicians of London* 19 (1985): 255–60.

Salerno, Luigi. "Seventeenth-Century English Literature on Painting." *Journal of the Warburg and Courtauld Institutes* 14 (1951): 234–58.

Sawday, Jonathan. *The Body Emblazoned: Dissection and the Human Body in Renaissance Culture.* New York: Routledge, 1995.

Scott, Jonathan. *The Pleasures of Antiquity: British Collectors of Greece and Rome.* New Haven, CT: Yale University Press, 2003.

Scott, Katie, and Genevieve Warwick, eds. *Commemorating Poussin: Reception and Interpretation of the Artists.* New York: Cambridge University Press, 1999.

Scouloudi, Irene. "Sir Theodore Turquet de Mayerne: Royal Physician and Writer, 1573–1655." *Huguenot Society of London* 16 (1940): 301–37.

Shapin, Steven. "'A Scholar and a Gentleman': The Problematic Identity of the

Scientific Practitioner in Early-Modern England." *History of Science* 29 (1991): 278–327.

———. *A Social History of Truth: Civility and Science in Seventeenth-Century England.* Chicago: University of Chicago Press, 1994.

———. "Who Was Robert Hooke?" In *Robert Hooke: New Studies,* edited by Michael Hunter and Simon Schaffer, 253–85. Woodbridge, Suffolk: Boydell Press, 1989.

Shapin, Steven, and Simon Schaffer. *Leviathan and the Air-Pump: Hobbes, Boyle, and the Experimental Life.* Princeton, NJ: Princeton University Press, 1985.

Shapiro, Barbara. "Natural Philosophy and Political Periodization: Interregnum, Restoration and Revolution." In *A Nation Transformed: England after the Restoration,* edited by Alan Houston and Steve Pincus, 299–327. Cambridge: Cambridge University Press, 2001.

Sharpe, Kevin, and Steven Zwicker, eds. *Refiguring Revolutions: Aesthetics and Politics from the English Revolution to the Romantic Revolution.* Berkeley and Los Angeles: University of California Press, 1998.

Simon, Robin. *Hogarth, France, and British Art: The Rise of the Arts in 18th-Century Britain.* London: Paul Holberton, 2007.

Siraisi, Nancy. "Anatomizing the Past: Physicians and History in Renaissance Culture." *Renaissance Quarterly* 53 (2000): 1–30.

———. "*Historiae,* Natural History, Roman Antiquity, and Some Roman Physicians." In Pomata and Siraisi (2005), 325–54.

———. "History, Antiquarianism and Medicine: The Case of Girolamo Mercuriale." *Journal of the History of Ideas* 64 (2003): 231–50.

Sloan, Kim. *"A Noble Art": Amateur Artists and Drawing Masters, c. 1600–1800.* London: British Museum, 2000.

Smart, Alastair. *Allan Ramsay: A Complete Catalogue of His Paintings.* New Haven, CT: Yale University Press, 1999.

———. *Allan Ramsay: Painter, Essayist, and Man of the Enlightenment.* New Haven, CT: Yale University Press, 1992.

Smith, Charles Saumarez. "Wren and Sheldon." *Oxford Art Journal* 6 (1983): 45–50.

Smith, Pamela. *The Body of the Artisan: Art and Experience in the Scientific Revolution.* Chicago: University of Chicago Press, 2004.

Smith, Pamela, and Paula Findlen, eds. *Merchants & Marvels: Commerce, Science, and Art in Early Modern Europe.* New York: Routledge, 2002.

Snow, C. P. *Two Cultures and the Scientific Revolution.* Cambridge: Cambridge University Press, 1960.

Solkin, David. *Painting for Money: The Visual Arts and the Public Sphere in Eighteenth-Century England.* New Haven, CT: Yale University Press, 1993.

———. "Samaritan or Scrooge? The Contested Image of Thomas Guy in Eighteenth-Century England." *Art Bulletin* 78 (1996): 467–84.

Soo, Lydia. "Reconstructing Antiquity: Wren and His Circle and the Study of Natural History, Antiquarianism, and Architecture at the Royal Society." Ph.D. diss., Princeton University, 1989.

————. *Wren's "Tracts" on Architecture and Other Writings.* Cambridge: Cambridge University Press, 1998.

Soros, Susan Weber, ed. *James "Athenian" Stuart, 1713–1788: The Rediscovery of Antiquity.* Exhibition catalogue. New Haven, CT: Yale University Press, 2006.

Sorrenson, Richard. "Towards a History of the Royal Society in the Eighteenth Century." *Notes and Records of the Royal Society of London* 50 (1996): 29–46.

Springell, Francis. *Connoisseur & Diplomat: The Earl of Arundel's Embassy to Germany in 1636.* London: Maggs Brothers, 1963.

Stafford, Barbara Maria. *Artful Science: Enlightenment, Entertainment, and the Eclipse of Visual Education.* Cambridge, MA: MIT Press, 1994.

————. *Body Criticism: Imaging the Unseen in Enlightenment Art and Medicine.* Cambridge, MA: MIT Press, 1991.

————. *Good Looking: Essays on the Virtue of Images.* Cambridge, MA: MIT Press, 1996.

————. "'Illiterate Monuments': The Ruin as Dialect or Broken Classic." *The Age of Johnson* 1 (1987): 1–34.

————. *Visual Analogy: Consciousness as the Art of Connecting.* Cambridge, MA: MIT Press, 1999. ————. *Voyage into Substance: Art, Science, Nature, and the Illustrated Travel Account (1760–1840).* Cambridge, MA: MIT Press, 1984.

Stafford, Barbara Maria, and Frances Terpak. *Devices of Wonder: From the World in a Box to Images on a Screen.* Exhibition catalogue. Los Angeles: Getty Research Institute, 2001.

Standring, Timothy. "Poussin et le cardinal Massimo d'après les archives Massimo." In *Nicolas Poussin (1594–1665): Actes du colloque organisé au Musée du Louvre par le Service culturel, du 19 au 21 octobre 1994,* edited by Alain Mérot, 2 vols., 1:363–92. Paris: La documentation française, 1996.

Stevenson, Christine. *Medicine and Magnificence: British Hospital and Asylum Architecture, 1660–1815.* New Haven, CT: Yale University Press, 2000.

Stewart, Larry. *The Rise of Public Science: Rhetoric, Technology, and Natural Philosophy in Newtonian Britain, 1660–1750.* Cambridge: Cambridge University Press, 1992.

Sturdy, David, and Neil Moorcraft. "Christopher Wren and Oxford's Garden of Antiquities." *Minerva* 10, no. 1 (1999): 25–28.

Summerson, John. *Sir Christopher Wren.* London: Collins, 1953.

————. *The Sheldonian in Its Time.* Oxford: Clarendon Press, 1964.

Sutton, Denys. "Aspects of British Collecting: The Age of Sir Robert Walpole." *Apollo* 114 (1981): 328–39.

Suzuki, Akihito. "Dualism and the Transformation of Psychiatric Language in the Seventeenth and Eighteenth Centuries." *History of Science* 33 (1995): 417–47.

————. "Psychiatry without Mind in the Eighteenth Century: The Case of British Iatro-Mathematicians." *Archives Internationales d'Histoire des Sciences* 48 (June 1998): 119–46.

Swan, Claudia. "From Blowfish to Flower Still Life Painting: Classification and Its Images, circa 1600." In Smith and Findlen (2002), 109–36.

Syson, Luke, and Dora Thornton, eds. *Objects of Virtue: Art in Renaissance Italy.* Exhibition catalogue. Los Angeles: Getty Museum, 2001.

Talley, Mansfield Kirby. "Extracts from Charles Jervas's 'Sale Catalogues' (1739): An Account of Eighteenth-Century Painting Materials and Equipment." *Burlington Magazine* 120 (1978): 6–8, 11.

———. *Portrait Painting in England: Studies in the Technical Literature before 1700.* London: Paul Mellon Centre for Studies in British Art, 1981.

Tave, Stuart. *The Amiable Humorist: A Study in Comic Theory and Criticism of the Eighteenth and Early Nineteenth Centuries.* Chicago: University of Chicago Press, 1960.

Taylor, Francis Henry. *The Taste of Angels: A History of Art Collecting from Ramses to Napoleon.* Boston: Little, Brown & Co., 1948.

Tinniswood, Adrian. *His Invention So Fertile: A Life of Sir Christopher Wren.* Oxford: Oxford University Press, 2001.

Todd, Denis. *Imagining Monsters: Miscreations of the Self in Eighteenth-Century England.* Chicago: University of Chicago Press, 1995.

Torrey, Harry. "Athanasius Kircher and the Progress of Medicine." *Osiris* 5 (1938): 246–75.

Trapp, J. B. "Ovid's Tomb." *Journal of the Warburg and Courtauld Institutes* 36 (1973): 35–76.

Trevor-Roper, Hugh. "The Court Physician and Paracelsianism." In *Medicine at the Courts of Europe, 1500–1837,* edited by Vivian Nutton, 79–94. New York: Routledge, 1990. ———. *Europe's Physician: The Various Life of Theodore de Mayerne.* New Haven, CT: Yale University Press, 2006.

———. "Mayerne and His Manuscript." In Howarth (1993), 264–93.

Tribby, Jay. "Cooking (with) Clio and Cleo." *Journal of the History of Ideas* 52 (1991): 417–39.

Ucko, Peter, Michel Hunter, Alan Clark, and Andrew David. *Avebury Reconsidered: From the 1660s to the 1990s.* London: Unwin Hyman, 1991.

Uglow, Jenny. *Hogarth: A Life and a World.* London: Faber & Faber, 1997.

Van Eerde, Katherine. *Wenceslaus Hollar: Delineator of His Time.* Charlottesville: University of Virginia Press, 1970.

Vaughan, William. *British Painting: The Golden Age from Hogarth to Turner.* London: Thames & Hudson, 1999.

Vigne, Randolph. "Mayerne and His Successors: Some Huguenot Physicians under the Stuarts." *Journal of the Royal College of Physicians of London* 20 (1986): 222–26.

Wardropper, Bruce. "*Don Quixote:* Story or History." *Modern Philology* 63 (1965): 1–11.

Waterhouse, Ellis. *Painting in Britain 1530–1790.* New York: Penguin Books, 1953.

Webster, Mary. "Taste of an Augustan Collector: The Collection of Dr. Richard Mead." *Country Life* 147 (January 29, 1970): 249–51 and 148; (September 24, 1970): 765–67.

Wedd, Kit, Lucy Peltz, and Cathy Ross. *Artists' London: Holbein to Hirst.* Exhibition catalogue. London: Merrel, 2001.

Wendorf, Richard. *The Elements of Life: Biography and Portrait-Painting in Stuart and Georgian England.* Oxford: Clarendon Press, 1990.

Whinney, Margaret. *Sculpture in Britain 1530 to 1830.* Harmondsworth: Penguin Books, 1964.

———. "Sir Christopher Wren's Visit to Paris." *Gazette des Beaux-Arts* 51 (1958): 229-42.

Whinney, Margaret, and Oliver Millar. *English Art, 1625-1714.* Oxford: Clarendon Press, 1957.

White, Christopher. *Anthony van Dyck: Thomas Howard, the Earl of Arundel.* Malibu, CA: Getty Museum, 1995.

———. "Rubens's Portrait Drawing of Thomas Howard, Second Earl of Arundel." *Burlington Magazine* 137 (1995): 316-19.

Whitley, William. *Artists and Their Friends in England.* 2 vols. London: Medici Society, 1928.

Wills, Geoffrey. "An Early English China Formula." *Apollo* 67 (January 1958): 25.

———. "Salmon's *Polygraphice.*" *Apollo* 67 (February 1958): 58.

Wilson, Philip. "An Enlightenment Science? Surgery and the Royal Society." In *Medicine in the Enlightenment,* edited by Roy Porter, 360-86. Atlanta: Rodopi, 1995.

———. *Surgery, Skin, and Syphilis: Daniel Turner's London (1667-1741).* Atlanta: Rodopi, 1999.

Wimsatt, William. *The Portraits of Alexander Pope.* New Haven, CT: Yale University Press, 1965.

Woolfson, Jonathan. *Padua and the Tudors: English Students in Italy, 1485-1603.* Toronto: University of Toronto Press, 1998.

Wolstenholme, Gordon, and John Kerslake. *The Royal College of Physicians of London Portraits, Catalogue II.* Oxford: Excerpta Medica, 1977.

Wolstenholme, Gordon, and David Piper. *The Royal College of Physicians of London Portraits.* London: J. & A. Churchill, 1964.

Zimmermann, T. C. Price. *Paolo Giovio: The Historian and the Crisis of Sixteenth-Century Italy.* Princeton, NJ: Princeton University Press, 1995.

Zuckerman, Arnold. "Dr. Richard Mead (1674-1754): A Biographical Study." Ph.D. diss., University of Illinois, Urbana, 1965.

Note: Page numbers in italic indicate figures; pl. indicates color plate.

Kennedy, John, 155–56

Kelly, Jason, 268n2

Kent, William, 185, *186*, 187

Keynes, Geoffrey, 30–31

Kirby, Joshua, 190

Kircher, Athanasius, 25, 54–57, 63, 219n107

Klein, Lawrence, 6

Klestinec, Cynthia, 220n5

Kneller, Godfrey: Academy in Great Queen Street, 152–53; dedicatee of Salmon's *Polygraphice*, 114, 120; Jervas's teacher, 144; Kit Cat portraits as step toward a native school of English painting, 15; Locke portrait, owned by Alexander Geekie and Robert Walpole, 153; Mead's collection and portraits by, 138, 185, *pl. 1*; Radcliffe portrait, 138, *pl. 1*; Radcliffe quarrel, 1–2

Lambert, Charles, 188

Lanfranco, Giovanni, 102, 172

Lavater (Swiss physician), 97

Lazius, Wolfgang, 177

Le Brun, Charles, 98, 188

Le Camus, Antoine, *Abdeker: or, The Art of Preserving Beauty*, 243n106

Leeuwenhoek, Antonie van, 64

Le Fèvre, Nicolas (royal apothecary), 9, 62, 224n36

Lely, Peter: auction of his collection after his death, 241n86; Hooke apprenticed to, 71; house in Covent Garden, 2; and Royal Society, 92; school for life drawing, 152, 240n77

Leonardo da Vinci, 22–24, 32–33, 44, 89, 102–3, 106

Leoni, Giovanni, 60, *61*, *pl. 4*

Leti, Gregorio, *Il Nipotismo di Roma: or, The History of the Popes' Nephews*, 95

Levine, Joseph, 135, 204n39, 204n41

libertines, as foil to the ideal virtuoso, 5, 201n16

libraries: Arundel, 65–66, 89, 223n29; Bodleian, 39, 74, 89, 169, 216n75, 218n98; Cottonian, 89, 169–70; Don Quixote's study, 127; Douglas, James, 129; Evelyn, John, his advice on, 62, 222n13; Folkes, Martin, 247; Hearne, Thomas, 244n113; Marsigli, Luigi, 191; Mead, Richard, 129, 161, 164, *165*, 168–71, 177, 260n49; Merrett, Christopher, his ideals for, 133–34; Naudé, Gabriel, *Instructions Concerning Erecting of a Library*, 222n13; Radcliffe Camera in Oxford, 168–69, 251n53; Radcliffe, John, 168–69; Salmon, William, 110, 119; Thoresby, Ralph, 244n113

life drawing, 41, 152–53, 240n77

Linacre, Thomas, 53

Lipking, Lawrence, 99

lithotomies, and stones, 63, 158, 160, 253n79

Locke, John, 3, 5, 7, 17, 21, 70, 126, 153, 162, 172, 202nn23–24, 247n6

Lomazzo, Giovanni Paolo, *Tracte Containing the Artes of Curious Paintinge, Carvinge, and Buildinge. See* Richard Haydocke

Lorrain, Claude, 171, 260n50

Louis XIV (king), 106, 131

Loutherbourg, Philip James de, 196

Louvre, 75, 85, 89

Lower, Richard, 62, 69, 70

Lucretius, 77, *78*, 229n77

Ludovisi, Ludovico (cardinal), sale of his collection, 27–28

Mancini, Giulio, 55–56

Mandeville, Bernard, 122–24

Mapp, Sarah, 157, *158*, 192

Marat, Jean-Paul, 196

Maratti, Carlo, 67, 68, 171

Marcantonio Raimondi, 82–83